Listen

Listen

Rhona Bitner

Contributions by Natalie Bell,
John Hammer, Greil Marcus,
Jason Moran, and Iggy Pop

Edited by Éric Reinhardt

RIZZOLI
NEW YORK

New York · Paris · London · Milan

Foreword

Here are the ghost ships of American music.

17 Nussbaum Road, a square, bare room, potbellied stove, deer head on the wall. An American room. No tradition to speak of, nothing to cushion the psyche. Without music you could see a murder happening here. Turn to a bare gray-toned warehouse with nothing warmer and more human than a twelve-foot ladder and a rubber hose. AC ducts on the ceiling. This is the original 40 Watt Club in Athens, Georgia. Ah, this is a little better—a small club space with a stage at one end, set up with stools, folding chairs, and many tables for a polka-dot feeling of gaiety. The later 40 Watt Club, as it expanded its grip on the changing social territory of this volatile state. Gone is the constant threat of brute violence that led to the buttoned-up style of James Brown, and in its place here is the romper room of the white, whining irony and confidence of REM. A red guitar shaped like a woman, a set of drums to beat on, a fireplace in the background. A Renaissance print of the virgin on the mantel. 366 North Kilkea Drive in Los Angeles, the American communal home studio of Alain Johannes. Raw back stairs of the cold, gray USA alleyway. 508 Park Avenue, in Dallas, where Don Law recorded Robert Johnson.

Warehouse after warehouse. See the vital semen of America. Titillated into action by the raw and desperate efforts of half-sane musicians in the elegantly shaped, modestly appointed ballrooms and mini rooms of wet dreams. Churches made into music dens. Racetracks made into music dens. The specters of alcohol and Satan vigorously hovering. Can you hear the deep, excited breathing of the heaving crowds of US kids and the not so young? Can you see into the past by staring long enough into these eloquent photographs of the nearest thing America ever had to culture? Yes, yes, you can. Here are the places where love is to be found. A do-it-yourself love, nobody spelling it out for you from beginning to end on a screen, or a sports field as you watch, inert, castrated, neutered, a spectator. No, here is life in all its spectacular whimsy.

Behold the Moorish columns of the Aragon Ballroom. Yes, I have played there. I've done battle against the Ramones, a younger band, against the crowd that always threatens a latent indifference, and against death, which is what it's all about. But nothing in this world could have prepared

me for the utter wanton frenzied destruction that befell the Grande Ballroom, where I learned my trade. The Grande was one of a number of working men's and women's social spaces left over from the heyday of Detroit Industrial Power and reoccupied by mostly innocent and naïve groups of high school kids and dropouts trying to make sense of our lives in the LSD 1960s. A small stage and proscenium at one end, a sunken dance floor and a promenade surrounding the space like a horseshoe, where the boys and girls would walk and check each other out, an American version of the respectable mating rituals of old Spain. Most of the greats of the psychedelic era played here, and we kids of Michigan were privileged to appear in our own groups alongside them on the weekend bills. And now what? No graceful decline, no elegant decadence, no faded glory even—just a pile of frightening rubble in a dark catacomb.

Behold the American drum kit, no marching to victory here, no tom-tom to the gods, just a straight-four, get down motherfucker. Checkerboard floors, alcohol, some whores. One step away from jail, but that's here, too. See the eloquent jail door ajar. Waiting for he or she who trips and falls in escaping the American depression. See the big pink house of Bob Dylan alchemy. See the juke, the club, the lounge, the tabernacle, the rink, the opera; see the only decent competition that America has ever mounted against the movies. See the sports arena. See the strangely arid and clinical recording studio where your dream of the music you thought you were making becomes either crushed to dust, or amplified and deified into a genie who will serve you riches and liberties beyond the dreams of any ancient king. Behold the underground parking. Behold the grimy decorations. Listen for the beat of the perverse and ugly nation, and look at yourself in these settings, and find yourself beautiful, find yourself satisfied, find yourself undefeated. Behold Madison Square Garden and the gasps of chubby boys from New Jersey worshipping the Rolling Stones. Realize the suicidal emptiness of the dirt road through the American field—this field is the birthplace of the great American music that is now gone, gone, gone. And in this almost endless parade of significant and genuine images of the American musical nervous system, do what you will—dream with it, study it, exploit it for the future, have a wank, but here is great beauty and it is gone from the world.

Here are the ghost ships of American music.

—Iggy Pop

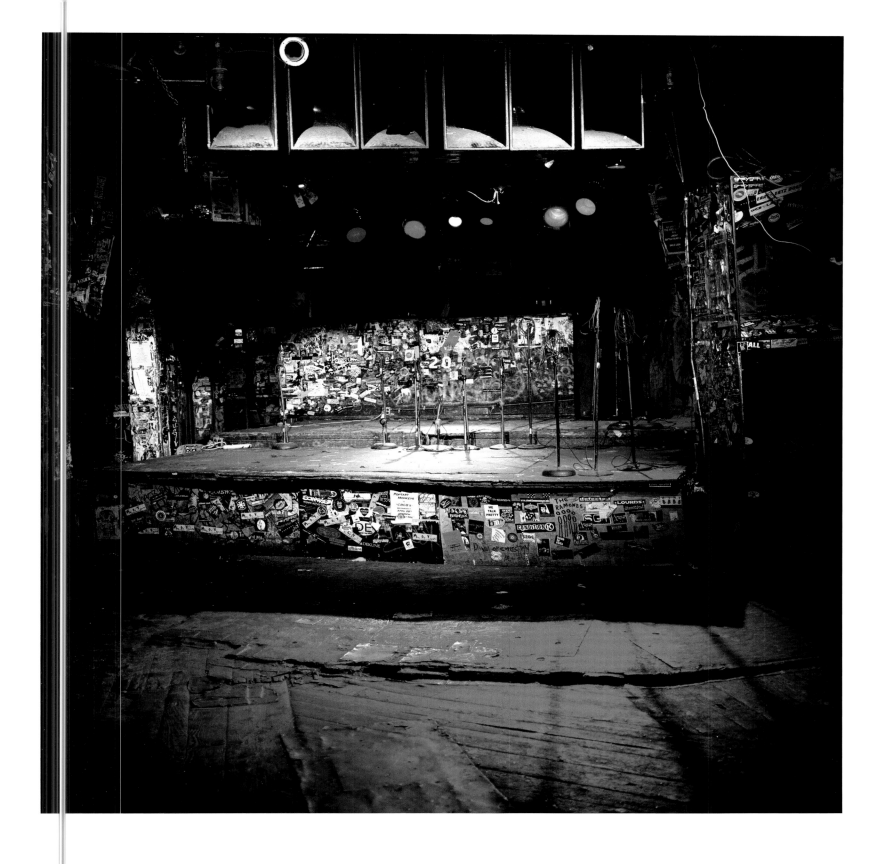

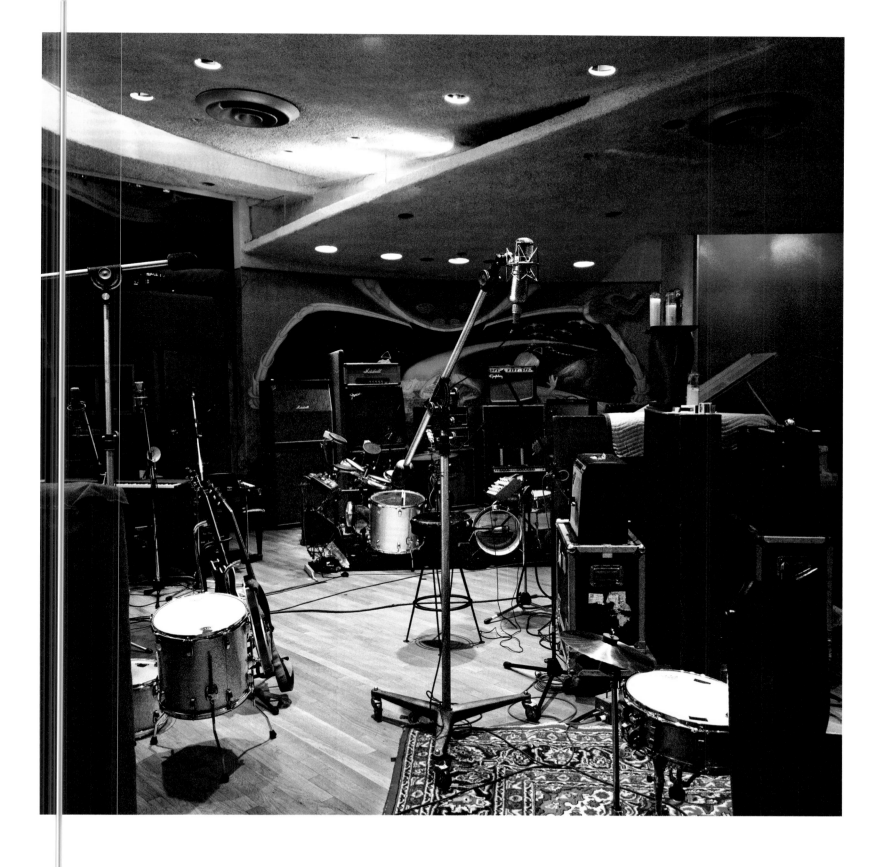

Electric Lady Studios, New York, NY — November 9, 2007

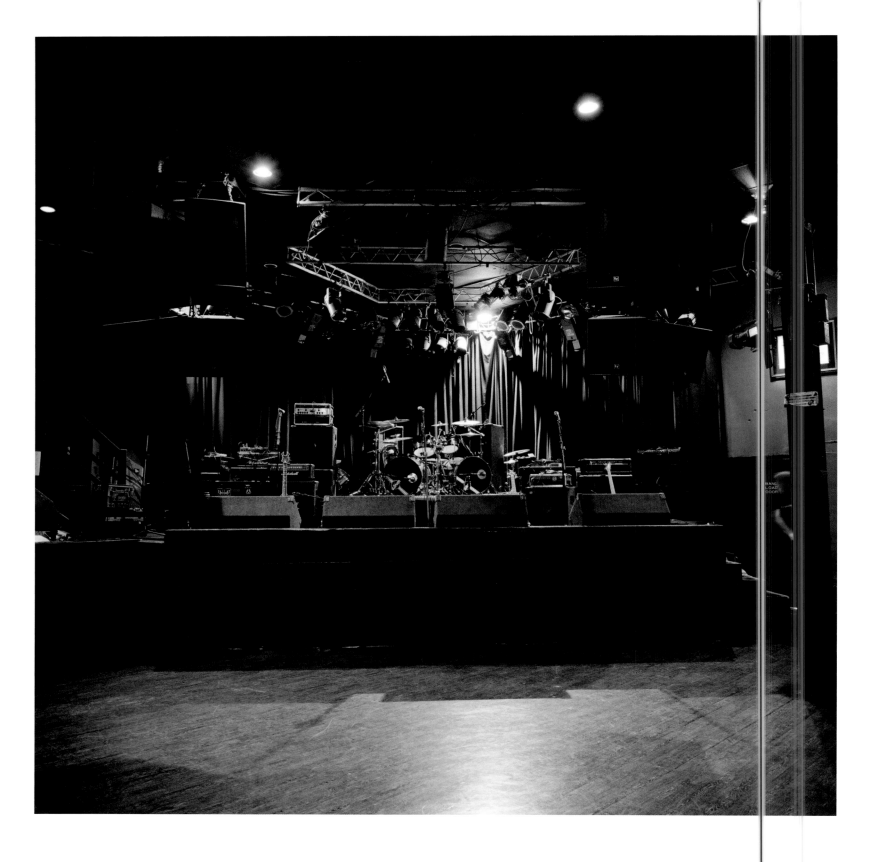

Whisky a Go Go, Los Angeles, CA — August 7, 2009

Utility Muffin Research Kitchen, Los Angeles, CA — July 29, 2015

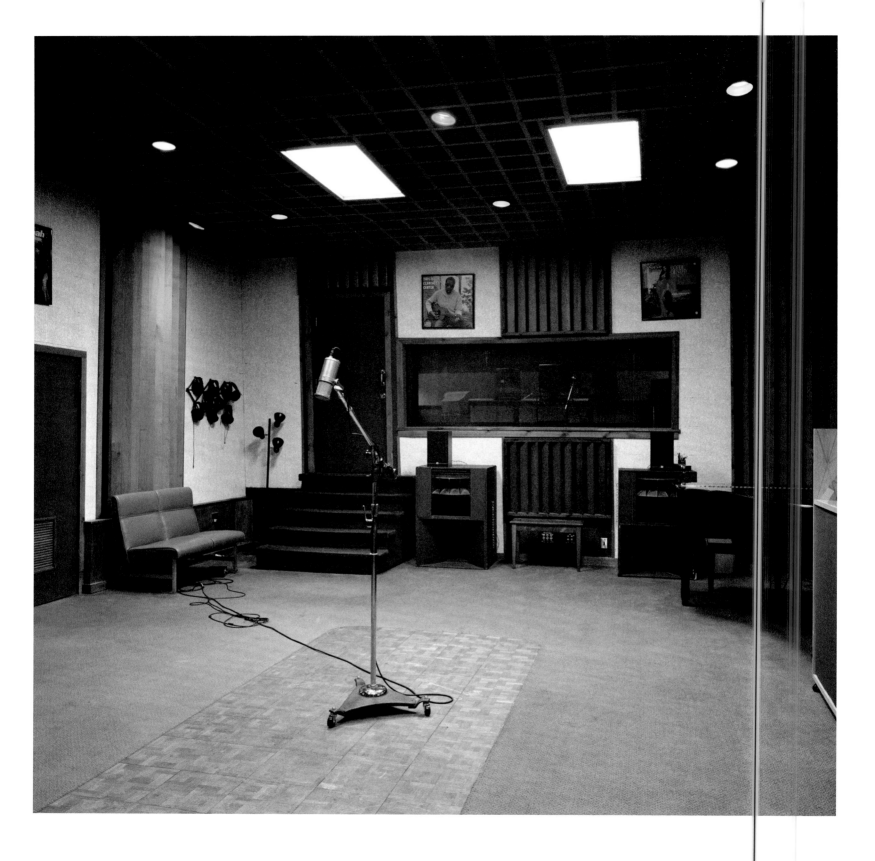

FAME Recording Studios, Studio A, Muscle Shoals, AL — May 8, 2008

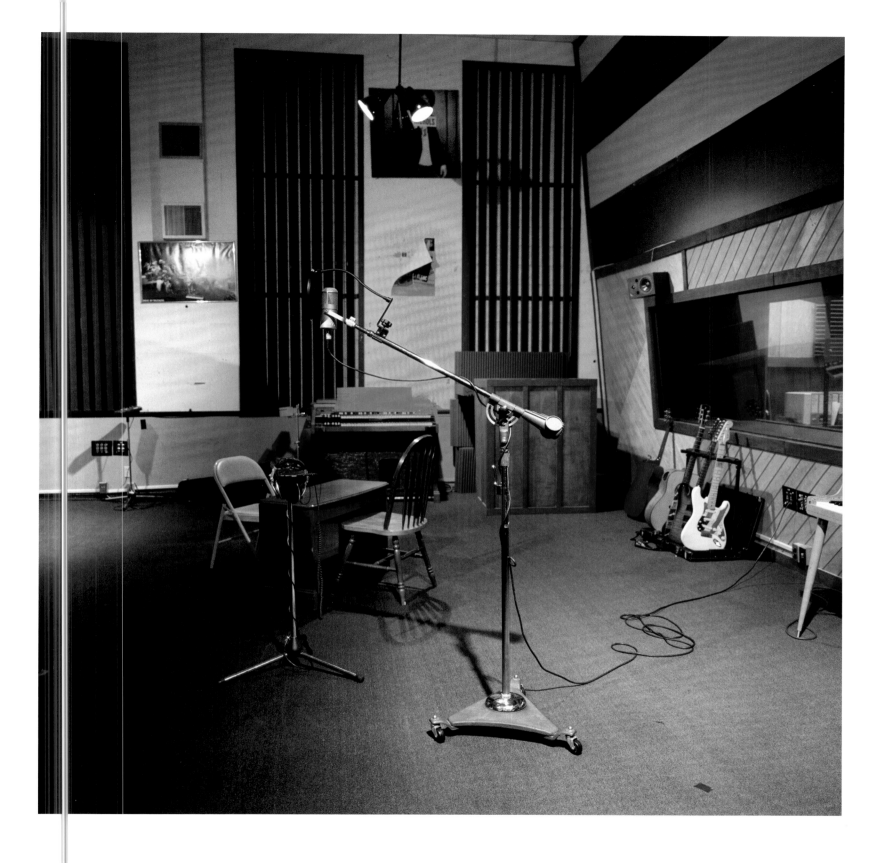

FAME Recording Studios, Studio B, Muscle Shoals, AL — May 8, 2008

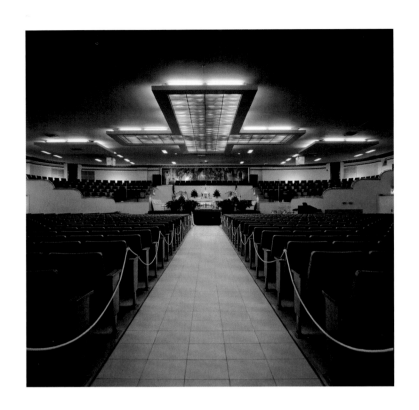

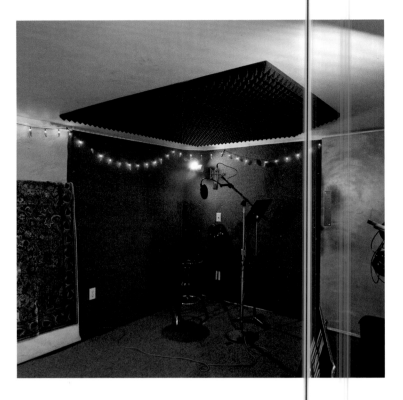

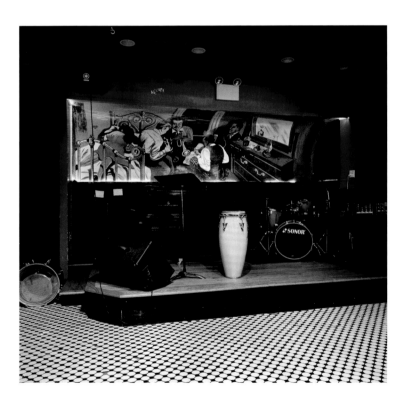

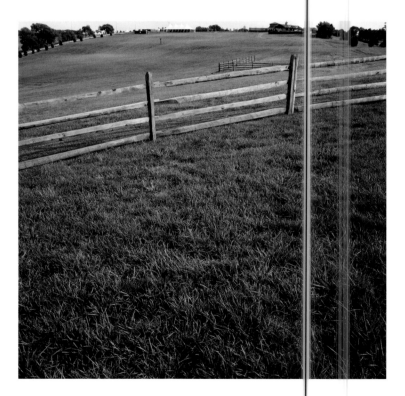

First Church of Deliverance, Chicago, IL — September 18, 2008
Egg Studios, Seattle, WA — November 18, 2015
Minton's Playhouse, New York, NY — September 30, 2009
Max Yasgur's Farm (Woodstock site), Bethel, NY — August 9, 2007

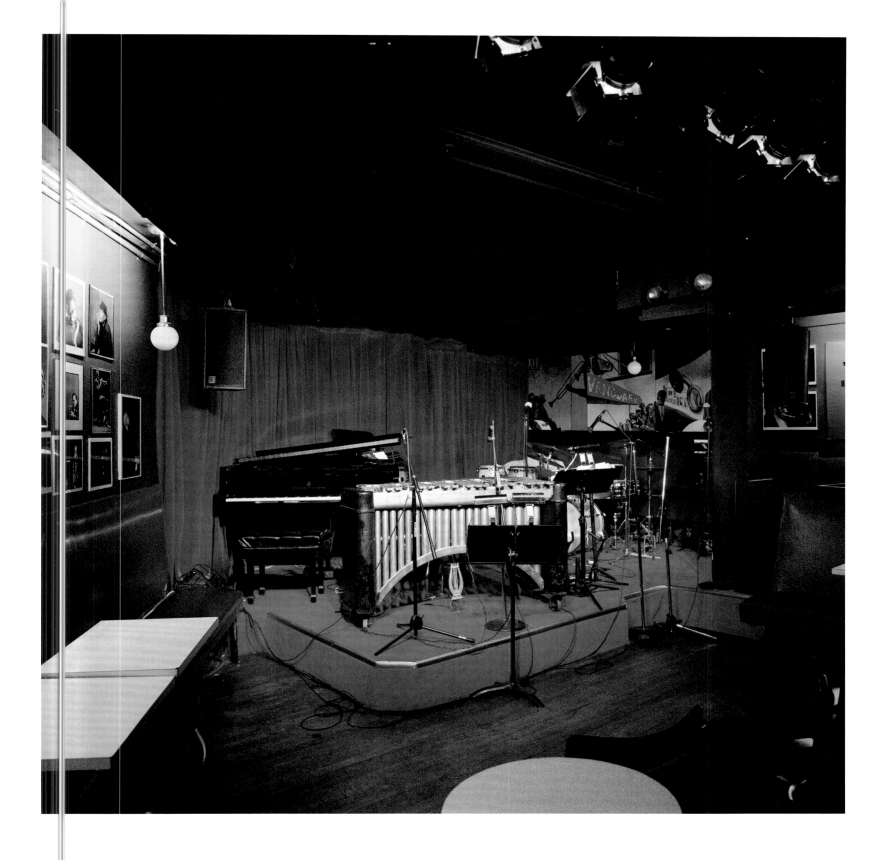

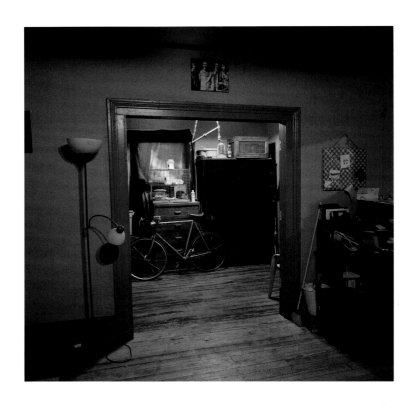

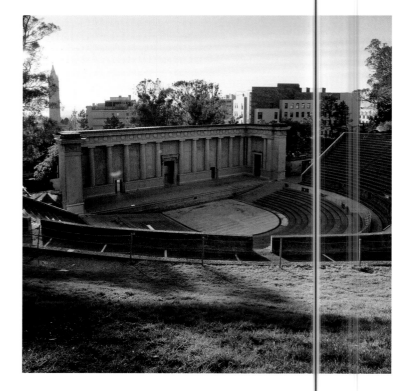

653 North Milledge Avenue, Athens, GA — June 22, 2015
Double Bayou Dance Hall, Anahuac, TX — January 16, 2013
Anderson Fair, Houston, TX — January 15, 2013
Greek Theatre, Berkeley, CA — November 12, 2015

Royal Studios, Memphis, TN — May 7, 2008

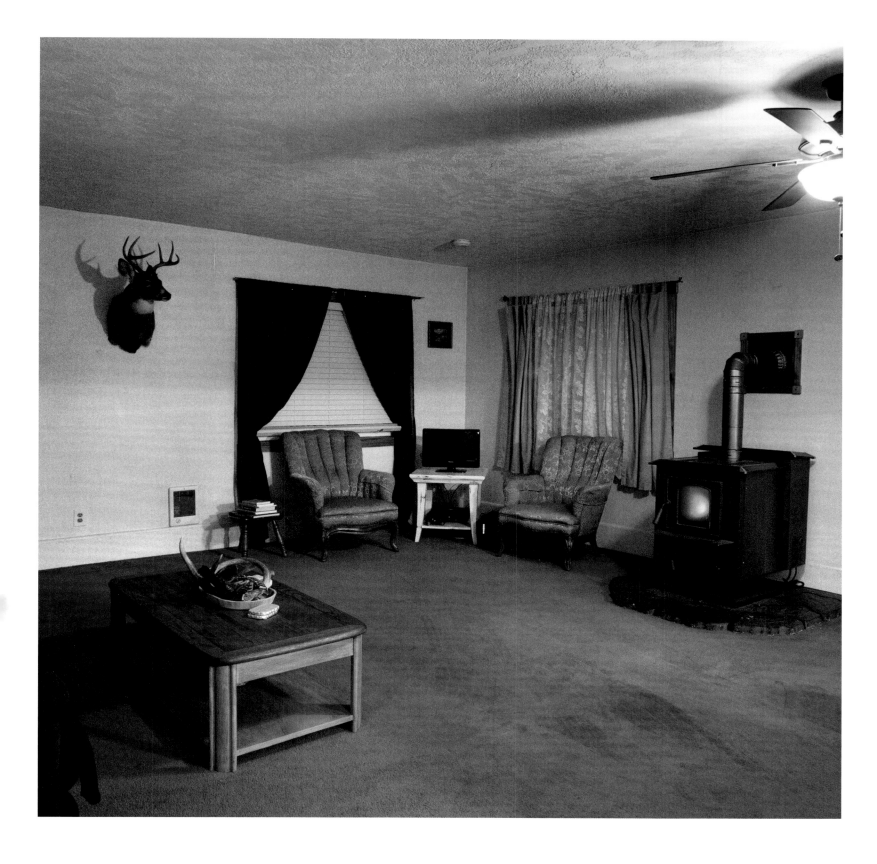

17 Nussbaum Road, Raymond, WA — November 17, 2015

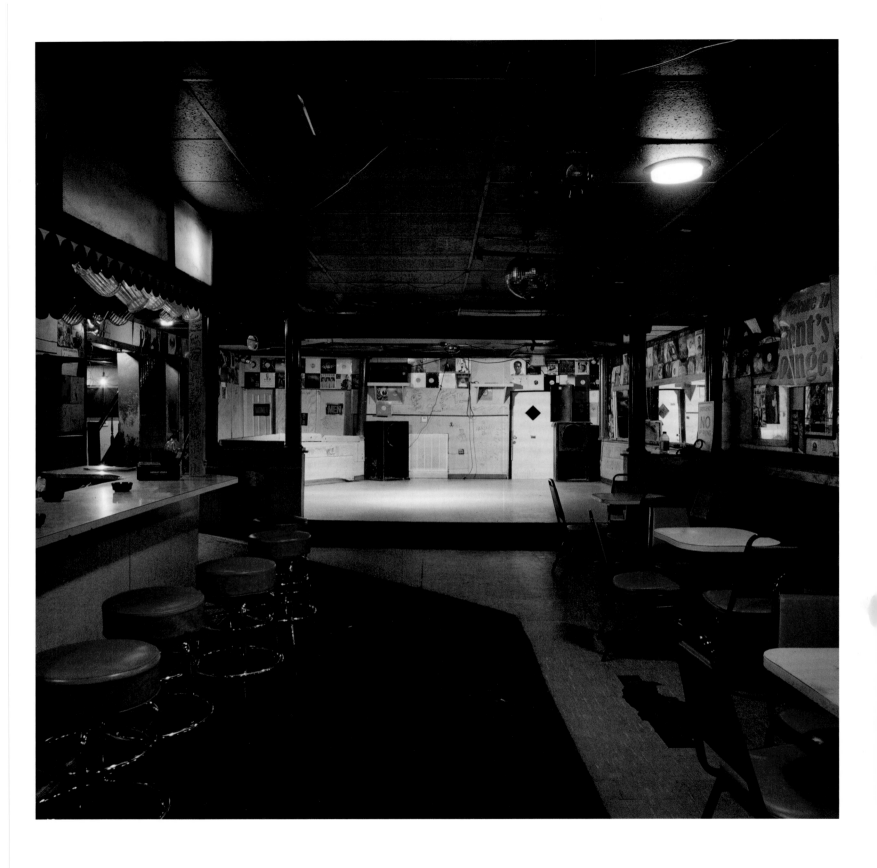

Grant's Lounge, Macon, GA — June 24, 2015

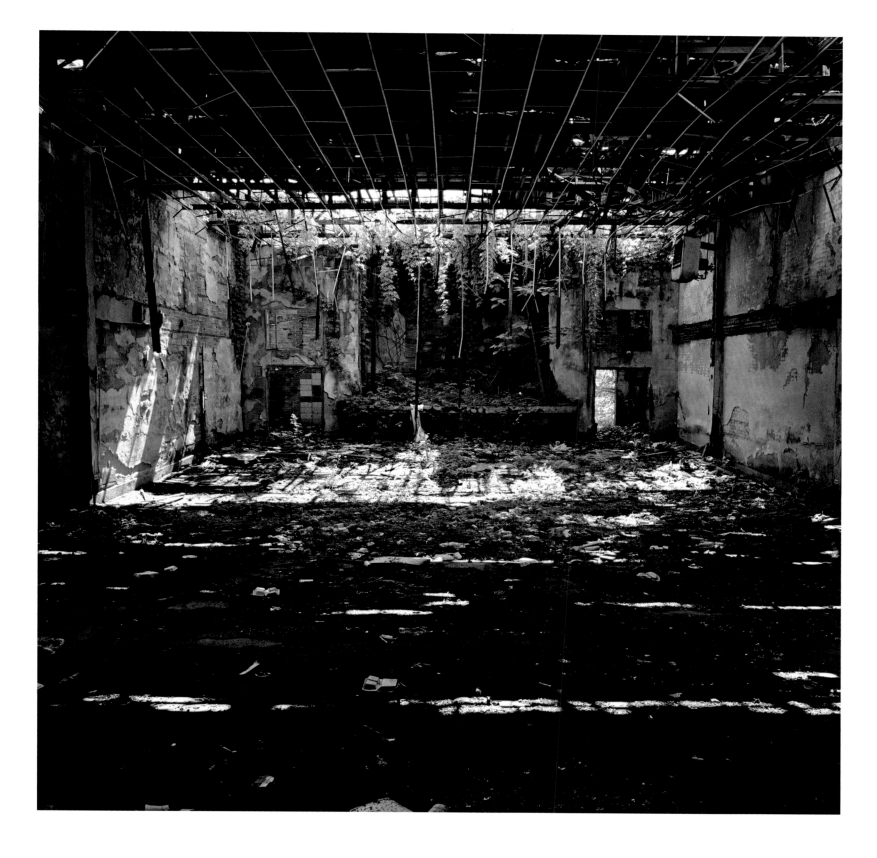

New Roxy Theater, Clarksdale, MS — May 9, 2008

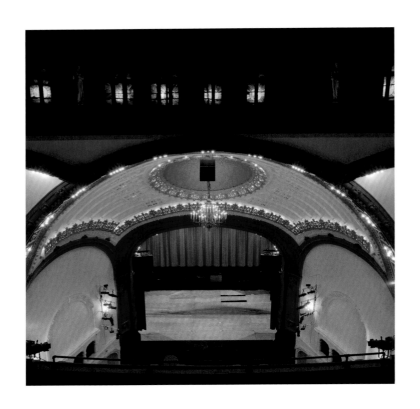
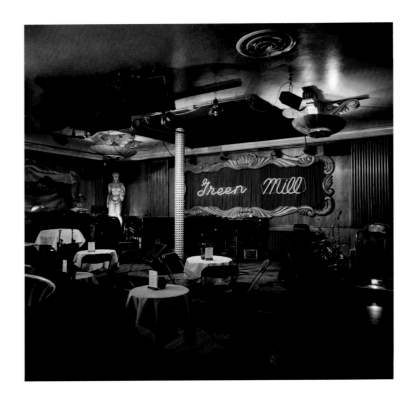

Moore Theatre, Seattle, WA — November 18, 2015
Green Mill Gardens, Chicago, IL — September 19, 2008
The Bitter End, New York, NY — June 6, 2008
Dockery Plantation, Cleveland, MS — May 9, 2008

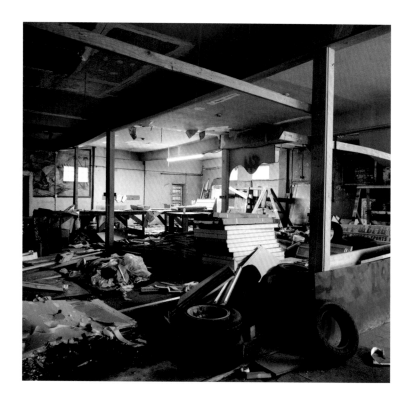

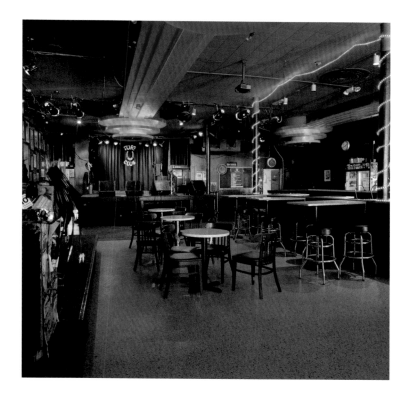

Mabuhay Gardens (site), San Francisco, CA — August 27, 2015
Freebody Park, Newport, RI — April 9, 2014
Shady's Playhouse (site), Houston, TX — January 15, 2013
Turf Club, St. Paul, MN — November 13, 2013

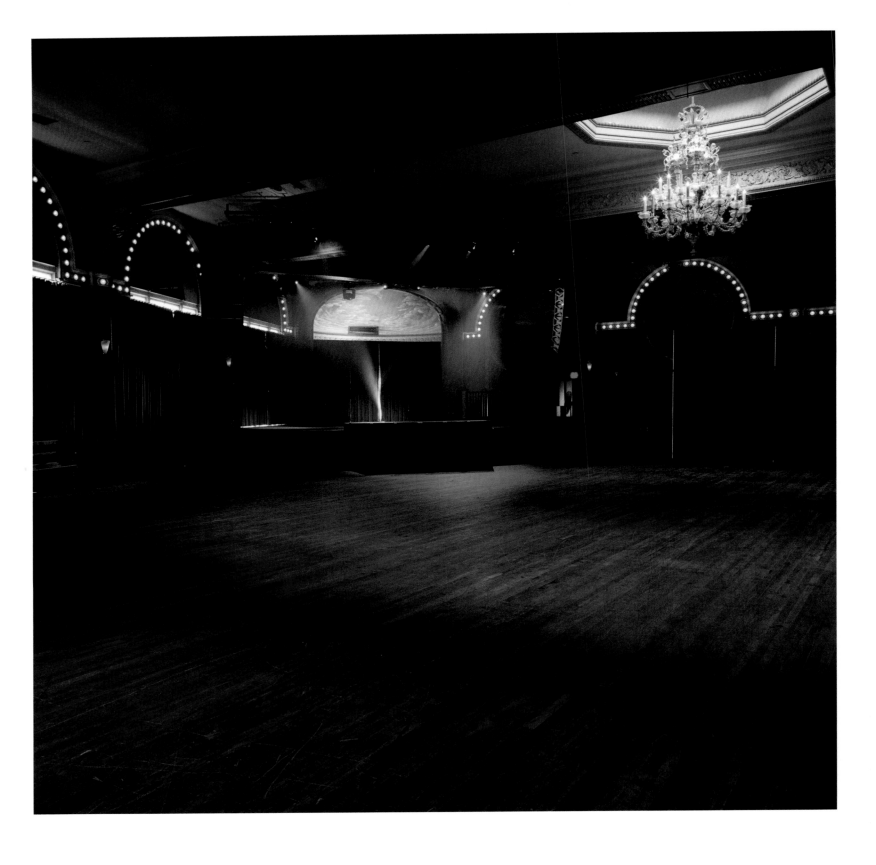

Crystal Ballroom, Portland, OR — November 16, 2015

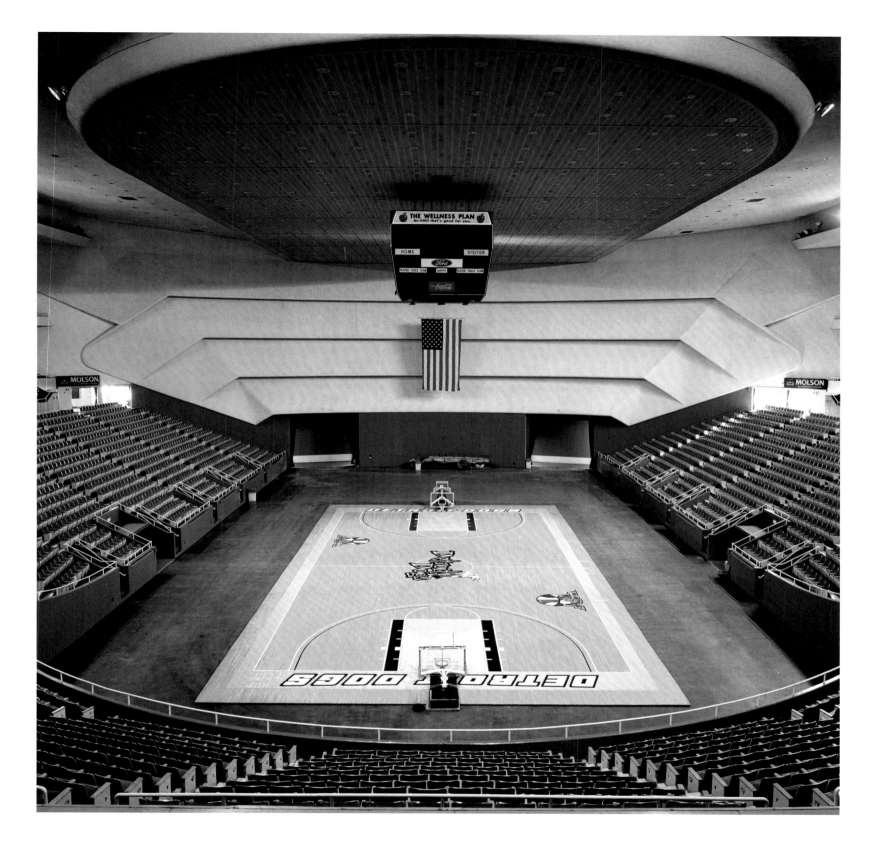

Cobo Arena, Detroit, MI — October 31, 2008

The Sutler, Nashville, TN — January 21, 2010

Club Paradise, Memphis, TN — May 8, 2008

Savoy Tivoli, San Francisco, CA — August 27, 2015

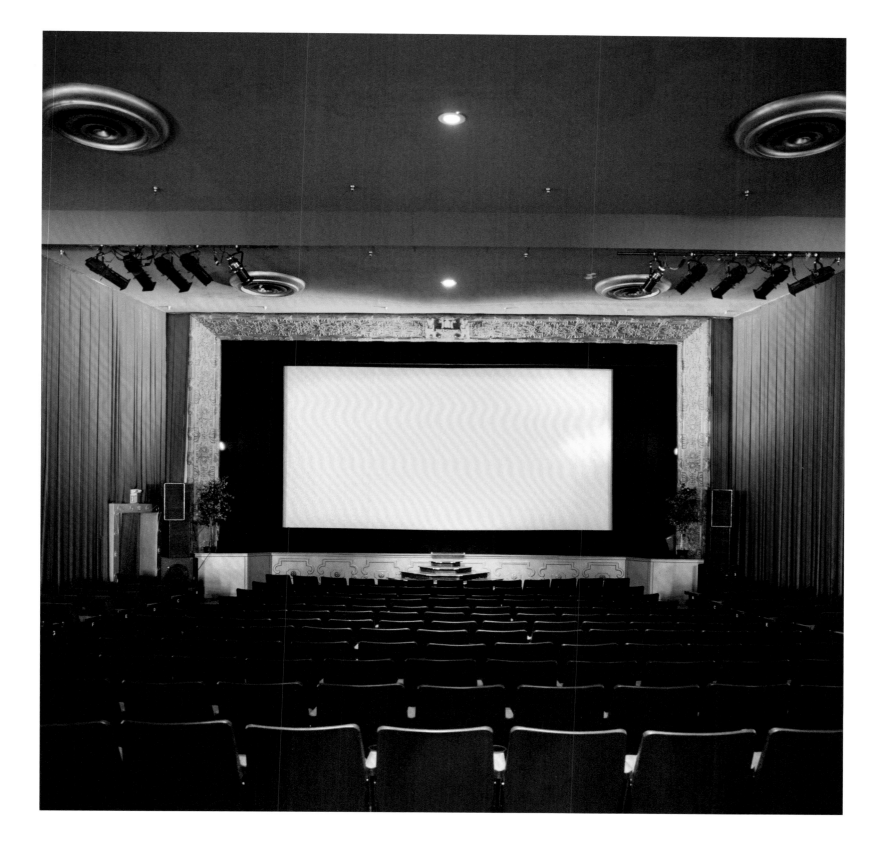

Belcourt Theatre, Nashville, TN — January 18, 2010

Harvard Square Theatre, Cambridge, MA — July 25, 2014

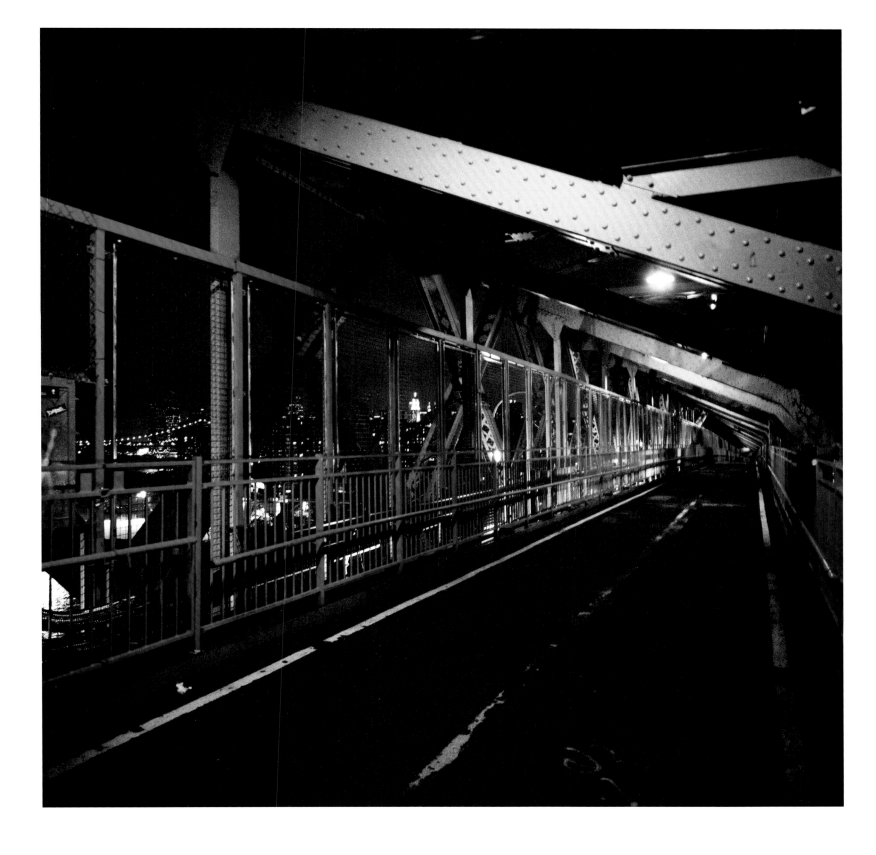

Williamsburg Bridge, New York, NY — May 23, 2009

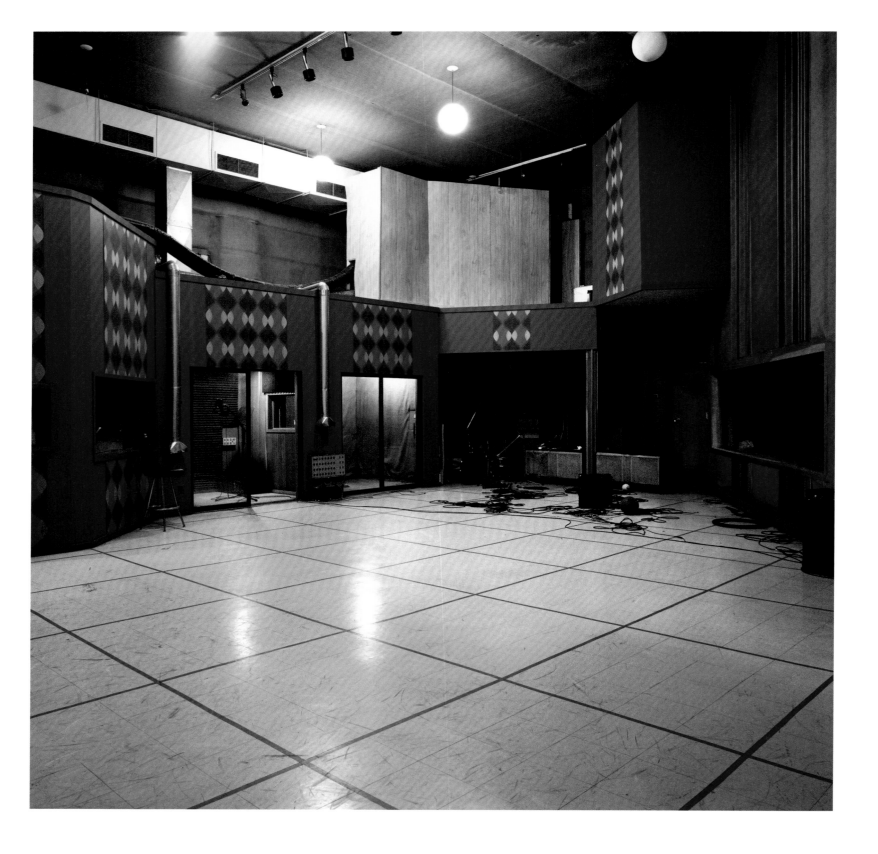

United Sound Systems, Detroit, MI — October 27, 2008

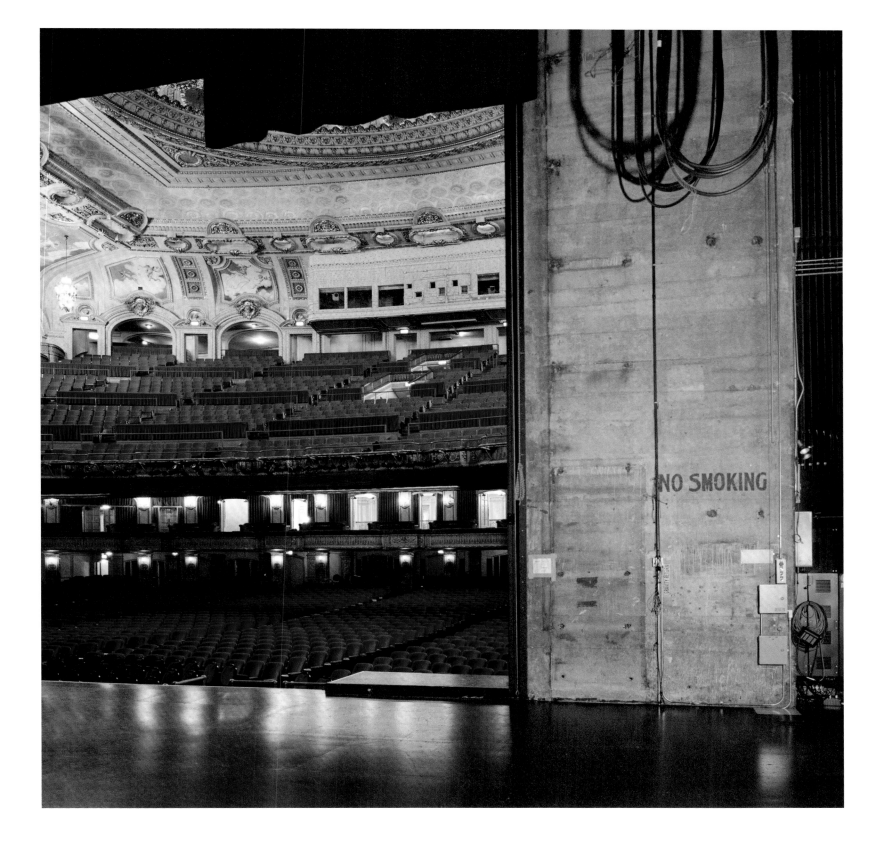

Chicago Theatre, Chicago, IL — September 17, 2008

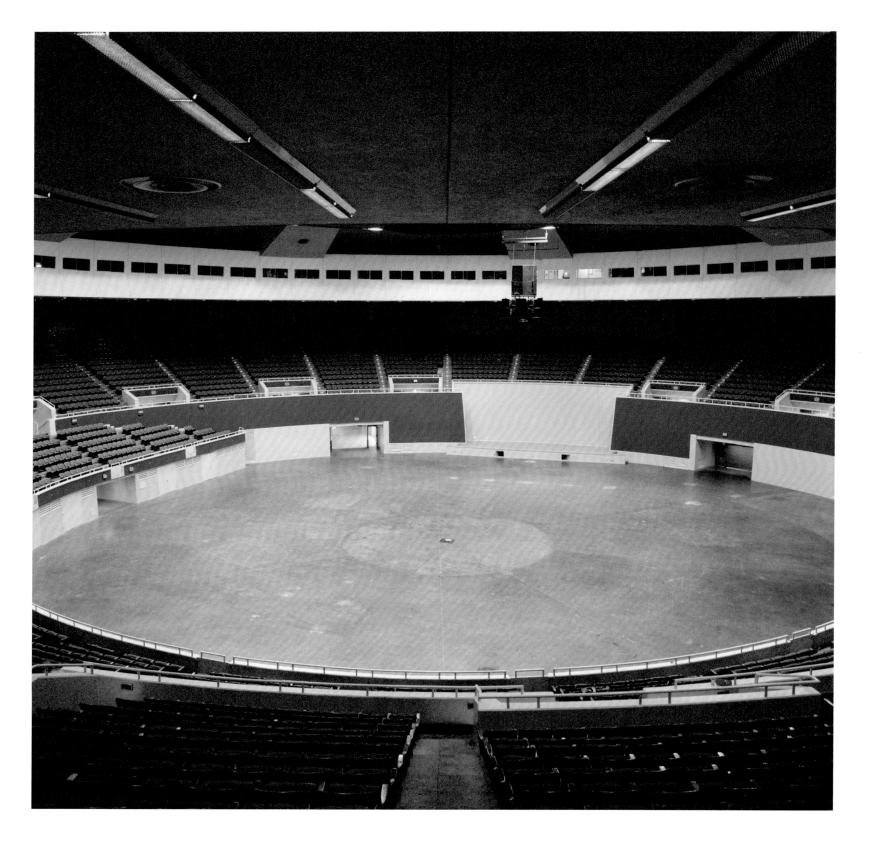

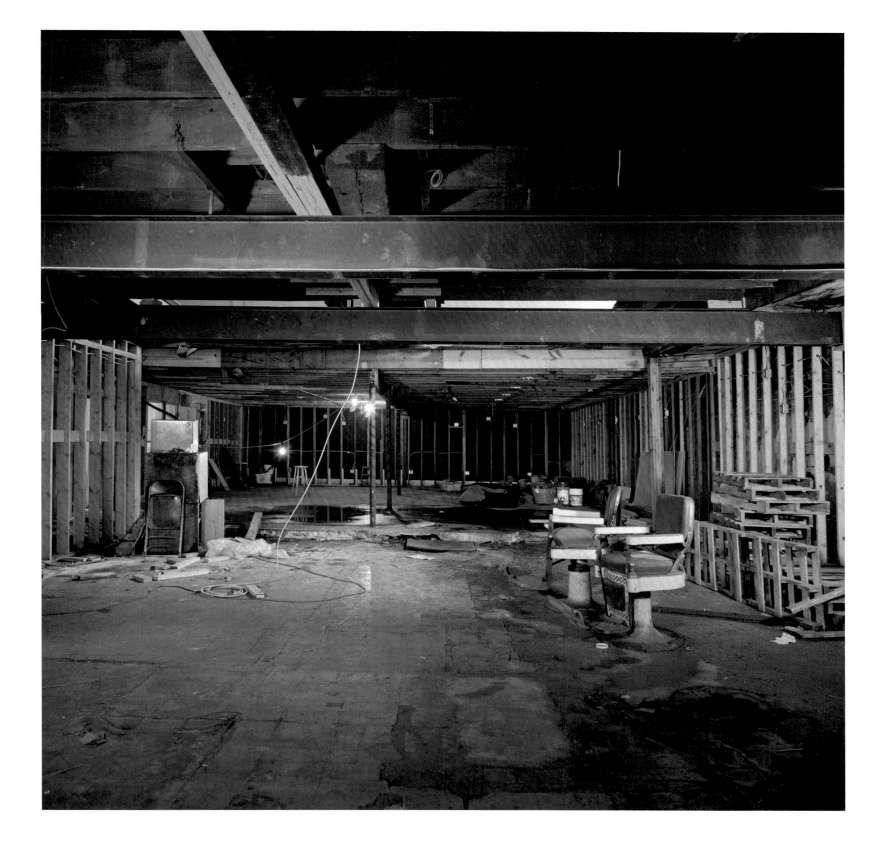

Dew Drop Inn (site), New Orleans, LA — June 7, 2016

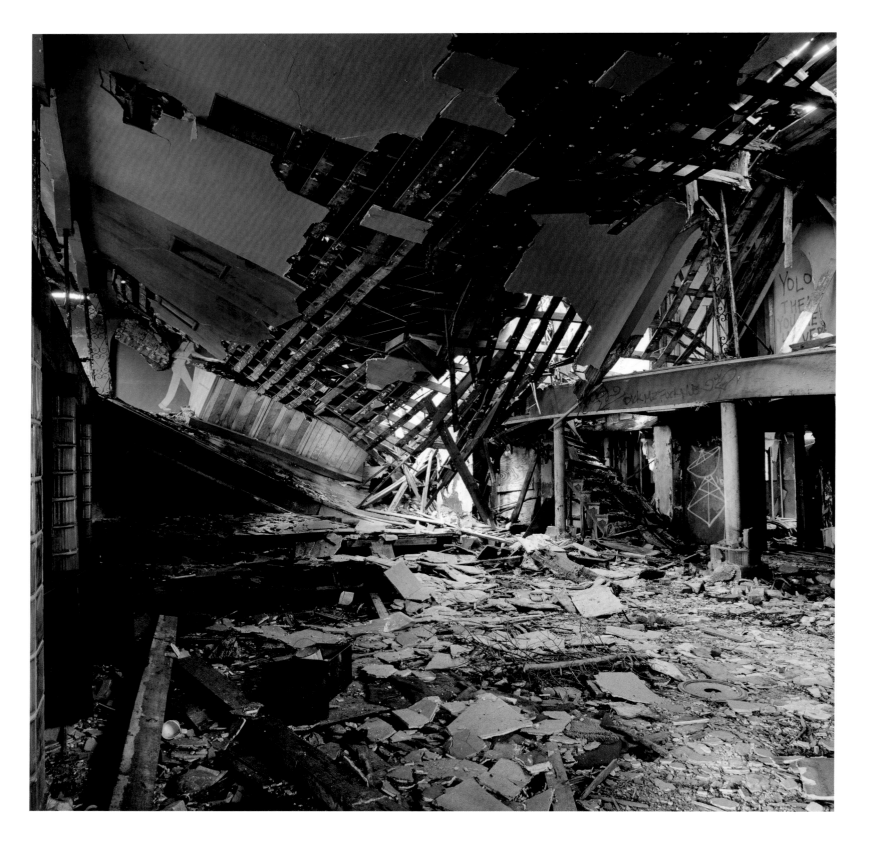

Club Desire, New Orleans, LA — March 15, 2016

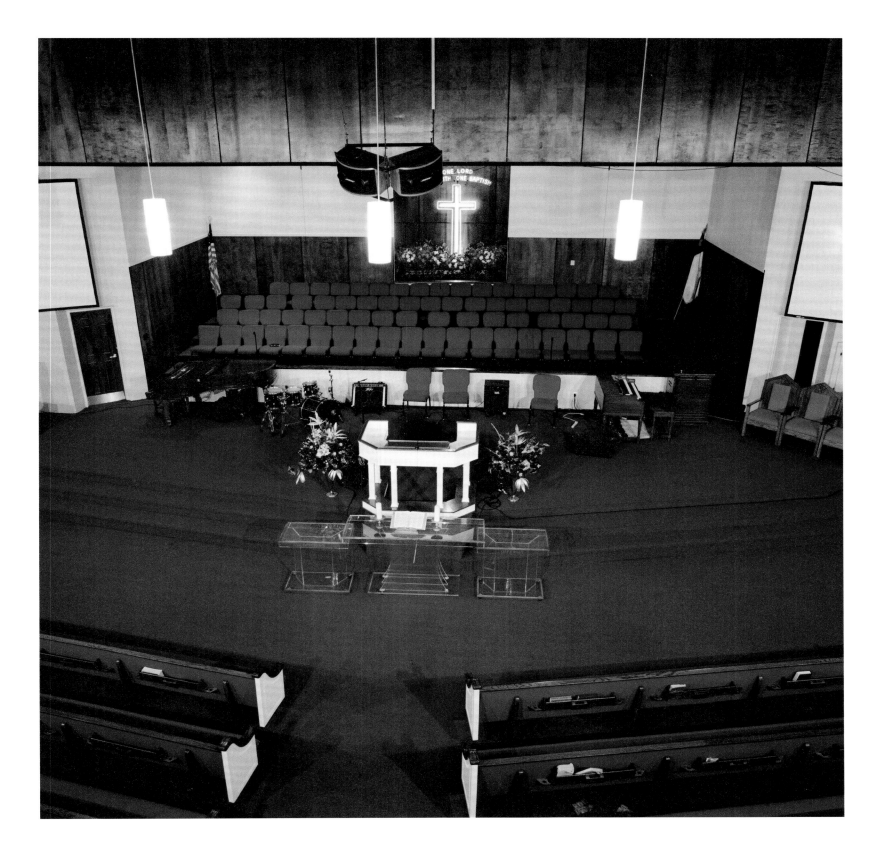

New Bethel Baptist Church, Detroit, MI — October 27, 2008

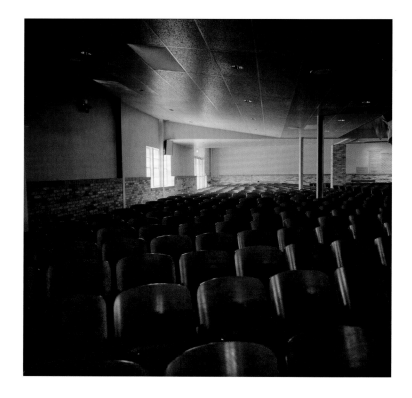

Ryman Auditorium, Nashville, TN — January 18, 2010
Kiel Opera House, St. Louis, MO — January 16, 2010
Village Club (site), Detroit, MI — October 30, 2008
Mason Temple, Memphis, TN — May 6, 2008

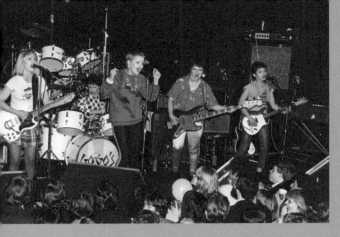

CBGB,
NEW YORK, NY

Hilly Kristal opened CBGB in December 1973 on a desolate strip of the Bowery. The announcement of the club's closing in 2006 motivated this project. The name on the awning, CBGB & OMFUG, was an acronym for "Country, Blue Grass, and Blues and Other Music For Uplifting Gormandizers." While country and bluegrass were never the dominant style, "Other Music" would prove to be prophetic, as a group of artists in the 1970s transformed the club into the birthplace of a popular music revolution that came to be called punk and new wave. The club supported countless musicians, and inspired a generation of fans outside the popular culture mainstream. The music created here, often carelessly classified as "punk," was so iconoclastic in those early years as to render any label completely meaningless. If there is one umbrella term we can use to bring together the aggressive art noise of Suicide; abrasive new wave bands like

DNA and Teenage Jesus and the Jerks; the self-conscious art-rock of Television, Talking Heads, Richard Hell and the Voidoids, and the Patti Smith Group; the bubble-gum juvenile delinquent rock of the Ramones and the Dead Boys; the irony-soaked stroll through pop music history of Jayne County, Blondie, the Fleshtones, and the Mumps; the B-movie horror rock of the Cramps and the Misfits; and the deconstructed jazz and funk of the Lounge Lizards and James Chance and the Contortions—"punk" seems as imprecise as simply calling it "music." The crucial thing all these bands shared is the stage and the audience at CBGB. More than a nightclub, CB's was a community.

ELECTRIC LADY STUDIOS,
NEW YORK, NY

The basement that became Jimi Hendrix's recording studio was a country-themed nightclub, the Village Barn, in the 1930s and '40s. It was then a nightclub called the Generation when Hendrix and his manager bought it in 1968 and began constructing

the facility known as Electric Lady Studios. To celebrate the studio's opening, a party was thrown on August 26, 1970, and the next day Hendrix made his last recording here. In less than three weeks he was dead. The studio proved to be a musician favorite. Stevie Wonder extensively used Electric Lady in the 1970s, and hits by Led Zeppelin, Lou Reed, and Blondie were recorded here. John Cale produced Patti Smith's *Horses* album at Electric Lady in 1975. The song "Fame" from the album *Young Americans* grew out of a 1975 jam session with John Lennon and David Bowie.

WHISKY A GO GO,
LOS ANGELES, CA

The first discotheque—a nightclub relying entirely on recorded music—opened in Paris in 1947 and was called the Whisky á Gogo. The name, with the Scottish spelling "whisky," came from the Compton Mackenzie novel *Whisky Galore*. In Chicago, a similar discotheque called the Whisky a Go Go opened in 1958, and the Sunset Strip Whisky opened on January 16, 1964. Unlike the Parisian disco, the Los Angeles Whisky supplemented records with live bands, and the opening night featured a performance by Johnny Rivers. Another innovation was placing a DJ booth above the stage, and hiring a female DJ who danced while spinning records. This gimmick was so popular that soon clubs all over the country had go-go dancers in cages suspended above dance floors. In the 1960s, the Whisky provided an important stage for LA bands like the Byrds, Buffalo Springfield, Love, the Turtles, and the Doors. The Whisky was the venue for early West Coast performances by Led Zeppelin, Cream,

and the Ramones. In the 1980s and '90s, heavy metal and hard rock groups like Guns N' Roses and Metallica, and grunge bands Soundgarden and Mudhoney, played the Whisky.

UTILITY MUFFIN RESEARCH KITCHEN,
LOS ANGELES, CA

This odd, narrow space was used as an echo chamber in the recording studio Frank Zappa built in his Hollywood home. The studio was completed in 1979. Two Zappa songs, which both predate the studio, mention a Utility Muffin Research Kitchen. The first is "Muffin Man," from the album *Bongo Fury*. The second is "A Little Green Rosetta" from *Joe's Garage*, the first album to be mixed in the new studio.

FAME RECORDING STUDIOS, STUDIO A,
MUSCLE SHOALS, AL

Established in 1959 in Florence, Alabama, and moved to Muscle Shoals in 1961, Florence Alabama Music Enterprises Studios produced multiple hit records. Producer Jerry Wexler brought Aretha Franklin to FAME Studio A after signing her to Atlantic Records in 1967. The first tracks she worked on with the house band were "I Never Loved a Man (the Way I Love You)" and "Do Right Woman, Do Right Man"—records that would help make her reputation as the undisputed "Queen of Soul." Those responsible for what became known as the Muscle Shoals sound, the house band sometimes called the FAME gang, or the Swampers, were a group of white musicians who backed up some of the era's most successful soul and R&B artists. Some of the greatest tracks of the late 1960s and early '70s recorded at FAME include Wilson Pickett's "Land of 1,000 Dances," the Staple Singers' "I'll Take You There," and Etta James's 1968 *Tell Mama*, praised as one of the best albums of the rock and roll era. **(See FAME Recording Studios, Studio B; Muscle Shoals Sound Studio, Muscle Shoals, AL.)**

FAME RECORDING STUDIOS, STUDIO B,
MUSCLE SHOALS, AL

Florence Alabama Music Enterprises Studios found their business growing by the mid-1960s. In order to handle surplus bookings, Studio B was constructed in 1967. Members of what would soon become the Allman Brothers Band used Studio B for auditions and jam sessions. Many of the great horn arrangements for FAME recordings were laid down in Studio B, along with "Hey Joe" by Wilson Pickett and "Greenwood, Mississippi" by Little Richard. More recently, Jason Isbell has recorded in Studio B, both solo and as a member of Drive-By Truckers. **(See FAME Recordings Studios, Studio A, Muscle Shoals, AL; Muscle Shoals Sound Studio, Sheffield, AL.)**

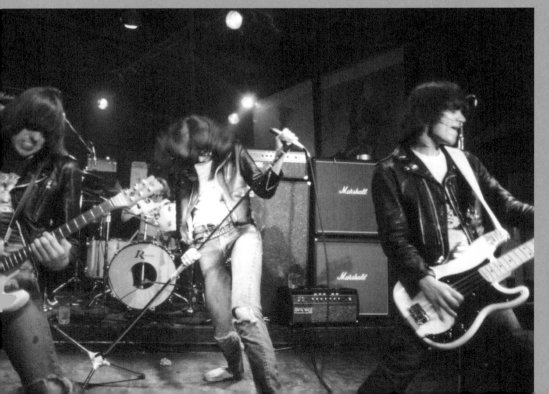

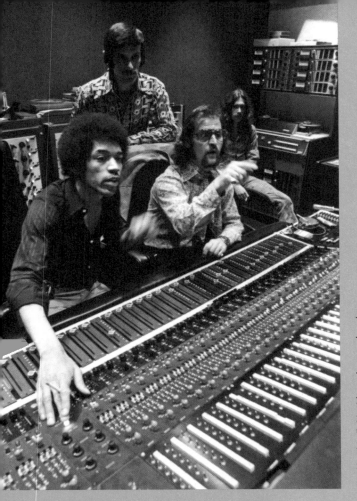

FIRST CHURCH OF DELIVERANCE,
CHICAGO, IL

This 1939 building is a gorgeous example of the Streamline Moderne style, and was designed by Walter T. Bailey, the first African American architect registered in Illinois. The First Church of Deliverance was founded in 1929, and in 1934 it launched a weekly radio program that gave Rev. Clarence H. Cobbs and his two hundred–person choir national exposure. After moving into their new building in 1939, music director Kenneth Morris brought in a Hammond electric organ, giving the choir a novel sound and creating a blueprint for modern gospel music. The weekly Sunday night broadcasts became so popular that they started to attract celebrity guests. Notable musicians Louis Armstrong, Nat King Cole, Dinah Washington, and the "mother of Gospel music" Sallie Martin appeared on Church of Deliverance broadcasts.

EGG STUDIOS,
SEATTLE, WA

Record producer, engineer, and label owner Conrad Uno began recording local Seattle bands in 1980. The Young Fresh Fellows' debut album, *The Fabulous Sounds of the Pacific Northwest*, was the first release of Uno's PopLlama label. Bands in the Seattle scene who recorded at Egg Studios span garage rock like the Mono Men and Dharma Bums, grunge from Mudhoney, and riot grrrls Bratmobile. Uno mixed New York noise rockers Sonic Youth's *Dirty* album at Egg in 1992. In an era when major recording studios had automated much of the recording process and the industry was quickly adopting digital recording as the standard, Uno built his studio around traditional analog equipment. Egg boasted a 1960s vintage recording console originally designed and used by Stax Records in Memphis. The studio closed in 2017 when Uno retired.

MINTON'S PLAYHOUSE,
NEW YORK, NY

Located on the ground floor of the Cecil Hotel, Minton's was the birthplace of a new form in jazz music called bebop. In 1938, the tenor saxophonist and musicians union delegate Henry Minton established the club with the idea that it would be a place for musicians to relax when not working. Minton's generosity with food and loans for economically distressed jazz players furthered this goal. Regular jam sessions and improvising music with their peers, free from the constraints of playing charts, also appealed to musicians. In 1940, bandleader Teddy Hill was asked to manage the club and was charged with putting together a house band. Pianist Thelonious Monk, drummer Kenny Clarke, Nick Fenton on bass, and Joe Guy on trumpet were the line-up, augmented by frequent appearances by trumpet player Dizzy Gillespie and electric guitarist Charlie Christian. The music created by this core band and the soloists sitting in at jam sessions was the foundation for a revolution in jazz harmony and rhythm called bebop. Monday night was Celebrity Night, where any musician headlining at the nearby Apollo Theater would be treated to a free meal at Minton's. A jam session would follow, resulting in the top jazz musicians engaging in a cutting contest—an instrumental duel. Dizzy Gillespie might have been pitted against his mentor Roy Eldridge, trading improvised choruses until one retired or the crowd loudly proclaimed a winner. Circa 1942, Charlie Parker, the innovative alto saxophonist, began appearing at jam sessions regularly. Soon other musicians interested joined in: Fats Navarro, Miles Davis, Art Blakey, and Max Roach were among this first generation of bebop. In the 1950s, the jam sessions were phased out to focus on shows starring bigger names. The club's reputation for cutting-edge music was gone by the 1960s. Mural pictured above the bandstand: © Charles Graham. **(See Apollo Theater, New York NY.)**

MAX YASGUR'S FARM (WOODSTOCK SITE),
BETHEL, NY

Max Yasgur rented his farm for the Woodstock Music and Art Fair on August 15–18, 1969. The stage would have been on the bottom left side of the photograph. Yasgur was a farmer, not a pop music fan, and politically conservative. However, he believed in free expression and remarked in the *New York Times* that older people should do more to close the generation gap. Some of the musicians invited to play included Jimi Hendrix, the Who, the Band, Janis Joplin, Johnny Winter, Creedence Clearwater Revival, Arlo Guthrie, Jefferson Airplane, Joan Baez, Santana, Joe Cocker, and Crosby, Stills, Nash & Young. As the documentary film of the festival by Michael Wadleigh shows, the hundreds of thousands of young people who showed up quickly overwhelmed the insufficient organization. Out of necessity, the festival became a free event and a financial disaster for the promoters. The critically acclaimed documentary film would be one of the most profitable films the year of its release, in 1970.

VILLAGE VANGUARD,
NEW YORK, NY

In 1934, Max Gordon, owner of the Village Fair coffeehouse, bought this building that had previously housed a speakeasy called the Golden Triangle. He named the basement of the odd, triangular structure the "Village Vanguard." Originally a venue for folk music and poetry readings, by the late 1950s the club booked almost exclusively jazz. It became the premier venue for modern jazz in Greenwich Village, regularly showcasing Thelonious Monk, Charles Mingus, and pianist Bill Evans. Dozens of live albums have been recorded at the Vanguard. When Max Gordon died in 1989, it continued under the management of his wife, Lorraine Gordon, until her death in 2018, and is now owned by their daughter, Deborah Gordon. The Vanguard Jazz Orchestra, formerly the Thad Jones/Mel Lewis Orchestra, held a Monday night residency here for more than five decades. Pianist and composer Jason Moran, author of one of this book's essays, has appeared at the club many times and recorded a live album in 2016 titled *Thanksgiving at the Vanguard*. Mural © David Ellis, 1996.

653 NORTH MILLEDGE AVENUE,
ATHENS, GA

The idea for the B-52s was dreamed up while the future bandmates shared an appropriately kitschy tiki cocktail at a Chinese restaurant in Athens, Georgia, in October 1976. Four short months later, the band played their first show, which was a house party in this private home on Valentine's Day 1977. They quickly established a reputation as the best party band in Athens. Through touring small out-of-town clubs, such as CBGB in New York, they increased their exposure in the press, leading to interest in the burgeoning music scene in Athens and paving the way to success not only for the B-52s, but also for their hometown peers, among them R.E.M., Pylon, Love Tractor, and the singer-songwriter Matthew Sweet.

DOUBLE BAYOU DANCE HALL,
ANAHUAC, TX

Known as the oldest blues bar in Texas, this dance hall was originally established in the 1920s. Damaged by a storm in 1941, it was rebuilt in 1946. The dance hall was a stop on the Chitlin' Circuit, which brought touring blues musicians to this rural African American community. An appearance by T-Bone Walker inspired one young Double Bayou lad, Pete Mayes, to become a blues musician himself, and in 1963 he took over the house band at the dance hall. In 1983, Mayes inherited the Double Bayou Dance Hall from his uncle and managed the business until his death in 2008.

ANDERSON FAIR,
HOUSTON, TX

Originally opened as a spaghetti restaurant in 1969, Anderson Fair is one of the oldest continually operating acoustic and folk music venues in the U.S. It became a meeting place for artists, iconoclasts, and folk singers. It evolved into an incubator of folk music talent through the 1970s and '80s. Performers who credit Anderson Fair with helping them develop their careers include Lucinda Williams, Nanci Griffith, Robert Earl Keen, Lyle Lovett, and Townes Van Zandt.

GREEK THEATRE,
BERKELEY, CA

Officially called the William Randolph Hearst Greek Theatre, this amphitheater was built in 1903 on the campus of the University of California, Berkeley. In addition to student theatrical productions, it has been a live music venue. In the 1960s, Jefferson Airplane, Joni Mitchell, and Neil Young were some of the acts, and the Grateful Dead played the Greek twenty-nine times. The Greek has been home to the Berkeley Jazz Festival since its inception in 1967. The first festival program included Miles Davis, the Modern Jazz Quartet, the Horace Silver Quintet, and the Bill Evans Trio. In 1964, in front of a campus building, activist Mario Savio gave an address that was pivotal to the Berkeley Free Speech Movement, which inspired student protests around the country in the coming years.

ROYAL STUDIOS,
MEMPHIS, TN

The original structure was built in 1915 and opened as the Shamrock movie theater, later called the Rex, and finally the Royal Theatre in the 1920s until its closing in 1955. In 1956, Hi Records president Joe Cuoghi bought the building and converted it into a recording facility. Bill Black, Elvis Presley's bass player from his Sun Records days, had the first hits recorded at Royal—a string of

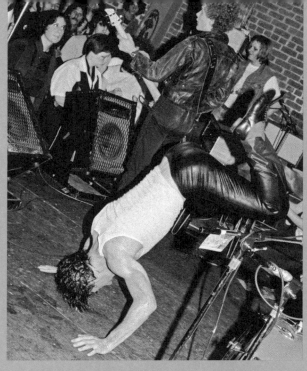

Lance Loud of the Mumps doing a headstand onstage at the Mabuhay in San Francisco, 1979.

instrumentals—earning the new studio the nickname "House of Instrumentals." Over the course of the 1960s, recording artist and record producer Willie Mitchell would steer Hi Records away from rockabilly and more toward R&B, creating a distinct Memphis soul sound at Royal. Mitchell signed Al Green to a record deal in 1968, setting the stage for a string of soul hits in the 1970s. Ann Peebles also had a series of hits recorded there in that decade, including "I Can't Stand the Rain" and "I'm Gonna Tear Your Playhouse Down." Mitchell guided Otis Clay and O. V. Wright through many successful records. In 1975, Rod Stewart recorded his hit cover of "This Old Heart of Mine," a song written by Motown songwriting team Holland-Dozier-Holland.

17 NUSSBAUM ROAD,
RAYMOND, WA

In this suburban living room on a rainy night in March 1987, Kurt Cobain, Krist Novoselic, and drummer Aaron Burckhard played their first show together before they had officially agreed to name their group Nirvana. The event was a house party at Tony Poukkula's home. The band was booked by Ryan Aigner, a classmate of Cobain and Novoselic, who had taken upon himself to convince them that they should play before an audience. Poukkula reportedly sat in on guitar for a Led Zeppelin cover during the band's sound check. Most of the audience stayed in the kitchen drinking beer while they played. A highlight of the show was Novoselic, covered in fake blood, jumping out a window while still playing his bass. The show ended with a twenty-minute version of "Sex Bomb," a song by the punk band Flipper.

GRANT'S LOUNGE,
MACON, GA

Established in 1971, Grant's Lounge became instrumental in the creation of Southern rock. Capricorn recording artists the Allman Brothers Band, Lynyrd Skynyrd, and Wet Willie all played here in the early stages of their careers. The club's location, between Capricorn's executive office and its studios, seems to have contributed to the heavy slant toward Southern rock. Wet Willie's singer got the Marshall Tucker Band a booking at the club, leading to a demo session and contract at Capricorn. Among the dozens of Southern rock bands heard at Grant's was Mudcrutch, Tom Petty's band before the Heartbreakers. **(See Capricorn Records site, Macon, GA.)**

NEW ROXY THEATER,
CLARKSDALE, MS

The New Roxy Theater opened in 1950 in a neighborhood of Clarksdale called the "New World," which was the commercial and artistic crossroads for the African American community in the early twentieth century. Blues, ragtime, and jazz flourished in the New World, sustained by the district's lively nightlife. W. C. Handy was just one of the important musicians who made his home here for a time, before World War I. Although the New Roxy was primarily a movie house, its opening featured a performance by Muddy Waters.

MOORE THEATRE,
SEATTLE, WA

Seattle's oldest theater in operation today, the Moore was built in 1907. The interior decor mixes Byzantine and Italianate revival elements. Through its long life the stage has seen theatrical

productions, vaudeville, films, boxing matches, minstrel shows, and cultural events of all description. Live music has included Pacific Northwest grunge stars Soundgarden, Alice in Chains, and Pearl Jam. The Who's rock opera *Tommy* received its first full-stage production in 1971 by the Seattle Opera, and featured Bette Midler in the roles of the Acid Queen and Mrs. Walker.

GREEN MILL GARDENS,
CHICAGO, IL

Originally opened in 1903 as Pop Morse's Roadhouse, it was renamed Green Mill Gardens in 1910. During Prohibition, as was the case with all speakeasies in Chicago, the club was controlled by organized crime—"Machine Gun" Jack McGurn, of Al Capone's mob, was part owner. Capone's booth was directly across from the short end of the bar because it afforded clear views of both the front and back entrances of the café. McGurn had singer/comedian Joe E. Lewis attacked and maimed in the club, an incident recounted in Lewis's autobiography and in the Hollywood film *The Joker Is Wild*, starring Frank Sinatra. Star entertainers who performed here in the 1930s include Billie Holiday and Al Jolson. After a period of decline, in the late 1980s the Green Mill reintroduced live music and now presents jazz nightly.

THE BITTER END,
NEW YORK, NY

Established as a nightclub in 1961, the Bitter End has provided a stage for generations of folk and rock musicians. A coffeehouse featuring poetry readings preceded the Bitter End in the late 1950s, and the club continued with poetry readings and stand-up comedy during its early years. In the 1960s, folk musicians found a home at the weekly Tuesday night hootenanny. Cabaret singers and blues, folk, and jazz musicians, from Bob Dylan to Lady Gaga, have honed their craft on the Bitter End's stage.

DOCKERY PLANTATION,
CLEVELAND, MS

This 25,600-acre cotton plantation had a profound influence on the development of blues. Established in 1895, Dockery relied on sharecroppers and as many as 2,000 day laborers, paid in the plantation's own currency. Besides housing this large labor force, Dockery had its own rail station, general store, school, doctor, and three churches to support the community. The music the workers created to entertain themselves was the roots of Delta blues. Composer W. C. Handy reported seeing a man in 1903 near Dockery fretting a guitar by dragging a knife's edge across the strings, and noted being struck by the "bluesy" effect this produced. Several blues innovators lived and worked at Dockery. Charley Patton's family moved in around 1900,

when he was nine years old. He was deeply influenced by an older musician named Henry Sloan. Patton went on to be the center of a group of Dockery bluesmen including Son House, Robert Johnson, Chester "Howlin' Wolf" Burnett, and Honeyboy Edwards. Besides his guitar playing and gruff shout-singing, Patton's showmanship was influential. He danced while playing and swinging his guitar around, often playing behind his back. This crowd-pleasing tradition lived on in the stagecraft of bluesmen like T-Bone Walker, Buddy Guy, and Prince. **(See Belzoni Jail, Belzoni, MS; 508 Park Building, Dallas, TX; One "Crossroads," Clarksdale, MS; 708 Club site, Chicago, IL; Chess Records site, Chicago IL.)**

MABUHAY GARDENS (SITE),
SAN FRANCISCO, CA

In the mid-1970s—the early days of punk—bands playing the new music would often have to find unconventional venues. The Mabuhay was a Filipino restaurant and nightclub that offered a floor show with Filipino celebrities. In 1976, punk fanzine publisher Jerry Paulsen began booking late-night shows featuring punk bands two nights a week. This quickly expanded to seven nights a week, and the San Francisco punk scene had its own club. Besides local bands like the Avengers, Crime, the Nuns, the Mutants, and Dead Kennedys, the Los Angeles scene was well represented by the Weirdos, the Screamers, the Germs, and the Go-Go's. The Mabuhay was an important early West Coast platform for touring acts like the Dead Boys, Patti Smith, and Devo.

FREEBODY PARK,
NEWPORT, RI

From 1955 to 1964, this was the site for the Newport Jazz Festival. The park has been a city trust of Newport since 1834. Around the turn of the twentieth century, there was an open-air theater, or gazebo structure, with lattice-work walls that presented plays and vaudeville acts. When it burned down during World

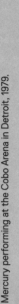
Freddie Mercury performing at the Cobo Arena in Detroit, 1979.

War I, the area became a recreation field. The stone wall surrounding the park was a 1930s federal Works Progress Administration project. The first Newport Jazz Festival was held in 1954 at the Newport Casino. The following year, a new venue was needed for what was anticipated to be a larger crowd, and the sports field at Freebody Park, with its stadium seating, was chosen. Freebody was the festival's venue until 1964. The film *Jazz on a Summer's Day* documents the 1958 festival here, showcasing a typical line-up of acts, from the traditional New Orleans style of Louis Armstrong and Jack Teagarden and swing-era stars like Anita O'Day, to the avant-garde music of the younger generation represented by Chico Hamilton and Eric Dolphy. The Newport Folk Festival also used this venue from 1959 through 1964. **(See Festival Field site, Newport, RI.)**

Dizzy Gillespie and his group onstage at the Newport Jazz Festival in Newport, Rhode Island, 1957.

SHADY'S PLAYHOUSE (SITE),
HOUSTON, TX

In the 1950s and '60s Shady's Playhouse was a blues club in Houston's Third Ward. Originally located on Simmons Street, in 1958 it moved to a two-story concrete block building at the northeast corner of Ennis and Elgin Streets, which had been the Swan Hotel. Shady's was a favorite with local and touring blues musicians to play or just hang out. From 1958 to 1963, the house band was the Dukes of Rhythm, including blues guitarists Joe Hughes and Johnny Copeland. Shady's closed in 1969.

TURF CLUB,
ST. PAUL, MN

Since the 1990s, the Turf Club has been popular with local bands, a sharp contrast to the 1980s when the most ambitious Twin Cities groups only wanted to play Minneapolis venues. The club is also an important stage for national and international touring acts. Japanese pop punk band Shonen Knife played its one-thousandth show here. Originally a grocery, since the 1940s the Turf Club has been a supper club, a ballroom, and a country music dance hall, as one of the earliest clubs to feature two-stepping in the Twin Cities. **(See Clown Lounge, St. Paul, MN.)**

CRYSTAL BALLROOM,
PORTLAND, OR

Originally called Ringler's Cotillion Hall, this 1914 vintage dance hall boasted a floating dance floor that was one-of-a-kind technology in that year, certainly for

the West Coast and possibly for the nation. It hosted square dances in the decades between 1930 and 1960. The name "Crystal Ballroom" dates from 1951. In the early '60s R&B acts like James Brown and Ike Turner, Motown shows featuring Marvin Gaye, and rock bands like Buffalo Springfield played here. In 1967, the space was a setting for the psychedelic rock of the Grateful Dead, Blue Cheer, and the Electric Prunes. After several decades of disuse, in 1997 the ballroom returned as a concert venue.

COBO ARENA,
DETROIT, MI

Built in 1960 for the Detroit Pistons basketball team and home to the annual Auto Show, in the '70s Cobo Arena was renowned as the archetypal stadium rock venue, selling out shows for big acts like Queen, Led Zeppelin, Alice Cooper, the Who, and Heart. Bob Seger and KISS chose to record live albums at Cobo Arena, and both proved to be among those artists' biggest sellers. The arena shuttered in 2010.

THE SUTLER,
NASHVILLE, TN

Established in 1976, the Sutler was located in a strip mall that held the 1942 Melrose Theatre and Melrose Lanes bowling alley. It was a place with food and drink, with occasional music and socializing among songwriters. Elite Nashville talent like Don Everly, Johnny Cash, Emmylou Harris, and Guy Clark might have been found giving a spontaneous performance on the restaurant's tiny stage. In 1993, the music scene at the Sutler became more

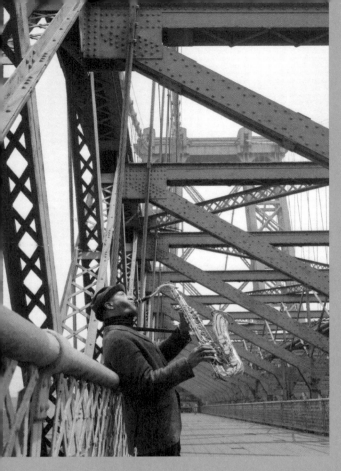

Sonny Rollins playing his saxophone on the Williamsburg Bridge, 1966.

HARVARD SQUARE THEATRE,
CAMBRIDGE, MA

Originally opened as the University Theatre in 1926, the Harvard Square Theatre's main function was as a movie house, but it has also hosted live music. In 1974, Bruce Springsteen opened for Bonnie Raitt here. The E Street band had played several spots in and around Cambridge and the Boston area; they had released their second album, *The Wild, the Innocent, & the E Street Shuffle*, but felt that they hadn't broken through yet. Jon Landau, covering the concert for a local alternative newspaper, wrote a rave review, in which he saw Springsteen as "rock and roll's future." A close relationship with the songwriter developed, leading to Landau coproducing the band's next album, their first major hit, *Born to Run*, and eventually becoming Springsteen's manager.

WILLIAMSBURG BRIDGE,
NEW YORK, NY

Nearly every day between the summer of 1959 and the end of 1961, tenor saxophonist Sonny Rollins walked from his Grand Street apartment in the Lower East Side to the Williamsburg Bridge. At a time when his peers agreed he was one of the best jazz players, Rollins chose to stop publicly performing and practice his horn standing on the bridge's pedestrian walkway, between four lanes of automobile traffic and the roar of the subway tracks, halfway to Brooklyn. His hiatus from the enervating and sometimes degrading life of playing in nightclubs was an act of self-preservation and artistic renewal. He took the time to reevaluate his approach to jazz and to sharpen his technique. In 1962, to mark his return to performing, Sonny Rollins recorded an album titled *The Bridge* with guitarist Jim Hall, bassist Bob Cranshaw, and Ben Riley on the drums. While the album did not appear to break new ground artistically, it was a rock-solid reaffirmation of his art.

UNITED SOUND SYSTEMS,
DETROIT, MI

Built as a private home in 1916 and converted to a recording studio in 1939, United Sound Systems was one of the earliest independent recording facilities in Detroit. The business offered transcription and production work to radio stations, and custom recordings for private citizens. In 1946, Bill Randle, a white DJ and nightclub promoter, produced *The Inter-Racial Goodwill Program* for a local radio station featuring jazz and R&B with the explicit goal of elevating African American culture. In 1947, alto saxophonist Charlie Parker, leading a group featuring drummer Max Roach and a young Miles Davis, cut four seminal bebop sides for the Savoy record label here. The following year, John Lee Hooker recorded "Boogie Chillen'" at the studio.

The first recording on Tamla, Berry Gordy's first label, predating Motown by several months, was produced at United Sound. Jackie Wilson, Dizzy Gillespie, and the funk bands Parliament and Funkadelic all recorded here. Inspired by the Beatles' 1964 appearance on *The Ed Sullivan Show*, a trio of Black Detroit teenagers formed a band. Initially called RockFire Funk Express, the music they played was funk, but concerts by the Who and Alice Cooper steered them in a hard rock direction and they changed their name to Death. In 1975, Death took their unique proto-punk style to United Sound Systems and recorded seven songs. These recordings languished in obscurity for decades, save for a slow-growing reputation among record collectors. This led to a 2009 release of the United Sound Systems sessions, a documentary about the band, and ultimately to Death reforming and creating new material.

CHICAGO THEATRE,
CHICAGO, IL

Originally the Balaban and Katz Chicago Theatre, the flagship of its namesake theater chain, this opulent neo-baroque French revival movie palace opened in 1921. The fare was a first-run film, accompanied by a fifty-piece orchestra or Wurlitzer pipe organ, plus a live stage show. Starting in 1922, a time when jazz was considered little more than a noisy novelty, the theater promoted the new music with an event called "Syncopation Week." Jazz bands became a popular regular feature at the Chicago Theatre, drawing large crowds. Doubtless some patrons were curious about the new fad but hesitant to seek it out in the less respectable environs of a speakeasy.

DALLAS MEMORIAL AUDITORIUM,
DALLAS, TX

Now called the Kay Bailey Hutchison Convention Center, this event hall was designed in 1957. In September 1964, the Beatles played their only Dallas concert here. Led Zeppelin opened their last U.S. tour at the auditorium in 1977. The Doors, Prince, Madonna, and the Who count among other notable acts. Queen filmed their 1978 appearance here, and the footage was later used for the video of "Fat Bottomed Girls."

DEW DROP INN (SITE),
NEW ORLEANS, LA

In 1939, Frank G. Painia opened a hotel and saloon that played a prominent part in the development of R&B and rock and roll music. The Dew Drop Inn was described in the African American press as the swankiest nightclub in town. In the years after World War II, visiting boogie woogie and jump blues artists like Amos Milburn and Joe Turner shared its stage with local talents Dave Bartholomew, Huey "Piano" Smith, and Allen Toussaint. The

formalized with an improved sound system and regular shows booked in the evening. By the late 1990s, the venue was a focal point for the Americana, or alternative country, scene that sought to revive Nashville's connection with roots music. Lucinda Williams, Jim Lauderdale, Dale Watson, and Jimmie Dale Gilmore were some of the Americana artists who regularly played in these years. The Sutler closed in 2005 but reopened in 2014.

CLUB PARADISE,
MEMPHIS, TN

Memphis entrepreneur Andrew "Sunbeam" Mitchell owned several establishments on the Chitlin' Circuit as well as a hotel for traveling musicians in the 1940s and '50s. From 1962 until 1985, Mitchell operated the largest nightclub in Memphis, Club Paradise, in a converted bowling alley. Bobby "Blue" Bland performed on opening night at the 3,200-seat venue. B. B. King, Count Basie, Nancy Wilson, and Ike and Tina Turner were some of the top names showcased. Bluesman Bobby Rush likened playing at the Club Paradise to playing Carnegie Hall—a symbol that you had succeeded at the highest level as a blues musician.

SAVOY TIVOLI,
SAN FRANCISCO, CA

The building dates from 1906, when it was a restaurant and boarding house. In the 1950s, the Savoy Tivoli became

popular with the Beat poets as the neighborhood of North Beach became the center of San Francisco's bohemian culture. On August 20, 1976, the Ramones played the Tivoli Gardens on their first West Coast tour, marking a first live exposure for many San Franciscans to a band from the CBGB punk and new wave scene. The Ramones shared the bill with the comedy troupe Duck's Breath Mystery Theatre.

BELCOURT THEATRE,
NASHVILLE, TN

This movie house was the first home of the Grand Ole Opry. Built in 1925 as the Hillsboro Theatre, it boasted the most modern motion picture projection equipment in Nashville. The first film screened was *America*, directed by D. W. Griffith. The Grand Ole Opry, which began as a one-hour radio program called the WSM Barn Dance, grew to become the most influential and beloved institution in country music. The Opry's 1934–36 tenure at the Belcourt shaped the format the radio show still uses today. Due to the small size of the room, the Opry began playing two shows to accommodate two-audience seatings. Performers played two fifteen-minute sets rather than the customary single half-hour performance. The Belcourt continues to operate as a movie house; a second screen was added in 1966. **(See Ryman Auditorium, Nashville, TN; War Memorial Auditorium, Nashville, TN.)**

club continued to draw top talent through the 1950s and '60s, booking Ray Charles, Sam Cooke, and Solomon Burke. The quality and frequency of the stage shows declined in the late 1960s. Painia died in 1972. Little Richard recorded a song about the club called "Dew Drop Inn" in 1970. The song was co-written with Esquerita, the R&B singer whose stage antics and flamboyant appearance influenced Little Richard in the early 1950s.

CLUB DESIRE,
NEW ORLEANS, LA

The motto "The downtown club with the uptown ideas" reflected the sophisticated aspirations of Club Desire in New Orleans's working-class Ninth Ward. It endeavored to be the kind of nightclub patrons would dress in their finest to attend. Club Desire opened in 1948 with music by Dave Bartholomew's band. Later that year a young pianist in the neighborhood, Antoine "Fats" Domino, appeared here in his career's earliest days. The floor show presented multiple high quality acts, featuring national touring bands like Billy Eckstine and Count Basie. While its high point was the 1950s, Club Desire continued for decades, ending its days as a discotheque sometime in the late twentieth century. The building has been razed.

NEW BETHEL BAPTIST CHURCH,
DETROIT, MI

After its founding in 1932, the Reverend C. L. Franklin led New Bethel Baptist from 1946 until 1979. Reverend Franklin and his congregation were at the forefront of the 1960s Civil Rights Movement. In the 1950s, the New Bethel gospel choir,

under the direction of Thomas Shelby, broadcast weekly on the radio. Gospel singer and composer James Cleveland was the organist in the early '50s. Among the choir's members were Reverend Franklin's daughters Erma, Carolyn, and Aretha. In 1956, Aretha Franklin—then fourteen years old—recorded her first songs for J-V-B Records here. The congregation eventually lost the building because of the construction of the Chrysler Freeway in 1961, and in 1963 New Bethel moved into a new facility, the previous ruin of the Oriole Theater that was renovated for the church's purposes. Aretha Franklin recorded a double album of gospel music at her father's church in 1987, called *One Lord, One Faith, One Baptism*. Recorded over three nights at New Bethel, the album combined the talents of Aretha, her sisters Erma and Carolyn, and gospel singer Mavis Staples.

RYMAN AUDITORIUM,
NASHVILLE, TN

The Union Gospel Tabernacle was built in 1892 by the Nashville tugboat captain and businessman Thomas Ryman. Religious conventions and academic functions filled the auditorium's early programs. As for music, John Philip Sousa led a concert here in 1894, and the Fisk Jubilee Singers offered a concert of spirituals in 1896. In 1901, a larger stage was installed for a performance by the visiting Metropolitan Opera Company. In 1906, the famed Sarah Bernhardt performed here. It was renamed the Ryman Auditorium in honor of its founder upon his death in 1904. In 1943, the Grand Ole Opry moved in. What started as a weekly radio barn dance grew into a country music institution, complete with membership by the invitation of Opry

management. Elvis Presley made his one and only appearance on the Opry in 1954. Singing the Bill Monroe tune "Blue Moon of Kentucky," Elvis did not convince management that he was Opry material. On December 8, 1945, Earl Scruggs made his debut with Bill Monroe's Blue Grass Boys, a band that was the prototype for the bluegrass sound. In 1950, Mother Maybelle and the Carter Sisters were invited to join the Opry. The Carter Family trio of the 1930s was a primary force in the development of country music, then called "old-time music." The Grand Ole Opry built a new venue and resort complex called Opryland and left the Ryman in 1974. The next two decades were a time of neglect, followed by a 1993 restoration. The auditorium continues to host concerts of a wide variety of music, from the Beach Boys to the Raconteurs and Lizzo. The Opry has since returned to the Ryman on a part-time basis. **(See Belcourt Theatre, Nashville, TN; War Memorial Auditorium, Nashville, TN.)**

KIEL OPERA HOUSE,
ST. LOUIS, MO

In 1965, Frank Sinatra, Dean Martin, and Sammy Davis Jr. organized a benefit concert, a recreation of their famous Las Vegas "Rat Pack" shows. The Count Basie Orchestra, under the direction of Quincy Jones, provided music for the concert. Because the number of tickets sold exceeded the theater's capacity, the concert was broadcast on closed-circuit television to the overflow audience in different rooms. The video of that feed is the only recording of a live Rat Pack show. Other groups who played the opera house in the 1960s include Cream, Canned Heat, Jeff Beck, Paul Revere & the Raiders, & Gary Lewis and the

Playboys. The Kiel Opera House was built in 1934 as part of the Municipal Auditorium and Opera House. The auditorium and opera house stages were built back-to-back so that both spaces could be used at the same time. In 1992, the auditorium portion of the complex was demolished and the opera house was restored.

VILLAGE CLUB (SITE),
DETROIT, MI

In 1958, the 509 Club moved from its original Woodward Avenue address into the vacant Garden Theater building. In 1962, the 509 became the Village Club, a teen dance club with live blues and R&B bands like Geno Washington, the Diablos, and Billy Lee and the Rivieras, who later found fame as Mitch Ryder and the Detroit Wheels. The Village Club lasted until about 1964. When the Garden Theater opened in 1912, it was one of the largest theaters in the area. The auditorium was decorated with a garden theme featuring imitation greenery. The theater closed in 1949. In the 1970s, the building became an adult cinema called the Sassy Cat.

MASON TEMPLE,
MEMPHIS, TN

As the main headquarters for the world's largest African American Pentecostal group, this Church of God in Christ building was named after founder Bishop Charles Harrison Mason, whose tomb is located in the Temple's marble crypt. Construction began in 1940. The church became a popular venue for gospel music, and touring acts like the Five Blind Boys and quartets such as the Spirit of Memphis and the Pilgrim Travelers appeared in concert here. In 1957, Mason Temple presented the Staple Singers with another gospel group called the Soul Stirrers featuring Sam Cooke. During the Civil Rights era of the 1950s and '60s, the temple, like many Southern religious institutions, became an important center of activism. On April 3, 1968, the Reverend Martin Luther King, Jr. gave his famous "I've Been to the Mountaintop" speech in support of striking sanitation workers in Memphis. The next day he was assassinated at the Lorraine Motel.

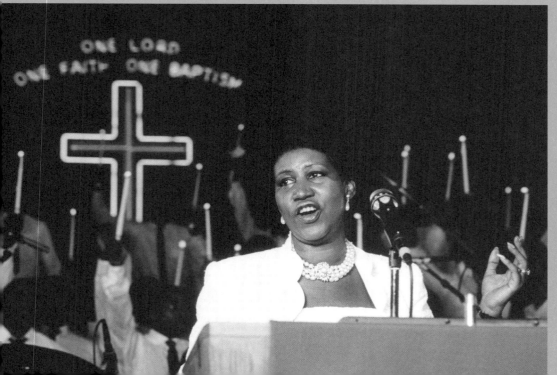

Aretha Franklin at New Bethel Baptist Church in Detroit, 1987.

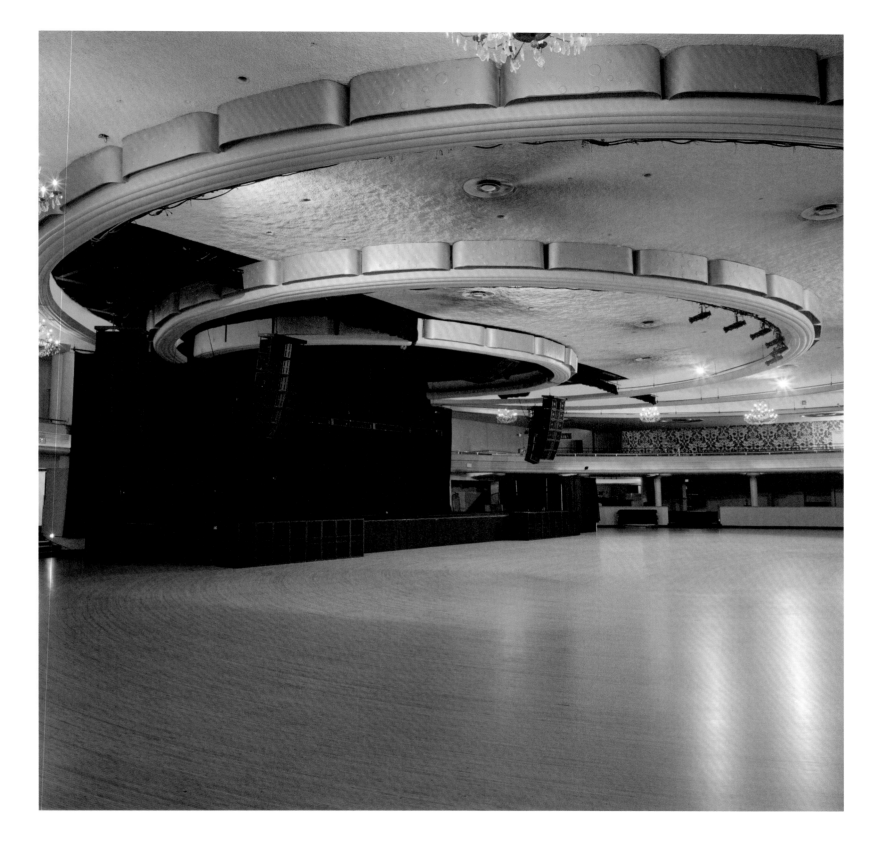

Hollywood Palladium, Los Angeles, CA — July 28, 2015

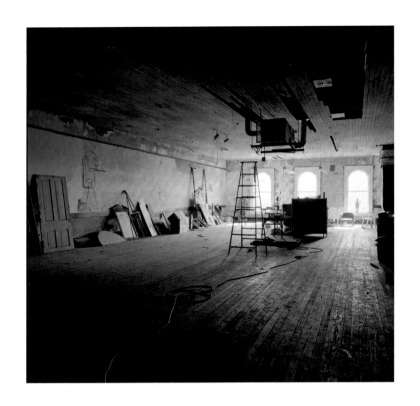
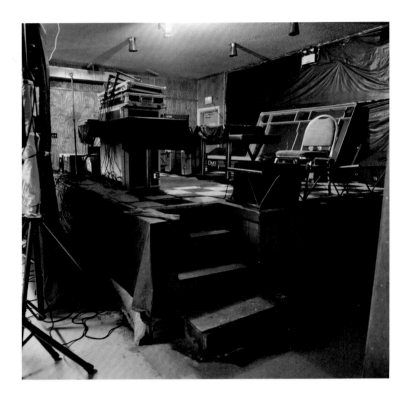
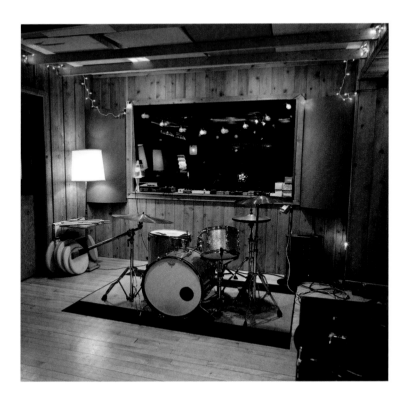
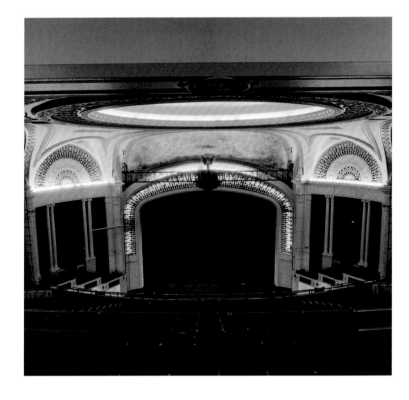

40 Watt Club (site), Athens, GA — June 23, 2015
Club Baron (site), Nashville, TN — January 20, 2010
Old Blackberry Way, Minneapolis, MN — November 12, 2013
Orpheum Theatre, Boston, MA — August 11, 2014

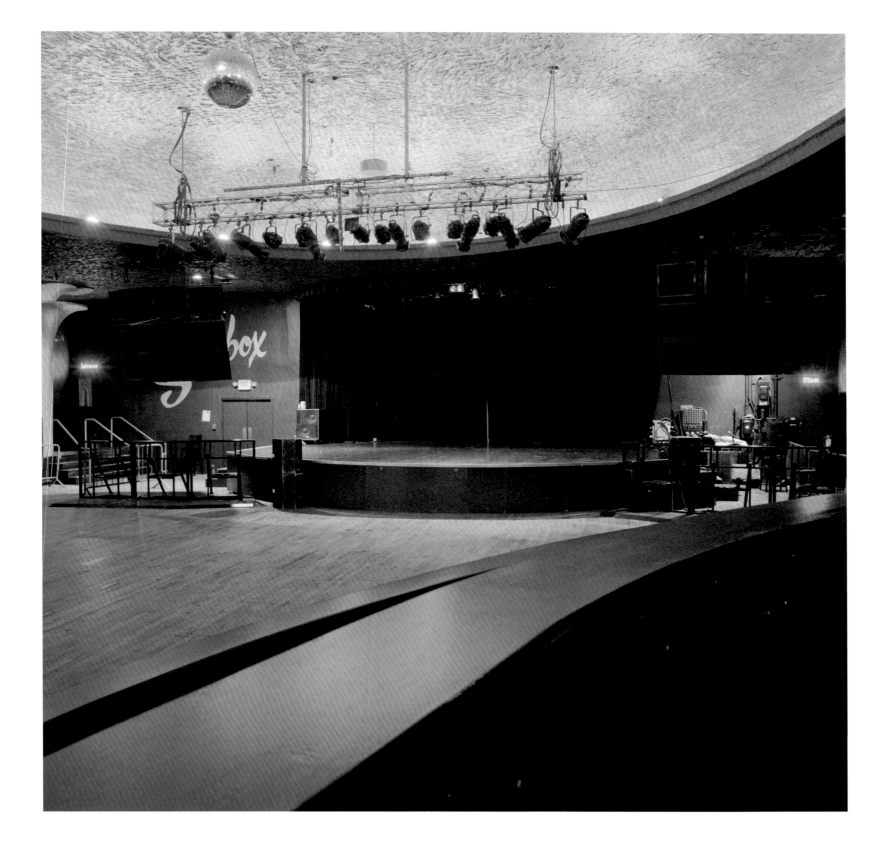

The Showbox, Seattle, WA — November 20, 2015

Radio Recorders Annex, Los Angeles, CA — July 30, 2015

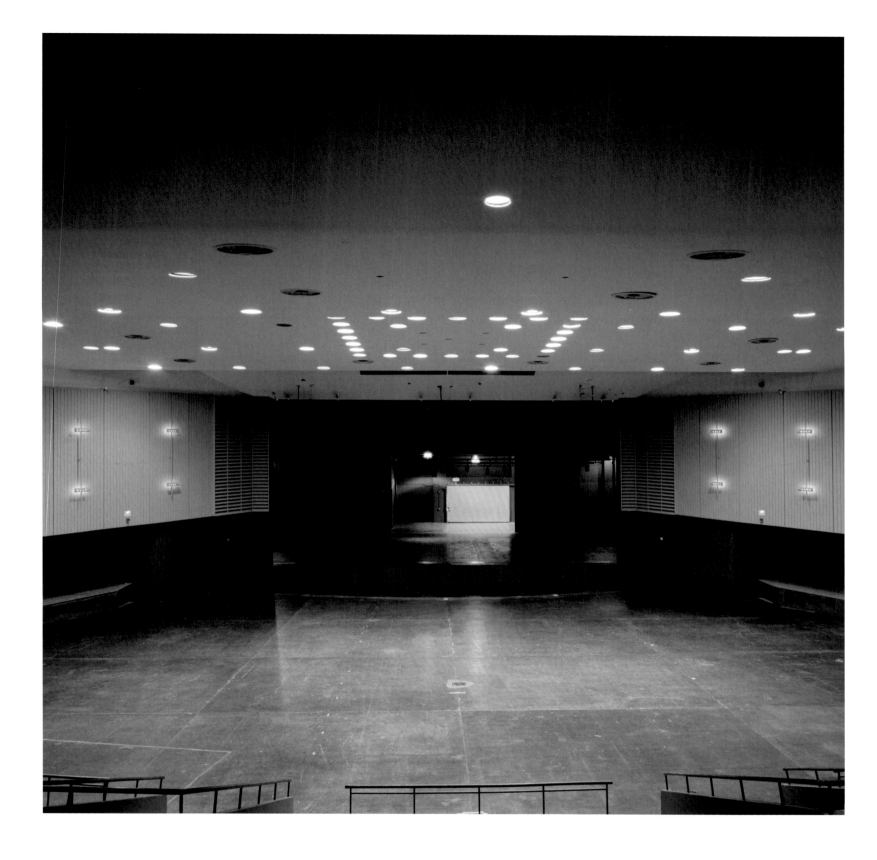

Santa Monica Civic Auditorium, Santa Monica, CA — August 6, 2009

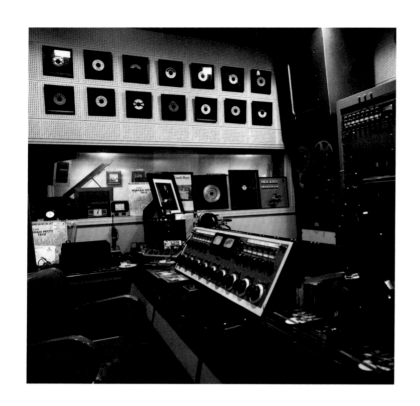
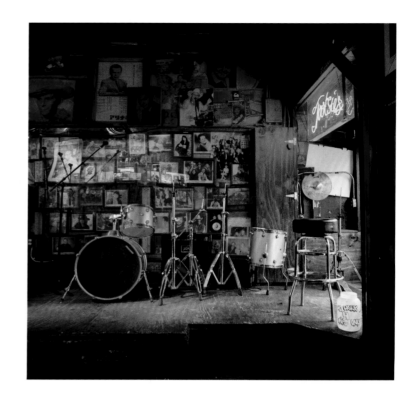

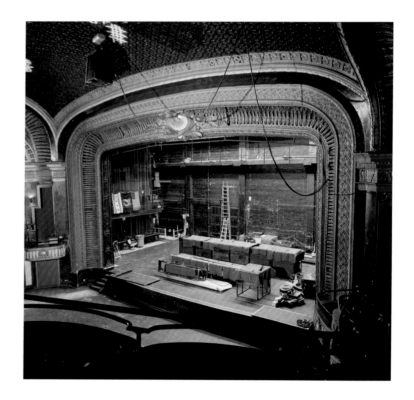

Norman Petty Recording Studios, Clovis, NM — June 8, 2009
Tootsie's Orchid Lounge, Nashville, TN — January 20, 2010
Candlestick Park (site), San Francisco, CA — August 26, 2015
Riviera Theatre, Chicago, IL — September 19, 2008

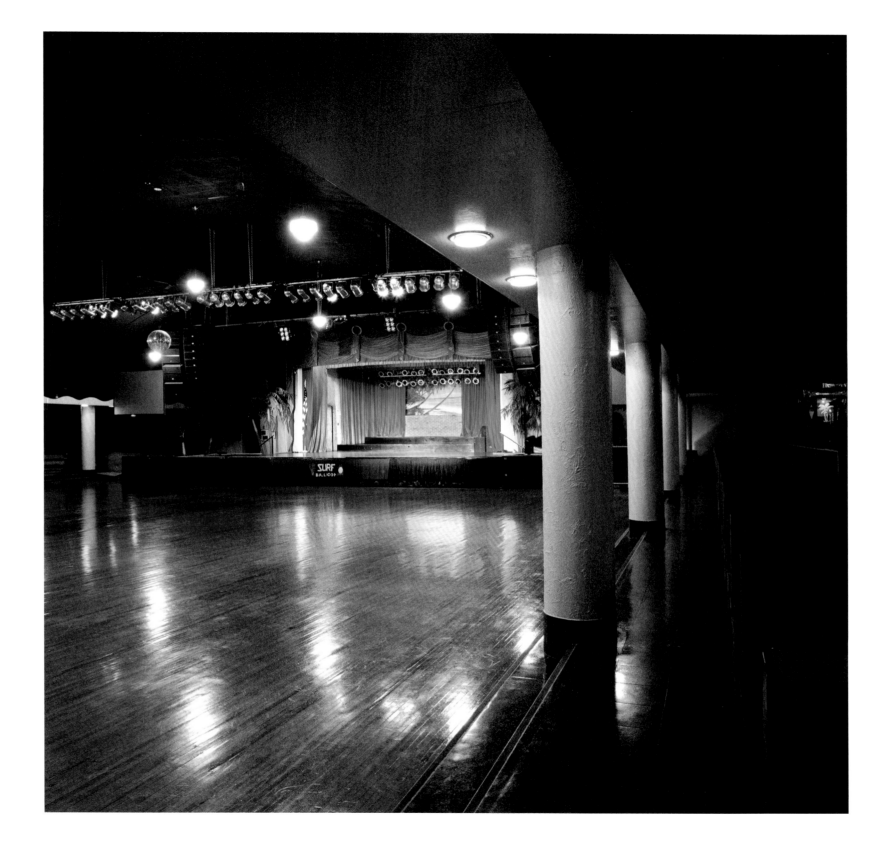

Surf Ballroom, Clear Lake, IA — November 14, 2013

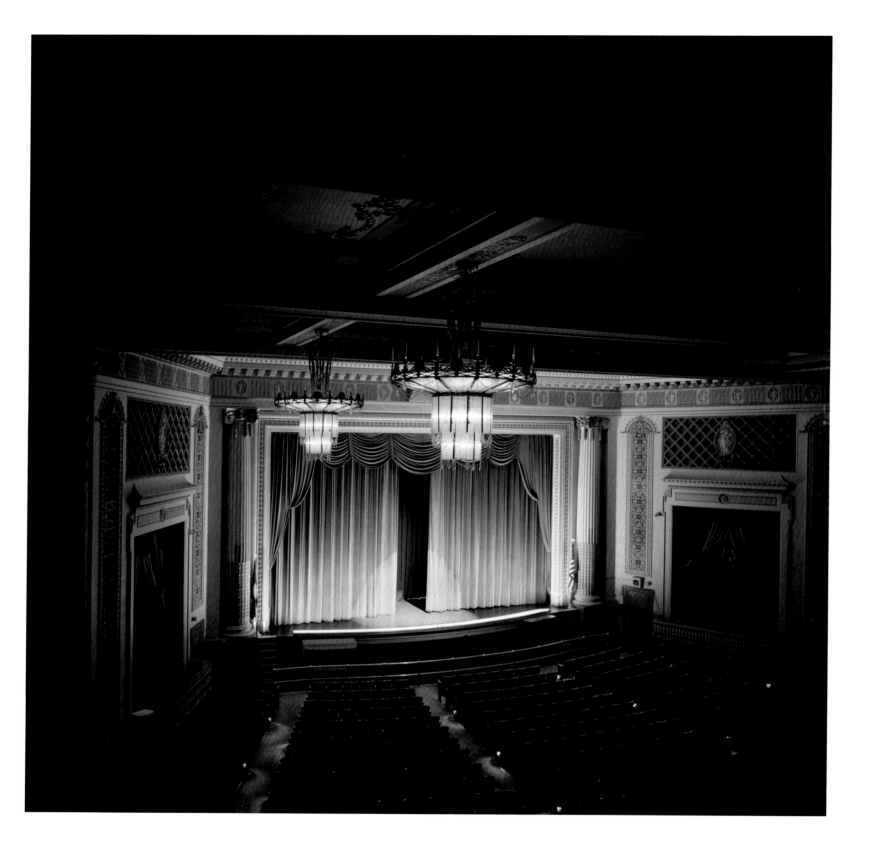

Hibbing High School, Auditorium, Hibbing, MN — July 10, 2006

Chess Records (site), Chicago, IL — September 20, 2008

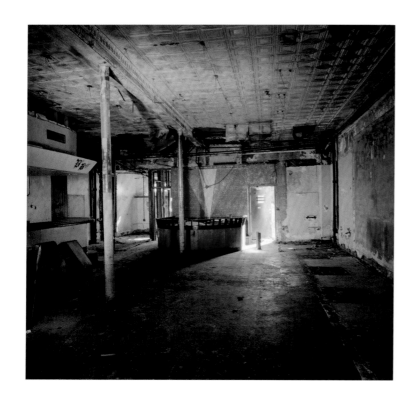
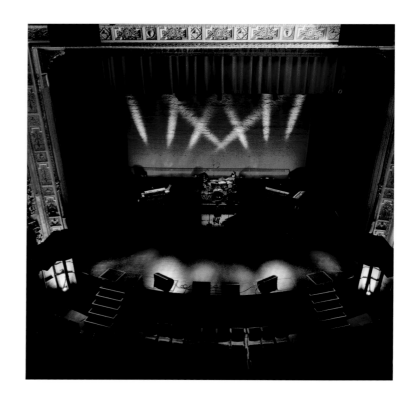
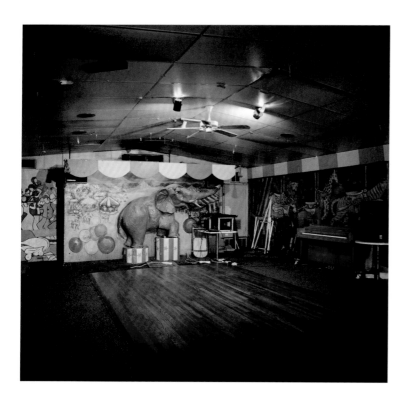
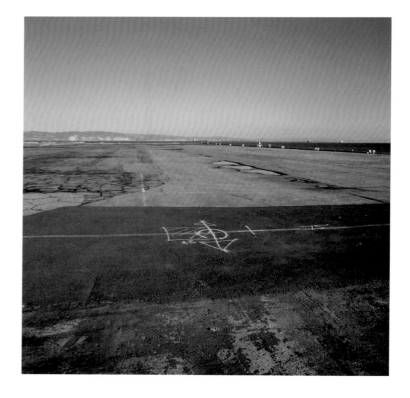

Blue Bird Inn, Detroit, MI — October 30, 2008
Apollo Theater, New York, NY — September 30, 2009
Carousel Lounge, Austin, TX — June 2, 2009
Piers 30–32, San Francisco, CA — November 11, 2015

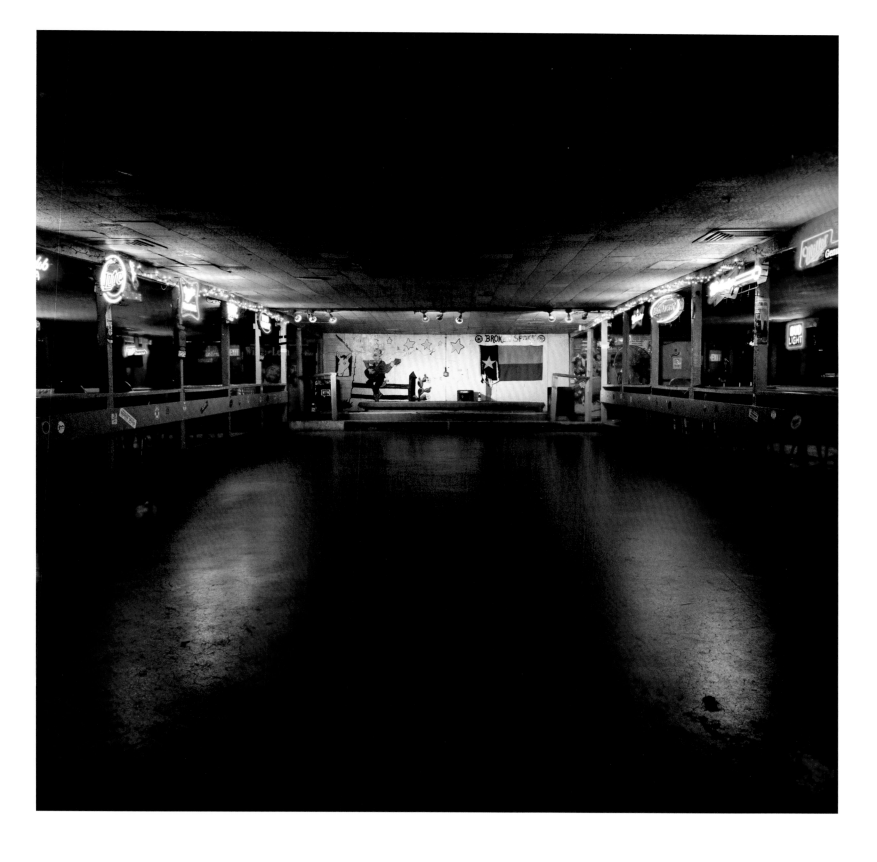

Broken Spoke, Austin, TX — June 2, 2009

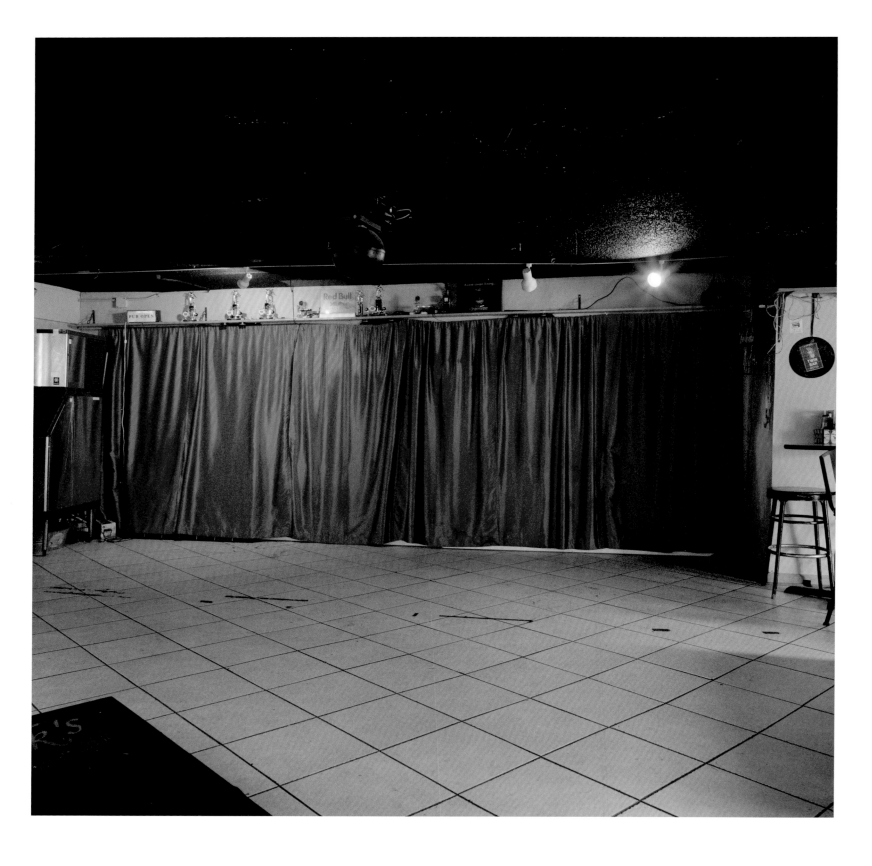

Twin Bar, Gloucester City, NJ — August 12, 2013

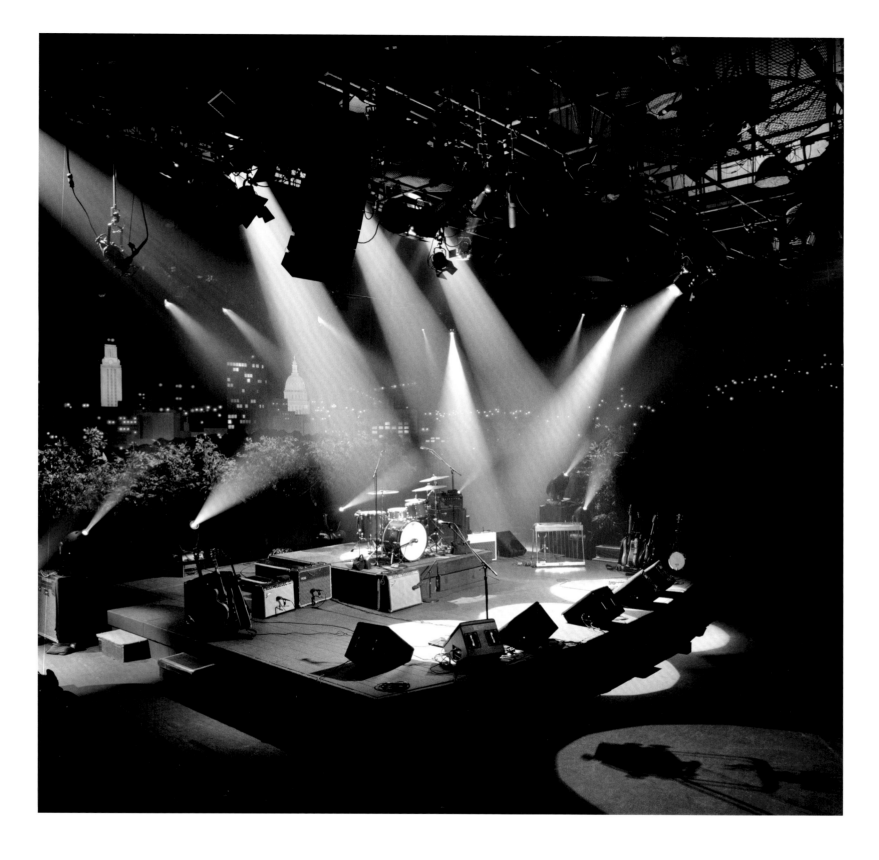

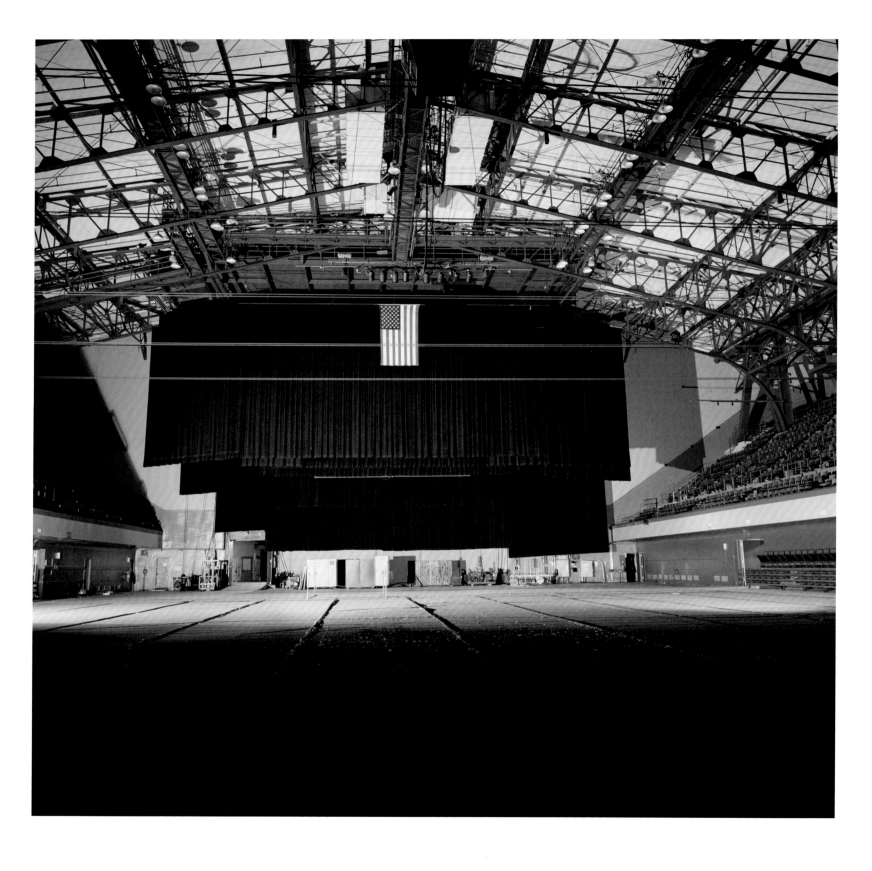

Kaiser Auditorium, Oakland, CA — August 26, 2015

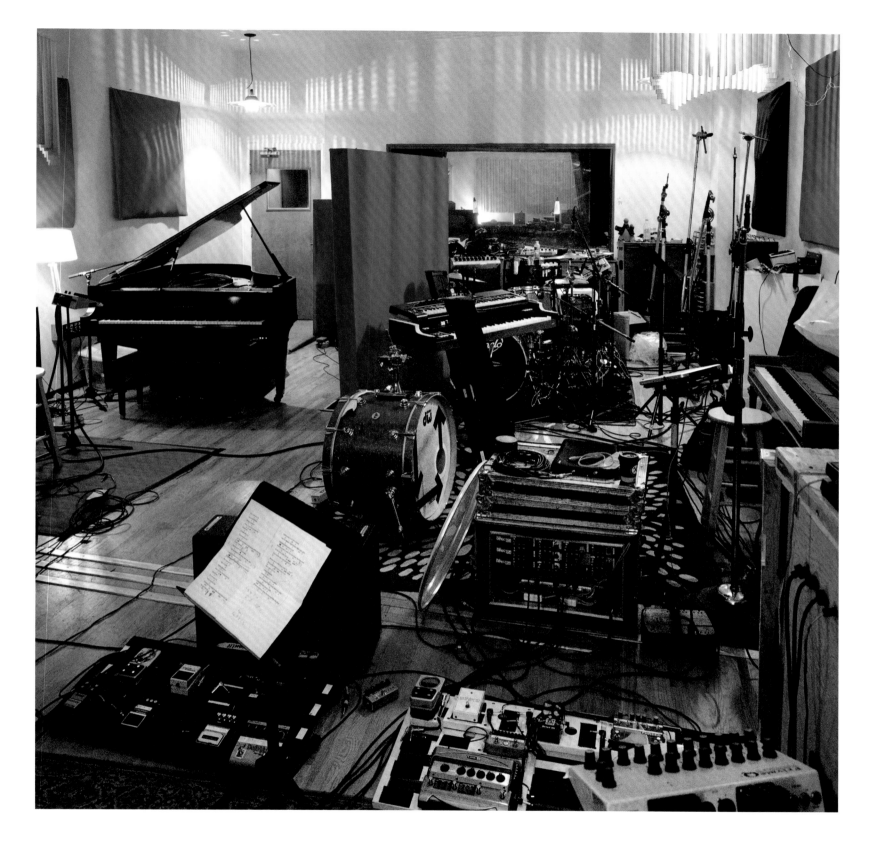

The Magic Shop, New York, NY — February 24, 2016

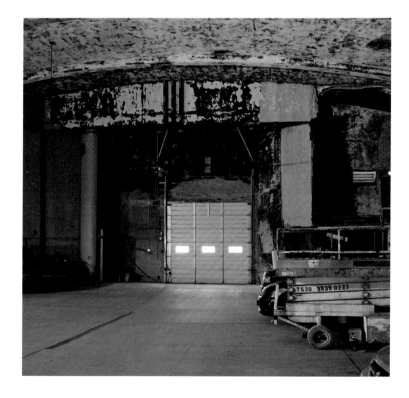

Station Inn, Nashville, TN — January 18, 2010
Red Fox Lounge, Baltimore, MD — August 13, 2013
Continental Club, Austin, TX — June 2, 2009
Grand Terrace (site), Chicago, IL — September 18, 2008

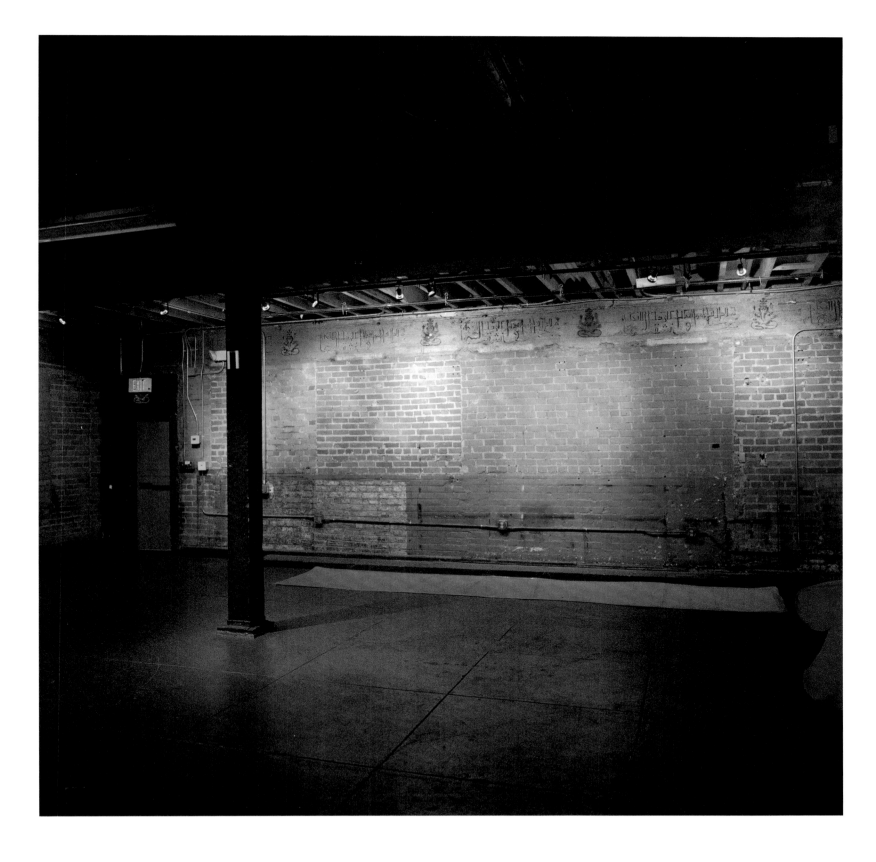

Cosmo Alley (site), Los Angeles, CA — July 28, 2015

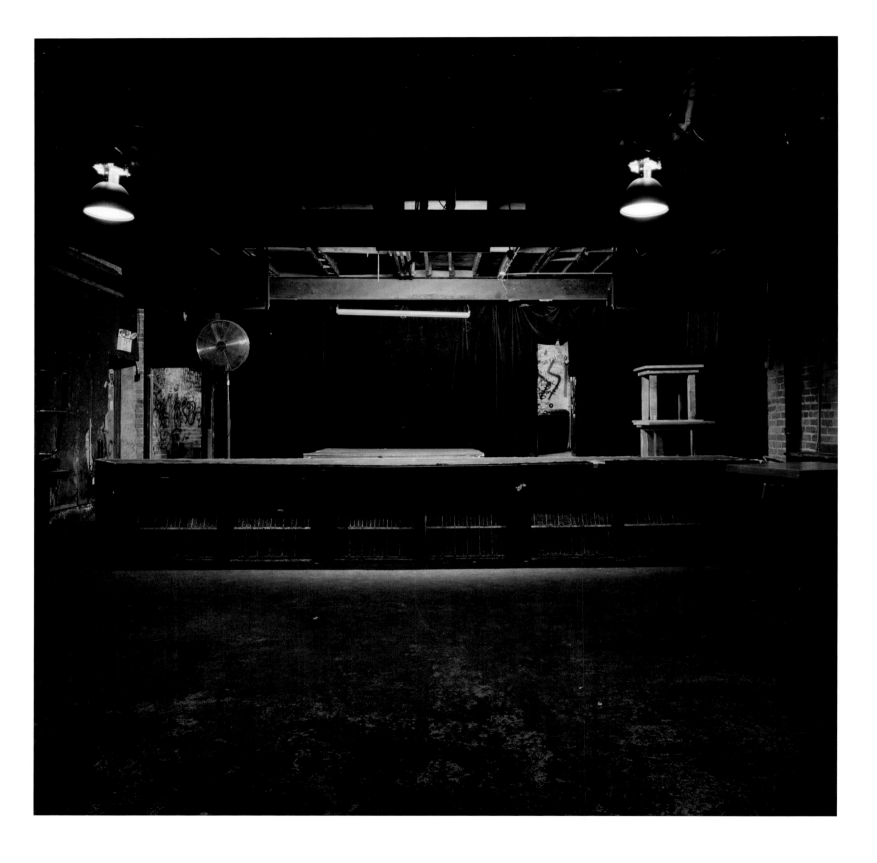

Alvin's Finer Delicatessen, Detroit, MI — October 27, 2008

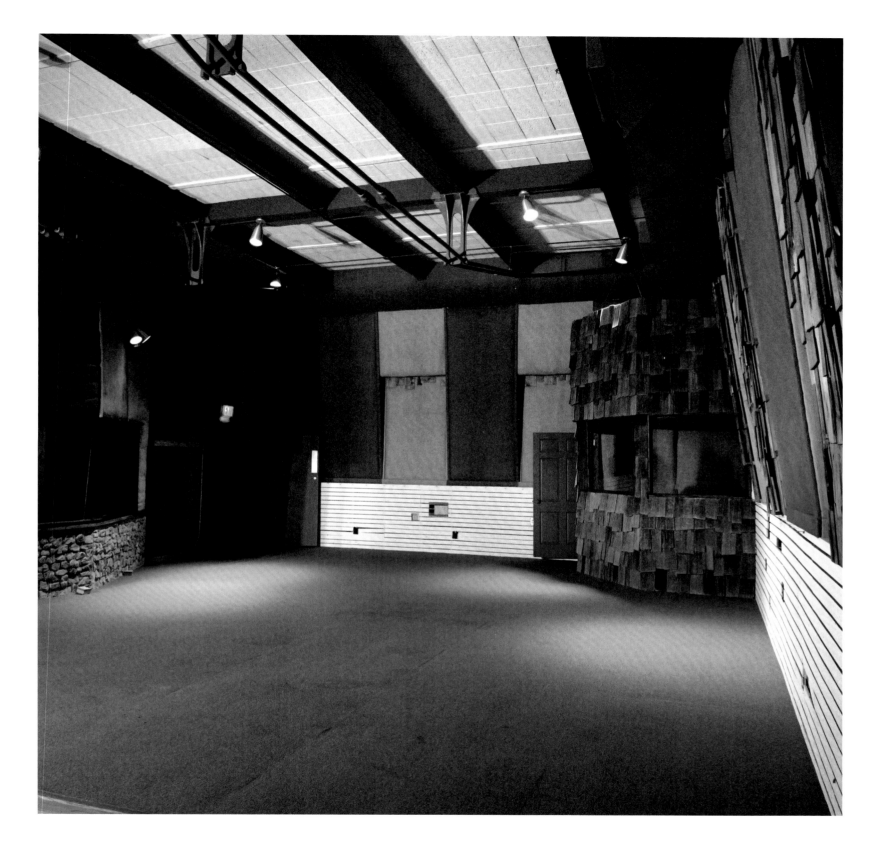

Capricorn Records (site), Macon, GA — June 24, 2015

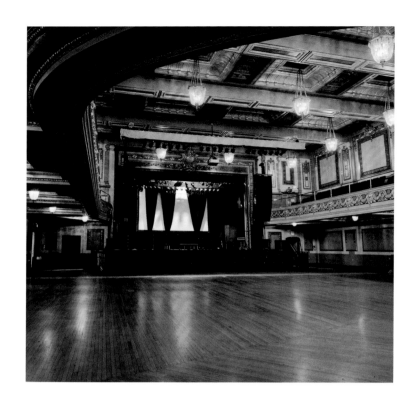

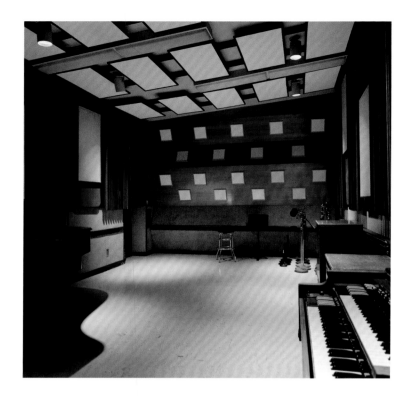

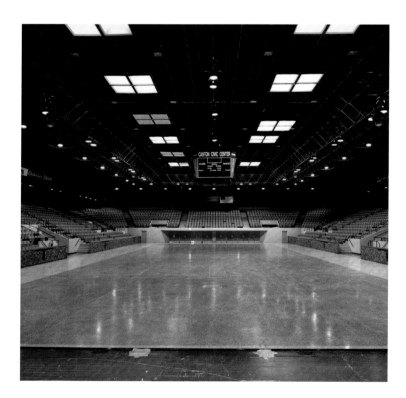

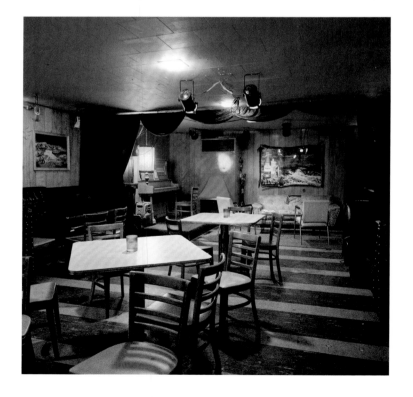

Regency Ballroom, San Francisco, CA — August 27, 2015
United Western Recorders, Studio 3, Los Angeles, CA — August 5, 2009
Canton Memorial Civic Center, Canton, OH — September 15, 2008
Clown Lounge, St. Paul, MN — November 13, 2013

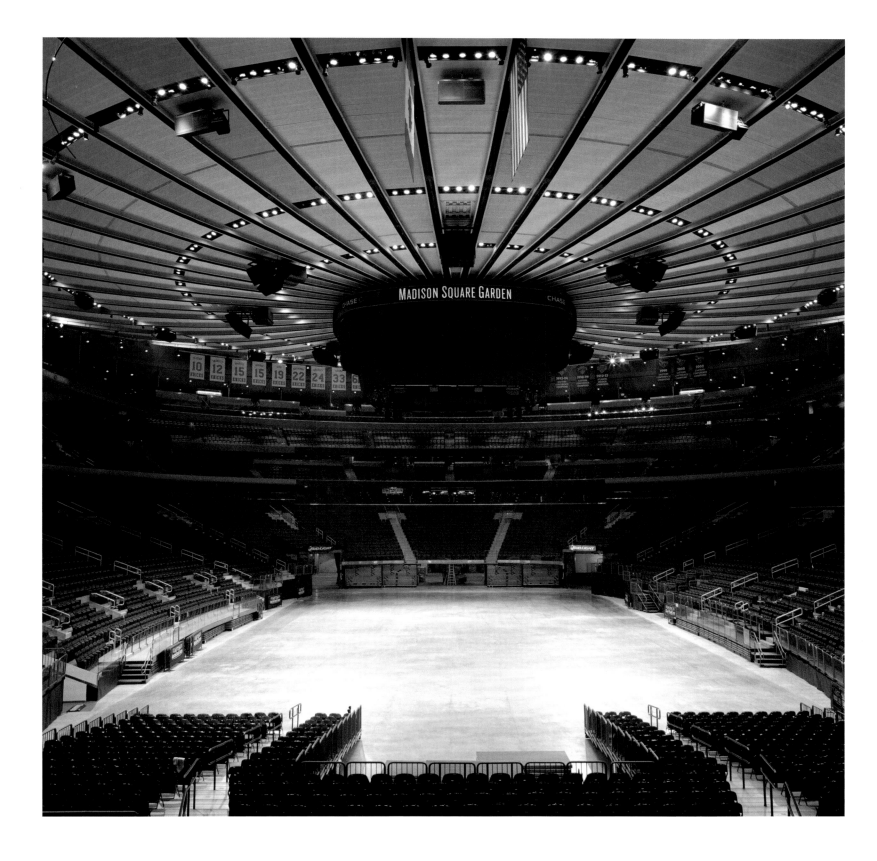

Madison Square Garden, New York, NY — July 9, 2015

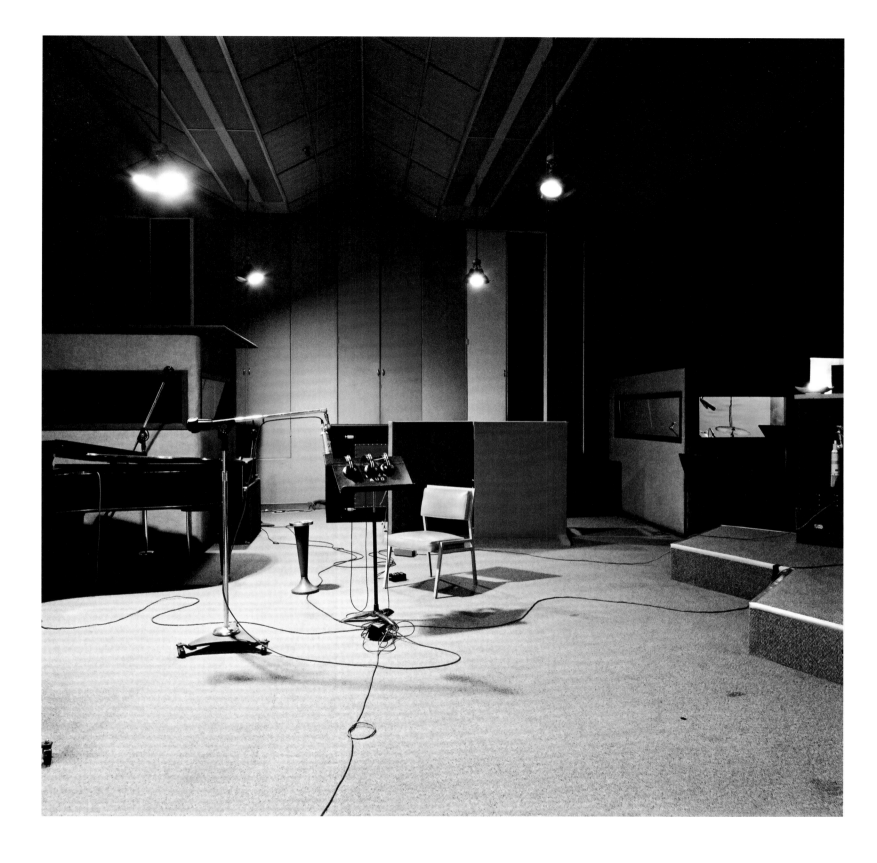

Sam C. Phillips Recording Service, Memphis, TN — May 7, 2008

Pasadena Civic Auditorium, Pasadena, CA — July 31, 2009

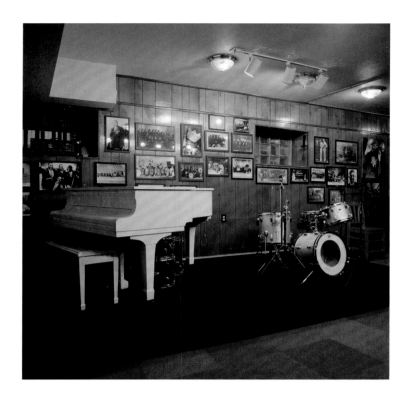

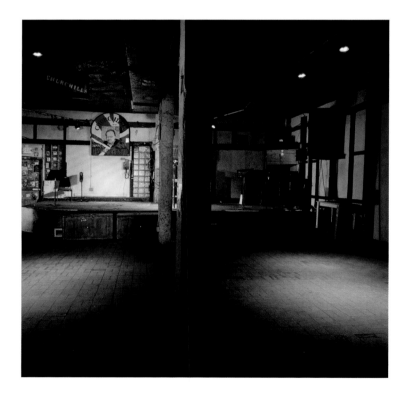

Morton Theatre, Athens, GA — June 22, 2015
Mutual Musicians Foundation, Kansas City, MO — January 14, 2010
Sound 80 (site), Minneapolis, MN — November 12, 2013
Churchill's Pub, Miami, FL — February 24, 2015

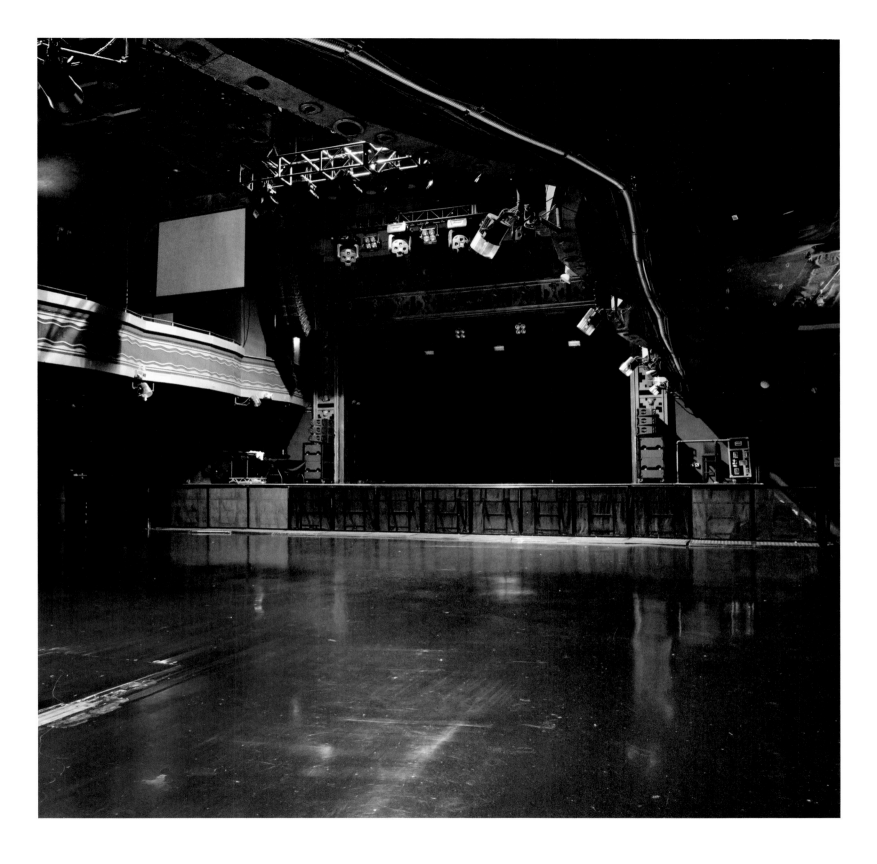

Webster Hall, New York, NY — May 11, 2015

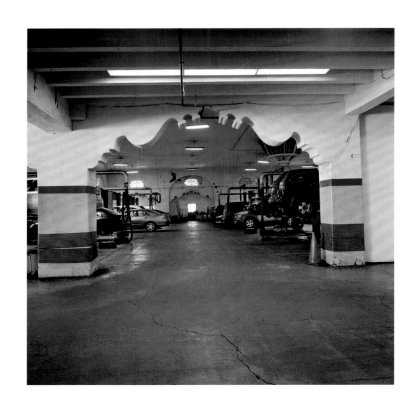

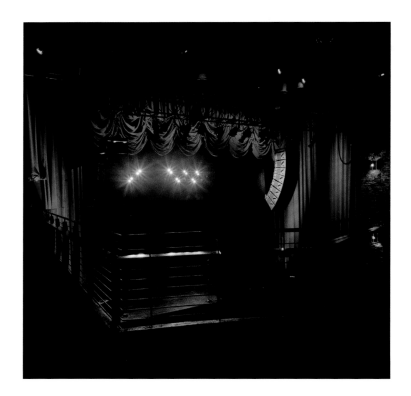

Carousel Ballroom (site), San Francisco, CA — November 11, 2015
Eagle Saloon (site), New Orleans, LA — June 7, 2016
Georgia Theatre, Athens, GA — June 22, 2015
Central Avenue Crossing Elm, Dallas, TX — January 12, 2013

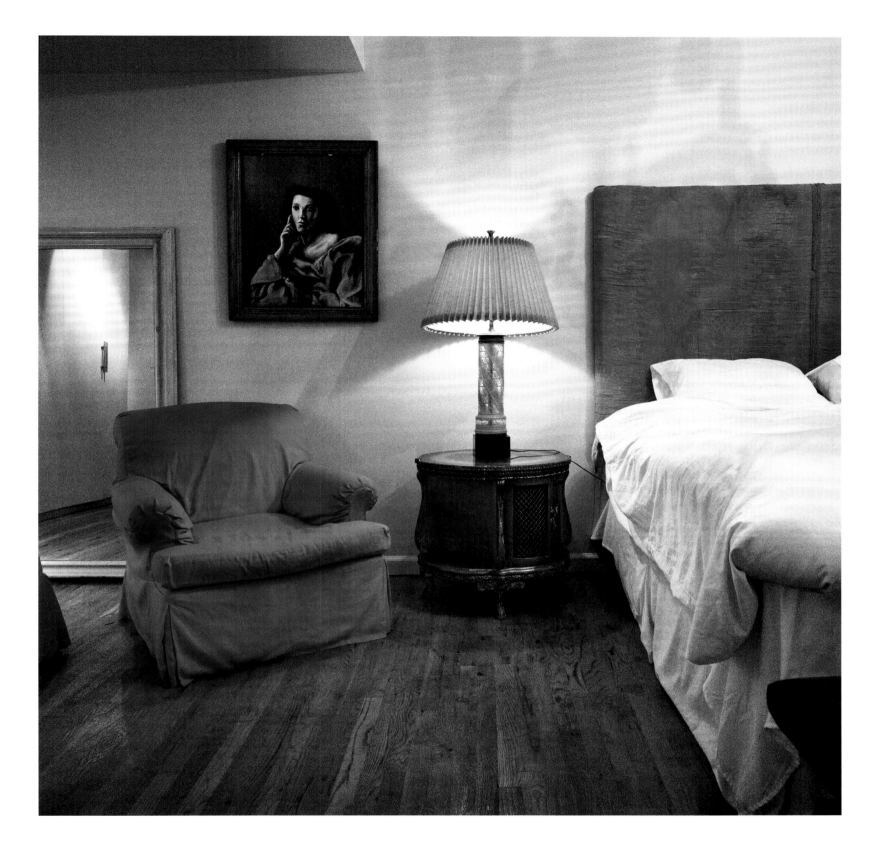

Max's Kansas City (site), New York, NY — September 14, 2013

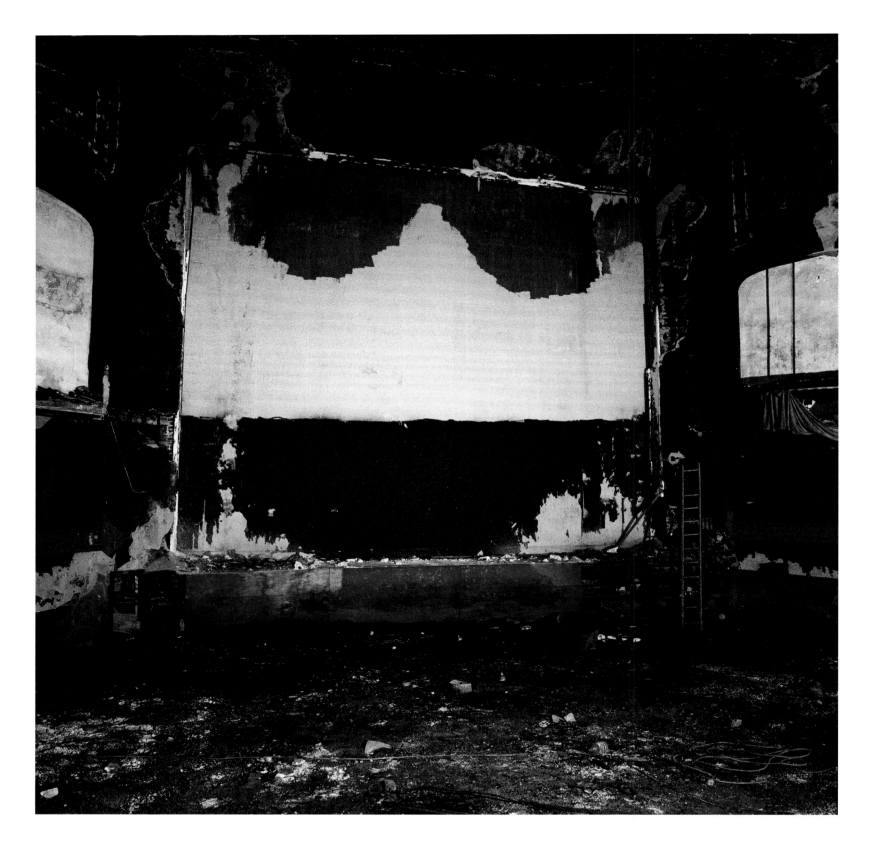

Howard Theatre, Washington, D.C. — April 2, 2008

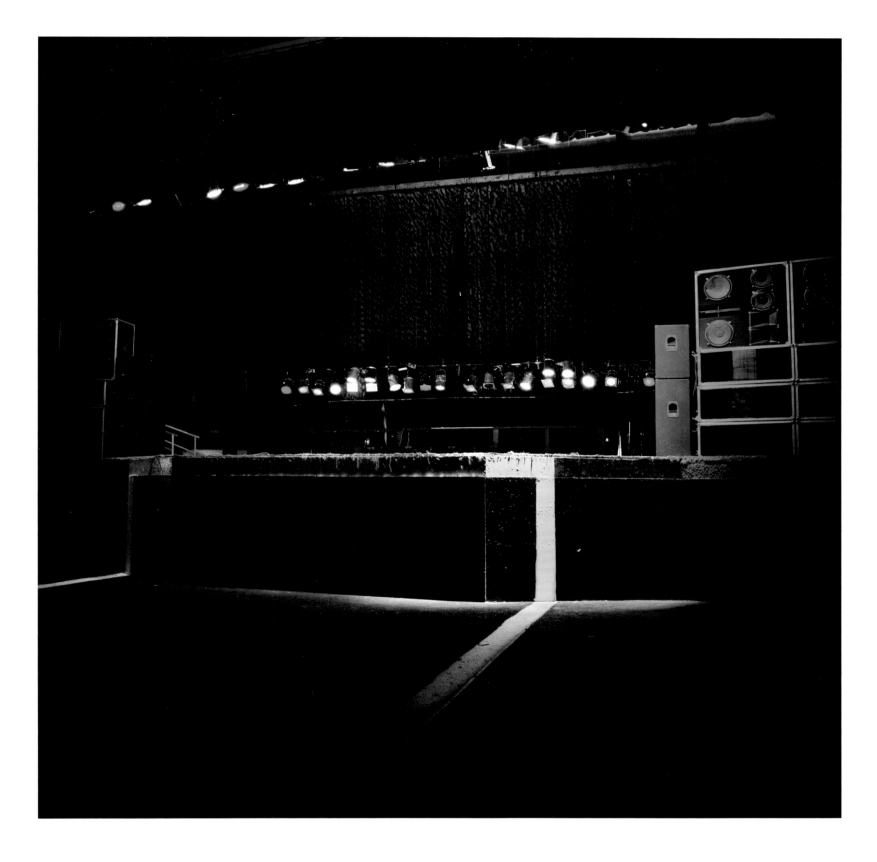

Harpos Concert Theatre, Detroit, MI — October 28, 2008

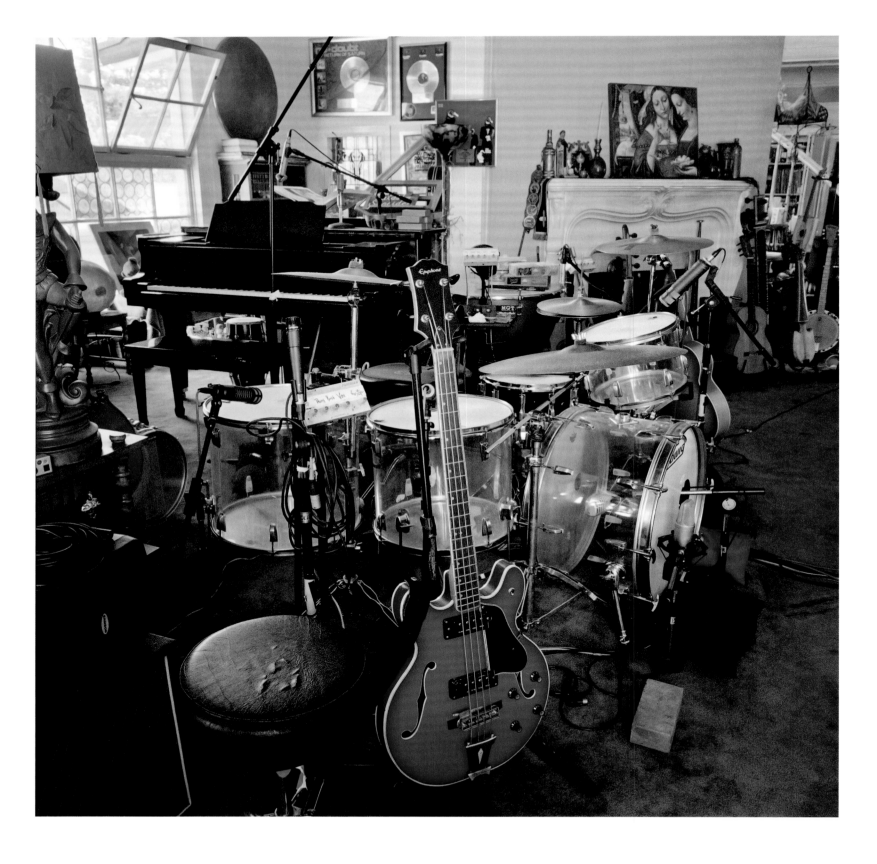

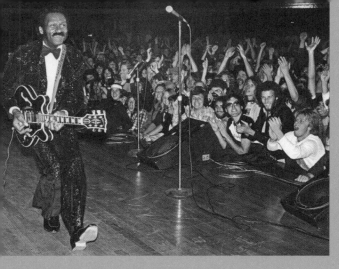

HOLLYWOOD PALLADIUM,
LOS ANGELES, CA

This theater and ballroom is a fine example of Streamline Moderne, with an interior of sweeping curves and chrome accents. Its 1940 grand opening starred Tommy Dorsey and his orchestra, with vocalist Frank Sinatra. During World War II, Betty Grable participated in radio shows broadcast here. As big swing bands lost popularity, filling the large theater became more difficult. In 1955, the *Lawrence Welk Show* was produced here, and after the production moved to another TV studio, the Welk orchestra played shows every weekend at the Palladium until 1976. From 1964 to '72, it was the site of the Teen-Age Fair, an annual week-long convention scheduled during high schools' spring breaks featuring booths selling teen-oriented products, guitars, fashions, and concerts. Sonny and Cher and Captain Beefheart and His Magic Band appeared at the fair in 1965. The 1969 event presented Jimi Hendrix and the MC5. The Grammy Awards broadcast from the Palladium four times in the mid-1970s. In the 1980s and '90s, punk and heavy metal shows kept the Palladium functioning, although the building's age was beginning to show. Los Angeles punk bands like Black Flag, the Weirdos, and the Dickies shared bills with touring bands like the Ramones, Blondie, and Devo.

40 WATT CLUB (SITE),
ATHENS, GA

Named for the single, bare 40-watt bulb illuminating the space, this loft was the first location for a significant venue of the nascent Athens new wave music scene. In 1979, it was the birthplace of pioneering post-punk bands Pylon and Guadalcanal Diary, and a showcase for countless local bands. As the club moved several times through the '80s, the roster of local bands that treated the 40 Watt Club as their home base expanded to include R.E.M., Love Tractor, and Drive-By Truckers. Beyond its importance to Athens, the 40 Watt

quickly became a valued part of the network of clubs across the country supporting indie rock, offering touring bands the opportunity to reach new fans. **(See 40 Watt Club, Athens, GA; Caledonia Lounge, Athens, GA.)**

CLUB BARON (SITE),
NASHVILLE, TN

In a middle-class African American neighborhood in Nashville, on Jefferson Street—the district's main commercial strip—Club Baron opened in 1955. An important link in the Chitlin' Circuit, it showcased rock and roll innovators Chuck Berry, Fats Domino, and Little Richard and R&B stars like Ike and Tina Turner, Otis Redding, and B. B. King. Nashville bluesman Johnny Jones bested up-and-comer Jimi Hendrix in a guitar duel in 1963. For the last three decades, the building has housed a chapter of the Benevolent and Protective Order of Elks, the fraternal organization more familiarly called the Elks Lodge.

OLD BLACKBERRY WAY,
MINNEAPOLIS, MN

Blackberry Way recording studio was founded in the early 1970s by three members of the rock band Fingerprints. During thirty-plus years of operation, the facility recorded dozens of indie bands including the Twin/Tone Records artists the Suburbs and Soul Asylum. Hüsker Dü made their first demos here in 1980, and the Replacements recorded their first three albums at Blackberry Way.

ORPHEUM THEATRE,
BOSTON, MA

Constructed in 1852 as the home of the Boston Symphony Orchestra, and originally called the Boston Music Hall, this is one of the oldest theaters in the U.S. The concert hall became a vaudeville theater in 1900 and was renamed the Orpheum in 1906. After spending much of the mid-twentieth century as a movie house, the Orpheum became a live music venue in 1971, with James Brown headlining the reopening show.

THE SHOWBOX,
SEATTLE, WA

The building began in 1909 as the Angeles Saloon and Café, owned by a brewery in Port Angeles, WA. The saloon closed shortly before Prohibition, and was replaced by a grocery. In 1939, the space was converted into an Art Deco nightclub and movie theater called the Show Box. Kerns Music shop, which sold instruments and records, opened in the street-level commercial space below the main ballroom in 1946. In 1967, the venue was transformed into the Happening Teenage Nite Club. For the one year it was open, the Happening presented bands from the San Francisco scene such as Buffalo Springfield and Country Joe and the Fish, and area groups like the Sonics and the Seattle-based band Merrilee Rush & the Turnabouts. The 1980s witnessed another resurrection of the Showbox with bookings of acts like Squeeze, XTC, the Jam, and the Psychedelic Furs. This coincided with a boom in local indie bands that took advantage of the nightclub being back in action. For a time in the early 1990s, the theater became a comedy venue and then a rock club again in 1996.

RADIO RECORDERS ANNEX,
LOS ANGELES, CA

Radio Recorders was founded in 1933 at 932 N. Western Avenue, and in 1949 moved to 7000 Santa Monica Boulevard. During the 1940s, the facility produced hundreds of transcription disks of radio programs originating from the East Coast for delayed broadcast on the West Coast. An additional recording studio called Radio Recorders Annex was built in 1946 in a warehouse around the corner. Jazz trumpeter and vocalist Chet Baker recorded here in 1954. Elvis Presley used the studio in the early 1960s. A New York–based studio, the Record Plant, moved their West Coast operations to the Radio Recorders space in 1985.

SANTA MONICA CIVIC AUDITORIUM,
SANTA MONICA, CA

Designed by the same architectural firm responsible for the Capitol Records tower, this striking modern auditorium was completed in 1958. Parabolic pylons support a canopy that fronts a glass curtain wall facade, shielded by a pierced concrete brise-soleil. The auditorium has hosted conventions, sporting events, the Academy Awards from 1961–68, film festivals, stage musicals, and live music. One of the many concerts staged here was the *T.A.M.I. Show*, filmed in 1964 by American International Pictures for theatrical release. Whether the acronym "T.A.M.I." meant "Teenage Awards Music International" or "Teen Age Music International" is unclear. Free tickets were distributed to local high schools to ensure a young, enthusiastic audience. Two shows were filmed on October 28 and 29, 1964—the best performances to be used for the film.

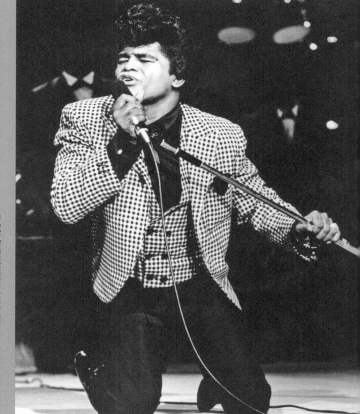

The acts included Chuck Berry; James Brown; Lesley Gore; the Barbarians; Jan and Dean; the Beach Boys; Motown stars Marvin Gaye, the Miracles, and the Supremes; and representing the British Invasion, Gerry and the Pacemakers; Billy J. Kramer and the Dakotas; and the Rolling Stones. The Stones agreed to close the show following James Brown and the Famous Flames, a decision Keith Richards would call the band's "biggest mistake." After the tear-jerking histrionics of "Please, Please, Please," Brown led his incredibly tight showband through a five-minute workout of "Night Train" while drawing on an arsenal of dance moves honed over a decade of touring. It was a tough act to follow for the young band from London, as they looked a little lost as they trotted out from the wings. **(See Capitol Studios, Los Angeles, CA.)**

NORMAN PETTY RECORDING STUDIOS,
CLOVIS, NM

Norm Petty was Buddy Holly's producer and manager through 1958. Petty built his studio in 1954 in what had been a grocery store. Holly recorded extensively here, including his smash hit single "Peggy Sue." When Holly died in 1959, Petty prepared Holly's unfinished recordings for commercial release. Although best known for his association with Buddy Holly, Petty also produced early hit singles by Roy Orbison and Buddy Knox. Waylon Jennings, Sonny Curtis, and Jimmy Gilmer and the Fireballs also recorded with Petty.

TOOTSIE'S ORCHID LOUNGE,
NASHVILLE, TN

Tootsie's Orchid Lounge is a honky-tonk bar with nightly music. It was called "Mom's" until Hattie Louise "Tootsie" Bess bought it in 1960. The stage door for the Ryman Auditorium, home to the Grand Ole Opry for many years, is just across the alley from the back door to Tootsie's basement bar. Before the Opry left the Ryman in 1974, Tootsie's was a convenient clubhouse for Opry performers and songwriters before, during, and after broadcasts. In the early 1970s, Kris Kristofferson had a job sweeping Tootsie's floors while he shopped songs on Music Row. Willie Nelson is said to have written "Crazy" and convinced Faron Young to record his song "Hello Walls" at a side table in Tootsie's. **(See Ryman Auditorium, Nashville, TN.)**

CANDLESTICK PARK (SITE),
SAN FRANCISCO, CA

Constructed for the San Francisco Giants baseball team in 1960, this stadium was the site of the last concert of the Beatles' final U.S. tour. On August 29, 1966—after the Ronettes, soul singer Bobby Hebb, the Cyrkle, and Barry and the Remains

opened—the Beatles played a thirty-three-minute set. Candlestick has been the scene of other large-scale concerts, notably the Rolling Stones for two dates in 1981, Van Halen in 1988, and Metallica in 2000 and 2003. Paul McCartney played the final concert at Candlestick Park on August 14, 2014. The stadium was razed in 2015.

RIVIERA THEATRE,
CHICAGO, IL

Designed in French Renaissance revival splendor, this Balaban and Katz movie palace opened in 1918. At the time, it was the largest and most opulent theater in the Uptown section of Chicago. By 1977, it was in its final days as a full-time movie theater and occasional live concerts were beginning to be staged. It became a nightclub in 1986, and a few years later one of Chicago's most popular concert venues—as it remains today.

SURF BALLROOM,
CLEAR LAKE, IA

The last performance by Buddy Holly, J. P. "The Big Bopper" Richardson, and Ritchie Valens was at the Surf Ballroom on February 2, 1959, part of the "Winter Dance Party" tour. The airplane they chartered to take them to their next show crashed, killing the three musicians and the pilot. The first Surf Ballroom was built in 1933, with a fanciful South Sea Island décor theme. Touring dance bands, like those that Duke Ellington and Tommy Dorsey led, made stops here in the 1930s and '40s. The original structure burned down in 1947 and a new ballroom was constructed on a site nearby the following year. With the rising popularity of rock and roll in the 1950s, the Surf Ballroom was a venue for many package tours that typically featured five or more acts for the price of one ticket.

HIBBING HIGH SCHOOL, AUDITORIUM,
HIBBING, MN

In the mid-1950s, Robert Zimmerman, the future Bob Dylan, was a student at Hibbing High School, where he participated in talent shows and performed for his classmates on the auditorium stage. In 1956, Dylan sang a Little Richard tune in the talent show and the principal rang down the curtain on him.

> Hibbing's got the biggest open pit ore mine in the world . . . / Hibbing's got souped-up cars runnin' full blast on a Friday night / Hibbing's got corner bars with polka bands / You can stand at one end of Hibbing's main drag an' see clear past the city limits on the other end / Hibbing's a good ol' town

Excerpted from the poem "My Life In a Stolen Moment," Bob Dylan, 1962. **(See Little Theater, Hibbing, MN.)**

CHESS RECORDS (SITE),
CHICAGO, IL

Founded in 1950 on Chicago's South Side, Chess Records became synonymous with the Chicago blues style, producing many archetypal recordings of the most influential generation of blues artists such as Muddy Waters, Howlin' Wolf, and Willie Dixon. Recordings by Bo Diddley and Chuck Berry helped define the evolving genre of rock and roll. Chess records had a unique sound—the result of experimental approaches to recording—like using the studio's tiled restroom as an echo chamber and a 10-foot length of sewer pipe to create a 1/10th of a second delayed sound. The label was established by Leonard and Phil Chess, immigrants from Poland, and it began during a post-war boom in the music business, a time when hundreds of small independent record labels were created. It took sharp business skills, often coupled with a rather amoral attitude about artist rights, to survive, let alone thrive, in this environment. Whether or not the Chess brothers exploited musicians to a greater degree than their industry peers is open to debate. One cannot deny the significance Chess recordings have had on popular music.

BLUE BIRD INN,
DETROIT, MI

In 1937, in the combined spaces formerly occupied by a tire repair shop and a metal plating works, the Blue Bird Inn opened. The café with a bar featured swing music and blues. To lure a younger crowd, bandleader and pianist Phil Hill was hired in 1948 to assemble a house band that could play bebop. The club's reputation as Detroit's premier venue for modern jazz grew throughout the 1950s, attracting the highest quality musicians. Among the local musicians who launched their careers on the Blue Bird's bandstand are trumpeter Donald Byrd, composer Thad Jones, drummer Elvin Jones, pianists Tommy Flanagan and Barry Harris, and multi-instrumentalist Yusef Lateef.

APOLLO THEATER,
NEW YORK, NY

The theater opened as Hurtig & Seamon's New Burlesque Theater in 1914—a time when Harlem was a middle-class white neighborhood. The acts and the audience were exclusively white. Twenty years later, the theater closed, a victim of Mayor Fiorello La Guardia's morality campaign against burlesque. Harlem, in the meanwhile, had become Manhattan's principal African American neighborhood. In 1934, the theater reopened with two changes: the name was now the Apollo, and the audience and the performers were African American. The Apollo's reputation as Harlem's cultural heart can scarcely be overstated. Star performers who appeared here were a Who's Who of African American popular entertainment. During the swing era, every top big band from Duke Ellington to Dizzy Gillespie was featured along with variety acts, comedians, and dancers like the Nicholas Brothers and Bill "Bojangles" Robinson. The Gospel greats who performed include Mahalia Jackson, the Staple Singers, and Sam Cooke with the Soul Stirrers. Soul acts like Ray Charles, Aretha Franklin, and Otis Redding always made an impact on the stage. Wednesday Amateur Night was a longstanding tradition that proved the launching pad for many careers, most notably Ella Fitzgerald, and in 1964 Jimi Hendrix won the first prize in an amateur contest. A live recording of James Brown and the Famous Flames became the hit album *Live at the Apollo*, which spent sixty-six weeks on the *Billboard* pop album charts, peaking at number two. Brown recorded three more live albums at the Apollo.

CAROUSEL LOUNGE,
AUSTIN, TX

Since 1963, the Carousel Lounge has presented live music in Austin in a room decorated with a unique circus theme. The music ranges from punk rock to honky-tonk. In the 1990s, the Carousel was a popular venue for dancers and bands in the swing revival scene.

Chess Records cofounder Phil Chess (left) with (left to right) Muddy Waters, Little Walter, and Bo Diddley in Chicago, 1967.

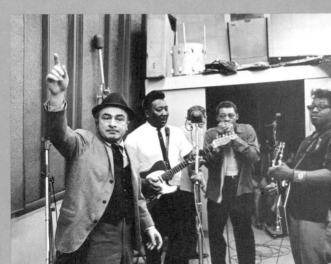

PIERS 30–32,
SAN FRANCISCO, CA

The American-Hawaiian Steamship Company built Piers 30 and 32 in 1912. Joined by Matson Navigation in 1927, the two companies shipped freight until World War II. The area between the two piers was connected by a concrete deck constructed in 1950. A huge fire destroyed transit sheds and the bulkhead building in 1984. The 13-acre site was used as a concert venue, including several years of the Warped Tour music festival in the 1990s and early 2000s, and an annual concert event called KaBoom sponsored by radio station KFOG from 1994–2010.

BROKEN SPOKE,
AUSTIN, TX

James White opened the Broken Spoke in 1964. Today, it is one of the last dance halls in Austin. The Texan dance hall tradition began with Swedish and German immigrants erecting community halls for social functions in the early twentieth century. The polkas and waltzes danced in these halls blended with other popular forms with the emergence of Western swing in the 1930s. The Broken Spoke has preserved the dance hall tradition in the face of ever-changing pop music trends by continuing to present live country music expressly intended for dancing. Western swing pioneer Bob Wills played here, as have Willie Nelson, George Strait, Dale Watson, and countless others.

TWIN BAR,
GLOUCESTER CITY, NJ

In the 1950s, this was a saloon that drew sailors from the nearby Philadelphia Naval Base across the Delaware River. For roughly eighteen months in 1951 and 1952, Bill Haley and his country band, the Saddlemen, played the Twin Bar. Their repertoire was mostly western swing, though they played with a shuffle beat more commonly associated with jump blues. During this early period they took some inspiration from African American R&B groups who were playing at other clubs on the same New Jersey circuit, among them the Treniers. Another model for a new direction was Ike Turner's "Rocket 88," considered by many the first rock and roll record, which the Saddlemen covered in 1951. The group's name was changed to the Comets as their sound became less country. As Bill Haley & His Comets, they brought the new sound of rock and roll into mainstream popular culture with a string of hits starting with 1954's "Rock Around the Clock."

KLRU-TV, *AUSTIN CITY LIMITS,*
AUSTIN, TX

Debuting in October 1974, *Austin City Limits* is the longest running television concert series in the United States.

Austin is called the "Live Music Capital of the World" due in part to this show. Originally charged with presenting Texas music, the show has expanded beyond its country roots to embrace a wide range of pop music, from folk to blues and rock. The first thirty-six seasons of *Austin City Limits* were taped in Studio 6A at KLRU-TV. Willie Nelson was the featured artist on the show's pilot. The first regular episode featured a set by original members of Bob Wills & His Texas Playboys and a set from the local Austin Western swing band Asleep at the Wheel, who have returned to the program an additional eleven times. Among other performers who have made multiple appearances are Lyle Lovett, Loretta Lynn, Merle Haggard, and Tex-Mex accordionist Flaco Jiménez. R&B legend and country music fan Ray Charles appeared twice, and bluesman Buddy Guy four times. In 2011, the show moved to the Moody Theater, a new facility in downtown Austin.

KAISER AUDITORIUM,
OAKLAND, CA

This city-owned Beaux Arts theater and events space—originally called the Oakland Civic Auditorium—was built in 1914 on Lake Merritt's shore. The building comprised an arena with a hardwood floor and surrounding balcony under a glassed roof; a theater (opera house); exhibit halls; and the municipal art gallery. The complex was renamed for industrialist Henry J. Kaiser after a 1984 renovation. The space has seen a variety of uses: temporary hospital during the 1918 influenza pandemic; home of the Ringling Brothers Circus until 1942; and a roller derby in the 1950s

and '60s. As a music venue, Elvis Presley played the auditorium twice, in 1956 and '57. The Grateful Dead played fifty-seven shows here, between 1967 and '89. In 1969, Western swing bandleader Spade Cooley, serving life in prison for his wife's murder, was granted a temporary furlough from Vacaville Prison to play a benefit for the Deputy Sheriffs Association of Alameda County. During intermission Cooley died of a heart attack backstage.

THE MAGIC SHOP,
NEW YORK, NY

Steve Rosenthal, a recording engineer and producer who learned the trade at Atlantic Records, founded this seminal studio on Crosby Street in SoHo in 1988. The Magic Shop opened at a time when electronic music was in vogue, and Rosenthal's vision of a big analog studio seemed anachronistic. In fact, it proved to be wildly popular with

musicians. Four albums recorded here helped solidify the studio's reputation: Lou Reed's *Magic and Loss*; Suzanne Vega's *99.9F°*; the Ramones' *Mondo Bizarro*; and Sonic Youth's *Dirty*. A variety of artists have chosen to record at the Magic Shop: Björk, Coldplay, Warren Zevon, Nada Surf, and She & Him, to name a few. David Bowie secretly recorded his last two albums, *The Next Day* and *Blackstar*, in this room. The equipment set-up pictured belongs to the band Blondie, who were recording their 2017 album *Pollinator*.

STATION INN,
NASHVILLE, TN

This single-story stone building has been home to the Station Inn since 1978. Founded in 1974, the original location was near Nashville's Centennial Park. The Station Inn offers an intimate listening room for bluegrass. A few seats from a tour bus once used by bluegrass

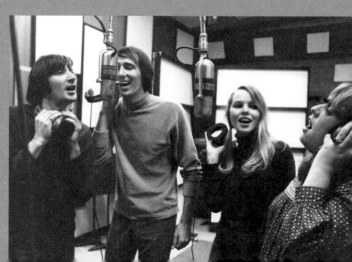

The Temptations onstage at the Apollo Theater in New York, 1964.

The Mamas and Papas recording in a Los Angeles studio, circa 1967.

pioneers Lester Flatt and Earl Scruggs now serve as seating. The club has drawn young musicians and established acts like Del McCoury, the Mavericks, and John Prine.

RED FOX LOUNGE,
BALTIMORE, MD

In the 1950s, Red Fox Lounge was one of the few nightclubs in Baltimore with an integrated audience. Owned by George and Reba Fox, the club presented African American blues and jazz entertainers. Jazz vocalist Ethel Ennis performed here regularly, as did bebop pianist Freddie Thaxton, both Baltimore natives.

CONTINENTAL CLUB,
AUSTIN, TX

Opening as a supper club in 1955, the Continental Club grew into a live music venue. In the late 1970s, it provided a stage for Texas blues and honky-tonk artists like Stevie Ray Vaughan and Joe Ely. The 1980s saw touring indie and punk bands like the Replacements and Social Distortion. A 1987 renovation brought back some of the 1950s glitz lost over the years, along with a commitment to feature roots music more prominently. Traditional country and blues, rockabilly, and garage rock revival bands have been the focus for the last three decades.

GRAND TERRACE (SITE),
CHICAGO, IL

This address held one of the most significant venues in the history of Chicago jazz. The 1909 automobile garage was converted into the Sunset Café in 1921. With possibly some organized crime backing, the proprietor, Joe Glaser, became the manager of many top jazz performers: Duke Ellington, Benny Goodman, Woody Herman, and, most significantly, Louis Armstrong. The Sunset Café was a "black and tan" club catering to an integrated crowd. In 1924, Carroll Dickerson's orchestra, with Earl "Fatha" Hines on piano, was the house band. Hines persuaded the hottest young cornetist in town, Louis Armstrong, recently separated from his mentor Joe "King" Oliver's Creole Jazz Band, to join the Sunset group. After hearing Armstrong play, Glaser immediately put his name in lights, billing him as "The World's Greatest Trumpet Player." No jazz player in Chicago disputed this hyperbole. White jazz-mad musicians, like cornet legend Bix Beiderbecke, began to frequent the Sunset to hear Armstrong. In 1937, the café was remodeled and renamed the Grand Terrace, in operation until 1950.

COSMO ALLEY (SITE),
LOS ANGELES, CA

This tiny club, previously the back room of an Armenian restaurant, opened in 1957. It was the Hollywood version of the typical beatnik coffeehouse: waitresses in black tights with straight hair and thick black eyeliner, poetry readings and folk singers, goatees and berets. The entertainment ranged from jazz musicians Bob Dorough and Ornette Coleman, to socially conscious comedians Lord Buckley and Lenny Bruce. Bruce once spent weeks attempting to teach the club's mynah bird mascot the phrase, "The Pope sucks." In the 1960s, rock groups like the Doors and Frank Zappa's Mothers of Invention were also regular performers.

ALVIN'S FINER DELICATESSEN,
DETROIT, MI

Cass Corridor is a stretch of Cass Avenue anchored by the Detroit Institute of Arts to the north and the Masonic Temple to the south in midtown Detroit. Lured by cheap rents and proximity to Wayne State University and other nearby cultural institutions, Cass Corridor became a popular neighborhood for artists and musicians in the 1960s. Alvin's Finer Delicatessen, opened in 1970, was the hub of this bohemian community through the next decade. The café was a favorite daytime hangout for hungry students and in the evenings a music venue called the Twilight Bar at the rear offered a stage for rock and blues musicians. The bands were often short-lived combos composed of members of Mitch Ryder's Detroit Wheels, the MC5, or musicians from John Lee Hooker's band, or they were more established long-running Detroit bar bands like Shadowfax. In the early 1980s Alvin's started booking Detroit area garage rock and hardcore punk bands. **(See Masonic Temple, Detroit, MI.)**

CAPRICORN RECORDS (SITE),
MACON, GA

In the early 1960s, Phil and Alan Walden managed several R&B performers, soul singers Otis Redding and Al Green among them. Seeking to expand their business into production, they assembled a recording studio in an office building in Macon. The project stalled after Redding's death in 1967, but by 1969 Capricorn Records, having secured a distribution deal with Atlantic Records, was ready to open its doors. Using Stax and FAME studios as a model, Capricorn offered state-of-the-art production and a house backing band. The Allman Brothers were an early success, setting the template for what would be called southern rock, a genre expanded by labelmates like the Marshall Tucker Band and the Dixie Dregs. The first incarnation of Capricorn Records ended in 1979.

REGENCY BALLROOM,
SAN FRANCISCO, CA

This restored Beaux Arts theater was built in 1909 as part of the Scottish Rite Temple, a Masonic fraternal society. The ballroom housed a dance school. In 1967, it was converted into a movie house that operated until 1998. From 2003 through 2005, in something of a neo-hippie revival, a series of seventy concerts were staged in the space, as the Avalon Ballroom. The Avalon, which had existed from 1966 to 1969 in the adjacent building, was an important venue of the psychedelic counterculture, staging dances featuring the psychedelic San Francisco bands with the requisite light shows.

UNITED WESTERN RECORDERS, STUDIO 3,
LOS ANGELES, CA

In 1961, United Western Recorders was created by merging two studios, United Recording Corp. and Western Studio. The new two-building complex quickly became one of the busiest and sought-after Hollywood studios. Initially favored by older acts like Bing Crosby and Nat King Cole, United Western soon became the choice of rising stars like the Monkees, the Turtles, and Sam Cooke. The Western Studio suite is currently called East West Studios. Studio 3, the smallest of the spaces, was the favorite of the Beach Boys' Brian Wilson, who used it for much of the *Pet Sounds* and *Smile* albums. The Mamas and the Papas also favored Studio 3, recording "California Dreamin'" and "Monday, Monday" here. **(See United Western Recording, Studio A, Los Angeles, CA.)**

CANTON MEMORIAL CIVIC CENTER,
CANTON, OH

This multi-use arena was built in 1951 and has hosted a variety of sporting events, trade shows, and conventions. It has also presented concerts. This photo is the single image in this book representing an event that never happened. Hank Williams was scheduled to appear at the Canton Civic Center on January 1, 1953. Williams was in Montgomery, Alabama, when he learned that an ice storm would prevent him from flying to the concert. He hired a college student to drive him to Canton, leaving the afternoon of

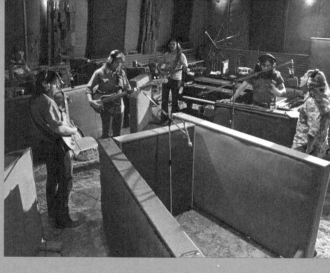

The Marshall Tucker Band recording at Capricorn Records in Macon, Georgia, 1973.

New Year's Eve. That night, somewhere between Bristol, Tennessee, and Oak Hill, West Virginia, Williams suffered a heart attack and died in the backseat of his 1952 baby blue Cadillac.

CLOWN LOUNGE,
ST. PAUL, MN

This small 350-person capacity venue can be found in the basement of the Turf Club, decorated with kitsch clown paintings. Although the intimate room is primarily known for jazz, Clown Lounge has hosted local musicians playing a range of styles, from country to rock and hip-hop. **(See Turf Club, St. Paul, MN.)**

MADISON SQUARE GARDEN,
NEW YORK, NY

Madison Square Garden has hosted more high-profile concerts than any other New York City venue. Elvis Presley sold out four performances in 1972, the first and last of his New York performing career. Elton John has given sixty-four concerts at the Garden, and John Lennon made his final concert appearance during an Elton John show on Thanksgiving night 1974. Madonna has performed here thirty-one times, U2 twenty-eight times, and the Grateful Dead a respectable fifty-three. Billy Joel holds the record with 120. Three previous venues bore the name Madison Square Garden: the first, an open-air stadium at 26th Street, was leased by promoter P. T. Barnum from 1879 to 1890. The second, a more conventional structure designed by Stanford White in a Beaux Arts style with Moorish accents, featured a large main hall with a separate concert hall and a rooftop garden. This building lasted until 1925. The third Garden, open from 1925 to 1968, was located at Eighth Avenue between Forty-Ninth and Fiftieth Streets. To build the current Garden, which sits above the Pennsylvania Railroad, the Penn Station's above-ground elements had to be destroyed. The uproar caused by the destruction of what was considered an architectural highlight led to the creation of New York City Landmarks Preservation Commission.

SAM C. PHILLIPS RECORDING SERVICE, MEMPHIS, TN

Sun Records owner Sam Phillips bought what had previously been an auto repair shop in 1958. After an extensive remodeling of both interior and exterior, Phillips turned the space into a new state-of-the-art recording facility to replace the cramped, outmoded Sun Studio. The decor was late-1950s design, with a checkerboard linoleum floor, pastel seafoam green walls, pink stripe accents, and miniature Space Age Sputnik door handles. Sam C. Phillips Recording Service launched in September 1960. The first project was "Lonely Weekends," a major hit for Charlie Rich. The studio recorded Sun Records' stable of artists until 1969, when the label was sold to Mercury Records. Alex Chilton, from the band Big Star, used the studio to produce *Songs the Lord Taught Us*, the debut album of punk/rockabilly band the Cramps, and recorded portions of his own solo album, *Like Flies on Sherbert*. Sam Phillips and his sons Jerry and Knox all share production credit on John Prine's 1979 album *Pink Cadillac*.

PASADENA CIVIC AUDITORIUM, PASADENA, CA

Van Halen—featuring Pasadena natives Eddie and Alex Van Halen—played many shows here from 1975 to 1978 before their first album's release. Designed in Beaux Arts style with Mediterranean revival detail, the auditorium was built in 1931. In addition to a variety of civic events, graduation ceremonies, and benefit concerts, the space hosted big band radio broadcasts in the 1930s and '40s. In the late 1940s and '50s, Gene Norman staged his Just Jazz concert series here. The auditorium has programmed music, dance, and theater productions of all kinds, as well as special television events including "Motown 25: Yesterday, Today, Forever" featuring Michael Jackson dancing his "moonwalk" for the first time during the song "Billie Jean."

MORTON THEATRE, ATHENS, GA

One of the first vaudeville houses that was owned and operated by African Americans, the Morton Theatre opened in 1910. In addition to housing the theater, the Morton building rented offices to Black medical professionals and businessmen, a rare resource in the days of segregation. Comedy duo Butterbeans and Susie; bandleaders Cab Calloway and Duke Ellington; and bluesmen like Curley Weaver and Blind Willie McTell were some of the acts in the theater's prime. In the 1930s, it was converted into a movie house. The theater fell out of use after a fire in 1954. In 1980, the building was purchased by the nonprofit Morton Theatre Corporation with a combination of state and federal funds. The theater has been used as a music video location and rehearsal space for local bands such as the B-52s, Dreams So Real, and R.E.M. After a decade of restoration, the theater reopened as a community arts space in 1991.

MUTUAL MUSICIANS FOUNDATION, KANSAS CITY, MO

This building was the original headquarters of American Federation of Musicians Local 627, established in 1917, then known as the "Colored Musicians Union," which operated as a social center, clearinghouse for engagements, and a vehicle for grievances of unfair practices against Black musicians in Kansas City. White musicians had their own separate union, Local 34. From the earliest days of the art form, Kansas City played an important part in jazz's development. In the 1920s union members formed jazz combos led by Dave Lewis and Bennie Moten. By the mid-1920s, Moten's band was making an impact on the East Coast through touring and recording. The 1930s were the time of the Territory Bands, touring dance bands based in Kansas City creating their own style of swing music: Andy Kirk and His Twelve Clouds of Joy, featuring pianist and composer Mary Lou Williams; Walter Page's Blue Devils; and soon Count Basie would take over the Moten organization in 1935. In the late 1930s, Jay McShann's band was the training ground for the young Charlie Parker. In the 1940s, Local 627 boasted blues shouter Big Joe Turner and boogie woogie pianist Pete Johnson as dues-paying members. At the union hall, visiting musicians would drop in to jam with members in the lounge. While the Big Band era was long gone, Local 627 thrived throughout the 1960s as the flourishing local blues and soul scene attracted new members. In 1970, the national union leadership ended their segregation policy, merging Local 627 with Local 34. The old 627 building continued as a social club for Black musicians as the Mutual Musicians Foundation. As they have since 1930, musicians gather at the foundation on Friday and Saturday nights after midnight to jam into the early morning hours. **(See Colored Musicians Club, Buffalo, NY.)**

SOUND 80 (SITE), MINNEAPOLIS, MN

Sound engineer Tom Jung and composer Herb Pilhofer, who had previously worked together at Kay Bank Studios, founded Sound 80 in 1969. A 1974 recording session produced five songs released on Bob Dylan's *Blood on the Tracks* album. Local disco act Lipps Inc. had a smash hit with "Funkytown," recorded at Sound 80. Prince produced elements of the demo recordings that landed him a major record deal at this studio. **(See Kay Bank Studios site, Minneapolis, MN.)**

CHURCHILL'S PUB, MIAMI, FL

The C&H Bar opened in 1948. Renamed "Churchill's" in 1979, this saloon became a staple of the Miami music scene, sometimes referred to as the "CBGB of the South." Churchill's claims to have offered a stage to more than twenty thousand individual acts through its existence. Established artists like Social Distortion, surf guitarist Dick Dale, and Iggy Pop have all played the pub.

WEBSTER HALL, NEW YORK, NY

This gorgeous Queen Anne structure was built in 1886 as an event hall on the edge of New York's Kleindeutschland, a large enclave of German immigrants. In the 1910s and '20s, fabulous masquerades and bacchanals for New York's bohemian art scene were staged here. The hall was used as a concert space in the early 1950s, and recognizing its superior acoustic quality, RCA bought the building to use for recording from 1953 through 1968. Countless pop and Broadway artists recorded here. Bob Dylan's vinyl debut is his harmonica playing on a Harry Belafonte album. The 1980s saw a decade-long stretch as the Ritz, one of the top mid-size concert halls featuring up-and-coming rock and world music acts. In the early 1990s, change of management and a return to the original name, Webster Hall, saw more rock shows plus an increasing number of dance parties.

CAROUSEL BALLROOM (SITE), SAN FRANCISCO, CA

The Carousel Ballroom was originally a swing-era dance palace called El Patio Ballroom on the second floor of an automobile dealership. For six months in 1968 it was operated by a collective formed by San Francisco psychedelic bands the Grateful Dead, Jefferson Airplane, Quicksilver Messenger Service, and Big Brother and the Holding Company as a social/musical "laboratory experiment." In addition to the partnered bands, other acts included Chuck Berry, Buffalo Springfield, the Charlatans, Dan Hicks, and the Steve Miller Band. Later that year promoter Bill Graham began booking shows at this venue, dubbing this venture the "Fillmore West." After three years of promoting shows, Graham closed the Fillmore West on July 4, 1971. A documentary film on the last series of concerts, titled *Fillmore*, was released in 1972.

EAGLE SALOON (SITE), NEW ORLEANS, LA

This stretch of South Rampart Street, in the neighborhood known as "Back of Town," is among the most significant locations in jazz history. Louis Armstrong grew up not far from this 1850 neoclassical revival building that housed the Eagle Saloon on street level and the Odd Fellows and Masonic Dance Hall on the top floor. Established in 1897, the Odd Fellows and Masons sponsored dances featuring a band with cornet legend Buddy Bolden. Although Bolden never recorded, the earliest generation of jazz musicians—including Louis Armstrong—idolized him for the fire and power of his horn playing. Society bandleader John Robichaux also performed here, as did trumpeter Bunk Johnson and pianist/composer Jelly Roll Morton. On New Year's Eve 1912, a young Armstrong fired a pistol on the street in front of the Eagle Saloon and was arrested. He was sentenced to eighteen months in the Colored Waifs' Home, where he received his first formal musical instruction on the cornet. **(See Iroquois Theater site, New Orleans, LA.)**

GEORGIA THEATRE, ATHENS, GA

The Athens YMCA built this structure in 1889 and remaining here until 1919. In later years it served as a music store, movie house, hotel, Masonic Temple, furniture company, and Sears Roebuck store before the Elite Theatre took over and expanded the original building in 1935. After spending much of the 1960s as a movie theater and Methodist church, in 1977 the building was converted into a concert hall called the Georgia Theatre. The B-52s performed here on May 20, 1978, and the

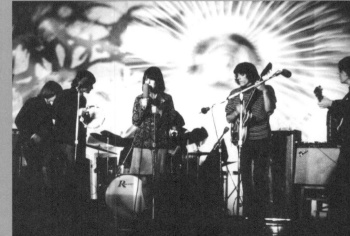

Jefferson Airplane's first New York appearance at Webster Hall, January 8, 1967.

following year the Police played as part of the band's first U.S. tour. Shows stopped for several years in the mid-1980s, and then in 1989 the Georgia Theatre once again opened with Athens post-punk band Pylon the first to play the renovated venue. The theater has hosted other Georgia artists like Widespread Panic and the Black Lips, as well as national and international touring acts.

CENTRAL AVENUE CROSSING ELM,
DALLAS, TX

From 1912 to 1925 bluesman Henry "Blind Lemon" Jefferson could be found playing guitar for tips at this corner. This chiefly African American neighborhood was known as "Deep Ellum." "Deep" referred to the long distance from downtown Dallas and "Ellum," a phonetic spelling of the street name Elm, as spoken in the local dialect. This was the principal strip for commerce and entertainment in Dallas's African American community in the early twentieth century. Blues clubs, movie houses, and cafés provided a stream of customers for street performers. Another musician Jefferson befriended here was Huddie Ledbetter, later known as folk and blues singer Lead Belly. In 1925, a scout from Paramount Records heard Jefferson playing in Deep Ellum and brought him to Chicago to record. His successful career lasted three years until his premature death in 1929 at thirty-six years of age. He is widely recognized as a major influence on Texas blues and popular music in general, as evidenced by tributes by artists like Lightnin' Hopkins, Mance Lipscomb, Bessie Smith, Carl Perkins, and the Beatles. Deep Ellum gained fame through the many blues and country songs referencing the exciting, sometimes dangerous, nightlife of its heyday from the 1910s through the '30s. **(See Knights of Pythias Temple, Dallas, TX.)**

MAX'S KANSAS CITY (SITE),
NEW YORK, NY

Opened by Mickey Ruskin in December 1965, Max's closed in 1981. In that time span the nightclub and restaurant, a half block off Union Square on Park Avenue South, became a gathering spot for musicians, poets, and artists. Its back room became a de facto annex of Andy Warhol's Factory. In addition to the artists and underground filmmakers who revolved around Warhol's Factory, the New York art world was well represented at Max's by Pop painters Robert Rauschenberg, Roy Lichtenstein, and Larry Rivers and sculptor John Chamberlain. The Velvet Underground performed here, as did the New York Dolls. David Bowie, Marc Bolan, and Iggy Pop would often be found hanging out, making Max's the center for the glam scene in the early '70s. Younger bands inspired by the New York Dolls and the CBGB scene made Max's a prime venue in the early days of punk and new wave. The space is now divided between a convenience store

and a loft apartment. This photo is roughly where the audience would have stood, facing a stage that no longer exists.

HOWARD THEATRE,
WASHINGTON, D.C.

Opened in 1910, the Howard Theater anchored a strip of U Street that became known as "Black Broadway." At a time when theaters in the South were strictly segregated, the Howard hosted the best African American talent in vaudeville. The facade is a stately Renaissance revival with Spanish influence. The Howard preceded New York's Apollo and Chicago's Regal Theater as a venue that catered to Black audiences. The Howard presented musicals, road shows, vaudeville acts, theater productions, and lecturers like educator Booker T. Washington. Duke Ellington's orchestra opened an era of big band jazz in 1931. Ella Fitzgerald, Billy Eckstine, Charlie Parker, Louis Armstrong, and Billie Holiday preceded the Supremes, Marvin Gaye, Chuck Brown, Aretha Franklin, Al Green, Roberta Flack, Ray Charles, and Sarah Vaughn on its stage. The theater shuttered in 1970, beginning a period of short revivals and repeated closures. **(See Apollo Theater, New York, NY.)**

HARPOS CONCERT THEATRE,
DETROIT, MI

Built for the Wisper and Westman theater chain, the Harper Theatre opened in 1939. It was designed in Streamline Moderne style, with an 80-foot vertical sign spelling out "Harper." In the 1970s, the movie theater was converted to a disco and renamed "Harpos" by altering the original sign. The illuminated acrylic dance floor dates from 1974, three years before the film *Saturday Night Fever* featured a similar one. In 1979, it became a concert venue, opening with a performance by Mitch Ryder. Its reputation as primarily a heavy metal venue solidified in the late 1980s with memorable appearances by Motörhead, Ronnie James Dio, and Megadeth. In the early 1990s, the club expanded its bookings to hip-hop, with shows by the Detroit artist known as the creator of "acid rap," Esham, and also Insane Clown Posse, Snoop Dogg, and Run-DMC.

366 NORTH KILKEA DRIVE,
LOS ANGELES, CA

The private home of musician, recording engineer, and producer Alain Johannes prompts a meditation on home studios. Musicians have always had spaces in which to practice their craft, whether a dedicated rehearsal hall or a home music room. In the age of recorded sound, home recording often became a tool for musicians to track progress. The evolution of home recording in the twentieth century moved from machines that would record 78-rpm acetate records to

reel-to-reel tape, to portable four-track cassette tape recorders. Each iteration of the technology became less expensive, smaller, and simpler to use. Over the last two decades, digital technology has replaced tape and become so affordable and simple that some music for commercial release is made in home studios. Music created at home can now be made to technical standards approaching that produced in traditional studios. Johannes, not content with restricting his music-making to one room, has let the studio spill out to occupy the entire house. This is a portrait of the contemporary musician, who sees no boundary between the domestic and his art.

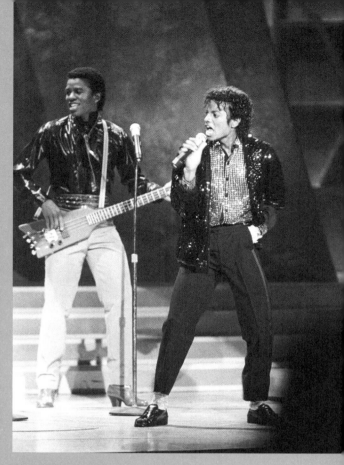

Jermaine and Michael Jackson on *Motown 25* at the Pasadena Civic Auditorium in California, May 16, 1983.

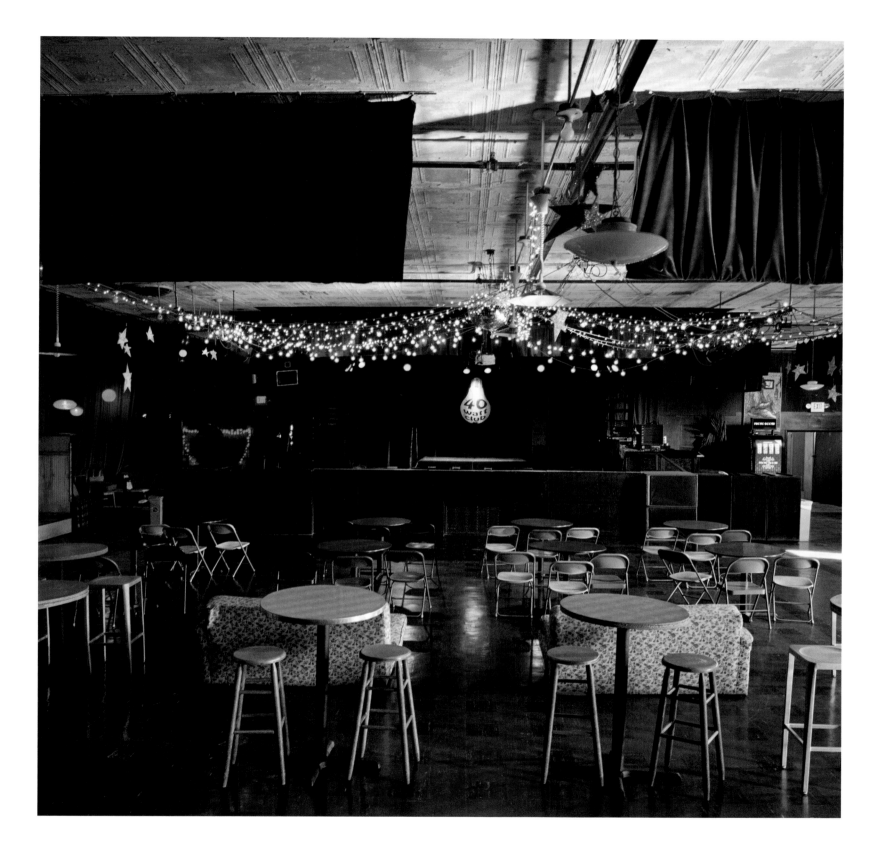

40 Watt Club, Athens, GA — June 22, 2015

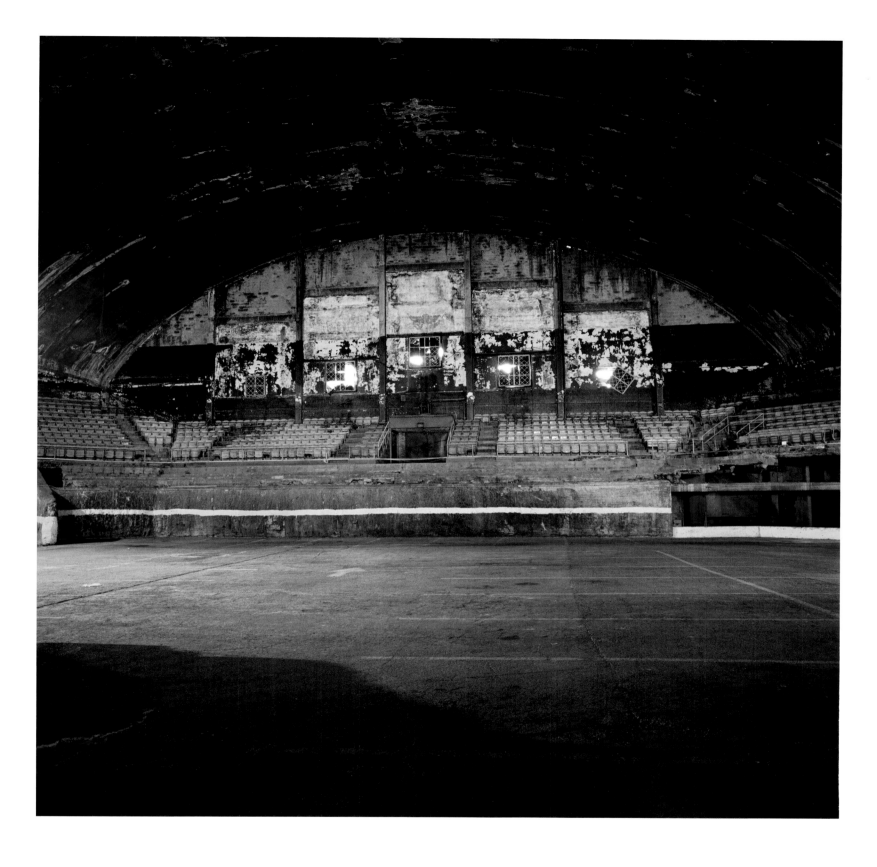

Washington Coliseum (site), Washington, D.C. — April 2, 2008

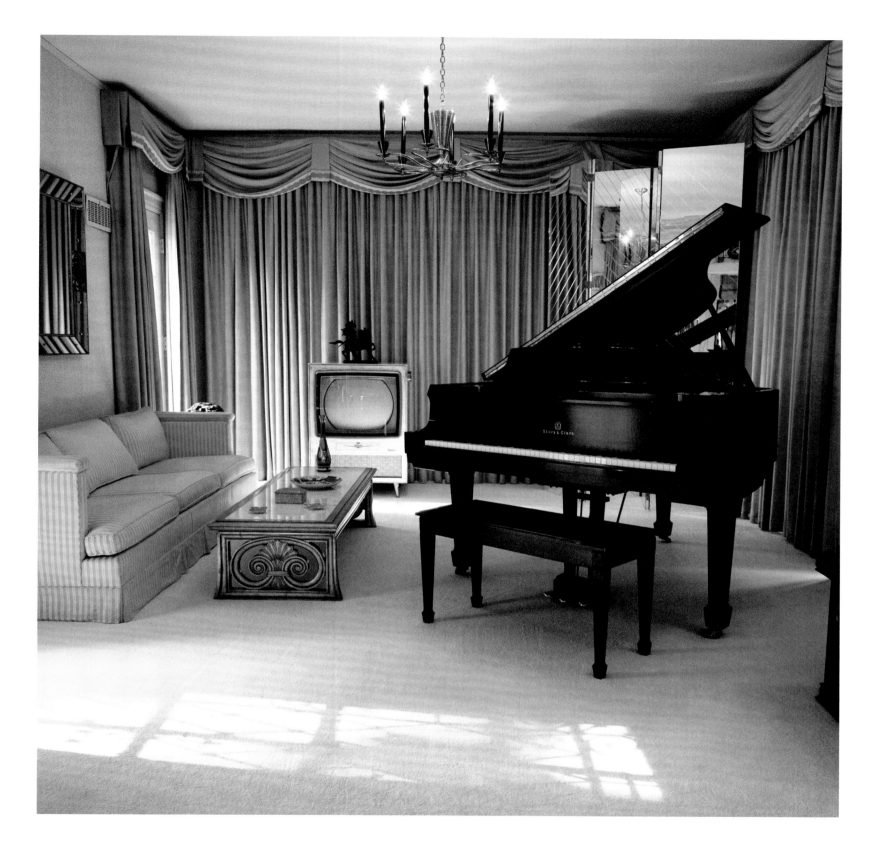

Graceland, Memphis, TN — May 6, 2008

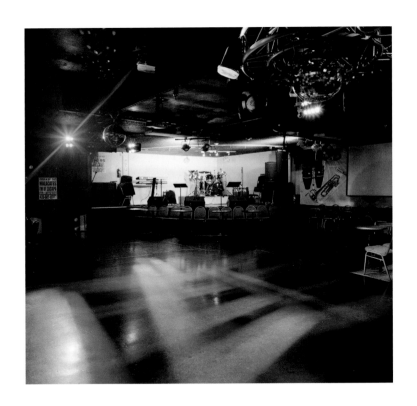

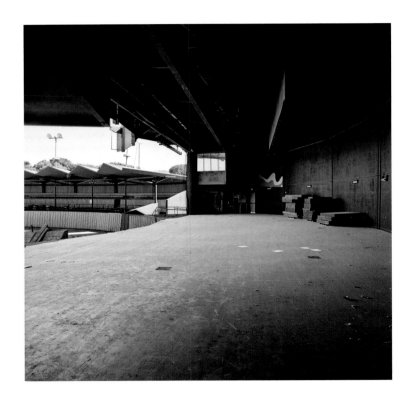

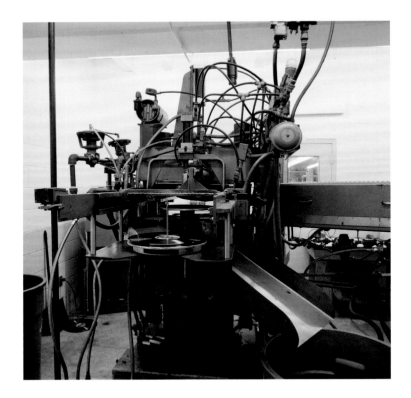

The Rock Garden (site), San Francisco, CA — November 12, 2015
Monterey County Fairgrounds, Monterey, CA — August 24, 2015
United Record Pressing, Nashville, TN — January 18, 2010
New York State Pavilion, Corona Park, Queens, NY — May 27, 2015

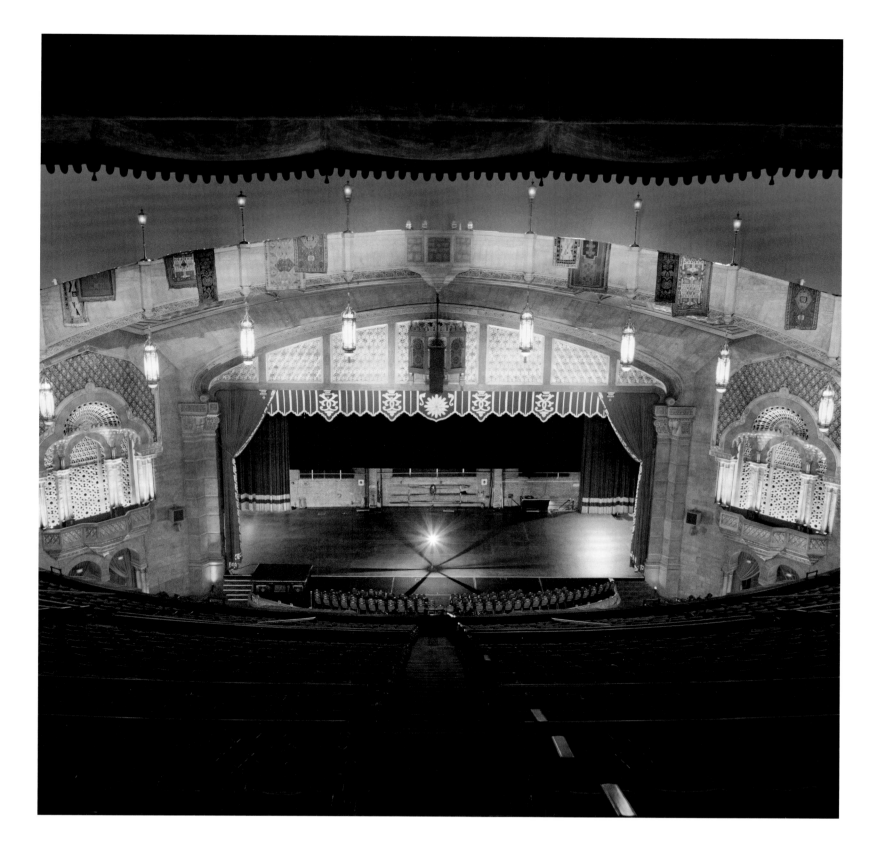

Fox Theatre, Auditorium, Atlanta, GA — June 25, 2015

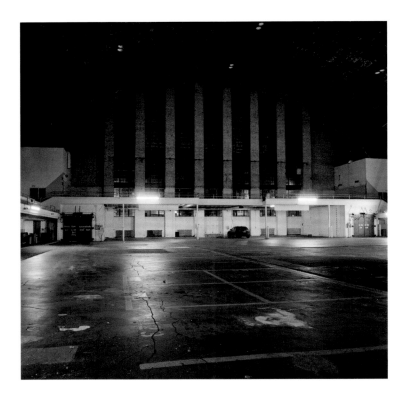

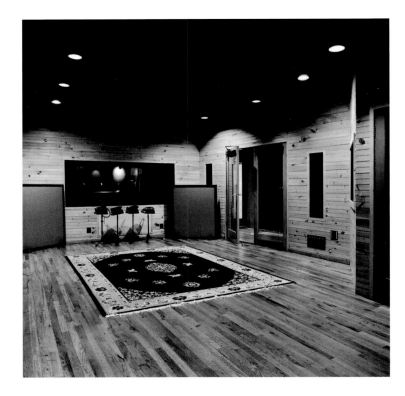

Beacon Theatre, New York, NY — June 19, 2015
708 Club (site), Chicago, IL — September 20, 2008
Minneapolis Armory, Minneapolis, MN — November 13, 2013
Quad Studios, Studio A, Nashville, TN — January 18, 2010

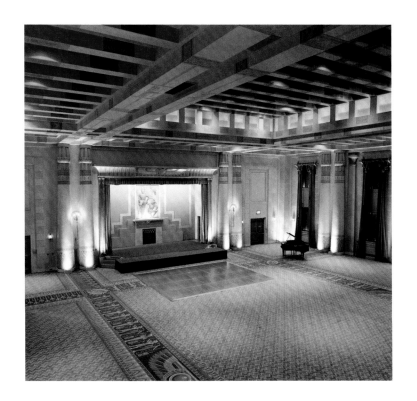

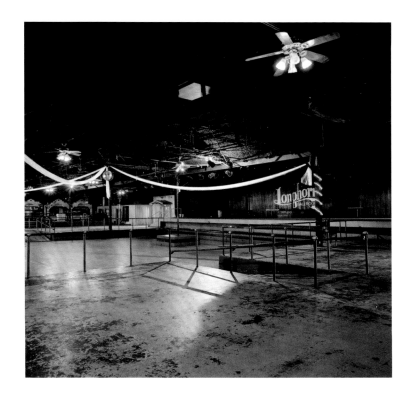

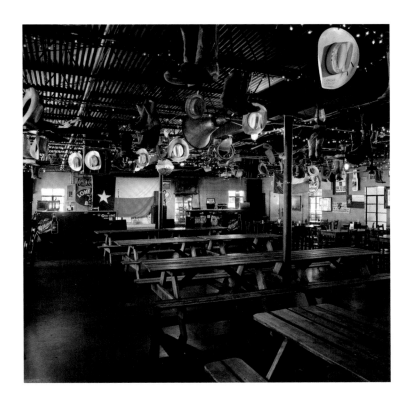

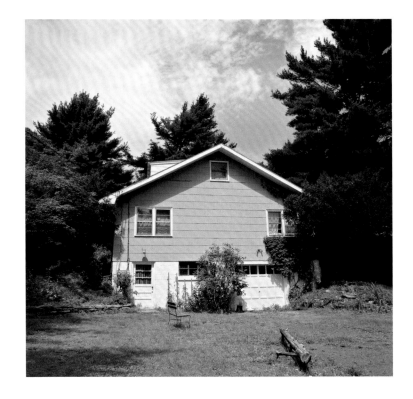

Fox Theatre, Egyptian Ballroom, Atlanta, GA — June 25, 2015
Longhorn Ballroom, Dallas, TX — January 11, 2013
John T. Floore's, Helotes, TX — June 4, 2009
Big Pink, Woodstock, NY — August 9, 2007

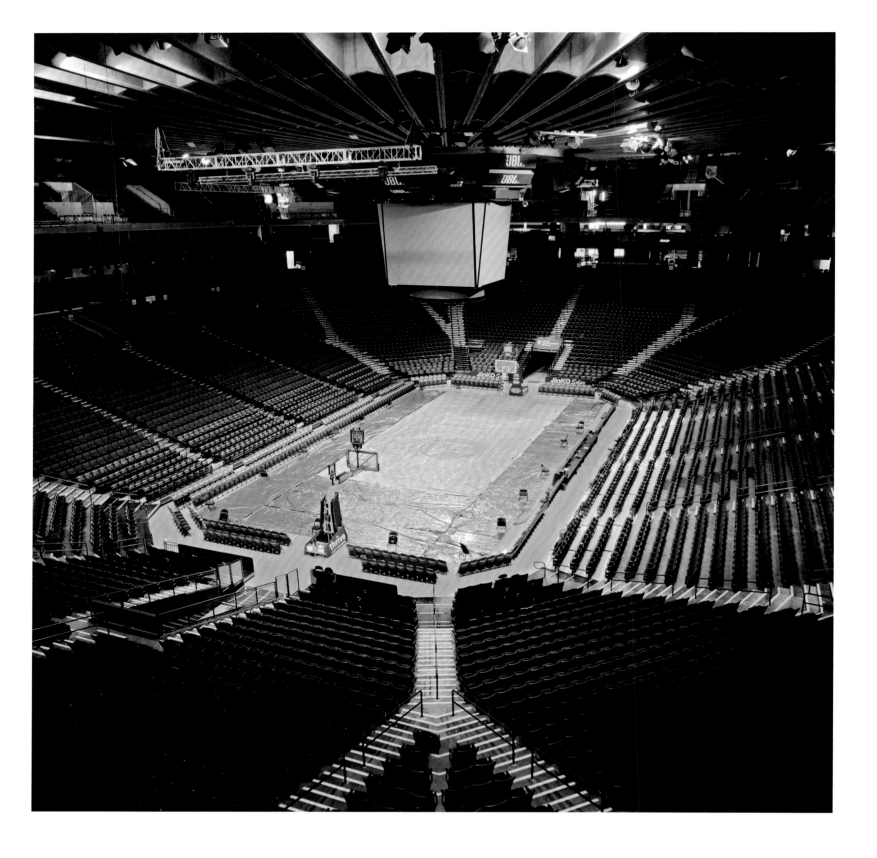

Kleinhans Music Hall, Buffalo, NY — May 7, 2015

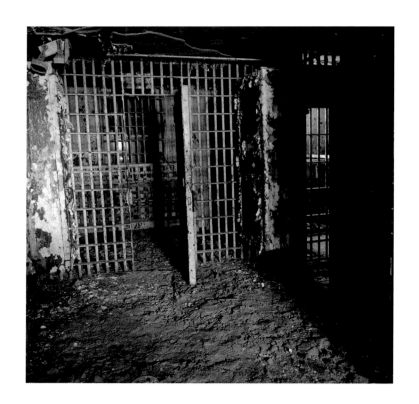
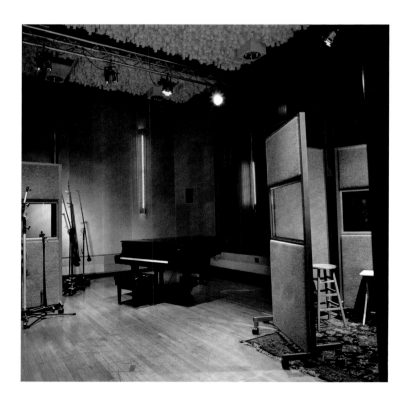
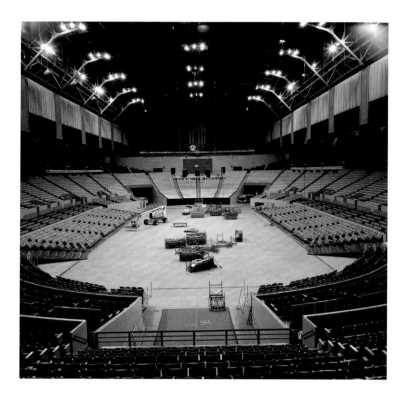
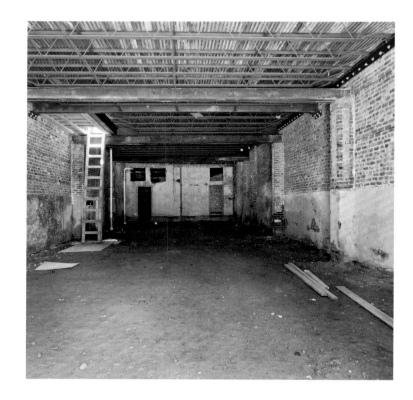

Belzoni Jail, Belzoni, MS — May 11, 2008
Criteria Recording Studios, Studio C, Miami, FL — February 24, 2015
Cow Palace, Daly City, CA — August 26, 2015
Iroquois Theater (site), New Orleans, LA — June 7, 2016

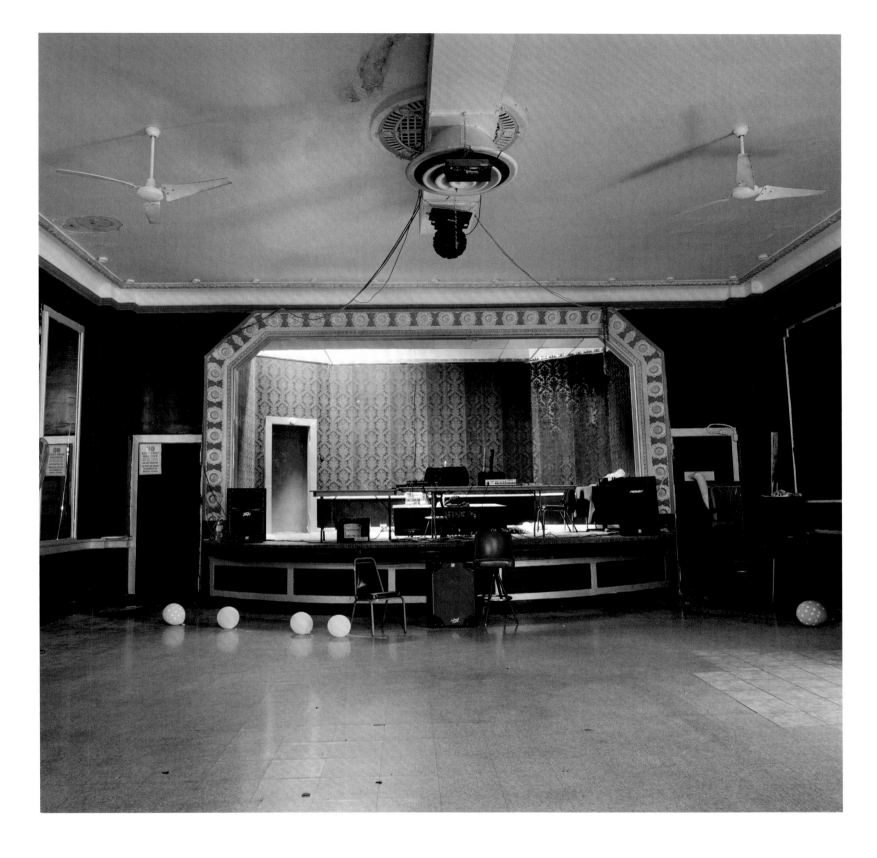

The Arch Social Club, Baltimore, MD — August 13, 2013

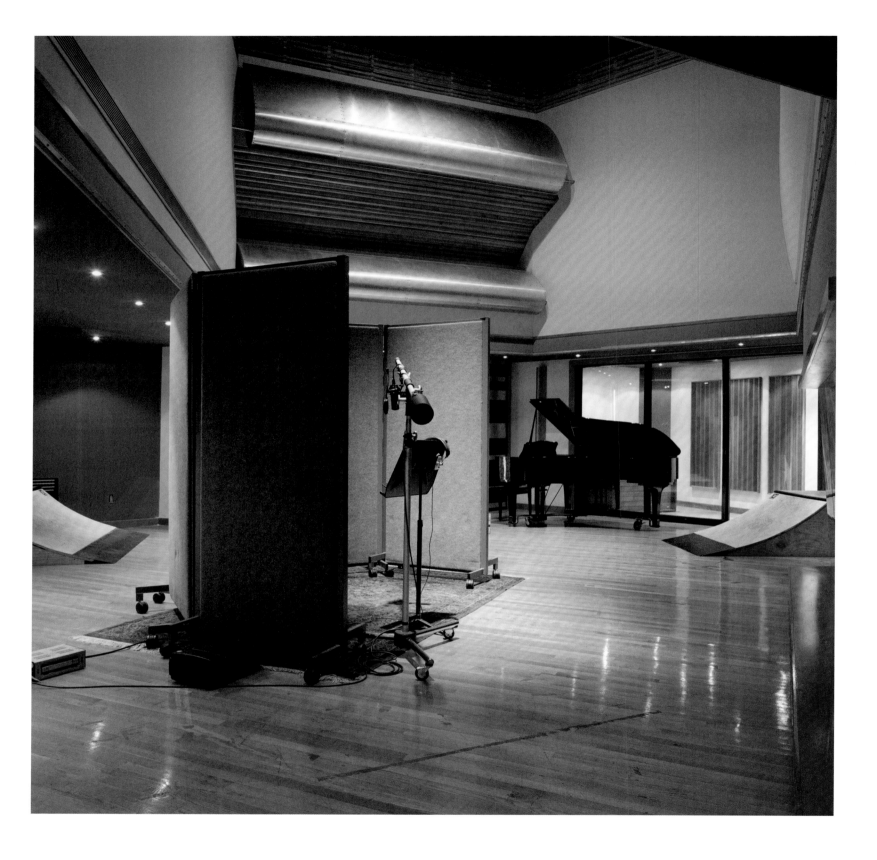

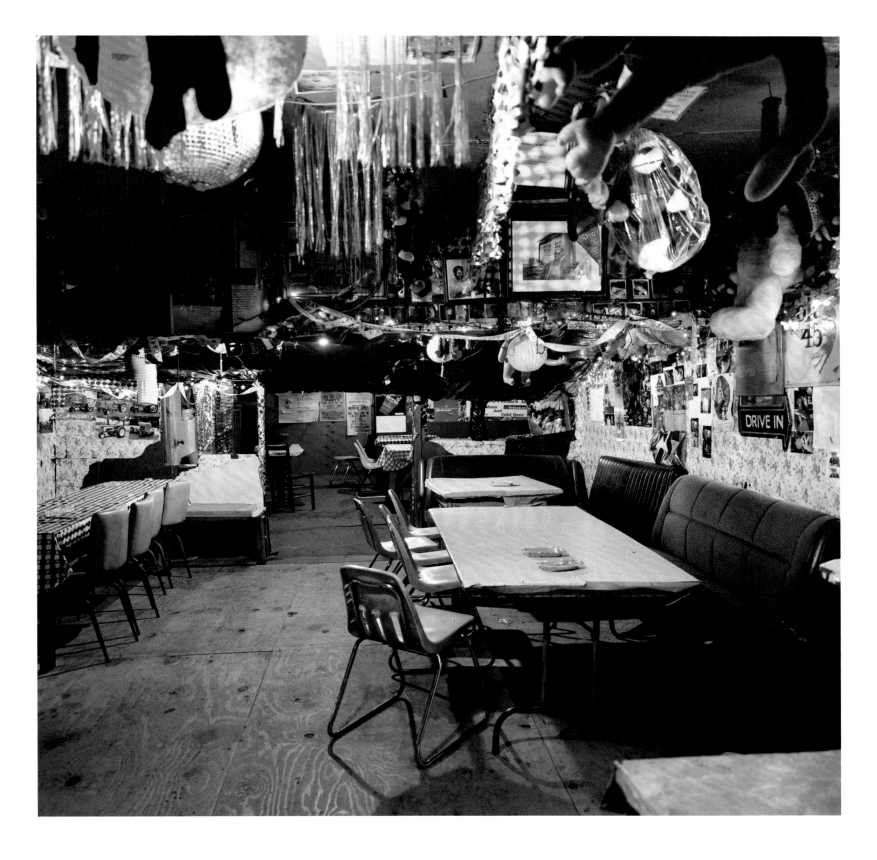

Po' Monkey's, Merigold, MS — May 10, 2008

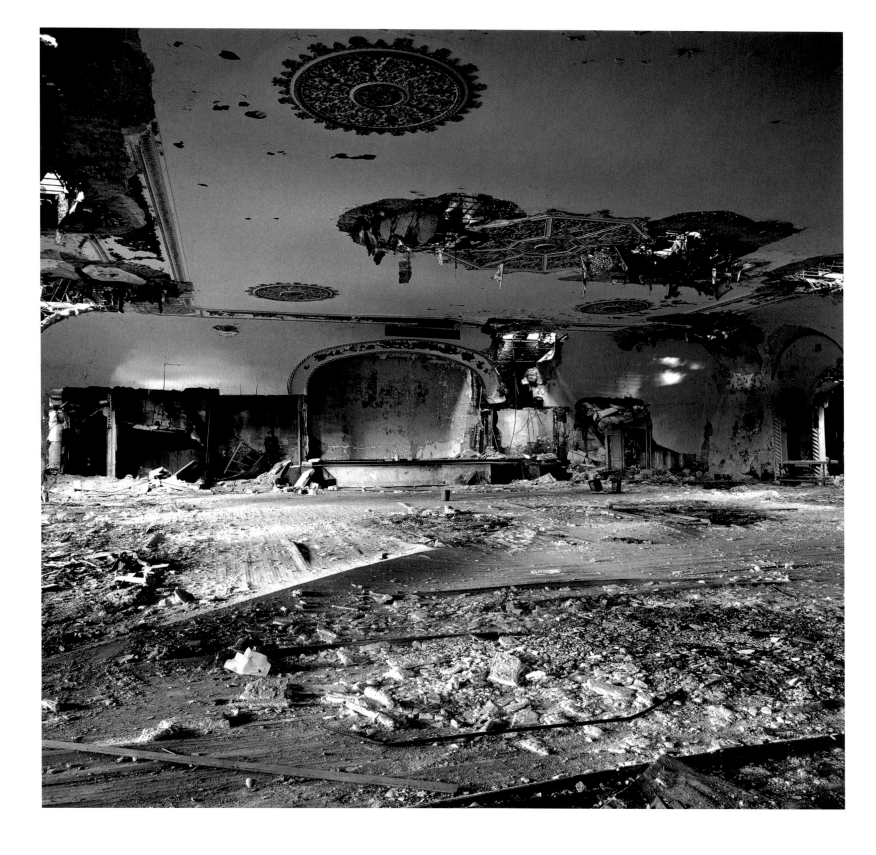

Grande Ballroom, Detroit, MI — October 29, 2008

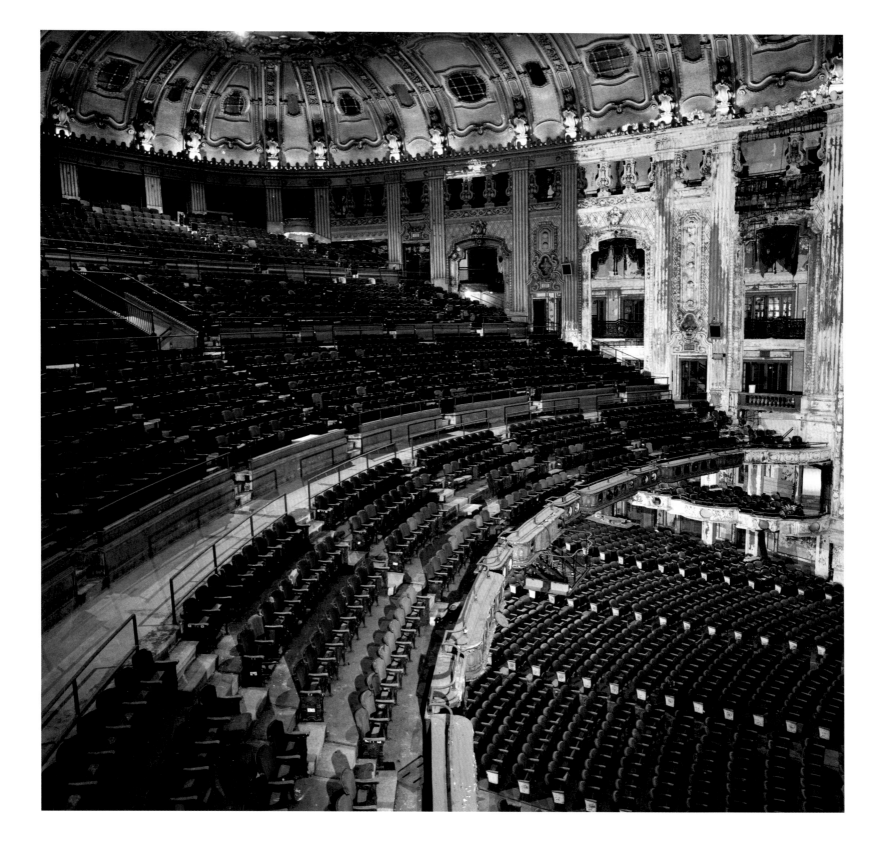

Uptown Theatre, Chicago, IL — September 19, 2008

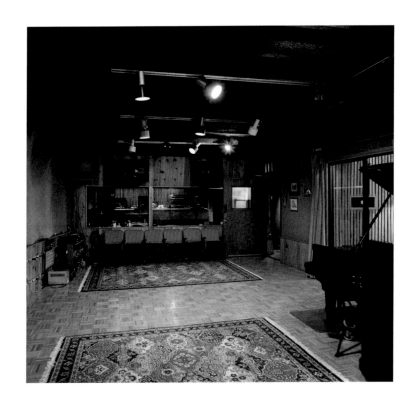

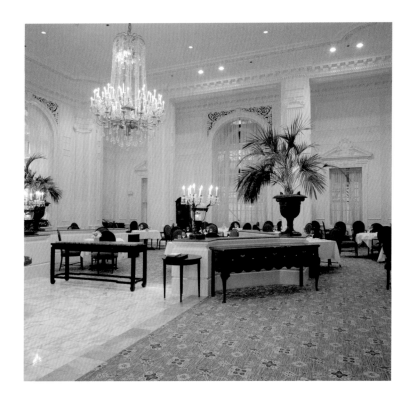

Sear Sound, New York, NY — March 18, 2016
Love Street Light Circus Feel Good Machine (site), Houston, TX — January 15, 2013
Miscoe Hill Middle School, Mendon, MA — April 8, 2014
Olympic Hotel, Georgian Room, Seattle, WA — November 18, 2015

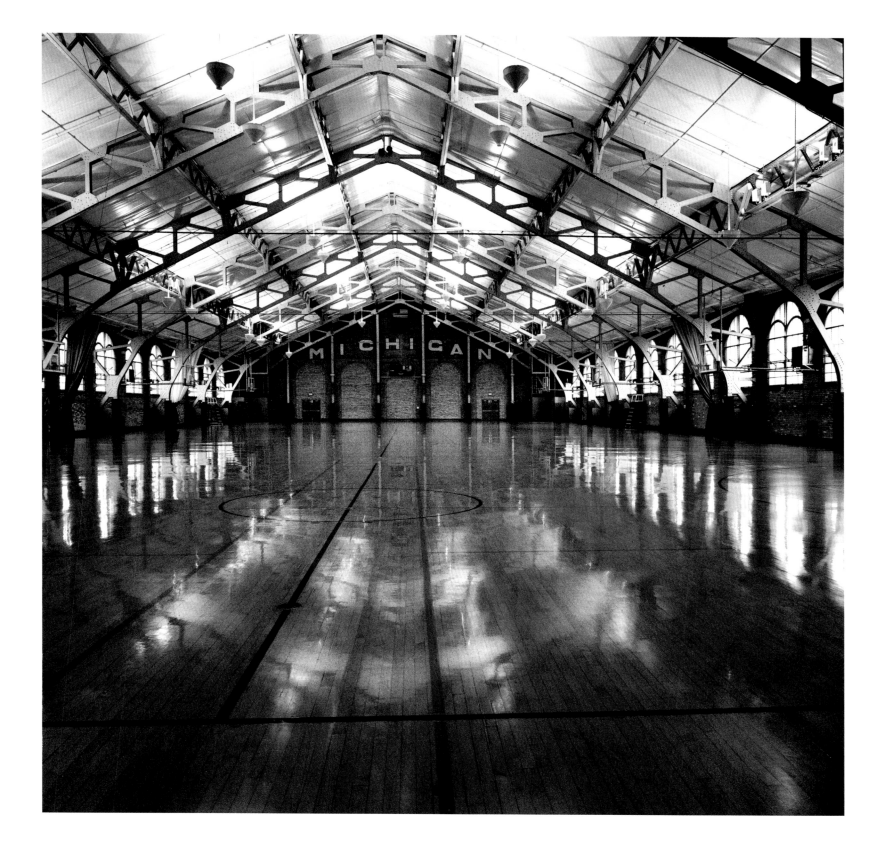

Intramural Sports Building, University of Michigan, Ann Arbor, MI — April 22, 2015

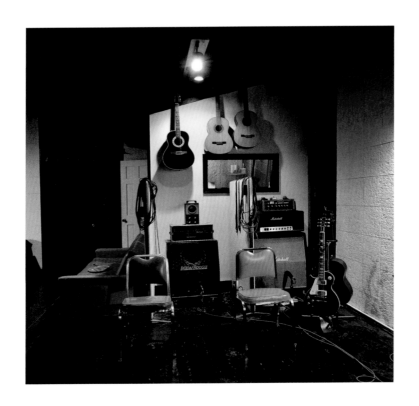

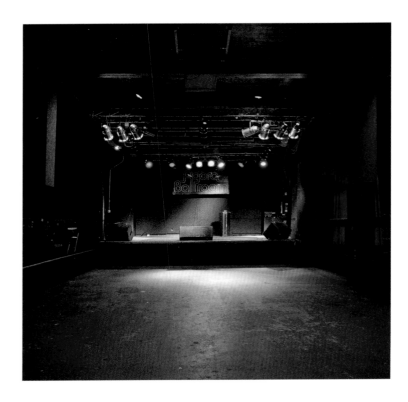

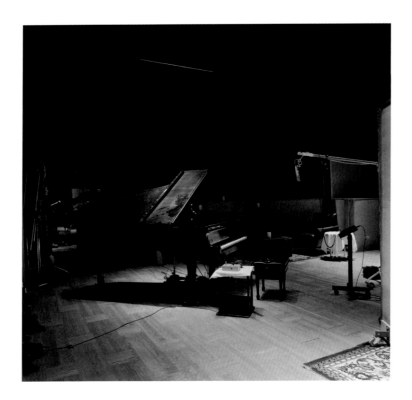

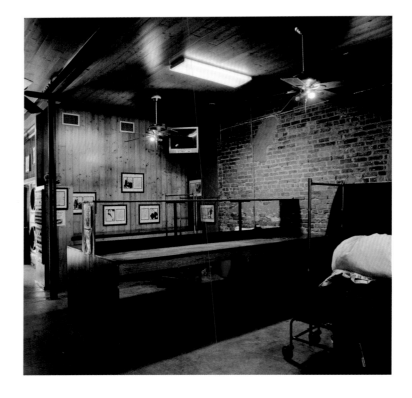

Muscle Shoals Sound Studio, Sheffield, AL — May 8, 2008
Agora Theatre and Ballroom, Cleveland, OH — September 15, 2008
Radio Recorders Annex, Los Angeles, CA — July 30, 2015
J&M Recording (site), New Orleans, LA — March 15, 2016

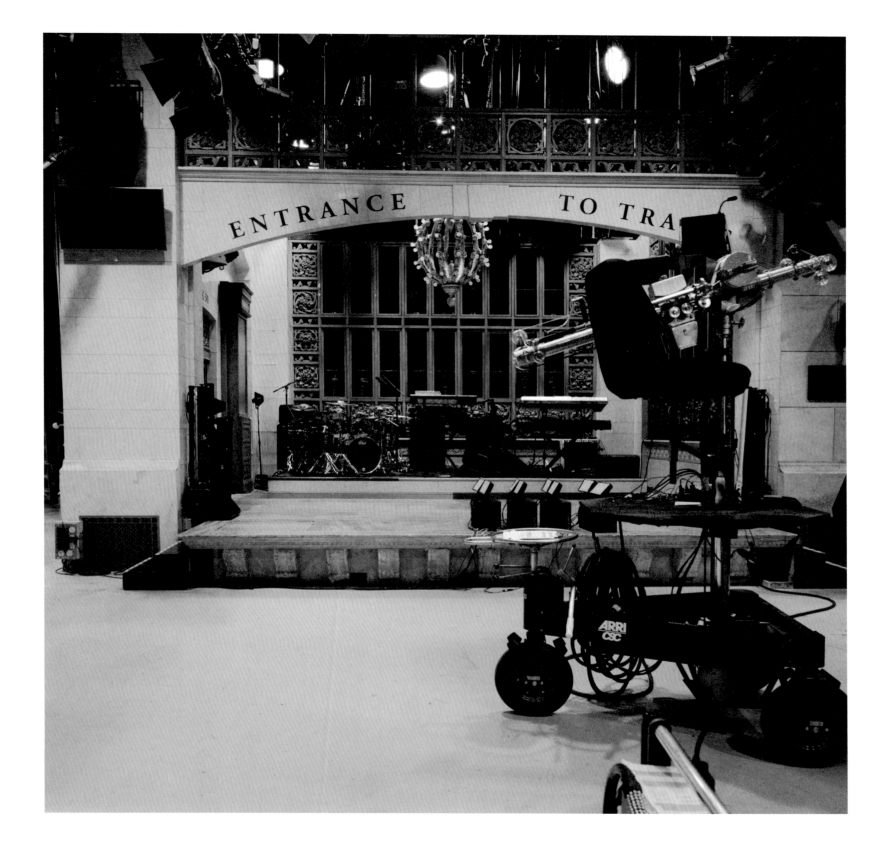

NBC Studio 8-H, *Saturday Night Live*, New York, NY — April 7, 2011

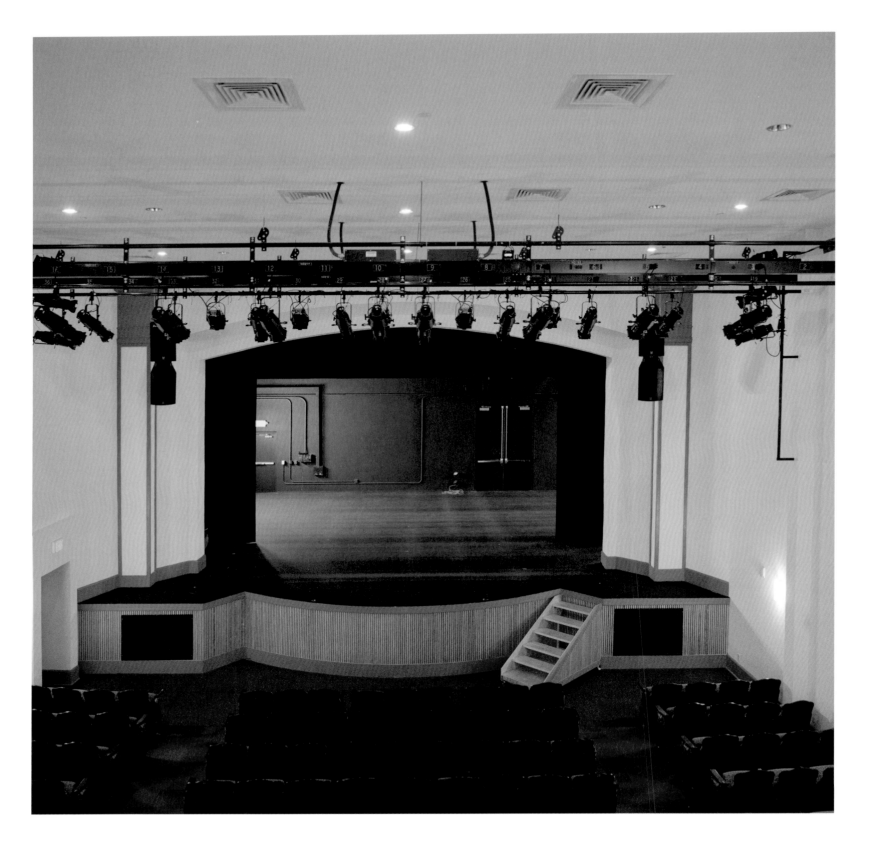

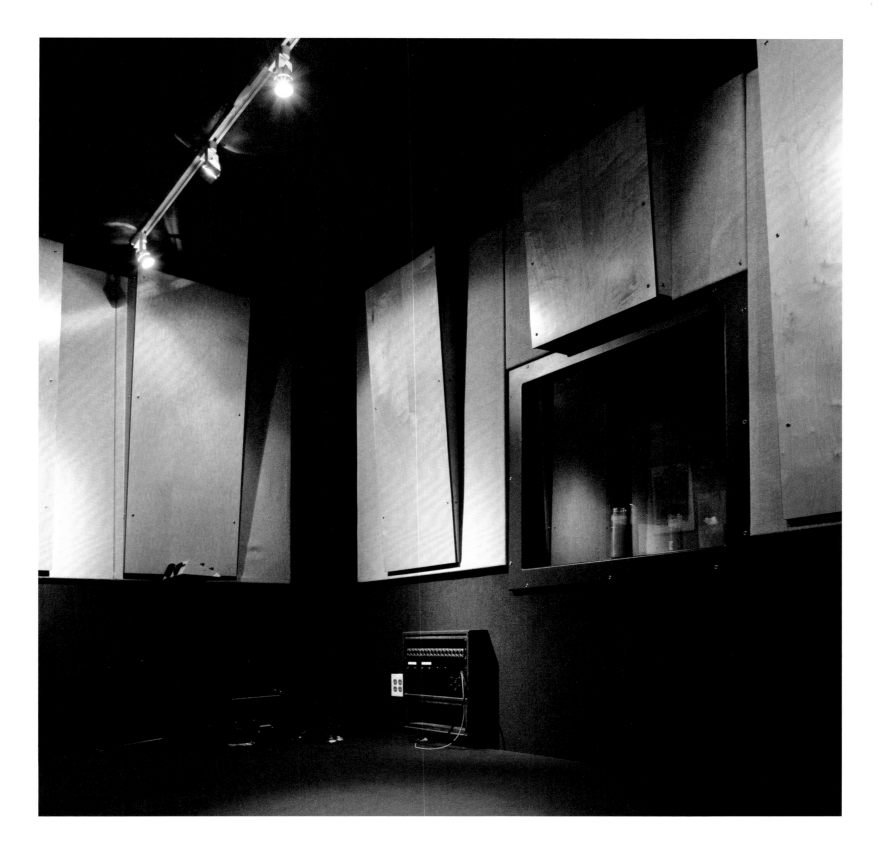

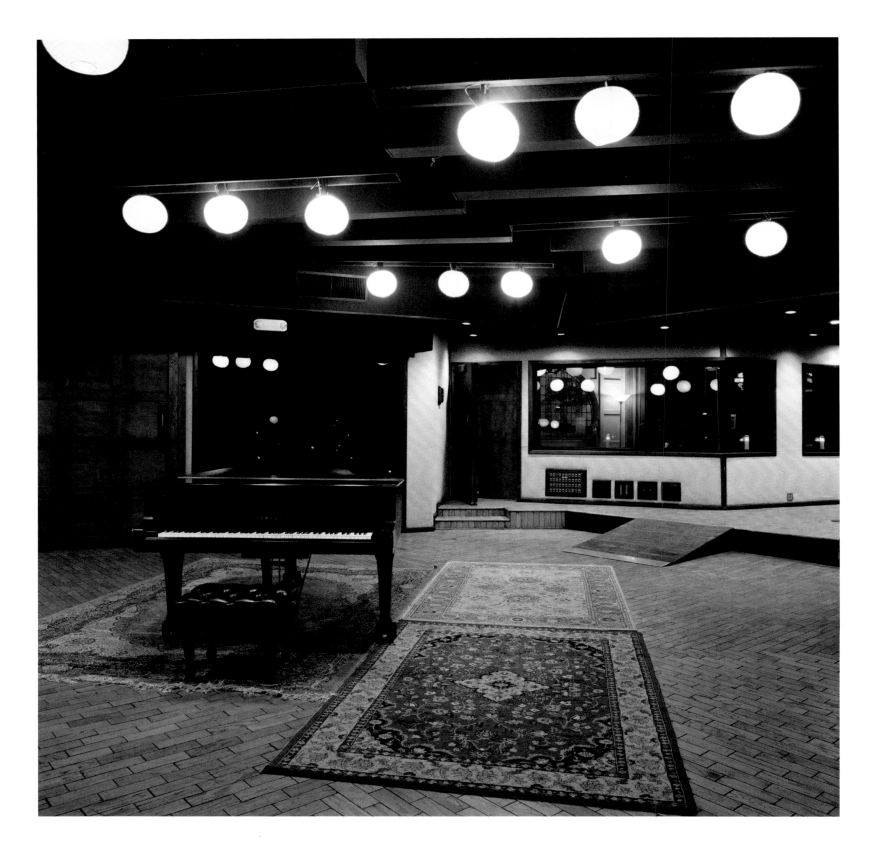

Village Recorder, Studio D, Los Angeles, CA — August 1, 2015

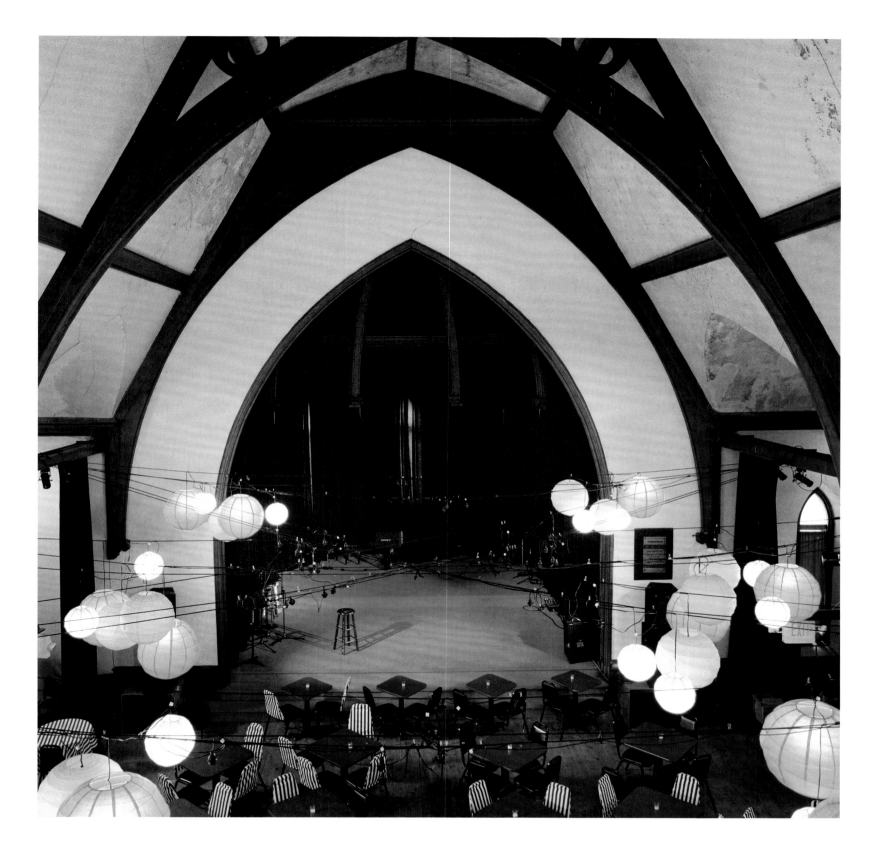

Alice's Restaurant (site), Great Barrington, MA — April 8, 2014

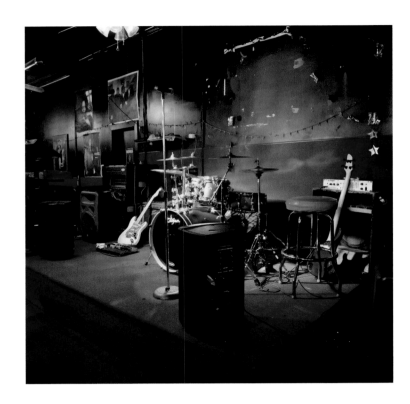
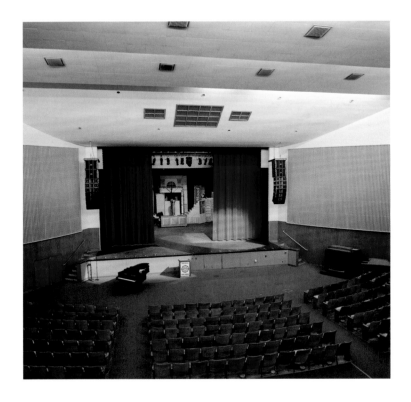

Sound Factory, Los Angeles, CA — August 8, 2009
Lee's Unleaded Blues, Chicago, IL — February 5, 2010
Hollywood High School, Auditorium, Los Angeles, CA — August 3, 2009
Roseland Ballroom (site), New York, NY — April 26, 2015

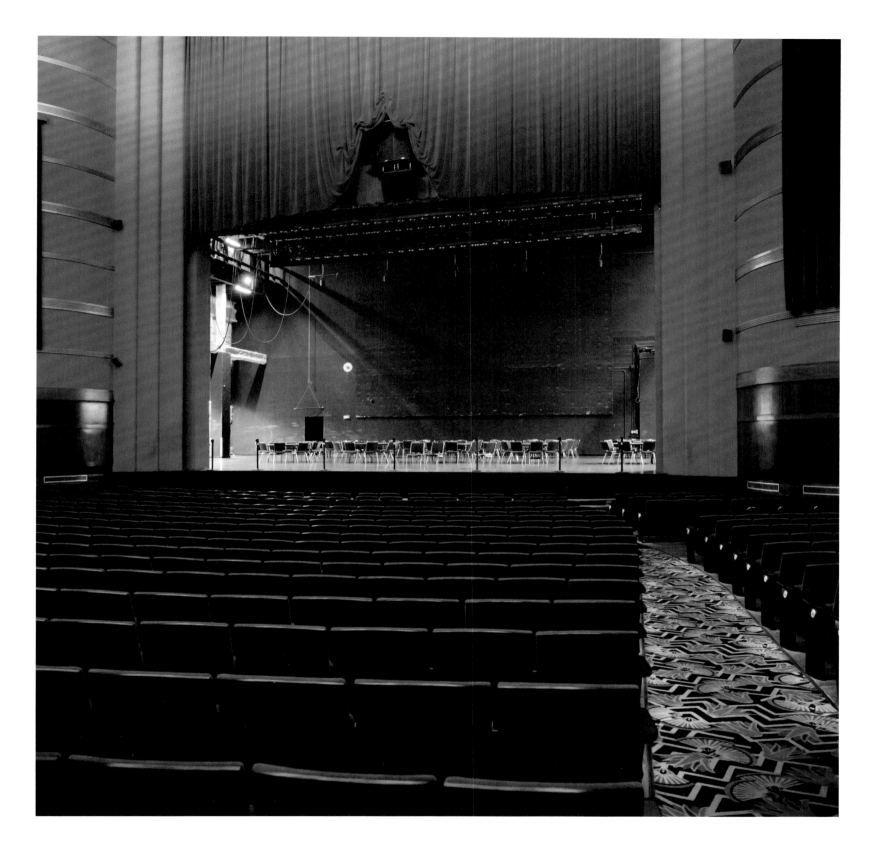

Municipal Auditorium, Music Hall, Kansas City, MO — January 15, 2010

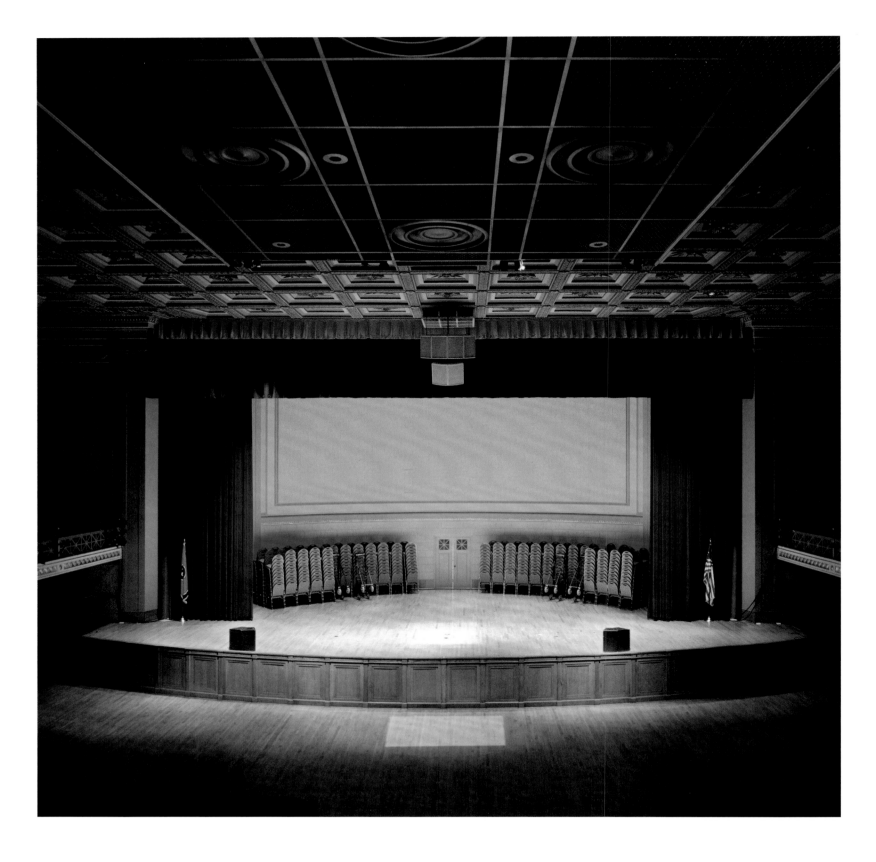

War Memorial Auditorium, Nashville, TN — January 20, 2010

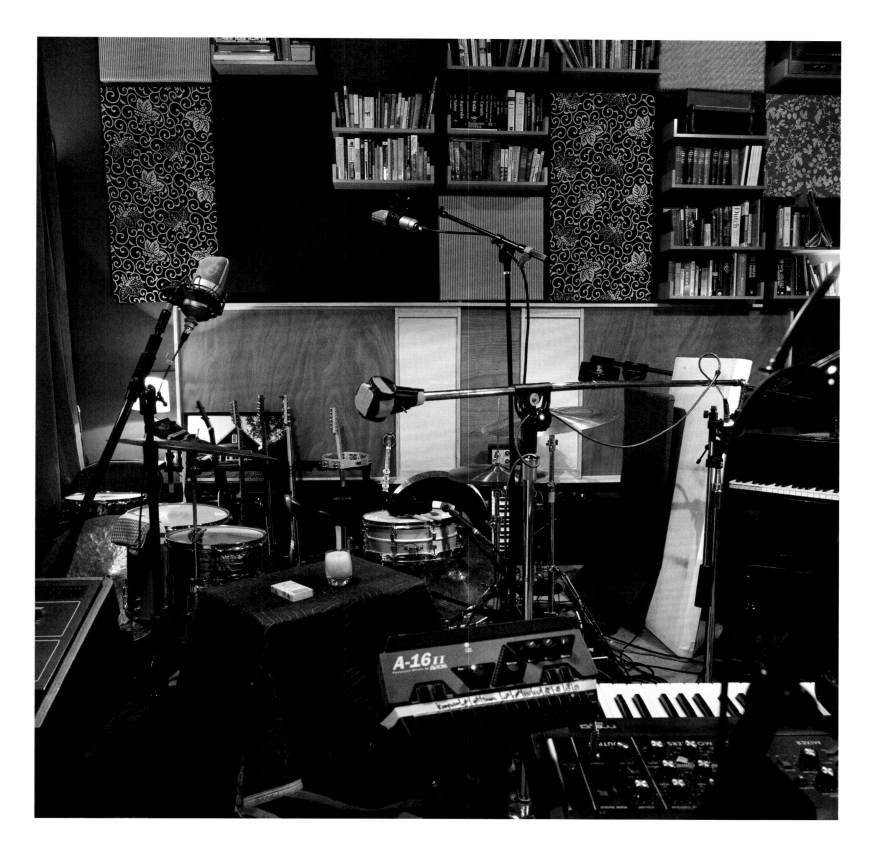

Triangle Recording (site), Seattle, WA — November 19, 2015

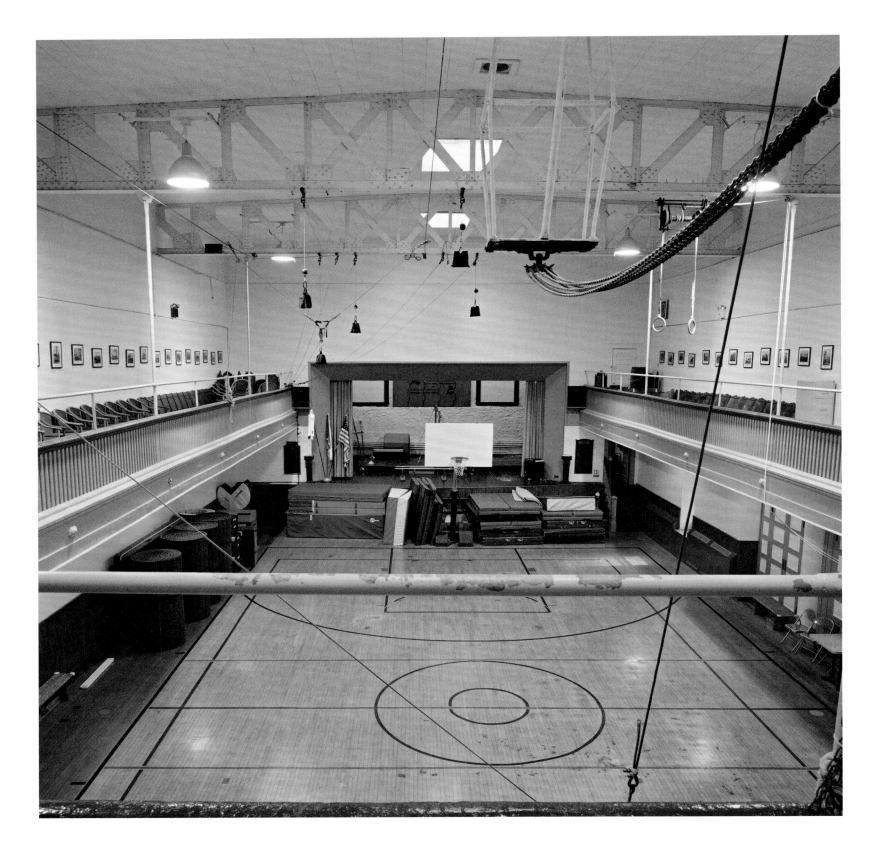

The Gymnasium, New York, NY — March 27, 2018

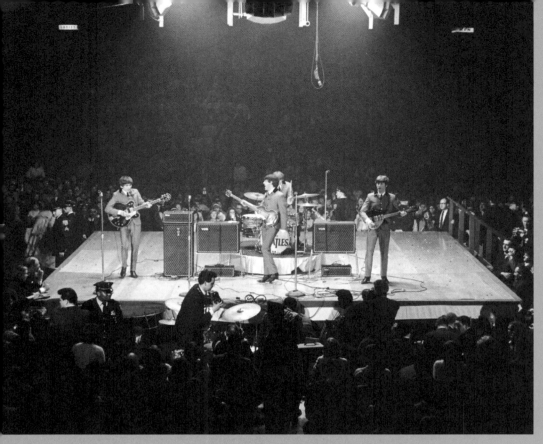

Children to the Haight-Ashbury section of San Francisco. Monterey Pop was organized by John Phillips, leader of the Mamas and the Papas; record producer Lou Adler; the publicist Derek Taylor; and entrepreneur Alan Pariser. The acts performed for free, with proceeds from the event going to charity. In addition to the Mamas and the Papas, Jimi Hendrix, the Who, Eric Burdon and the Animals, Otis Redding, and Ravi Shankar were among the highlights.

UNITED RECORD PRESSING,
NASHVILLE, TN

This vinyl record pressing plant began in 1949 as a subsidiary of Bullet Records, an independent Nashville label. The factory began operations the same year that RCA introduced a new durable, compact record format: the 45 rpm single. In the early 1950s, the pressing business split from the record label and became Southern Plastics, Inc., concentrating on pressing 45s for independent labels. A new facility was built in 1962 to service a growing account list, including African American–owned companies Motown and Vee-Jay Records. In 1963, Vee-Jay was the first U.S. company to press and release a Beatles single. In the 1970s, the business became United Record Pressing. When compact disks began to supplant 45s in the 1990s as the industry standard, United retained their old equipment. Their vinyl record pressing business has increased in recent years—a result of renewed interest in the format.

NEW YORK STATE PAVILION, CORONA PARK,
QUEENS, NY

Designed by architects Philip Johnson and Richard Foster, with engineer Lev Zetlin, this striking futuristic structure represented New York State in the 1964 World's Fair. Although most of the structures for the Fair were demolished, the New York State Pavilion was spared. For a time it was used in television and movie productions and later neglected, falling into ruin. In 1969, the pavilion was used as one of the stages for a series of rock concerts called the Singer Bowl Music Festival; among the acts were Led Zeppelin, the Grateful Dead, and Joe Cocker and the Grease Band. The MC5 also headlined in 1969, with another Michigan band, Iggy and the Stooges, who were making their New York debut. The Ramones played as part of the 1987 Queens Festival.

FOX THEATRE, AUDITORIUM,
ATLANTA, GA

The Fox Theatre was originally to be the headquarters of the Atlanta chapter of the Shriners fraternal organization. Designed in a Moorish revival style, the opulent decor proved too expensive for the Shriners, so they leased it to Fox, which converted the space into another

40 WATT CLUB,
ATHENS, GA

In 1991, the 40 Watt Club moved into its current location. Local favorites Flat Duo Jets, featuring Dexter Romweber, and a reformed Pylon were early bookings at this site. Alternative bands like Nirvana, the Melvins, Flaming Lips, and Guided By Voices are among the hundreds of acts presented here. **(See 40 Watt Club site, Athens, GA; Caledonia Lounge, Athens, GA.)**

WASHINGTON COLISEUM (SITE),
WASHINGTON, D.C.

The Beatles played their first public concert on U.S. soil at the Washington Coliseum on February 11, 1964, two days after their first television appearance on the *Ed Sullivan Show*. The building was constructed in 1941 for the Washington Lions hockey team and named Uline Ice Arena after the building's developer. The arena hosted many functions, from basketball games to an inaugural ball for President Eisenhower. In 1959, it was renamed the Washington Coliseum. In 1965, Bob Dylan played here, and a photograph taken at the concert was used for the cover of the album *Bob Dylan's Greatest Hits*. By the early '70s, the Coliseum had fallen into disuse, hitting rock bottom when it served as a garbage transfer station in the 1990s and early 2000s. **(See Ed Sullivan Theater, New York, (NY); Napoleon Ballroom, Miami Beach, FL.)**

GRACELAND,
MEMPHIS, TN

This is the music room in Elvis's mansion, a place he would go to be alone, play piano, and sing gospel for himself. Approximately eight miles south of downtown Memphis, Graceland was Presley's home from 1957 until his death in 1977. The Colonial revival mansion was built in 1939 by Ruth Moore on her family's property known as Graceland Farms, named for owner Stephen C. Toof's daughter Grace. In 1957, with his career skyrocketing, and wanting to protect his privacy, Elvis asked his father Vernon to find a farm near Memphis for the family to live. The Graceland mansion, set on 13.8 acres, fit the bill. After Elvis's death, the estate became a shrine to fans, and in 1982 his home and grounds were opened to the public where many still visit to honor a unique figure in popular music.

THE ROCK GARDEN (SITE),
SAN FRANCISCO, CA

For a short period in 1967, in the unfashionable far reaches of the Excelsior district of San Francisco, a converted movie theater hosted several notable underground bands of the time. The club was called the Rock Garden, advertising itself as having "the best light show in [the] U.S.A." The psychedelic bands included the Grateful Dead, Janis Joplin's Big Brother and the Holding Company, Buffalo Springfield, and Love. The young hippie audience these bills were geared for did not show up; the location was

removed from the Haight, and the club served alcohol, which kept out anyone younger than legal drinking age. This experiment in psychedelia lasted only a few months, and the renamed the Ghetto Club began booking show bands and Latin acts, and bands with a Latin/Soul fusion sound and managed to draw a racially diverse crowd.

MONTEREY COUNTY FAIRGROUNDS,
MONTEREY, CA

The fairground was built in 1936 on 22 acres of state land for the annual county fair. The earliest structures were constructed in collaboration with the Works Progress Administration. In 1958, the fairgrounds became home to the Monterey Jazz Festival, an annual three-day event that continues to draw top jazz talent. Pattee Arena was built in 1961 as the main stage. Building on the popularity of the jazz festival, 1963 saw the first Monterey Folk Festival, also at the fairgrounds. This event was the first West Coast appearance of Bob Dylan. The arena was the site of the Monterey Pop Festival in 1967, whose success inspired dozens of rock music festivals, like Woodstock, two years later; Altamont in December of 1969; and today's Lollapalooza and Coachella festivals. The three days of concerts and the D. A. Pennebaker film documenting the event, *Monterey Pop*, established California as the epicenter of the youth counterculture and was the inspiration for the "Summer of Love," the mass migration of Flower

movie palace jewel in 1929. Through the years, in addition to screening films, the stage presented light opera and popular music. In 1956, Elvis Presley played the Fox with the Wilburn Brothers and June Carter also on the bill. Bruce Springsteen has performed here three times in 1976, 1978, and 1996. The Fox hosted Bob Marley and the Wailers in 1979, and Pearl Jam in 1994. Georgia musicians the Allman Brothers, Ray Charles, James Brown, R.E.M., the B-52s, and the Black Crowes have all played here. **(See Fox Theatre, Egyptian Ballroom, Atlanta, GA.)**

BEACON THEATRE,
NEW YORK, NY

Built in 1929 as a movie palace with an ornate neo-Grecian interior featuring 30-foot-tall goddesses flanking the proscenium, the Beacon offered Warner Brothers movies and vaudeville acts. It screened first-run film releases into the early 1970s. Live concerts began in 1974. 2,894 seats—arranged in three tiers—make the Beacon a comfortable mid-size venue. Over the years, acts that could have filled larger arenas have chosen to stage short residencies here. The Allman Brothers Band settled into annual engagements running eight to nineteen shows between 1989 and 2014, and Bob Dylan, Queen, and Steely Dan have also had notable Beacon residencies.

Lou Reed at the Beacon Theatre in New York, 1984.

708 CLUB (SITE),
CHICAGO, IL

Chicago blues, the reinterpretation of an older acoustic country blues style using electric instrumentation, reached its fully developed form at clubs like the 708 Club. The leading artists of this music—Howlin' Wolf, Muddy Waters, and Willie Dixon—played here. This red brick building in the Bronzeville district of Chicago's South Side was where many blues legends started. Bo Diddley, after several years busking on street corners and the Maxwell Street market, got his first steady gigs at the 708. In 1958, a young and unproven Buddy Guy found the courage to take the stage during an Otis Rush show at the club, launching his career. **(See Chess Records site, Chicago, IL.)**

MINNEAPOLIS ARMORY,
MINNEAPOLIS, MN

Built as the armory of the Minnesota National Guard in 1935, the building was funded with a grant from the Public Works Administration and designed in characteristic Streamline Moderne style, distinguished by its strong geometry and integrated ornamentation. It has been used for a variety of civic events; political conventions; and sports, including professional basketball and motorcycle racing. As a music venue, the Armory

hosted James Brown and Janis Joplin, among others. Minneapolis native Prince shot the music video for "1999" in 1982. In 1998, Aerosmith recorded the video for "I Don't Want to Miss a Thing" here.

QUAD STUDIOS, STUDIO A,
NASHVILLE, TN

Originally known as Quadrafonic [sic] Sound Studios, this four-studio facility is located on Nashville's famed Music Row. The studio was created in 1970 by two session musicians, Norbert Putnam and David Briggs, who had worked together in Muscle Shoals. They built the facility in an old two-story house, converting the front porch into a control room and several of the downstairs rooms as studio spaces. At one of the studio's first sessions, Joan Baez recorded her one and only top-ten hit: "The Night They Drove Old Dixie Down." In the same year, Neil Young recorded *Harvest*, his most successful album. In 1977, Jimmy Buffett recorded his biggest hit and the song that transformed him from a singer-songwriter into an international media and lifestyle brand, "Margaritaville," at Quad Studios.

FOX THEATRE, EGYPTIAN BALLROOM,
ATLANTA, GA

The Fox Theatre was designed in a vibrant pastiche of Moorish and Egyptian revival styles originally for the Shriners, leased to Fox to be converted into a movie palace in 1929. In addition to its main auditorium, there is the Egyptian Ballroom, which in the 1940s hosted weekly dances with the leading big bands and Western swing bands. Elvis Costello and the Attractions played in 1978. The Georgian new wave band Pylon appeared in 1979. Peter Wolf, vocalist for the J. Geils Band, has also played with his R&B band the Midnight Travelers. **(See Fox Theatre, Auditorium, Atlanta, GA.)**

LONGHORN BALLROOM,
DALLAS, TX

This was one of three stops in Texas on the Sex Pistols' catastrophic 1978 U.S. tour. The marquee out front advertised "Tonite Sex Pistols" and Merle Haggard the following night. The Pistols' manager, Malcolm McLaren, booked the band into a series of honky-tonk venues, expecting that stark contrast in musical styles would generate controversy and publicity for his group. He was correct. During the show, Sid Vicious received a headbutt from a woman audience member, bloodying his nose. He proceeded to smear blood on his bare chest for the duration of the set. The Longhorn was built in 1950 as Bob Wills' Ranch House by O. L. Nelms, an eccentric Dallas millionaire, with participation from Western swing bandleader Bob Wills. The club became a financial disaster for Wills, a victim of the bar's corrupt management. Wills was forced to sell valuable songwriting rights to cover the club's

debts, and quickly ended his association. For a short time in the early 1950s, Jack Ruby was the manager a decade before he killed Lee Harvey Oswald. In 1958, Dewey Groom took over the business and the dance hall was renamed the Longhorn Ballroom. Groom decorated the 1,900-person-capacity hall with murals of a cattle drive and placed a statue of a 20-foot-long steer out front. In addition to country favorites like Merle Haggard, George Jones, and Conway Twitty, the club periodically booked R&B acts. B. B. King, Lionel Hampton, and Al Green have also played the Longhorn. **(See Cain's Ballroom, Tulsa, OK; Randy's Rodeo, San Antonio, TX.)**

JOHN T. FLOORE'S,
HELOTES, TX

Initially opened as a grocery in 1942, by the 1950s Floore converted the store into a dance hall and began booking country music performers like Ray Price, Bob Wills, Johnny Cash, and Ernest Tubb. By the 1960s, the venue was drawing such large crowds that an outdoor amphitheater was added, increasing the potential audience from four hundred to two thousand. When Willie Nelson —disappointed by his experience with the country music establishment in Nashville—returned to Texas, he began to play at Floore's frequently. For a period in the early 1970s, Nelson had a weekly residency. Dwight Yoakam is another longstanding regular performer.

BIG PINK,
WOODSTOCK, NY

In June 1967, Rick Danko, a former member of Ronnie Hawkins's backing band the Hawks, who had been working in Bob Dylan's tour band, rented this pink house in Saugerties, New York. He and other members of the Hawks set up a studio in the basement to rehearse and record with Dylan, who was living in Woodstock while recovering from a motorcycle accident. The demo tracks recorded with Dylan would eventually be called the "Basement Tapes." At some point during that summer, they started calling the studio "Big Pink" and their group the "Band." The sessions continued through the fall, generating original songs without Dylan. This material became the basis for the Band's first album, titled *Music From Big Pink*, released in 1968.

OAKLAND ARENA,
OAKLAND, CA

From its opening in 1966 until 1996, it was known as the Oakland-Alameda County Coliseum Arena. Basketball, hockey, and roller derby were the main events. As a concert stage, the Grateful Dead played here sixty-six times—more than any other venue. Marvin Gaye played here on January 4, 1974, ending a three-year hiatus from live performance. A recording of the show became the basis of *Marvin*

Gaye Live!, his second live album. Artists ranging from Queen to Nirvana to Parliament-Funkadelic have made notable appearances at the Arena. Elvis Presley played here twice. Frank Sinatra also appeared twice: once at a fundraiser for Hubert Humphrey in 1968, and again in 1988 with Dean Martin and Sammy Davis Jr.

KLEINHANS MUSIC HALL,
BUFFALO, NY

This graceful International Style concert hall was designed by Eliel and Eero Saarinen. Kleinhans is known for the beauty of its design and extraordinary acoustics. It opened in 1940 with a performance by the Buffalo Philharmonic Orchestra. While the hall's purpose was to present classical music, in the 1970s Kleinhans started offering rock concerts as well. Led Zeppelin, Elton John, Yes, Chicago, Aerosmith, and all the biggest touring groups made stops at Buffalo's premier concert hall. Glam rockers the New York Dolls played this venerable venue, supporting Mott the Hoople and Lynyrd Skynyrd, in 1973.

BELZONI JAIL,
BELZONI, MS

Born circa 1891, Charley Patton was an early and extraordinarily influential Mississippi blues musician, sometimes called the "Father of the Delta Blues." Known for his gravel-voiced delivery and showmanship, he was seen as a mentor by many younger bluesmen, most significantly Robert Johnson and Chester "Howlin' Wolf" Burnett. Early in 1934, living in Belzoni, Mississippi, Patton got into a drunken brawl with his wife, prompting the sheriff to throw them both in the city jail. An agent of Vocalion Records bailed the couple out and brought them to New York for a recording session. In what would be the last recording session of his life, on February 1, 1934, Patton recorded his song "High Sheriff Blues," telling of his recent ordeal at the Belzoni Jail. He died just three months later of heart disease. The jail was constructed in 1921. **(See Dockery Plantation, Cleveland, MS.)**

Members of the Grateful Dead performing at the Oakland Coliseum in California, 1979.

Wilson Pickett with producer Tom Dowd at Muscle Shoals Sound Studio in Alabama, 1969.

CRITERIA RECORDING STUDIOS, STUDIO C,
MIAMI, FL

Criteria Recording Studios was founded in 1957, and in 1965 James Brown recorded "I Got You (I Feel Good)" here. The studio was the source of numerous hits in the 1970s. Legendary recording engineer/producer Tom Dowd used these studios throughout the decade, recording Aretha Franklin's album *Young, Gifted and Black*; Derek and the Dominos' smash "Layla;" and the Allman Brothers' *Eat a Peach*. Some of the Eagles' *Hotel California* and parts of the Fleetwood Mac album *Rumours* were recorded at Criteria. In 1999, another successful recording studio, New York–based the Hit Factory, renovated the studio and relaunched the business as the "Hit Factory Criteria Miami." In 2017, the facility took back its original name, Criteria Studios. **(See Criteria Recording Studios, Studio E, Miami, FL.)**

COW PALACE,
DALY CITY, CA

As a concert venue, the Beatles played the Cow Palace in 1964 and 1965; the Rolling Stones in 1975; and Elvis Presley in 1976. One of the oddest shows was in 1973, when the Who headlined, kicking off their *Quadrophenia* tour. Drummer Keith Moon struggled to remain awake through the set, feeling the effects of powerful tranquilizers he had taken. When he passed out and fell off the drum riser, Pete Townshend asked for volunteers from the audience, and a nineteen-year-old amateur played the drums for a few last songs before the band called it an evening. Another memorable event was a six-night stand by Prince, supporting his *Purple Rain* album with an expertly staged show replete with special effects. Situated between Daly City and San Francisco, the indoor arena was built in 1941 for agricultural expositions. The first event was the Western Classic Holstein Show. Ringling Brothers Barnum & Bailey Circus, the San Francisco Sport and Boat Show, and the Golden Gate Kennel Club Dog Show number among longtime tenants.

IROQUOIS THEATER (SITE),
NEW ORLEANS, LA

This block of South Rampart Street is significant in the development of jazz. Next door to the building that housed the Eagle Saloon and Odd Fellows and Masonic Hall, the Iroquois Theater was an African American vaudeville and movie theater that operated from 1911 to 1920. One of the first theaters featuring jazz in a concert setting, it was eventually eclipsed by the larger Lyric Theater that opened in 1920. As a boy, Louis Armstrong went to the movies

here with his mother and sister, and he once won an amateur talent contest at the theater performing in whiteface. **(See Eagle Saloon, New Orleans, LA.)**

THE ARCH SOCIAL CLUB,
BALTIMORE, MD

Founded in 1905, Arch Social is the oldest known continuously operating African American men's club in the U.S. The club brought together Black tradesmen, laborers, clergy, professionals, and entrepreneurs to craft strategies for addressing the issues of a segregated society. For fifty years the clubhouse was at 676 West Saratoga Street until the historic structure was demolished in an urban renewal scheme. In 1972, the former Schanze Theatre became the new clubhouse. Concerts and dances at the Arch Social Club have always played an important role in jazz, and it is now the last remaining venue for live entertainment on Baltimore's historic Pennsylvania Avenue commercial strip—a key element of Black America's storied Chitlin' Circuit.

CRITERIA RECORDING STUDIOS, STUDIO E,
MIAMI, FL

Established in 1957, Criteria Recording Studios was the source of hits by artists including James Brown, Aretha Franklin, the Bee Gees, and Fleetwood Mac. The last constructed studio was Studio E, completed in 1981. The room was mainly used for mastering—creating the final model, or master, from which all copies of a commercial release derive. **(See Criteria Recording Studios, Studio C, Miami, FL.)**

PO' MONKEY'S,
MERIGOLD, MS

In 1963, Willie "Po' Monkey" Seaberry opened a juke joint in his home: a tin-roofed shack built as a sharecropper's cabin. A juke joint was a makeshift party venue in the South during the twentieth century. The juke was often little more than a farmer's shack, open to neighbors on a weekend night for a house party with alcohol for sale to supplement income, and entertainment in the form of a traveling blues musician. Some of these part-time parties became fully established businesses—the rural equivalent to a city nightclub. Seaberry continued to live here until his death in 2016, even as the bar's fame as the last genuine juke joint grew. Beginning in the 1990s, college students and tourists in search of an authentic juke joint experience made up a large proportion of patrons at Po' Monkey's.

GRANDE BALLROOM,
DETROIT, MI

Built in 1928, the Grande (pronounced "gran-dee") was originally a dance hall that became a hangout for the Prohibition gangsters known as the Purple Gang. In 1966, Russ Gibb, a DJ on WKNR-AM radio, acquired the space. Inspired by the Fillmore in San Francisco and with the help of counterculture entrepreneur and leader of the White Panther Party, John Sinclair, and record producer/artist manager Jeep Holland, Gibb started booking psychedelic bands from California and emerging Midwest bands. The MC5 recorded a live set for their debut album, *Kick Out the Jams*. Iggy and the Stooges, Alice Cooper, and SRC were among the Detroit acts regularly featured. Touring bands stopped at the Grande, including Janis Joplin, Jeff Beck, Cream, Jefferson Airplane, Led Zeppelin, Steppenwolf, Joe Cocker, and Procol Harum as well as John Lee Hooker and Bo Diddley. The Who performed their rock opera *TOMMY* for the first time in the U.S. (and their second performance ever) here on May 9, 1969. The Grande closed in 1972. **(See Eastown Theatre, Detroit, MI; Vanity Ballroom, Detroit, MI.)**

UPTOWN THEATRE,
CHICAGO, IL

This glorious Spanish baroque revival movie palace opened in 1925. The orchestra pit housed a sixty-person orchestra and a grand Wurlitzer theater organ. The extravagant interior included a six-story-high lobby with paintings and a statuary, ceilings with painted skies, and a twinkling starlight as the lights were lowered. Vaudeville and musical acts preceded the featured film program, as was the standard practice in the 1920s and '30s. In the 1950s, broadcasts of the popular television game show *Queen for a Day* were occasionally produced here. As movie attendance waned in the 1960s and '70s, ticket sales scarcely supported the massive theater. In the 1970s, the

Uptown enjoyed a new life as a rock music venue, featuring headliners like the Electric Light Orchestra, the Who, and Bob Marley. The last concert was J. Geils Band in December 1981.

SEAR SOUND,
NEW YORK, NY

Built in 1964 by sound engineer Walter Sear, Sear Sound has a unique collection of vintage analog recording gear and electronic instruments, including an early Moog synthesizer built by Sear and Robert Moog. The studio has attracted artists like David Bowie, Steely Dan, and Wynton Marsalis. Sonic Youth recorded their 1987 album *Sister* with the analog tube equipment, giving the tracks a warm, vintage sound. The band returned to record the albums *Experimental Jet Set, Trash and No Star* and *Rather Ripped* at Sear Sound.

LOVE STREET LIGHT CIRCUS FEEL GOOD MACHINE (SITE),
HOUSTON, TX

Built in the 1930s for the Sunset Coffee Company, this irregular pentagon-shaped space was used for storage through the 1950s. In 1967, the space became a nightclub and the center of Houston's psychedelic youth culture for the decade's remaining years. Its light show and the bands that played here made it one of the first Texan venues devoted to the psychedelic music scene as popularized in San Francisco. Regulars included local groups playing the new, experimental style: Red Krayola, the 13th Floor Elevators, and the Moving Sidewalks. The Sidewalks' guitar player formed a new band, ZZ Top, which played some of their first shows at Love Street in 1969.

MISCOE HILL MIDDLE SCHOOL,
MENDON, MA

Aerosmith's first professional gig took place on November 6, 1970. The venue was the gymnasium at Nipmuc Regional High School, now Miscoe Hill Middle School, in Mendon, Massachusetts. The band received $50.

OLYMPIC HOTEL, GEORGIAN ROOM,
SEATTLE, WA

This dining room in a stodgy downtown Seattle hotel was the scene of one of the oddest shows the Ramones ever played. The Olympic Hotel was built in 1924 in Italianate Renaissance revival style. In 1977, two rock fans just out of high school booked the Ramones in a roadhouse called Parker's Ballroom on Seattle's outskirts. When the club unexpectedly canceled, the young promoters found themselves scrambling with less than a week's time to find a replacement. They managed to book the Georgian Room, a banquet hall off the main lobby in the Olympic Hotel. The rock and roll crowd presented a bizarre contrast to the typical staid Sunday night scene at the hotel. The music's volume shook the lobby.

INTRAMURAL SPORTS BUILDING, UNIVERSITY OF MICHIGAN,
ANN ARBOR, MI

Dating from 1928, this was the first collegiate intramural sports facility in the U.S. Beginning in the 1960s, it also hosted pop and rock music concerts. The Doors performed on October 20, 1967. A young

Ann Arbor musician named Jim Osterberg was in the audience, finding inspiration in Jim Morrison's transgressive stage persona. Osterberg had just formed a band called the Psychedelic Stooges (later just the Stooges), and the Doors concert provided the spur to get them out of the rehearsal space and on stage. Soon after, Osterberg adopted the stage name Iggy Pop.

MUSCLE SHOALS SOUND STUDIO,
SHEFFIELD, AL

Established by four session musicians who had been the core of FAME Studio's house band, Muscle Shoals Sound Studio opened its doors in 1969. The group, sometimes called the Swampers, consisted of David Hood on bass; Jimmy Johnson on rhythm guitar; Roger Hawkins on drums; and Barry Beckett at the keyboard. Their studio was the very first recording facility owned and operated cooperatively by session musicians. Muscle Shoals relied on the good relationship the musicians had built with Atlantic Records vice-president Jerry Wexler for help with funding and early clients. The first project recorded was Cher's sixth solo album, the title of which was the studio's address, *3614 Jackson Highway*. Other early clients were Boz Scaggs, Lulu, and R. B. Greaves. The Rolling Stones cut three tracks for their *Sticky Fingers* album here. Paul Simon, Bob Seger, and the Staples Singers all recorded hit songs here. The studio remained at this address for a decade, before finally moving to a larger facility in 1978. **(See FAME Recording Studios, Muscle Shoals, AL.)**

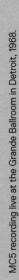

MC5 recording live at the Grande Ballroom in Detroit, 1968.

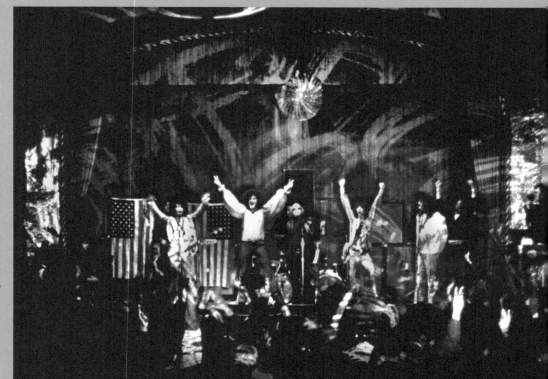

Patti Smith performing on *Saturday Night Live* in New York, April 17, 1976.

television exposure: Elvis Costello, Devo, Talking Heads, the Replacements, and the Specials were among new artists introduced to a wider audience.

LYRIC THEATER,
MIAMI, FL

The four-hundred-seat Lyric Theater was built in 1913, and quickly became a popular vaudeville and movie house for African Americans in the district of Miami known as "Little Broadway," an area with hotels, restaurants, and nightclubs frequented by both Black and white tourists and residents. An important stop on the Chitlin' Circuit, every top African American star played here, from Cab Calloway and Count Basie to Josephine Baker and Billie Holliday. Its days as a music venue lasted through the 1950s; after, the space became a church. Following a long period of decline and abandonment, it has since been restored, reopening in 2000 as a theater managed by the Black Archives, History and Research Foundation of South Florida.

AGORA THEATRE AND BALLROOM,
CLEVELAND, OH

Established in 1967, the Agora existed at two earlier locations, both now destroyed. The second location burned in 1984. The current Agora was built in 1913 as the Metropolitan Theatre, opening with a performance of the Verdi opera *Aida*. In the 1930s, it was a burlesque house and then was used as a cinema in the 1940s. From 1951 to 1978, the venue housed a radio station. In 1986, the Agora moved into the old Metropolitan, where it has two performance spaces: a five hundred–person capacity, standing-room-only ballroom with an adjoining bar, and a 1,800-seat theater. It has hosted concerts in every genre of rock music, from heavy metal bands Rush, Scorpions, and Megadeth, to pop artists like Bryan Adams and Meat Loaf.

RADIO RECORDERS ANNEX,
LOS ANGELES, CA

Radio Recorders was founded in 1933 at 932 N. Western Avenue, and in 1949 moved to 7000 Santa Monica Boulevard.

During the 1940s, the facility was responsible for producing hundreds of transcription disks of radio programs originating on the East Coast for delayed broadcast on the West Coast. An additional recording studio called Radio Recorders was built in 1946 in a warehouse around the corner. Jazz trumpeter and vocalist Chet Baker recorded here in 1954. Elvis Presley used the studio in the early 1960s. A New York studio, the Record Plant, moved their West Coast operations to the Radio Recorders annex space in 1985.

J&M RECORDING (SITE),
NEW ORLEANS, LA

The recording studio operated by Cosimo Matassa from 1945 to 1956 is often cited as the birthplace of rock and roll. Seminal tracks coming out of the J&M studio that helped define the genre were "Good Rocking Tonight," a jump blues by Roy Brown from 1947, and "The Fat Man" by Fats Domino in 1949. One of the most influential and enduring of J&M's rock and roll recordings was Little Richard's "Tutti Frutti" from 1955. The studio grew out of a jukebox business owned by Joe

Mancuso and John Matassa, Cosimo's father. The studio was set up in an elegant 1835 Federal-style building on North Rampart Street. J&M began recording for a few small record labels—Imperial out of Los Angeles, Deluxe from New Jersey—that were looking for an authentic New Orleans sound to sell in the rhythm & blues market. As independent labels proliferated in the postwar boom years, so did new clients: Atlantic, Mercury, Aladdin, Specialty, Chess, Savoy, and Modern. To back local talent, the studio relied on a core of session musicians, often led by bandleader Don Bartholomew and including tenor saxophone Lee Allen, Huey "Piano" Smith, guitarist Ernest McLean, bassist Frank Fields, and the drummer Earl Palmer. In addition to R&B, the studio recorded Cajun, hillbilly, and Gospel records and worked with artists from outside New Orleans, such as Jerry Lee Lewis and Big Joe Turner.

NBC STUDIO 8-H, *SATURDAY NIGHT LIVE,*
NEW YORK, NY

30 Rockefeller Plaza, completed in 1933, is a part of the Radio City complex in Rockefeller Center. On its eighth floor is Studio 8-H, built to be the world's largest radio broadcast studio and designed for orchestral performances and variety programs with large audiences. It became the home of Arturo Toscanini's NBC Symphony Orchestra in 1937. The studio was converted for television broadcasting in 1950. Its first tenant was the prestige drama series Kraft Television Theatre, but it is most famous for being the home of *Saturday Night Live*, the sketch comedy series that has featured live music from its very beginning in 1975. Although established pop stars were often guests in the early seasons of the show, *SNL* is occasionally a band's first national

VILLAGE RECORDER, STUDIOS F AND D,
LOS ANGELES, CA

The Freemasons built this West Los Angeles Masonic temple in 1922. The building was used as a center for transcendental meditation by Maharishi Mahesh Yogi in the mid 1960s, and it was converted into a recording studio in 1968. Some of the albums recorded here include *Aja* by Steely Dan, *Joe's Garage* by Frank Zappa, and *Planet Waves* by Bob Dylan. Steely Dan's *Pretzel Logic*, the Talking Heads' album *True Stories*, the Juice Newton album *Juice*, Fleetwood Mac's *Tusk*, and Snoop Dogg's *Doggystyle* demonstrate the range of projects recorded here.

ALICE'S RESTAURANT (SITE),
GREAT BARRINGTON, MA

Alice and Ray Brock both worked for the Stockbridge School, a progressive boarding school in Massachusetts. They began living in this deconsecrated church in 1964, turning it into a meeting place for friends, students, and bohemian counterculture types. An annual Thanksgiving dinner party at the Brocks' home became the inspiration for "Alice's Restaurant Massacree," written and sung by their friend and former student Arlo Guthrie. The eighteen-plus-minute epic is a tale of littering, the abuses of small town policemen, hippie camaraderie, and a satirical protest against the Vietnam War draft. The song ends with Guthrie calling for young men to sing the chorus to "Alice's Restaurant Massacree" during their Draft Board examination, the thought being that this inappropriate, unconventional behavior would be enough for the military to reject them. While the context of the song was clearly an

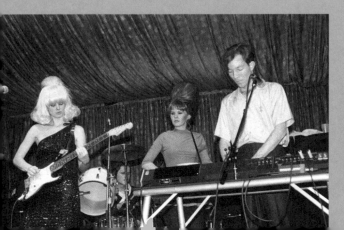

The B-52s performing at the Roseland Ballroom in New York, 1982.

unpopular war in Vietnam, Guthrie has said that its subject is broader than an antiwar anthem—rather, it is "anti-stupidity" and an anti-authority protest.

SOUND FACTORY,
LOS ANGELES, CA

This recording studio was built in 1964 by Moonglow Records. The Righteous Brothers made their first recordings here, including their breakout single "Little Latin Lupe Lu." In 1969, David Hassinger, a former RCA recording engineer and Reprise producer, bought the building and renamed the facility the Sound Factory. Linda Ronstadt recorded some of her most popular albums here, including 1974's *Heart Like a Wheel*. James Taylor recorded the album *JT*. Portions of the Gram Parsons album *Sleepless Night*, released after his death, were recorded with the Flying Burrito Brothers in 1970.

LEE'S UNLEADED BLUES,
CHICAGO, IL

The plain, two-story red brick building was built in 1905. From 1946, it operated as a bar under various names, including the popular Sweet Queen Bee's Lounge in the 1970s. In 1983, Ray and Leola "Lee" Grey purchased the business, changed the name to Lee's Unleaded, and began booking local blues musicians seven nights a week. The club gained a reputation as an authentic venue for Chicago blues in a distinct South Side style, which concentrated on soulful, jazz-inflected vocals as opposed to the guitar-oriented showmanship of the North Side Chicago blues. Lee's is now permanently closed.

HOLLYWOOD HIGH SCHOOL, AUDITORIUM,
LOS ANGELES, CA

This four-year secondary school dates from 1903, the year Hollywood was incorporated as a municipality. The current campus was built in the 1930s in the period's Streamline Moderne style. The auditorium was the site of several concerts by top name musicians, including the Byrds in 1966, and the Stone Roses in 1990. Elvis Costello and the Attractions played in 1978, and an EP of three songs recorded at the show, called *Live at Hollywood High*, was included in the initial release of his *Armed Forces* LP as a bonus, with the entire show issued on CD in 2010. Musical alumni of Hollywood High include Judy Garland, Cher, and Lowell George and Bill Payne from the group Little Feat. Another was Ricky Nelson, who had been in show business from the age of eight via *The Adventures of Ozzie and Harriet,* starring his bandleader father and vocalist mother. At age sixteen, Nelson cut a cover of Fats Domino's song "I'm Walking" for Verve Records, which shot to #4 on the *Billboard* charts. The musical career Ricky Nelson launched while still a student at Hollywood High lasted into the 1970s.

ROSELAND BALLROOM (SITE),
NEW YORK, NY

This second location of the Roseland Ballroom was originally built as an indoor ice skating rink in 1922 by a franchise called Iceland. One thousand skaters attended the opening night. Iceland went bankrupt in 1932 and it became the Gay Blades Ice Rink. In the 1950s, the rink was converted for roller-skating. The Roseland Ballroom originally opened in 1919 at

Broadway and Fifty-First Street. In 1956, when that building was demolished, Roseland moved into the former roller rink. It remained a venue for mid-century social dancing, unchanged over many years, while popular music moved beyond ballroom dancing. In the late 1970s, disco revived the business temporarily and in the 1990s the ballroom was used as a live music venue again, with shows by a wide variety of artists including Prince, the Beastie Boys, Graham Parker, Joan Jett, and Johnny Cash.

MUNICIPAL AUDITORIUM, MUSIC HALL,
KANSAS CITY, MO

With a striking Streamline Moderne facade, this 1934-vintage multipurpose event complex is composed of the Music Hall, an Art Deco proscenium theater seating 2,400; a sports arena; and the Little Theatre, an octagonal ballroom with capacity for four hundred. The Music Hall has presented the Beach Boys, the Kinks, and Bob Dylan. The Who played here in 1968, as did Quicksilver Messenger Service.

WAR MEMORIAL AUDITORIUM,
NASHVILLE, TN

This two-thousand-seat performance hall served as home of the Grand Ole Opry from 1939 to 1943 prior to moving to the Ryman Auditorium. The War Memorial Auditorium, designed in the neoclassical style, was built in 1925. As a music venue, it has been home to the Nashville Symphony Orchestra as well as countless pop concerts. In October 1957, a tour called the Fantabulous Rock and Roll Show, a fourteen-act package

with a Black cast, stopped at the auditorium. The show featured Ray Charles, Bo Diddley, Mickey and Sylvia, Larry Williams, and blues shouter Big Joe Turner. The auditorium presented Elvis Costello and the Attractions, with the Rubinoos opening in 1979. **(See Ryman Auditorium, Nashville, TN; Belcourt Theatre, Nashville, TN.)**

TRIANGLE RECORDING (SITE),
SEATTLE, WA

This small triangular building from 1911 housed a grocery and produce stand for many years. In 1976, it was converted to an eight-track recording studio called Triangle Recording. Through the late 1970s and into the '80s, local new wave and post-punk bands recorded here. The Pudz's "Take Me to Your (Leader)" is representative of productions in these years. New management arrived in 1984, and the studio became Reciprocal Recording. Bands important to the development of the grunge sound like Green River, Mudhoney, and Nirvana recorded at Reciprocal. In the 1990s, renamed John & Stu's, the studio recorded Sleater-Kinney, Blonde Redhead, and Harvey Danger. Since 2000, it has continued as Hall of Justice Recording, owned by Chris Walla.

THE GYMNASIUM,
NEW YORK, NY

In April 1967, the Velvet Underground —at the time still managed by pop artist Andy Warhol—played a series of shows in the gymnasium at Sokol Hall. Sokol is a social club with several international branches devoted to physical education and cultural growth. Sokol New York was founded in 1867 by Czech and Slovak immigrants. The Renaissance revival hall on East Seventy-First Street was built in 1896, financed by members' donations. The amenities offered were a restaurant, theatrical events and concerts, a gymnasium, and a comfortable social club. When the Velvet Underground played, the gym was in full use, with barbells, a pommel horse, and a trampoline pushed to the side to make room for the audience. An advertisement billed the show "Andy Warhol Presents The Velvet Underground Work Out At The Gymnasium."

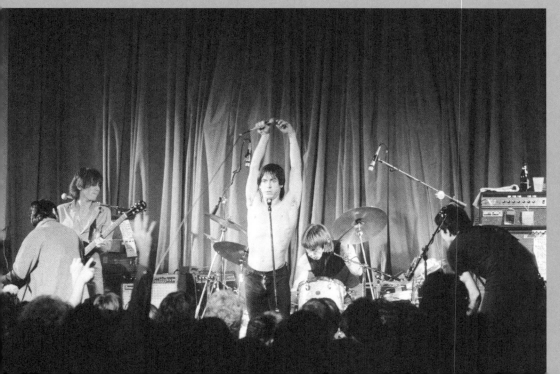

Iggy Pop performing at the Agora Theatre and Ballroom in Cleveland during his *New Values* tour, 1979.

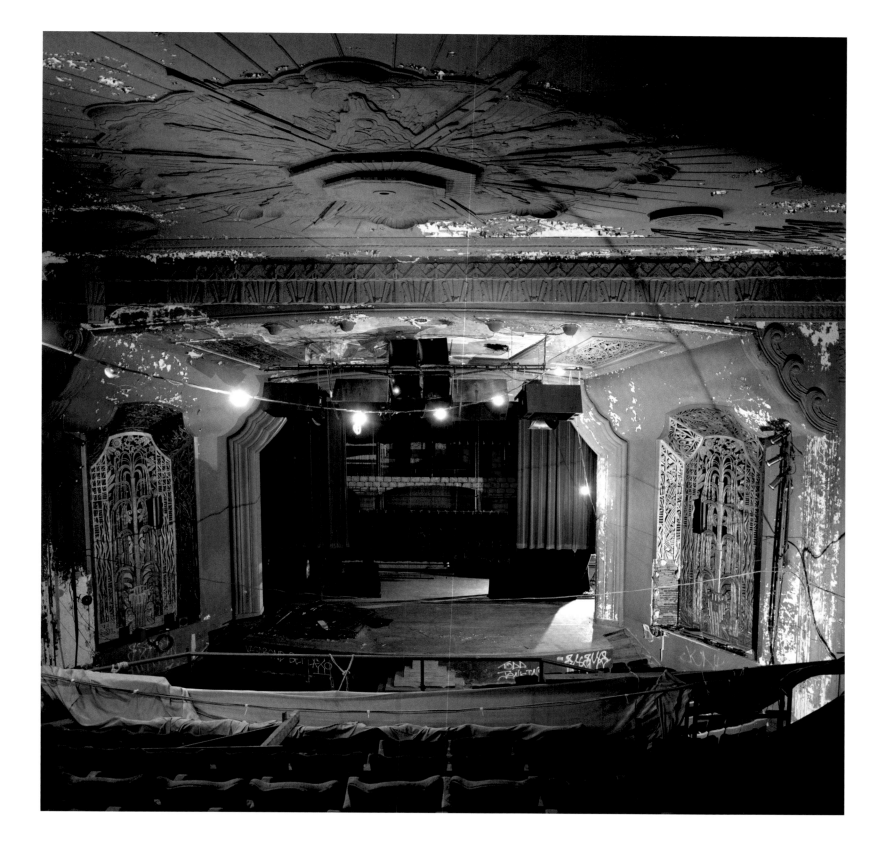

Uptown Theater, Philadelphia, PA — June 10, 2010

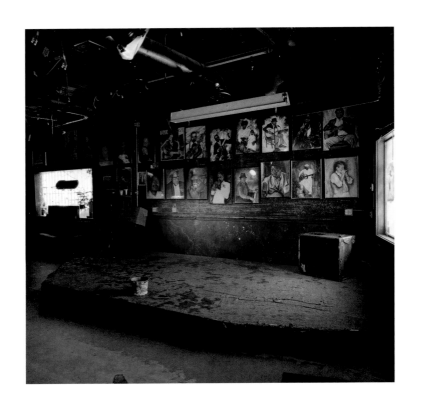

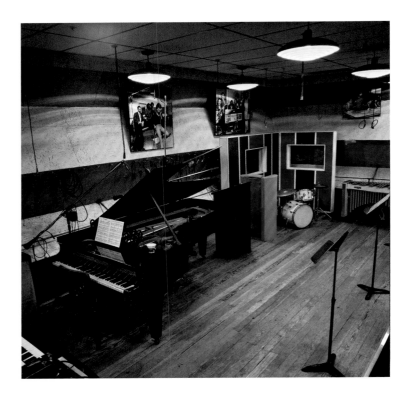

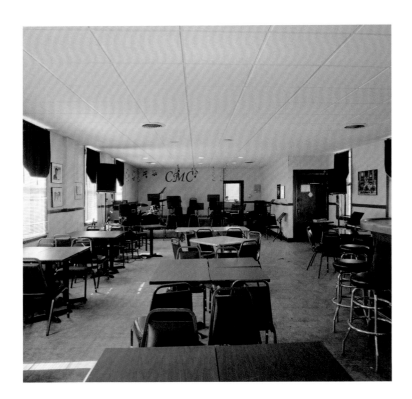

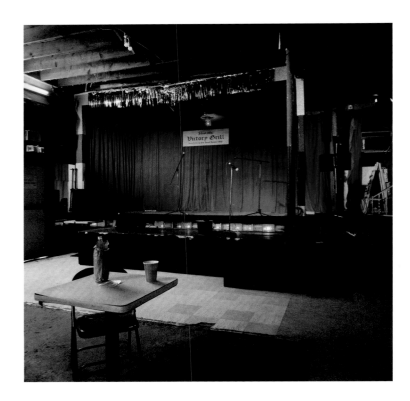

Northside Tavern, Atlanta, GA — June 22, 2015
Hitsville U.S.A., Detroit, MI — October 27, 2008
Colored Musicians Club, Buffalo, NY — May 7, 2015
Victory Grill, Austin, TX — June 2, 2009

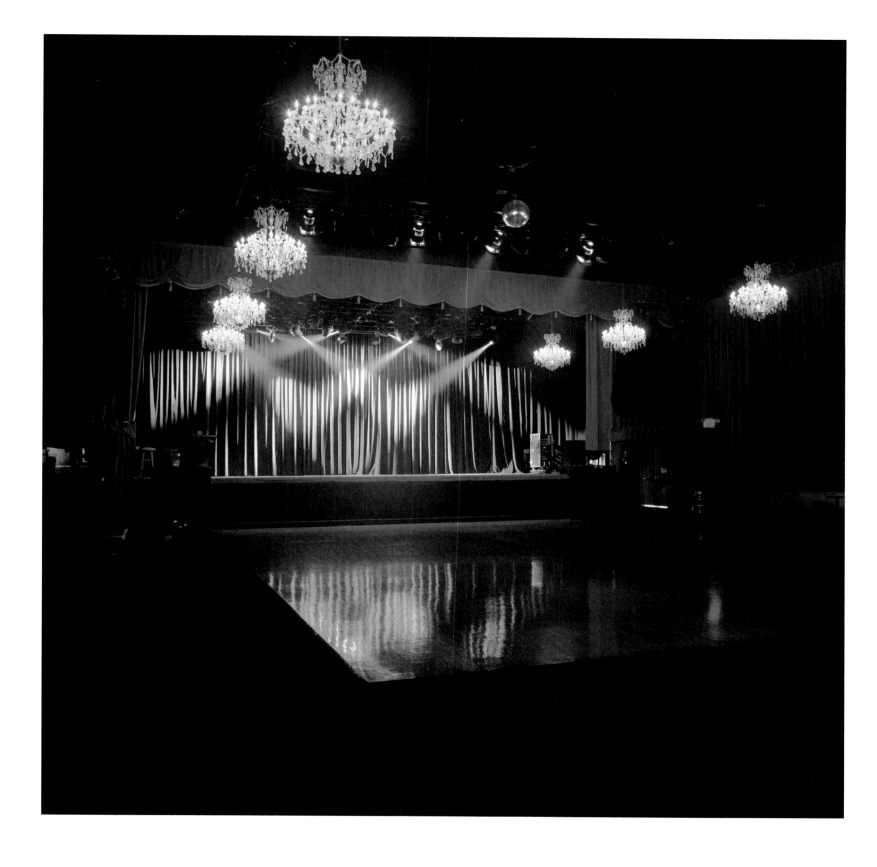

The Fillmore, San Francisco, CA — November 11, 2015

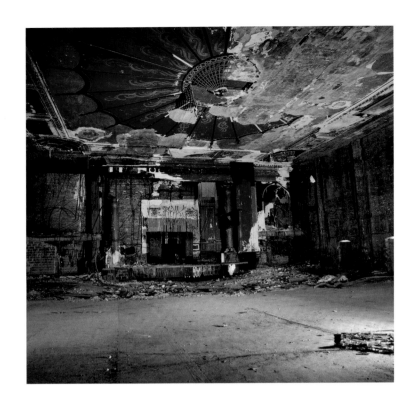

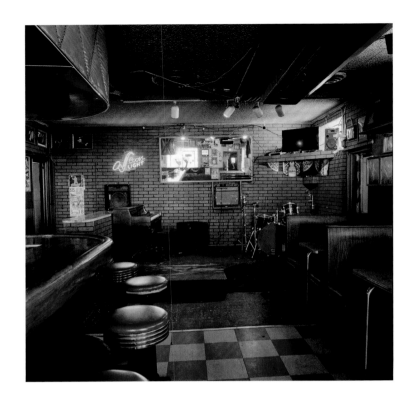

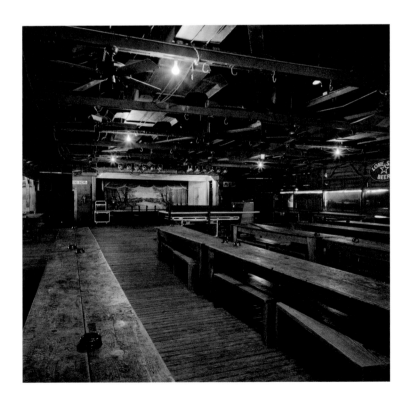

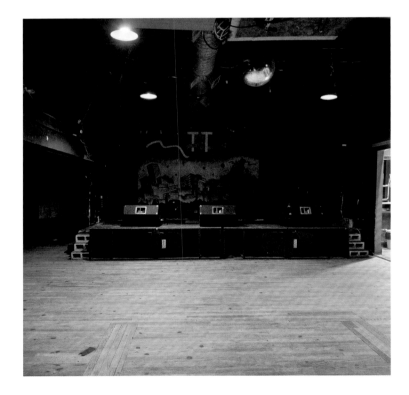

Royal Theater, Philadelphia, PA — September 16, 2013
El Chapultepec, Denver, CO — October 8, 2015
Gruene Hall, New Braunfels, TX — June 4, 2009
T.T. the Bear's Place, Cambridge, MA — August 12, 2014

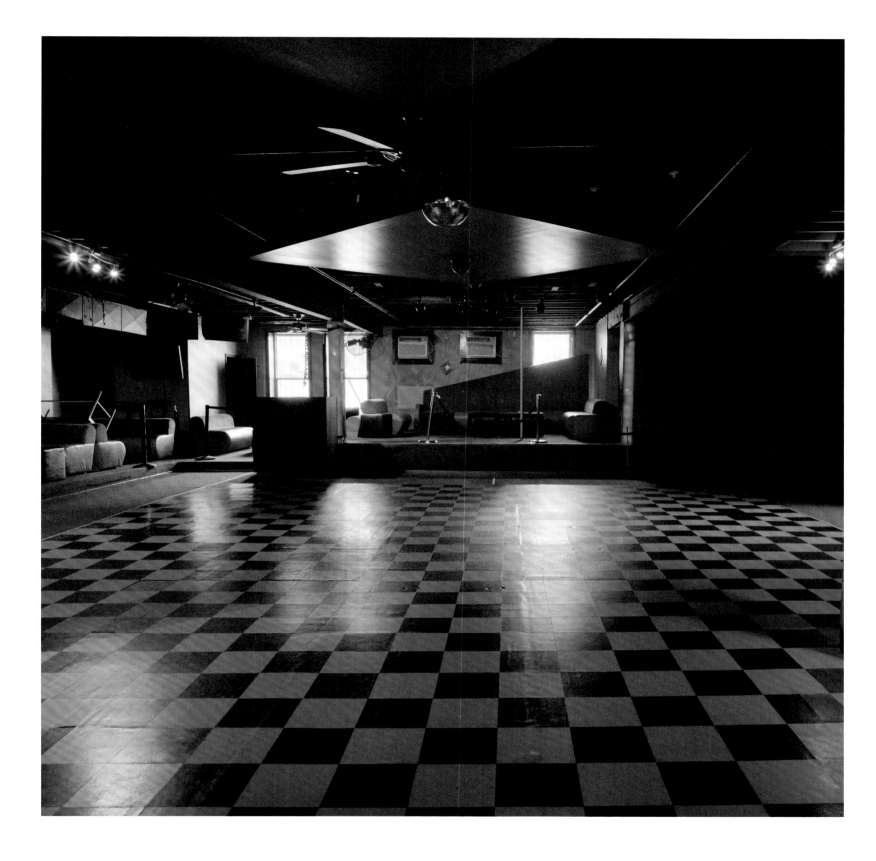

Royal Peacock, Atlanta, GA — June 25, 2015

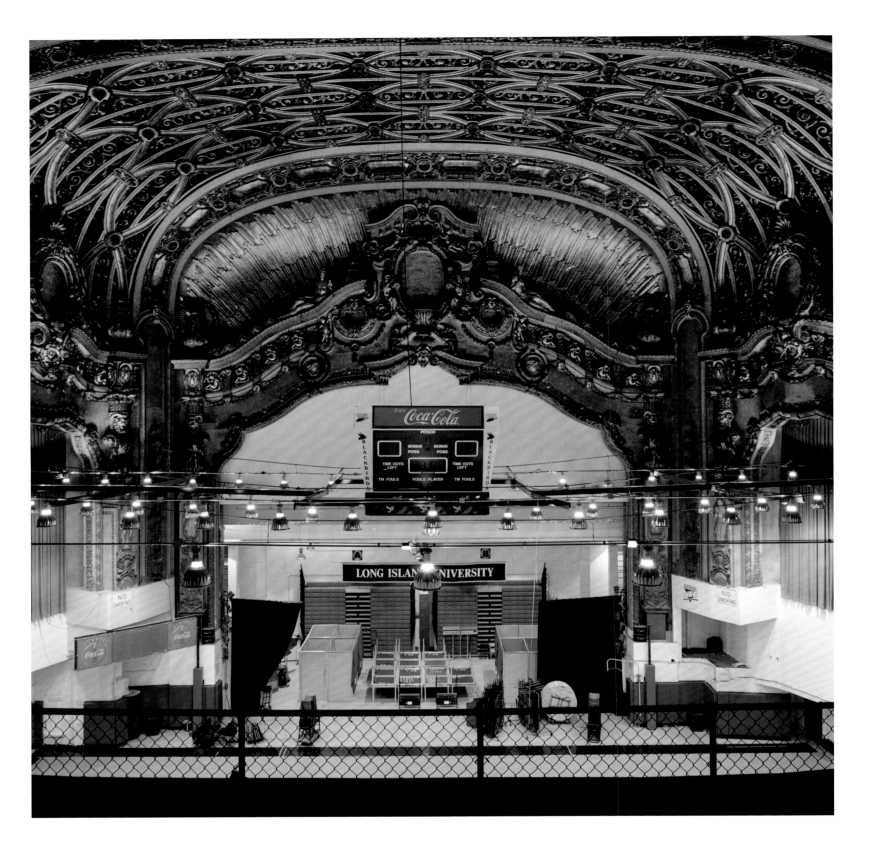

Brooklyn Paramount Theatre (site), Brooklyn, NY — April 29, 2014

Wilson High School, Music Room, Tacoma, WA — November 19, 2015

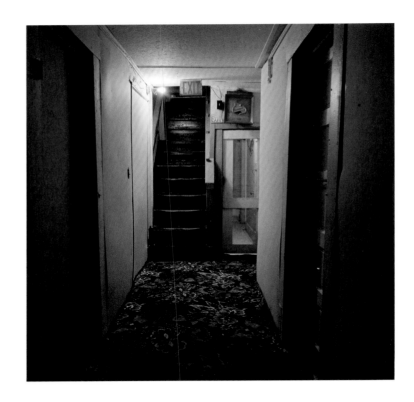

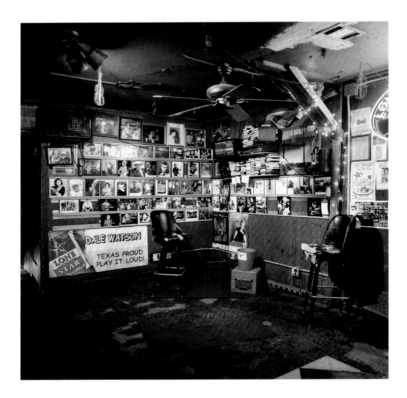

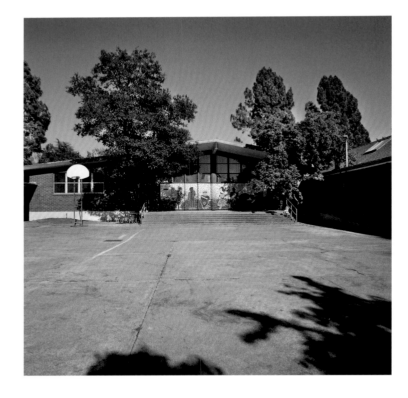

Conway Recording Studios, Studio A, Los Angeles, CA — July 30, 2015
Riverside Hotel, Clarksdale, MS — May 10, 2008
Ginny's Little Longhorn, Austin, TX — June 3, 2009
Napa State Hospital, Napa, CA — August 25, 2015

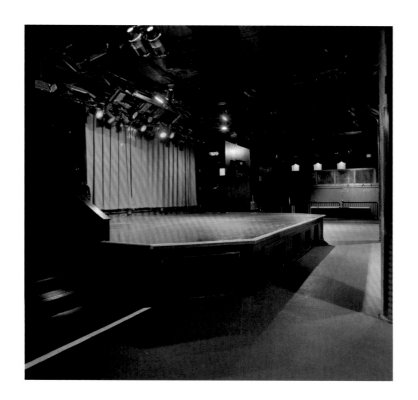

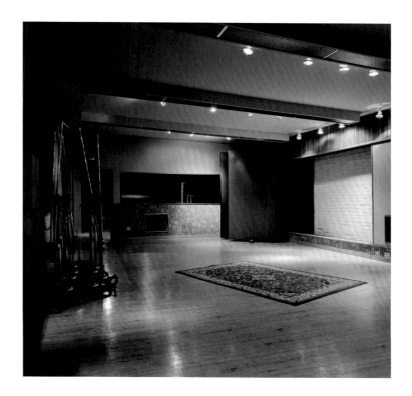

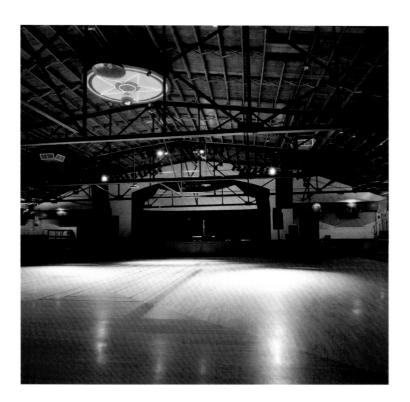

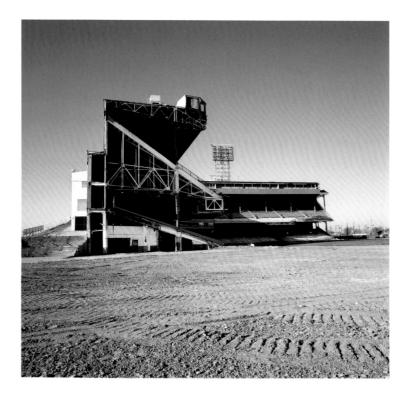

Paradise Club, Boston, MA — August 12, 2014
Sunset Sound Studios, Studio 1, Los Angeles, CA — August 5, 2009
Cain's Ballroom, Tulsa, OK — June 9, 2009
Tiger Stadium, Detroit, MI — October 31, 2008

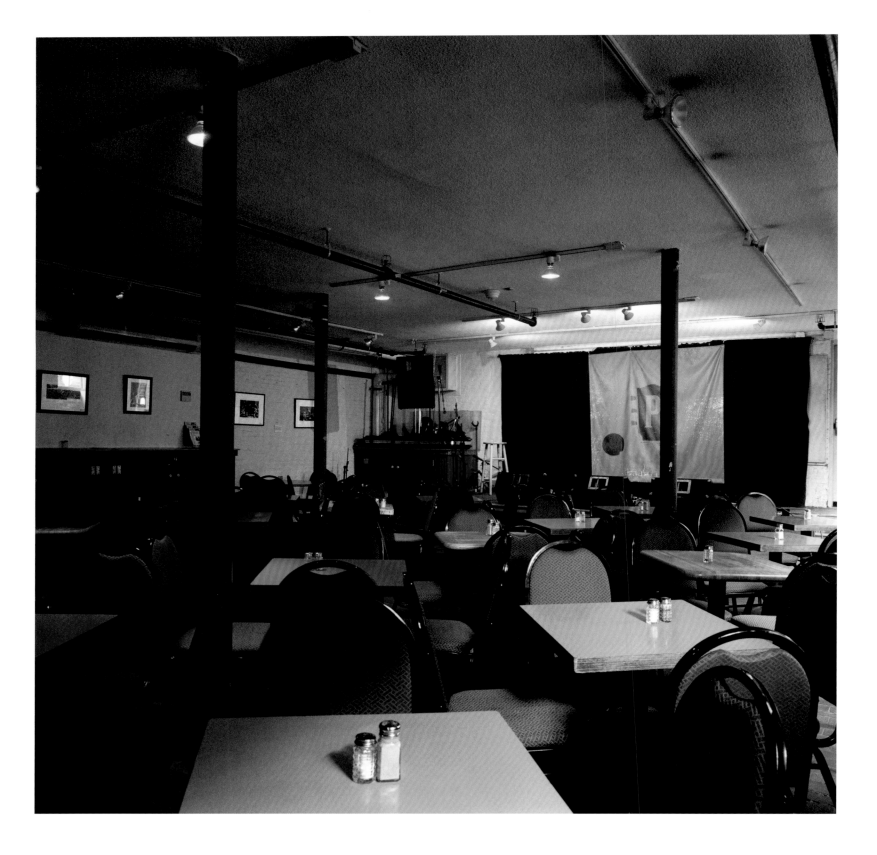

Club Passim (Club 47), Cambridge, MA — August 11, 2014

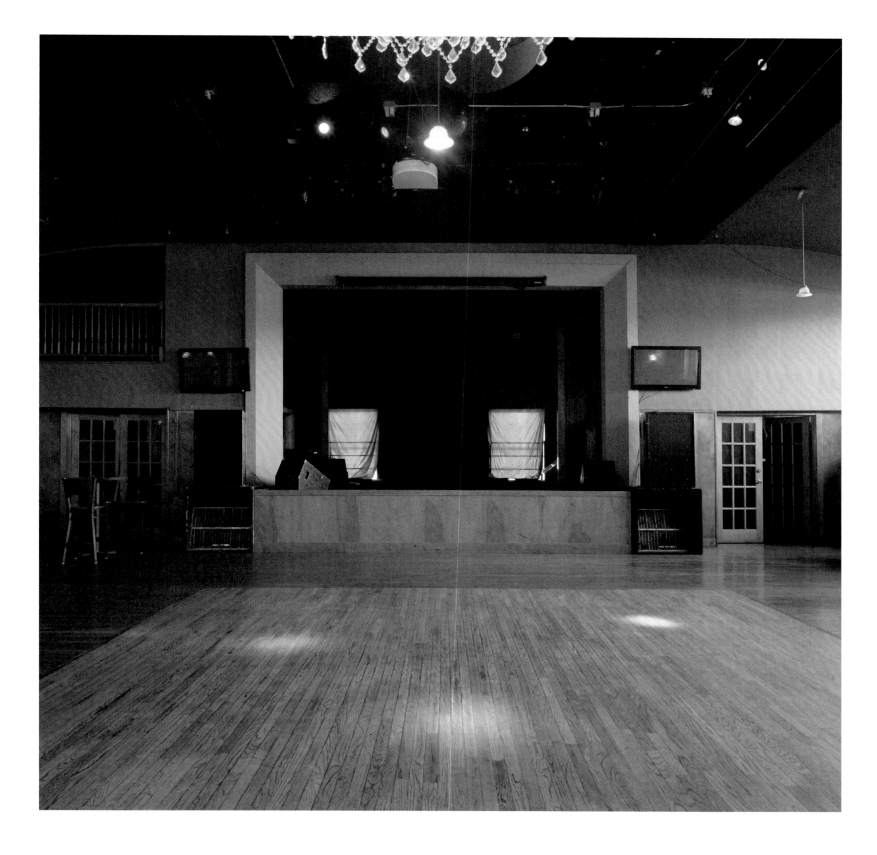

Odd Fellows Hall, Minneapolis, MN — November 14, 2013

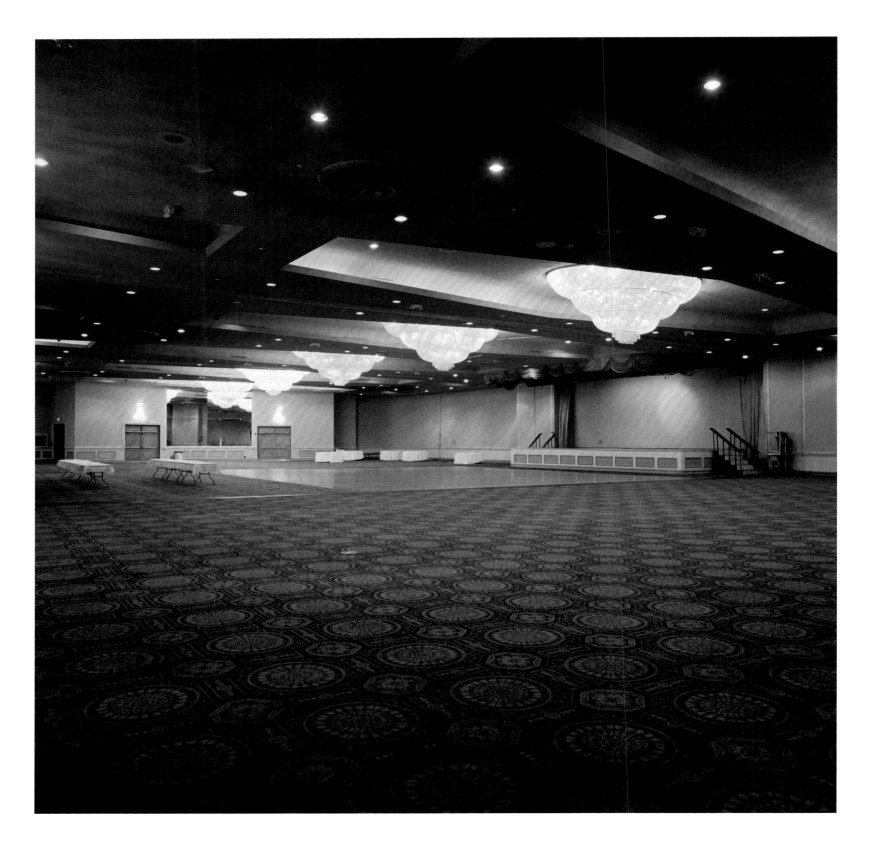

Napoleon Ballroom, Miami Beach, FL — February 23, 2015

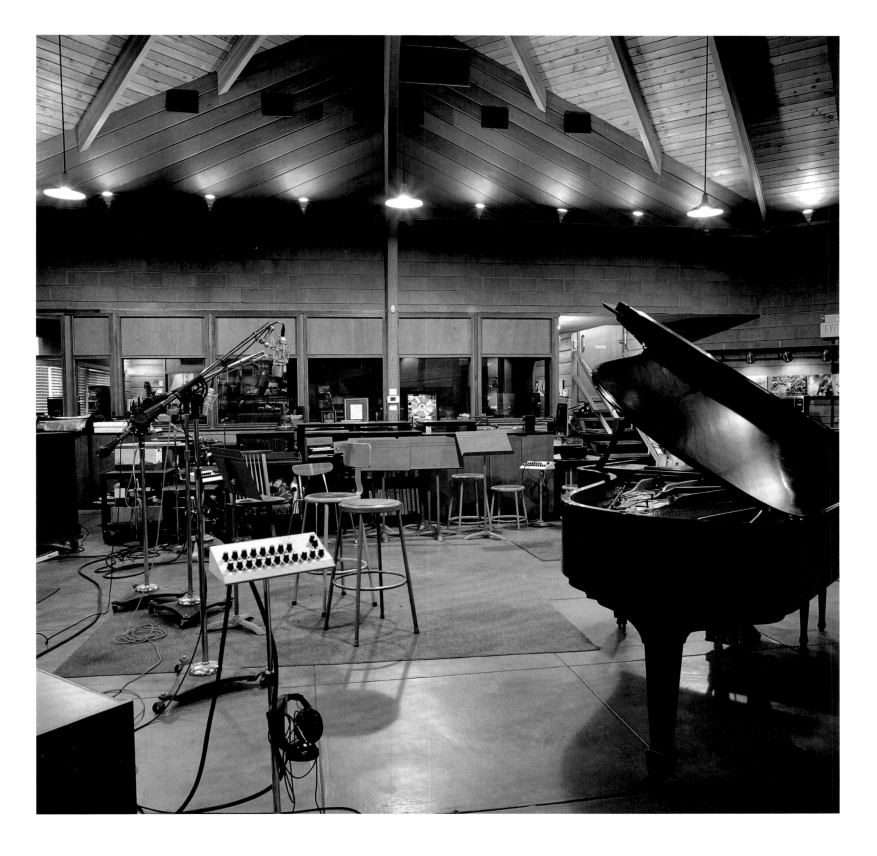

Van Gelder Recording Studio, Englewood Cliffs, NJ — May 6, 2016

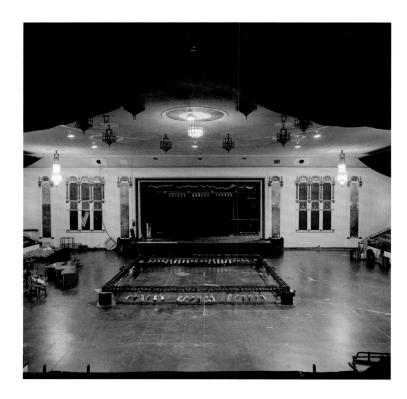

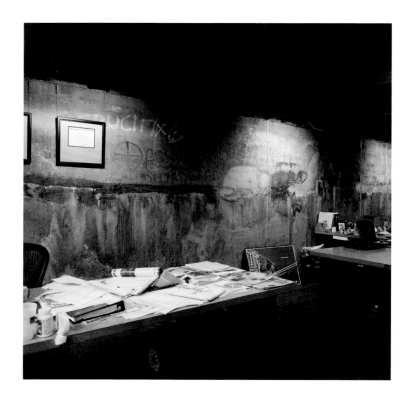

Ardent Studios, Studio C, Memphis, TN — May 7, 2008
Asbury Park Convention Hall, Asbury Park, NJ — August 14, 2013
Twilite Room (site), Dallas, TX — January 11, 2013
Riviera Club (site), St. Louis, MO — January 17, 2010

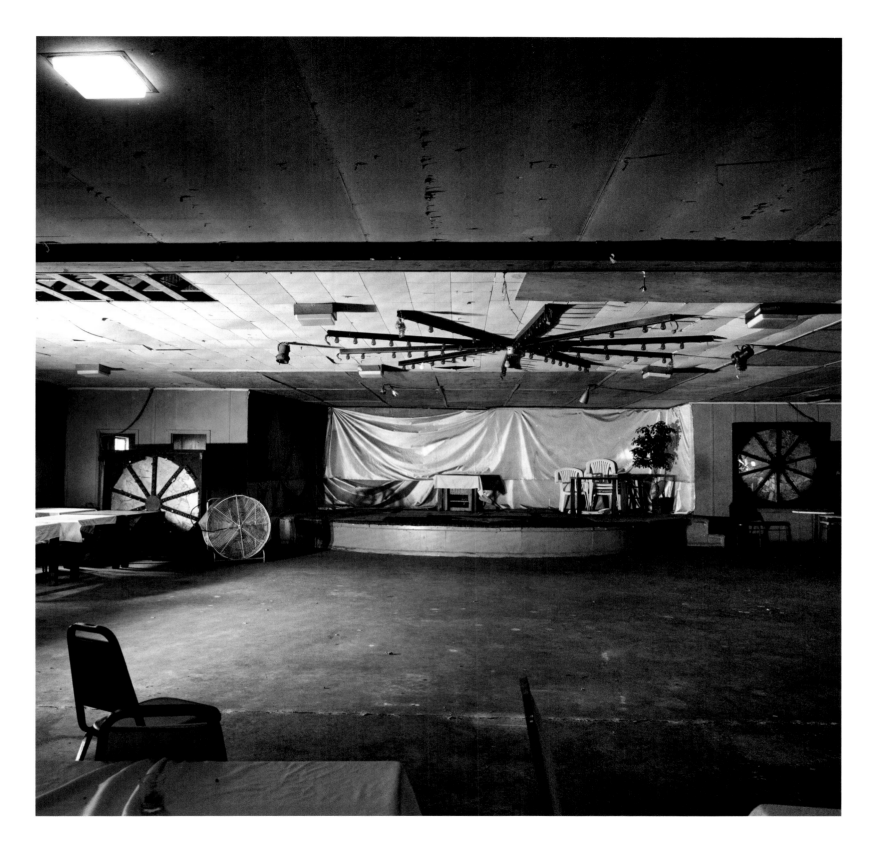

Adams Lounge, Macon, GA — June 24, 2015

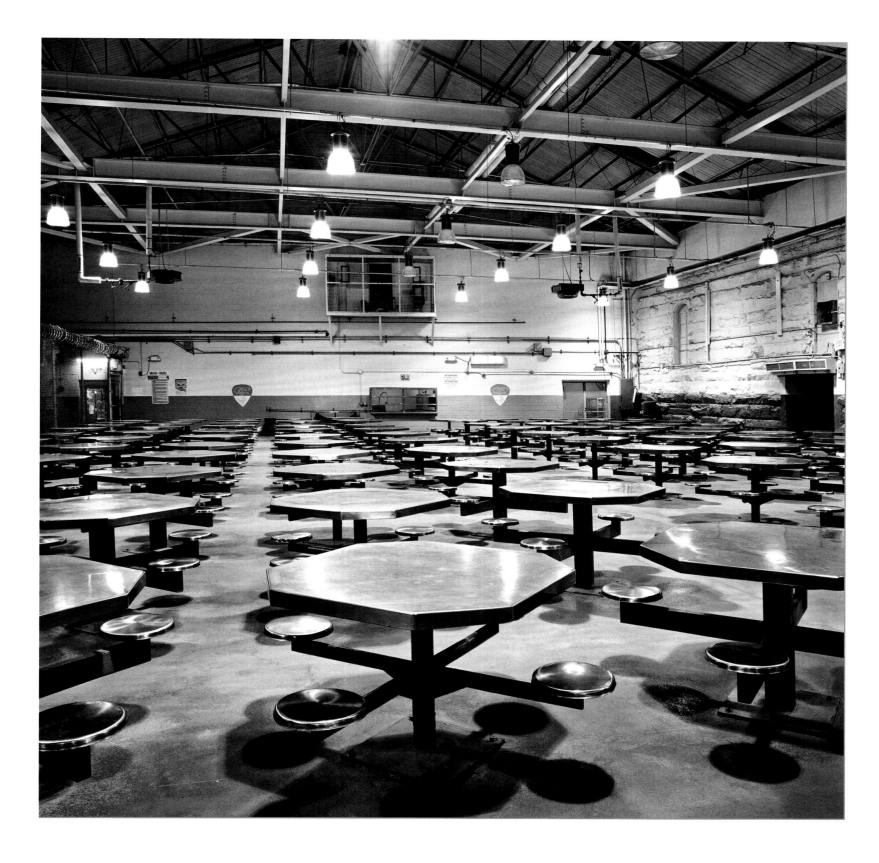

Folsom State Prison, Represa, CA — August 25, 2015

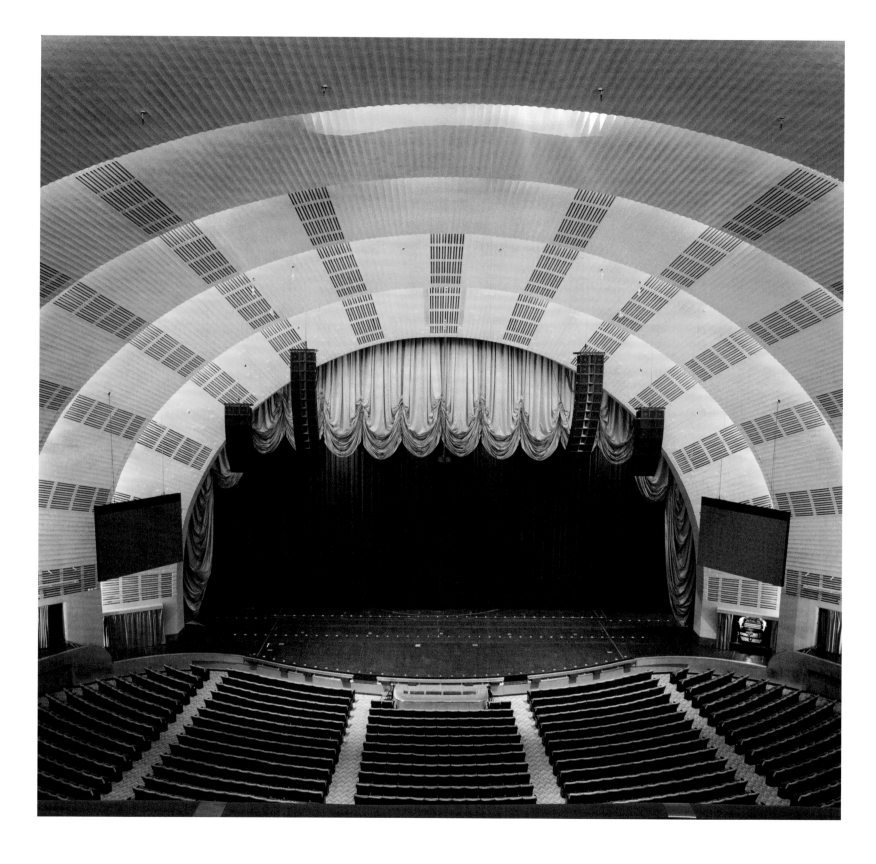

Radio City Music Hall, New York, NY — June 15, 2015

Randy's Rodeo, San Antonio, TX — June 4, 2009

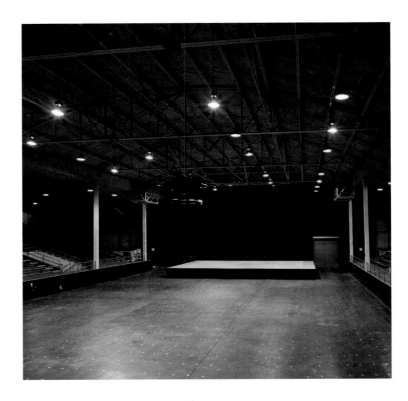
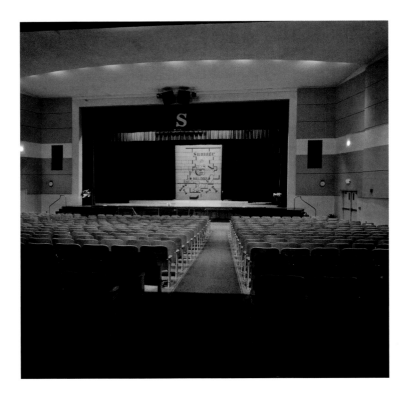
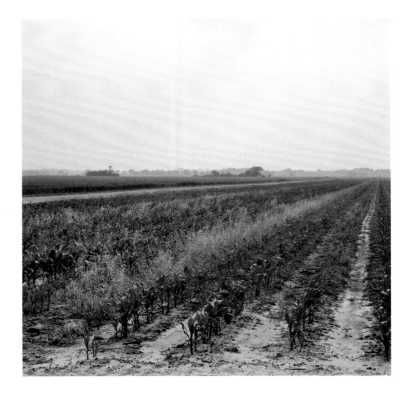

508 Park Avenue, Dallas, TX — January 11, 2013
South Plains Fair Park Coliseum, Lubbock, TX — June 8, 2009
Sumner High School, Auditorium, St. Louis, MO — May 28, 2015
Stovall Plantation, Clarksdale, MS — May 10, 2008

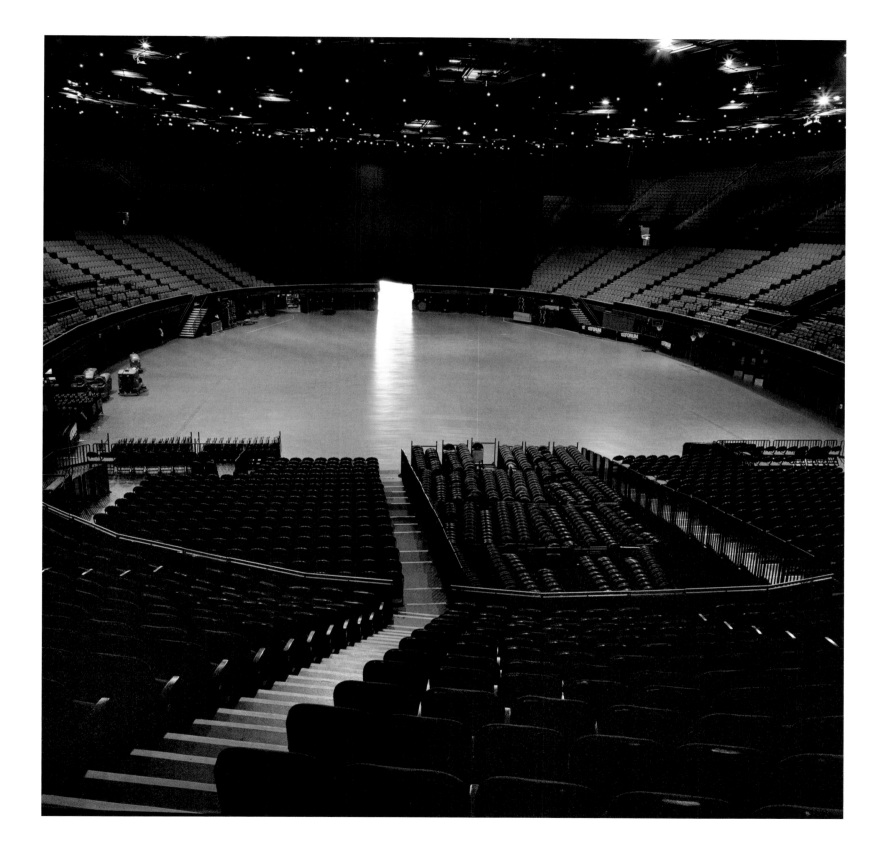

The Forum, Inglewood, CA — July 29, 2015

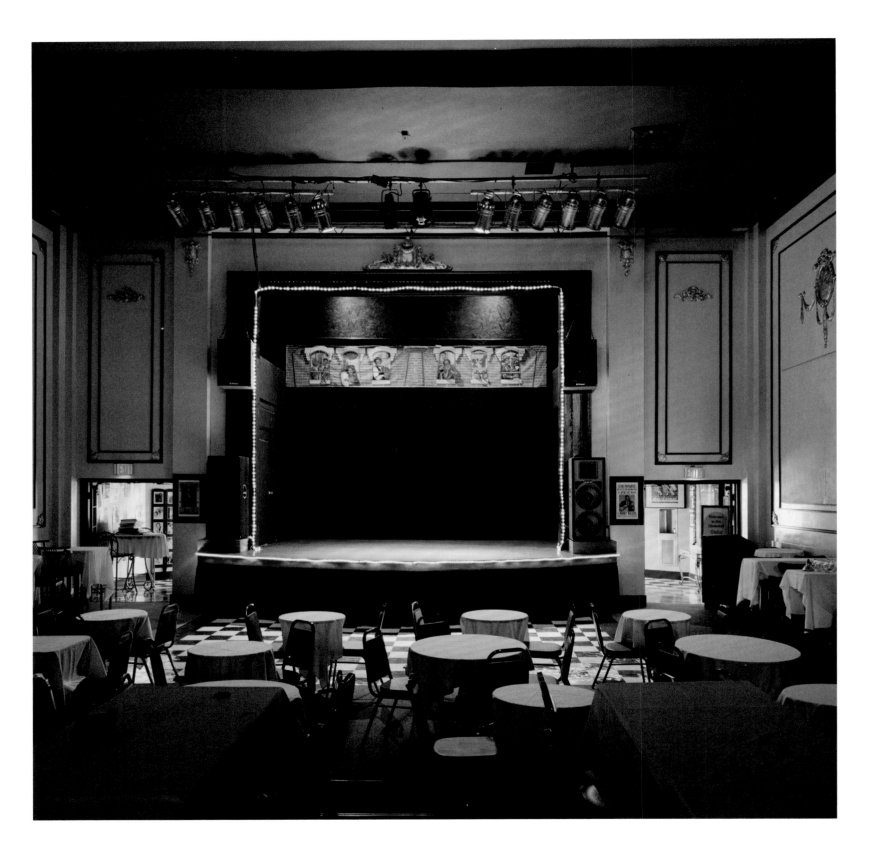

Daisy Theatre, Memphis, TN — May 6, 2008

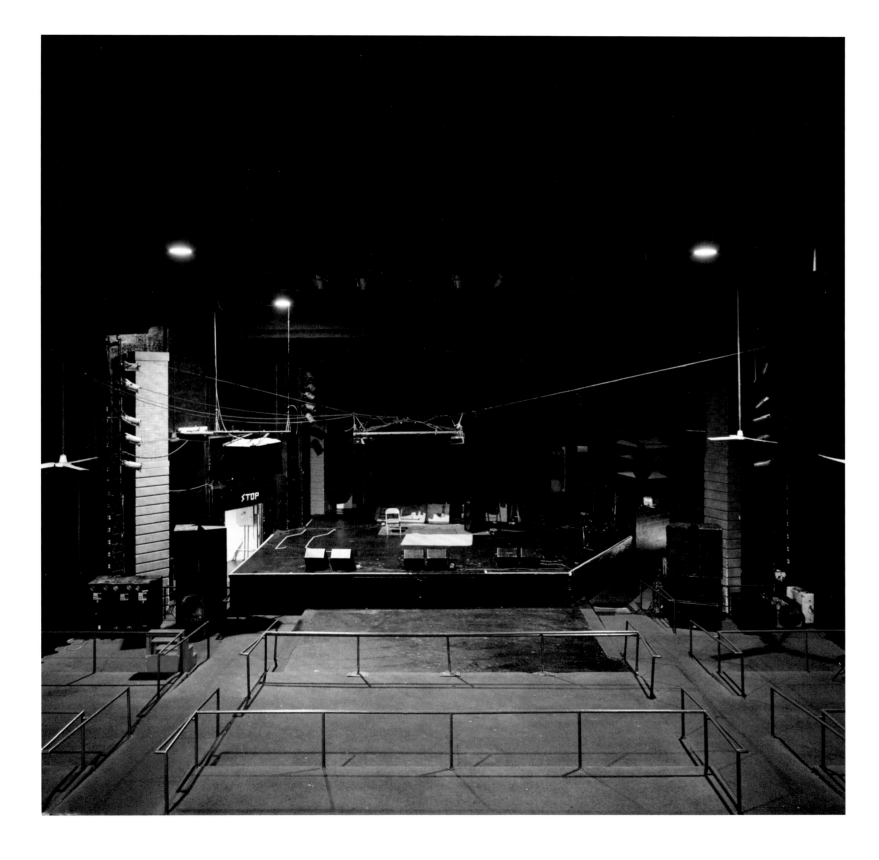

New Daisy Theatre, Memphis, TN — May 6, 2008

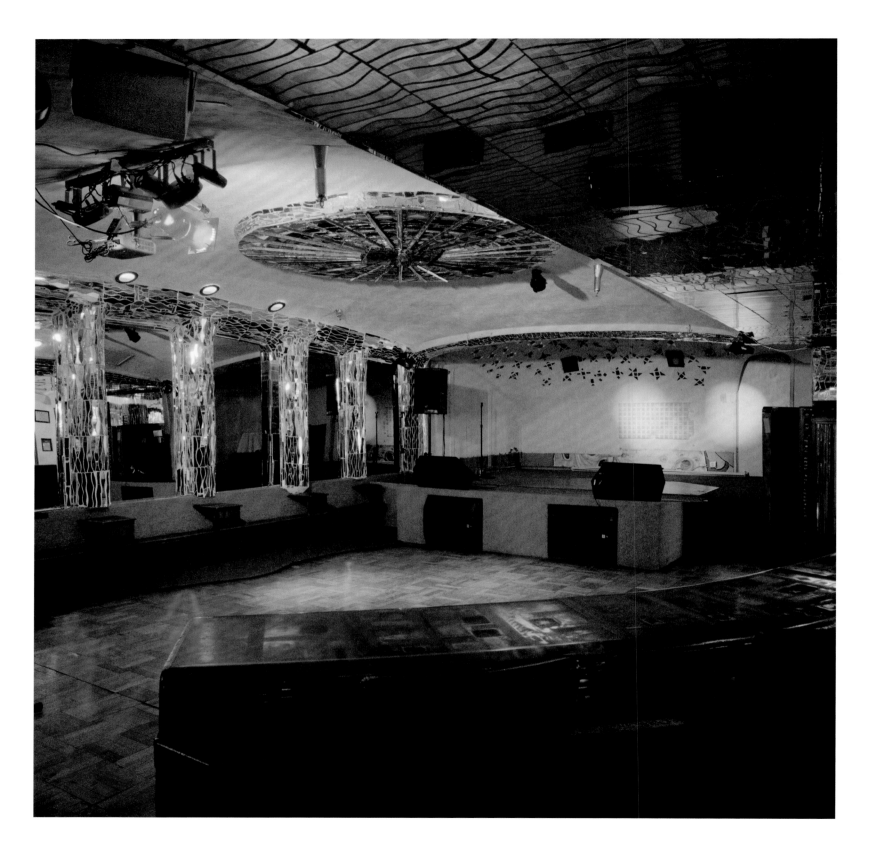

Maverick's Flat, Los Angeles, CA — July 29, 2015

Little Theater, Hibbing, MN — July 10, 2006

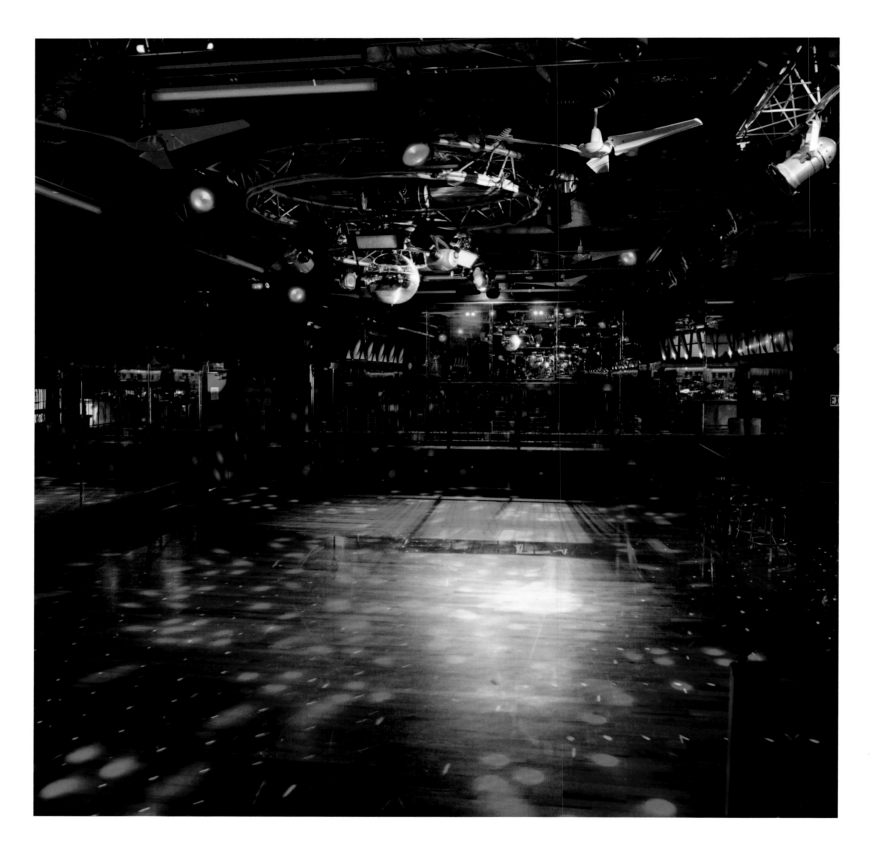

Hot Klub (site), Dallas, TX — January 12, 2013

Los Angeles Memorial Coliseum, Los Angeles, CA — July 31, 2009

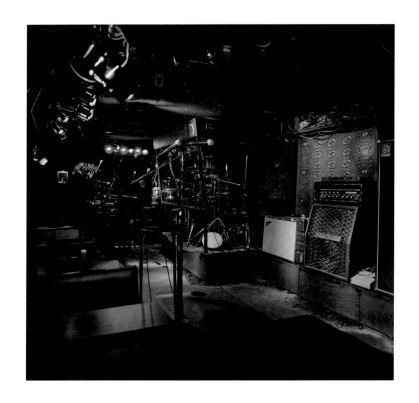

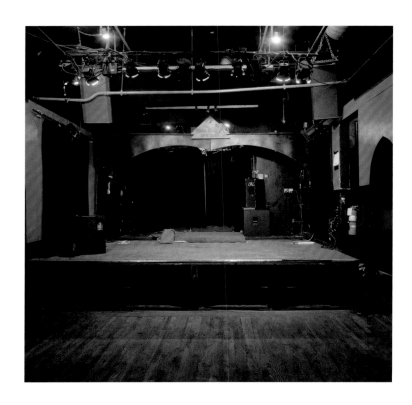

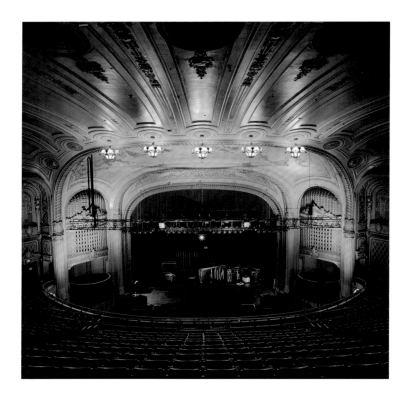

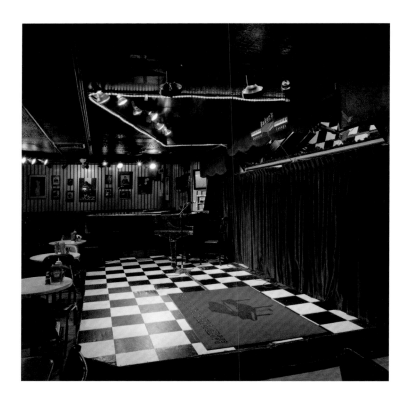

Cafe Wha?, New York, NY — August 26, 2008
The Middle East, Cambridge, MA — August 11, 2014
The Warfield, San Francisco, CA — August 27, 2015
Baker's Keyboard Lounge, Detroit, MI — October 30, 2008

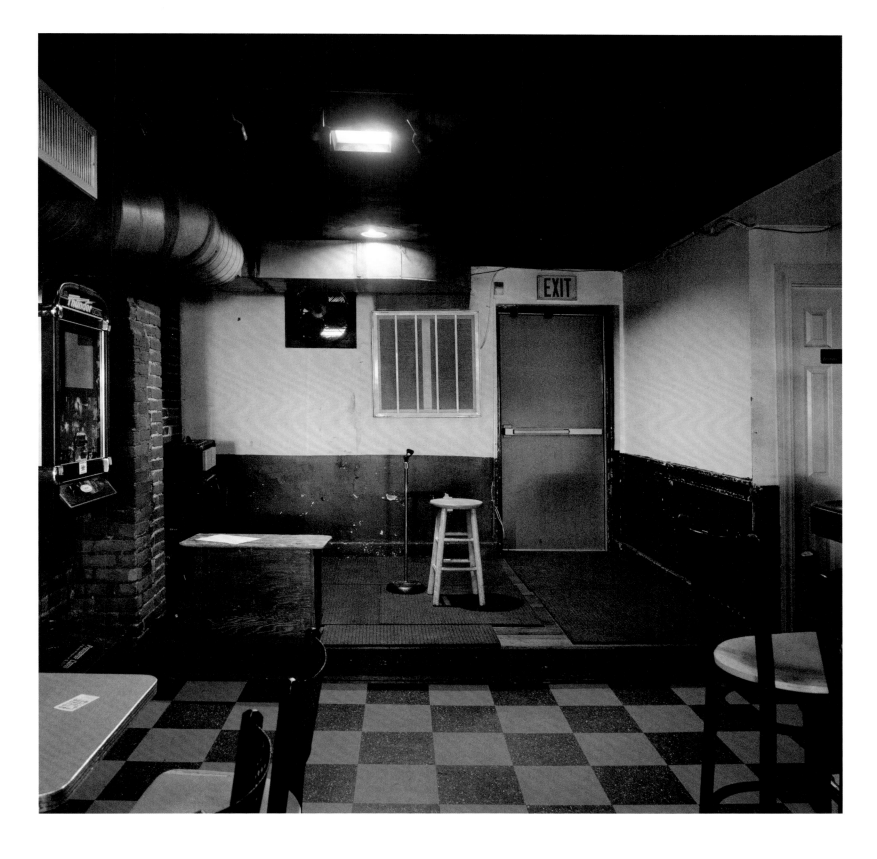

Wally's Cafe Jazz Club, Boston, MA — August 11, 2014

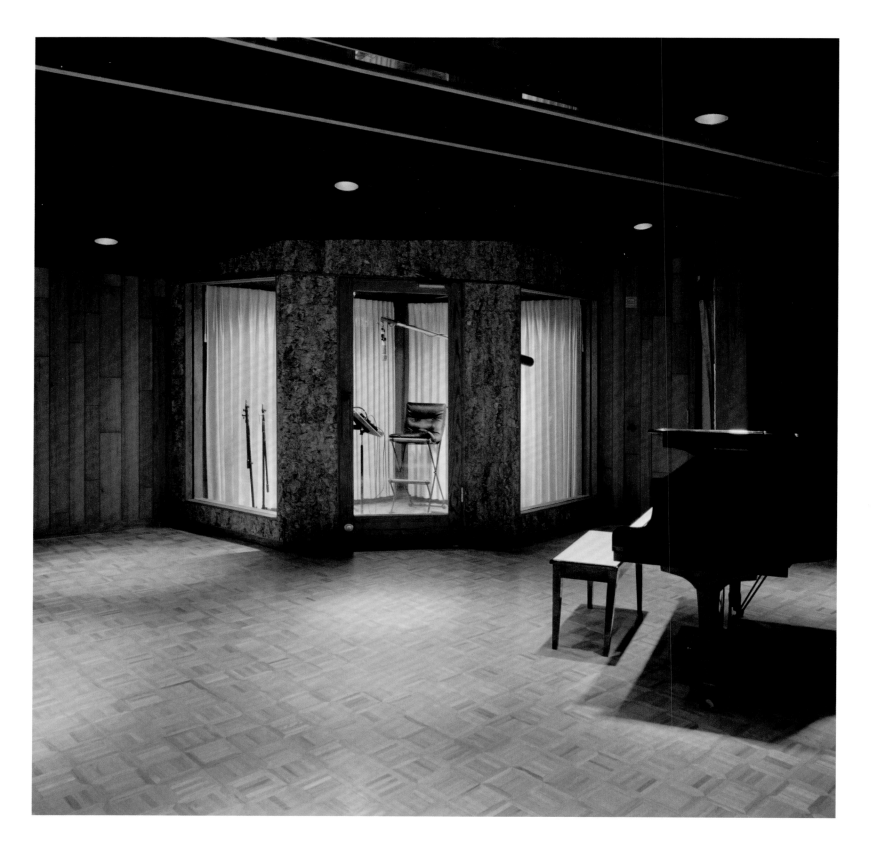

Westlake Recording Studios, Studio A, Los Angeles, CA — August 1, 2009

UPTOWN THEATER,
PHILADELPHIA, PA

An Art Deco movie palace topped with four stories of office space, the Uptown opened in 1929. In 1951, it became a significant stop on the Chitlin' Circuit, bringing the best African American entertainment to the theater. Local DJ Georgie Woods produced R&B shows from 1957 to 1972. The spectacular bills could feature as many as ten acts, from the top established Motown and Stax soul stars to emerging local Philadelphia talent. As teenagers, R&B record producers Kenny Gamble and Leon Huff came to the big shows and stayed for multiple performances through the day, often sneaking backstage to meet their music idols. Another pair of youngsters who were regulars at Woods' concerts were Daryl Hall and John Oates. As a college student, Hall entered a competitive amateur night contest at the Uptown, winning a prize and his first record deal. Earth, Wind, and Fire is one of the local groups that got a start playing at the Uptown. The neighborhood's decline in the 1970s led to the theater's closure in 1978. It briefly reopened as a church in the 1980s. Extensive damage over the years has required a restoration, which is ongoing.

NORTHSIDE TAVERN,
ATLANTA, GA

Built as a gas station and grocery in the 1940s, sometime in the 1960s it became a blue collar bar called Northside Package. Starting in 1992, the bar has featured blues and rock music seven nights a week.

HITSVILLE U.S.A.,
DETROIT, MI

This modest single-family house was purchased by Berry Gordy in 1959 as the first headquarters of Motown Records. The ground floor was converted to administrative offices and recording Studio A, and the second floor was Gordy's family living quarters. Within seven years, Motown occupied seven neighboring houses, with an organization employing 450 people and grossing $20 million dollars in revenue. Gordy's company was one of dozens of independent record labels to spring up in Detroit during the 1950s and '60s—none nearly as successful as Motown. Gordy had a knack for recognizing talent, a skill he made use of repeatedly, starting with Smokey Robinson and the Miracles. Later the Supremes, the Temptations, and Stevie Wonder were among the stars developed at Motown. He also had great instincts for teaming up songwriters and producers to get the best from them. And then there was the house band. Gordy assembled a unit of musicians, the Funk Brothers, who played an astounding string of hit records, rivaling any group of session players in either New York or Los Angeles.

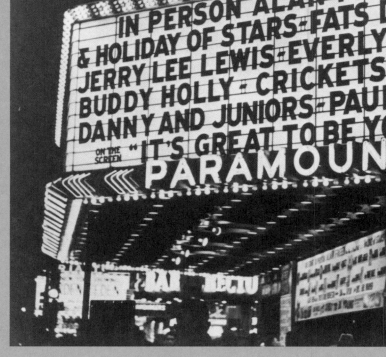

View of the marquee at the Paramount Theatre, Brooklyn, New York.

COLORED MUSICIANS CLUB,
BUFFALO, NY

When African Americans were denied membership to the Buffalo chapter of the American Federation of Musicians, they started their own organization, Musicians Local 533, in 1917. A year later, some members established a private social society, the Colored Musicians Club. For many years the club met at the Union Hall or Masonic Temple. In 1934, they found permanent residence in this former pool hall. The street level was used as a meeting hall, while the upstairs space was for rehearsing and performances. In 1964, the national musicians union leadership desegregated the remaining Locals. The Colored Musicians Club had separated from Local 533 years previous, and so they were able to preserve their social club. Over a century since its founding, the club continues to be a jazz venue. **(See Mutual Musicians Foundation, Kansas City, MO.)**

VICTORY GRILL,
AUSTIN, TX

The Victory Grill opened on Victory Over Japan Day (V–J Day) on September 2, 1945, marking the end of World War II and the beginning of a postwar boom. At the time, there were few entertainment venues for Black Austinites and soldiers on leave from nearby Fort Hood. The café thrived as a vibrant social hub for the African American community, and over the next fifteen years it became a valuable stop on the Chitlin' Circuit for traveling blues and R&B musicians. In its heyday, the Victory presented acts like B. B. King, Bobby "Blue" Bland, and the Grey Ghost (Roosevelt T. Williams.) As the

restrictions of segregation loosened in the 1960s, the need for exclusively African American venues somewhat lessened. The neighborhood's deterioration also contributed to lost business, leading to the Victory's nightclub closing in the mid-1970s, though the café remained open. Periodic fundraising through the 1980s led to a 1995 reopening of the Victory Grill as a music venue.

THE FILLMORE,
SAN FRANCISCO, CA

Built in 1912 as the Majestic Hall and Academy of Dancing, in 1936 it was renamed the Ambassador Dance Hall. From 1939 to 1952 it operated as a roller-skating rink. Around that time, the Fillmore was the San Francisco neighborhood with the largest concentration of African Americans. In 1954, an African American businessman, Charles Sullivan, bought the Ambassador, renamed it the Fillmore, and began putting on shows. In 1965, promoter Bill Graham started booking bands. In 1966, Andy Warhol staged his multimedia *Exploding Plastic Inevitable*—featuring the Velvet Underground and Nico—at the ballroom. Graham managed to retain their lighting engineer, Danny Williams, to design and build a new lighting rig for the Fillmore. This helped spark San Francisco's psychedelic rock scene, anchored by the music of the Grateful Dead, Quicksilver Messenger Service, Moby Grape, and Jefferson Airplane. For a time in the early 1980s, the Fillmore became a punk rock venue called the Elite Club, with performances by bands like Dead Kennedys, Black Flag, and Public Image Ltd. Structural concerns required a rehabilitation in the early 1990s. The Fillmore has since returned as a live music venue.

ROYAL THEATER,
PHILADELPHIA, PA

Called "America's Finest Colored Photoplay House" upon its opening in 1920, the Royal Theater quickly became a mainstay of arts and culture of African American Philadelphia. The exterior's neo-Georgian details contrasted with an Art Deco interior designed in 1925. In its 1920s and '30s heyday, the theater presented artists like Bessie Smith along with its film program. Fats Waller played the Wurlitzer theater organ for a summer in 1928. In 1931, tap dancing prodigies the Nicholas Brothers were featured. The Royal Theatre closed in 1970 and rapidly deteriorated.

EL CHAPULTEPEC,
DENVER, CO

The end of Prohibition saw the beginning of this long-lived Denver jazz venue, which opened its doors in 1933. In 1968, Jerry Krantz took over the business and started offering jazz nightly. The bar supported local players and became a popular stop for touring musicians. Count Basie, Doc Severinsen, Wynton Marsalis, and Branford Marsalis are among the many who have played here over the years.

GRUENE HALL,
NEW BRAUNFELS, TX

Built in 1878, this is the oldest Texan dance hall in continuous operation. Little has changed the look of the 6,000-square-foot hall, with its high-pitched tin roof and side flaps for open-air ventilation, a bar in the front, a small lighted stage in the back, and a huge outdoor garden. Since its

construction, the dance hall has been the social center of New Braunfels. In 1974, it was threatened by developers who had planned to build condominiums on the site. Gruene Hall was placed on the National Register of Historic Places in 1975. Its life as a live music venue enjoyed a revival as well, and since the 1970s it has presented top country acts too numerous to list: Merle Haggard, Dixie Chicks, and Willie Nelson, are among the superstars who have played here.

T.T. THE BEAR'S PLACE,
CAMBRIDGE, MA

From 1984 to 2015, T. T. the Bear's was a busy music venue in Central Square, Cambridge. The name honors the owners' pet hamster, Tough Teddy. The club was known for supporting local bands as well as providing an intimate venue for touring acts. The Pixies, the Mighty Mighty Bosstones, and the Magnetic Fields are some of the Boston acts that started here.

ROYAL PEACOCK,
ATLANTA, GA

Situated in the African American business and entertainment district known in the first half of the twentieth century as "Sweet Auburn Avenue," in 1937 this nightclub was called the Top Hat Club, and in 1949 it was renamed the Royal Peacock. African American businesswoman and former circus performer Carrie B. Cunningham owned the club, booking top Black entertainers for chiefly Black audiences. The exceptions were Wednesday and Saturday performances, which were reserved for white patrons. Little Richard met his idol, jump blues singer Billy Wright, backstage at the Peacock in 1951. Wright shared with Richard the name of his preferred stage makeup, Pancake 31. The 1950s and '60s saw the height of the club's popularity.

In the 1970s, urban decay took a toll on Sweet Auburn Avenue, and the Royal Peacock closed in 1973. There have been several attempts to revive the club. In 2010, the Royal Peacock opened as a reggae dance club.

BROOKLYN PARAMOUNT THEATRE (SITE),
BROOKLYN, NY

Paramount Pictures commissioned this rococo movie palace, which opened in downtown Brooklyn in 1928. In addition to a feature film, a stage show with an orchestra was the standard program of entertainment offered, and in the swing era all the top big bands had engagements here. Duke Ellington's group played in 1931, and jazz legends Count Basie, Charlie Parker, Dizzy Gillespie, and Ella Fitzgerald all played in the 1940s. In the mid-1950s, radio personality and promotor of rock and roll Alan Freed produced concerts featuring as many as fifteen acts. The lineup of these spectaculars defined the emergent genre of rock and roll as it was being created. Teenage fans of the new music were treated to R&B shouters like LaVern Baker and the honking tenor sax of Red Prysock; slick vocal harmony groups like the Penguins and the Del-Vikings; the rolling New Orleans piano of Fats Domino; and rock and roll innovators like Chuck Berry, Little Richard, and Buddy Holly.

WILSON HIGH SCHOOL, MUSIC ROOM,
TACOMA, WA

Music made in the Pacific Northwest has often had a singular character, most noticeably in the 1990s with grunge, but also in the 1960s when garage bands like the Wailers and the Sonics produced a hard-driving brand of rock and roll. Few bands could match the Sonics for volume and aggressive power. The band's genesis happened in this music room

Berry Gordy and Barbara McNair in a Motown recording studio, 1965.

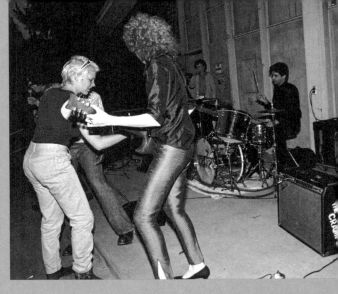

The Cramps playing an outdoor show on the steps of Napa State Hospital in California, 1978.

at Wilson High School, where Rob Lind discovered Gerry Roslie playing some Little Richard tunes on an old upright piano. Lind joined in on saxophone until the jam session drew the attention of the school's orchestra leader—not a rock and roll fan—who ejected them. Lind and Roslie formed a band called the Searchers with drummer Bob Bennett. The three were asked to join the Parypa brothers, Larry and Andy, to fill out their band called the Sonics. In 1964, they recorded their first single, "The Witch," on Etiquette Records. Their original material often had a dark, menacing edge unique for the time. Their powerful, distorted attack on songs like "Psycho" and "Strychnine" made the Sonics a precursor of punk bands like the MC5, the Stooges, the Dead Boys, and the Ramones.

CONWAY RECORDING STUDIOS, STUDIO A,
LOS ANGELES, CA

Started in the early 1970s as a record mastering studio, in 1976 Conway began to be a recording studio as well. Elton John, Stevie Wonder, Talking Heads, Avril Lavigne, and Blink 182 have recorded here. Conway's studio perimeter includes a tropical garden in a gated complex. This is a privacy feature designed to make it harder for paparazzi to photograph artists entering the facility—an attractive feature for publicity-shy musicians.

RIVERSIDE HOTEL,
CLARKSDALE, MS

In the segregated South, the Riverside provided vital service for African American travelers from the 1940s through the '60s. Countless touring musicians stopped here, notably Ike Turner in the mid-1940s. Reportedly he wrote the song that many consider the first rock and roll record, "Rocket 88," in what is now Room 7. Before it was the Riverside Hotel, this building was the G. T. Thomas Afro-American Hospital, Clarksdale's designated

hospital for Black patients. The hospital opened shortly before World War I and closed in 1940. On September 26, 1937, singer Bessie Smith, known as the Empress of the Blues, was in an automobile accident on Highway 61 outside Clarksdale. She was brought here, to the G. T. Thomas Hospital, where she died of her injuries.

GINNY'S LITTLE LONGHORN,
AUSTIN, TX

This Austin honky-tonk opened in 1963 as Dick's Little Longhorn. In 1982, when founder Dick Setliff died, leaving the business to longtime bartender Ginny Kalmbach, it became Ginny's Little Longhorn. Over many decades, it has been a cherished part of Austin's honky-tonk country music scene. Dale Watson got his start playing here regularly. In addition to live music, another attraction is a unique game of chance called Chicken Shit Bingo. This involves one of the chickens that roost outside behind the bar, an oversized Bingo card covered with a chicken wire hood, and the element of time. When Kalmbach retired in 2013, Dale Watson, Terry Gaona, and her husband, David Gaona took over the bar, ensuring its survival. (Watson has since sold his share.)

NAPA STATE HOSPITAL,
NAPA, CA

This facility was originally called Napa Insane Asylum, established in 1875. By the early 1890s, it had over 1,300 patients, more than double its intended capacity. The original main building, a Gothic-styled brick structure known as "the Castle," was razed after World War II. On June 13, 1978, the punk band the Cramps played a concert for Napa State inmates, supported by the Mutants, one of San Francisco's premier punk bands. A video of the show was released as *Live at Napa State Mental Hospital.*

PARADISE CLUB,
BOSTON, MA

The earliest tenant of this modest, single-story building was probably an auto dealer back when this strip of Commonwealth Avenue was known as "the Auto Mile." During the late 1960s, it was converted into a nightclub called the Together Garage, and in 1977 it became the Paradise Theater. Its location near the Boston University campus helps draw a large student audience. The intimate club is often the first stage many popular touring acts play in Boston. On their first U.S. tour in 1980, U2 played the Paradise to an audience of about 150.

SUNSET SOUND STUDIOS, STUDIO 1,
LOS ANGELES, CA

This recording complex was built by Walt Disney's Director of Recording, Tutti Camarata, in 1958 with the purchase of a former auto repair garage, and expanded to encompass several residential and commercial buildings. Audio for many Disney motion pictures was recorded in Studio 1 during the 1960s. The first popular music clients were Herb Alpert and A&M Records artists like Sérgio Mendes and Brasil '66. The Doors began recording in Studio 1 in 1966, working with engineer and producer Bruce Botnick, who also produced Love's album *Forever Changes* in this room. Van Halen recorded their first album, and Janis Joplin recorded *Pearl*, her last album, here.

CAIN'S BALLROOM,
TULSA, OK

This structure was built in 1924 as a garage for local politician W. Tate Brady. Madison W. "Daddy" Cain purchased the building in 1930, installed a sprung dance floor, and named it Cain's Dance Academy. In 1935, Bob Wills & His Texas Playboys broadcast a daily radio show from Cain's, making the dance hall the center of Western swing for the next decade. Bob's brother Johnnie Lee Wills's band took over duties as house band in 1942. Ernest Tubb, Hank Williams, Tex Ritter, Kay Starr, and Tennessee Ernie Ford were some of the important country acts to appear here. In January 1978, the Sex Pistols played Cain's, one of three Texas dance hall dates in their disastrous U.S. tour, which culminated in the band's break-up after their final concert in San Francisco. The band was greeted by a small group of Christian fundamentalists stationed across the street from the club, protesting the Pistols' appearance with a banner reading: "Life is Rotten without God's only begotten, Jesus." **(See Longhorn Ballroom, Dallas, TX; Randy's Rodeo, San Antonio, TX.)**

TIGER STADIUM,
DETROIT, MI

Previously called Navin Field, then Briggs Stadium, Tiger Stadium was the home of the Detroit Tigers baseball team from 1912 until the arena's 1999 closing. The stadium has been an infrequent music venue. In the 1990s, KISS, Rod Stewart, and the Eagles staged concerts. In 1968, after a summer of escalating protests against the Vietnam War, José Feliciano was asked to perform the "Star-Spangled Banner" at Tiger Stadium before Game Five of the World Series. His highly personal, melancholy reading of the national anthem was interpreted by some as disrespectful, and as a result of the controversy many radio stations refused to play Feliciano's songs. A recording was released as a single and peaked at #50 on pop charts.

CLUB PASSIM (CLUB 47),
CAMBRIDGE, MA

The blues and folk music venue Club 47 began in 1958 at a different location, and moved to the current address in 1963. Club 47 changed its name to Club Passim in 1969. In its earliest days it booked jazz and blues; it was one of the first Boston venues to book Delta blues musician Mississippi John Hurt and Gospel artist Reverend Gary Davis. Over time, it has become known for singer-songwriter, folk, and ethnic music. Joan Baez played here regularly on Tuesday nights as a teenage Boston College student. In the mid-1960s, the club had a role in promoting folk rock by booking acts with a non-traditional folk sound, like the Lovin' Spoonful.

ODD FELLOWS HALL,
MINNEAPOLIS, MN

This former home of an Independent Order of Odd Fellows fraternal organization was an occasional music venue in the early 1980s. Hüsker Dü played here several times. The four-story brick and stone building was built in 1909 for the Odd Fellows Flour City Lodge 118, which later moved to St. Paul. The third floor was a ballroom.

NAPOLEON BALLROOM,
MIAMI BEACH, FL

The Beatles made their first U.S. appearances in February, 1964. Following their performance on the *Ed Sullivan Show* on the 9th of that month, the Beatles played public concerts in Washington, D.C., and at Carnegie Hall in New York. On February 16, 1964, the Beatles flew to Miami Beach, where they made a second appearance on the *Sullivan* show, a remote broadcast live from the Napoleon Ballroom of the Deauville Beach Resort. The hotel was built in 1957 in the exuberant Miami modernist style representative of the era. **(See Ed Sullivan Theater, New York, NY; Washington Coliseum site, Washington, D.C.)**

VAN GELDER RECORDING STUDIO,
ENGLEWOOD CLIFFS, NJ

Record producer Rudy Van Gelder began using his parents' living room in Hackensack, New Jersey, as a recording studio in 1952. In 1959, he built a new studio in Englewood Cliffs, designed by David Henken, a student of Frank Lloyd Wright. With a circular plan and 39-foot ceiling with exposed wood beams, the studio presents the aspect of a chapel. Often working alone, Van Gelder engineered thousands of recordings of jazz musicians that were released on several record labels, including Blue Note, Prestige, Pacific Jazz, Bethlehem, and Savoy. John Coltrane frequently recorded here, including his most famous album, *A Love Supreme*. Sonny Rollins and Hank Mobley are two of the many exceptional musicians who recorded extensively at the studio. Other classic albums include Herbie Hancock's *Empyrean Isles*, Jimmy Smith's *Home Cookin'*, *Page One* by tenor saxophonist Joe Henderson, and Horace Silver's *Song for My Father*. Van Gelder left the studio to his longtime assistant, Maureen Sickler, upon his death in 2016.

ARDENT STUDIOS, STUDIO C,
MEMPHIS, TN

Initially Ardent was built in founder John Fry's parents' garage. In 1966, the studio moved to a storefront on National Street, and in 1971 to its present Madison Avenue location. From its early days, Ardent Studios fostered relationships with Stax recording artists like Isaac Hayes; Sam and Dave; the Staple Singers; and Booker T. and the M.G.'s. Young producers like Jim Dickinson learned their trade here while contributing their own ideas to the studio sound that drew more artists to Ardent. Spanning the decades, bands like Led Zeppelin, R.E.M., ZZ Top, the Replacements, and the White Stripes sought out the studio. Big Star, a band whose influence on musicians overshadows their record sales, did all their major recording at Ardent. Jody Stephens, a founding member of Big Star, joined the staff of Ardent Studios in 1987 and is currently Vice President of Production.

ASBURY PARK CONVENTION HALL,
ASBURY PARK, NJ

Construction of this multi-purpose exhibition space began in 1928, and it has hosted hundreds of conventions, trade shows, and sporting events. Rock and roll shows have been a staple for the hall since the 1950s. In 1956, fights at a Frankie Lymon and the Teenagers show spurred calls in the local newspapers to ban rock and roll. Through the 1960s and into the next century, major touring groups, from the Beach Boys to Black Sabbath, had shows here. Led Zeppelin played Convention Hall on the night they had been offered, but declined to play at the Woodstock Music Festival. Beginning in the 1990s, Bruce Springsteen used the hall to rehearse his band for upcoming tours.

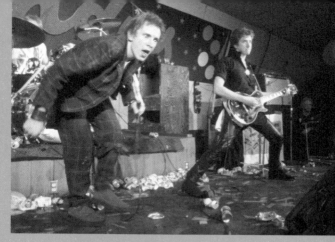

TWILITE ROOM (SITE),
DALLAS, TX

Opened in 1983, this club was the focus of the underground Dallas punk rock scene for three intense years. As a part of the nationwide network of clubs that kept independent bands alive, the Twilite Room booked local and touring hardcore, punk, and alternative bands like Black Flag, Hüsker Dü, the Minutemen, and Meat Puppets. In 1985, the Twilite Room changed the name of its music room to Charlie's Liberty Hall, then the Circle A Ranch, and for a few months in 1986, under new management, the club was the (Ob)Scene. On June 29, 1986, the Twilite Room's final show was Sonic Youth.

RIVIERA CLUB (SITE),
ST. LOUIS, MO

Destroyed by fire in 1970, this was the site of the Riviera, one of St. Louis's most popular nightclubs for African Americans. Starting in the early 1940s, the Riviera Club booked the best Black entertainment. Singer and bandleader Billy Eckstine built a remarkable big band in 1944 including the acme of modern jazz talent, among them three of the architects of bebop: trumpeter Dizzy Gillespie, alto saxophonist Charlie Parker,

and drummer Art Blakey. In July of that year, the Eckstine organization played the Riviera, and an eighteen-year-old Miles Davis was in the audience. When the band's third trumpeter was too ill to perform, Davis was invited to fill in and stayed through the rest of the two-week engagement. Playing with this extraordinary collection of musicians steeled Davis's resolve to move to New York, launching his lifelong career as a musical innovator. The Riviera's owner Jordan W. Chambers was a politician, stretching as far back as the 1920s, and used the club as his political headquarters. In 1936, Chambers became the first Black Committeeman in St. Louis and spent decades as a powerful local Democratic kingmaker. In 1962, upon Chambers's death, the club was purchased by an African American fraternal society and renamed the Riviera Civic Center.

ADAMS LOUNGE,
MACON, GA

Opened in 1947 and named for proprietress Sally Adams, this was a stop on the collection of nightclubs and theaters for African American entertainers and audiences known as the Chitlin' Circuit. In its 1950s and '60s heyday, the showroom

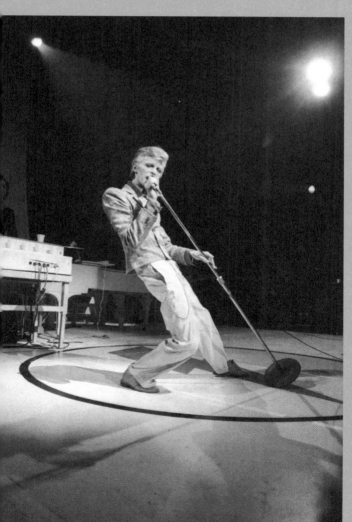

David Bowie performing at Radio City Music Hall in New York, 1974.

hosted regular performances of artists based in Macon, like James Brown and Little Richard, as well as touring R&B acts. Otis Redding, B. B. King, and Greg Allman have appeared here as well. For many years the club was managed by George Jackson Adams, Jr., the first African American sheriff of Jones County, Georgia.

FOLSOM STATE PRISON,
REPRESA, CA

California's second oldest prison, Folsom, dates from 1880. Although it is now a medium-security facility, it was one of the first maximum-security institutions in the United States, notorious for its harsh conditions. Johnny Cash was born poor in rural Arkansas and spent his life acutely sensitive to the plight of society's outsiders. He was inspired to write Folsom Prison Blues in 1953 after seeing the movie *Inside the Walls of Folsom Prison* while serving in the United States Air Force. He recorded his live concert for the inmates on January 13, 1968. Released as *At Folsom Prison*, it became a #1 hit on the country music charts in 1968 and went gold six months later. **(See San Quentin State Prison, San Quentin, CA.)**

RADIO CITY MUSIC HALL,
NEW YORK, NY

Part of the RCA Radio City complex, this elegant Art Deco theater was completed in December 1932. In addition to presenting first-run films, the giant stage produced hundreds of theatrical spectaculars, often featuring the theater's own dance troupe of chorus girls, the Rockettes. In the 1980s, Liberace set a box office record over a fourteen-show run. Radio City has hosted the Grammy Awards broadcast six times. Music at Radio City has ranged from Janet Jackson, Whitney Houston, and Cyndi Lauper to Mott the Hoople, David Bowie, and Devo. In 1985, Madonna played three dates from her Virgin Tour, with the Beastie Boys opening. In 1992, the jazz balladeer Little Jimmy Scott opened for Lou Reed. Heavy metal band Anthrax opened for hip-hop's Public Enemy in 1991. **(See NBC Studio 8-H, *Saturday Night Live*, New York, NY.)**

The Sex Pistols onstage at Randy's Rodeo in San Antonio, Texas, 1978.

RANDY'S RODEO,
SAN ANTONIO, TX

In the late 1950s, this building housed a bowling alley called Bandera Bowling. By the 1970s, it was well established as a quintessential Texas dance hall, complete with two-stepping cowboys and honky-tonk music. This made it an ideal stop for the Sex Pistols on their calamitous U.S. tour, at least for their manager Malcolm McLaren, whose goal was unending confrontation and conflict as a means of generating publicity. When the Sex Pistols took the stage at Randy's Rodeo on January 8, 1978, it was clear that a good portion of the crowd had paid their entrance fee just to express their negative opinion of punk rock in principle, and the band in particular. The show ended with Sid Vicious swinging his solid body Fender bass guitar at an audience member's head. Fortunately for both of them, he missed. **(See Cain's Ballroom, Tulsa, OK; Longhorn Ballroom, Dallas, TX.)**

508 PARK AVENUE,
DALLAS, TX

Only a dozen 78-rpm records—twenty-four sides—of Robert Johnson's music had been released when he died at age twenty-seven. These masterpieces of blues, labeled "race" records for the African American market, seemed destined for obscurity until reissues in the 1960s brought Johnson's music to a new, younger audience. His guitar playing, in particular, typically dumbfounded white rock musicians at first exposure. When Brian Jones of the Rolling Stones shared an album of Johnson recordings with his bandmates, Keith Richards was convinced he was listening to two guitarists. This Art Deco office building was built in 1929 as the Warner Brothers Film Exchange. Brunswick Records was one of the businesses with offices here. In 1937, Brunswick Records producer Don Law set up a makeshift studio in a storage area on the third floor to record local Texas talent, including Western swing pioneers Bob Wills and Al Dexter. Robert Johnson made his last two recording sessions here on June 19 and 20. **(See One "Crossroads," Clarksdale, MS; Dockery Plantation, Cleveland, MS.)**

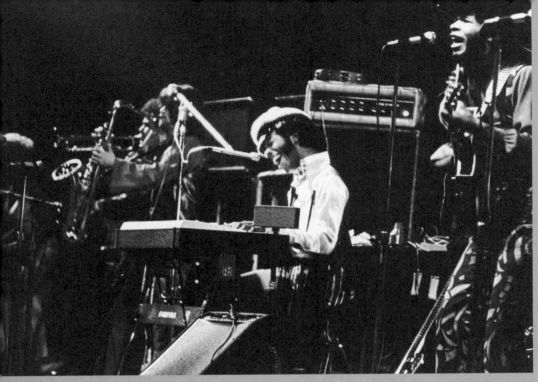

Sly and the Family Stone performing at the Fillmore in San Francisco, June 2, 1969.

SOUTH PLAINS FAIR PARK COLISEUM,
LUBBOCK, TX

This arena was constructed in 1954 on the South Plains Fairgrounds, which was the site of Lubbock's Panhandle-South Plains Fair since 1914. Elvis Presley played here five times in his career's early days. On two of these occasions, in 1955, Lubbock High School student Buddy Holly opened the show with his school friend and songwriting partner Bob Montgomery, billed as Buddy and Bob. The duo were also on the bill later that year when Bill Haley & His Comets played a concert at the Fair Park. The Coliseum has continued to be a concert venue.

SUMNER HIGH SCHOOL, AUDITORIUM,
ST. LOUIS, MO

Established in 1875, Sumner High School, also known as Charles H. Sumner High School, was the first high school for African American students west of the Mississippi River in the United States. Chuck Berry, the architect of rock and roll and poet of 1950s teenage culture, attended Sumner High. At a student talent show in 1944, Berry performed Jay McShann's song "Confessin' the Blues," scandalizing the faculty but earning applause from his classmates. Other alumni with notable musical careers include singer Tina Turner; Billy Davis Jr. and Ronald Townson from the 5th Dimension; and jazz trumpeter Lester Bowie. Comedian and activist Dick Gregory also graduated from Sumner.

STOVALL PLANTATION,
CLARKSDALE, MS

Muddy Waters lived most of his first thirty years on Stovall Plantation, a few miles outside Clarksdale, Mississippi. Prior to his move to Chicago in 1943, as a young man he entertained field hands at his house, which served as a juke joint. He also played at social functions for the Stovalls, as did the Mississippi Sheiks, a popular Black string band that Waters admired. On a field recording expedition in August 1941 sponsored by the Library of Congress and Fisk University, Alan Lomax and John Work set up portable equipment in Waters's house to document him and other local musicians, including fiddler Henry "Son" Sims. Lomax returned to make more recordings in 1942. Stovall was a cotton plantation on land originally purchased from Choctaw Indians around 1830, and built by William J. Oldham. **(See Chess Records site, Chicago, IL.)**

THE FORUM,
INGLEWOOD, CA

Inspired by the Roman Coliseum, this circular multipurpose arena was built in 1967. Sixty-foot-tall arches frame the exterior's red walls. The interior has no supporting columns to obstruct the view from the 17,000 seats. It was home of the Los Angeles Lakers basketball team and the Los Angeles Kings hockey team. It has hosted big musical events, among them the Rolling Stones on their 1969, 1972, and 1975 world tours. Led Zeppelin performed here sixteen times in the 1970s. Tracks recorded at shows KISS played here in 1977 were released on their *Alive II* album. Other top arena acts of the 1970s included Queen, Bruce Springsteen, and Alice Cooper.

DAISY THEATRE,
MEMPHIS, TN

Built in 1913, the Daisy is a beautiful example of movie theater architecture from the industry's early years. A grand entrance with a crimson red half dome and gilt decoration leads to a small stage and just six hundred seats. During the twentieth century, Beale Street served as the business and entertainment center for African Americans in the mid-South and the Daisy's stage was a prime venue on the Chitlin' Circuit from the 1930s into the '60s. In the 1980s, the theater was extensively renovated and repurposed as the Beale Street Blues Museum. **(See New Daisy Theatre, Memphis, TN.)**

NEW DAISY THEATRE,
MEMPHIS, TN

In 1942, the New Daisy Theatre opened across Beale Street from the original Daisy Theatre. For the first several decades the theater was primarily a movie house, with the occasional live performance. After a period of neglect, the theater saw a revival as a venue for blues and rock concerts in 1980s. Bluesmen Clarence "Gatemouth" Brown, John Lee Hooker, and Stevie Ray Vaughan; rock acts like Alex Chilton, Jerry Lee Lewis, and the Cramps; and soul artists Al Green, Sam and Dave, and Rufus Thomas have all played here. **(See Daisy Theatre, Memphis, TN.)**

MAVERICK'S FLAT,
LOS ANGELES, CA

Maverick's Flat opened in 1966 with an appearance by the Temptations. The music venue became a hub for arts, culture, and community activism for the African American community in the South Los Angeles neighborhood of Leimert Park. With acts including Marvin Gaye; Parliament-Funkadelic; Earth, Wind & Fire; the Commodores; and Ike and Tina Turner, it quickly earned the nickname "Apollo of the West." The club was an important stage for the socially relevant poetry and jazz of the Watts Prophets. Formed in 1967, the Prophets (like their East Coast contemporaries the Last Poets) mixed radical politics, spoken-word, and jazz and funk in performances that were a precursor of hip-hop. In the early 1970s, dance contests became a proving ground for new street dance forms called "popping and locking" that would become famous with the growth of hip-hop culture. Don Cornelius's influential television dance party program, *Soul Train*, scouted talent at these amateur contests.

LITTLE THEATER,
HIBBING, MN

Inside the Hibbing Memorial Arena, a multi-use sports arena operated by the city of Hibbing, is a small 260-seat venue called the Little Theater. Bob Dylan played here as a teenager. In his autobiography *Chronicles: Volume 1*, Dylan recounts that while playing here as a member of a local band, the pro wrestling star Gorgeous George made eye contact and winked at him. Dylan interpreted this as an affirmation from a major star and welcome encouragement at a time when he was first contemplating a music career. The much larger Memorial Arena was the preferred venue for touring acts passing through Hibbing. Dylan recalls in *Chronicles* seeing performances by Hank Snow, Slim Whitman, and Webb Pierce. **(See Hibbing High School, Auditorium, Hibbing, MN.)**

HOT KLUB (SITE),
DALLAS, TX

Though it existed for a short time (1980–83) the Hot Klub is remembered as an important venue for punk, new wave, and reggae music in Dallas. This was a time when the support for underground music relied entirely on small music venues and independent record labels. Places like the Hot Klub were a vital platform for local musicians to try out ideas that were of no commercial interest to the mainstream corporate entertainment business. Dozens of Dallas-based bands formed around the Hot Klub scene, a few of which are compiled on the 1983 release, Live at the Hot Klub, from the Dallas independent label VVV Records.

LOS ANGELES MEMORIAL COLISEUM
LOS ANGELES, CA

This multi-use sports stadium in Los Angeles' Exposition Park was built in 1923. It hosted Summer Olympic events

in 1932 and 1984 and served as the home of the University of Southern California's football team. In the era of stadium rock concerts, Bruce Springsteen, U2, Mötley Crüe, and Guns N' Roses are among the many acts that have played here. On August 20, 1972, the Coliseum was the venue for Wattstax, a concert benefiting the African American community of Watts in South Central Los Angeles. The concert was organized by Stax Records and showcased many of the label's biggest stars, such as the Staples Singers, the Bar-Kays, Carla Thomas, and Isaac Hayes. In an effort to preserve the grass for a football game the next day the crowd was restricted to the stands. However, this plan broke down temporarily during Rufus Thomas's set when he sang "Do the Funky Chicken," and hundreds stormed the field. The concert was delayed as the field was cleared. The show, which became known as "the Black Woodstock," was recorded and released as a double album on Stax. A film of the concert, titled *Wattstax*, won a Golden Globe for Best Documentary the following year.

CAFE WHA?,
NEW YORK, NY

At the corner of MacDougal Street and Minetta Lane in Greenwich Village, Cafe Wha? was founded in 1959 at the peak of the fascination with all things "beatnik." The club is important for having presented numerous musicians and comedians early in their careers, including Bob Dylan; Peter, Paul and Mary; Woody Allen, Lenny Bruce; Joan Rivers; Bill Cosby; and Richard Pryor. The Velvet

Underground played Cafe Wha? in 1965 for tips before their first paid show later that year. In 1966, Jimi Hendrix played here regularly, leading a band he called Jimmy James and the Blue Flames.

THE MIDDLE EAST,
CAMBRIDGE, MA

Originally a Lebanese restaurant opened in 1970, the space expanded over the years to encompass five adjacent dining and music venues. In the 1980s, what is now called Middle East Upstairs began booking jazz, blues, and rock shows. In 1993, a dedicated music venue, Middle East Downstairs, was created in what had been a basement bowling alley. The club plays no favorites in terms of genre: rock, blues, funk, or hip-hop, are all represented.

THE WARFIELD,
SAN FRANCISCO, CA

The Warfield was originally built as a vaudeville and movie palace and became a concert hall in 1979, when promoter Bill Graham booked a two-week run by Bob Dylan. The theater opened as the Loews Warfield in 1922, and in that decade presented performers like Louis Armstrong, Al Jolson, and Charlie Chaplin on its stage. After spending the intervening years primarily as a movie house, beginning in the 1980s it was a full-time music venue, hosting everyone from Van Morrison to Joan Jett, Tom Waits, and the Ramones, and British punk and new wave acts like the Clash, the Jam, and the Boomtown Rats.

BAKER'S KEYBOARD LOUNGE,
DETROIT, MI

Baker's Keyboard Lounge originally opened as a sandwich shop in 1933, and the addition of live music the following year set it on its path to become Detroit's premier intimate venue for jazz. Through the years performers have spanned the history of the art form—from Louis Armstrong, Fats Waller, and Art Tatum to the hard bop masters Miles Davis, Barry Harris, and Donald Byrd, to top musicians the present day. A discerning, appreciative audience is the standard for Baker's.

WALLY'S CAFE JAZZ CLUB,
BOSTON, MA

The oldest jazz club in Boston, Wally's opened in 1947 at 428 Massachusetts Avenue. In 1979, the club moved to its current location directly across the street. The nightclub's founder, Joseph Walcott, was born in Barbados and immigrated to the U.S. in 1910. He was the first African American nightclub owner in New England. A long-running attraction has been a Sunday jam session, which draws students in the jazz program at the nearby New England Conservatory of Music. Wally's culture of supporting jazz education and young musicians dates to the 1960s.

WESTLAKE RECORDING STUDIOS, STUDIO A,
LOS ANGELES, CA

Comprising seven studio spaces in two locations, the Westlake Recording Studios complex was founded in the early 1970s. Studios A and B were the first constructed and used extensively by producer Giorgio Moroder to record many of Donna Summer's hit singles. Studio A was also a favorite of Michael Jackson, who worked with producer Quincy Jones on much of his *Off the Wall* and *Thriller* albums here. Van Halen and Alanis Morissette have also produced successful albums in Studio A. **(See Westlake Recording Studios, Studio D, Los Angeles, CA.)**

The Clash performing at the Warfield in San Francisco, 1980.

The Staples Singers performing at Los Angeles Memorial Coliseum, 1972.

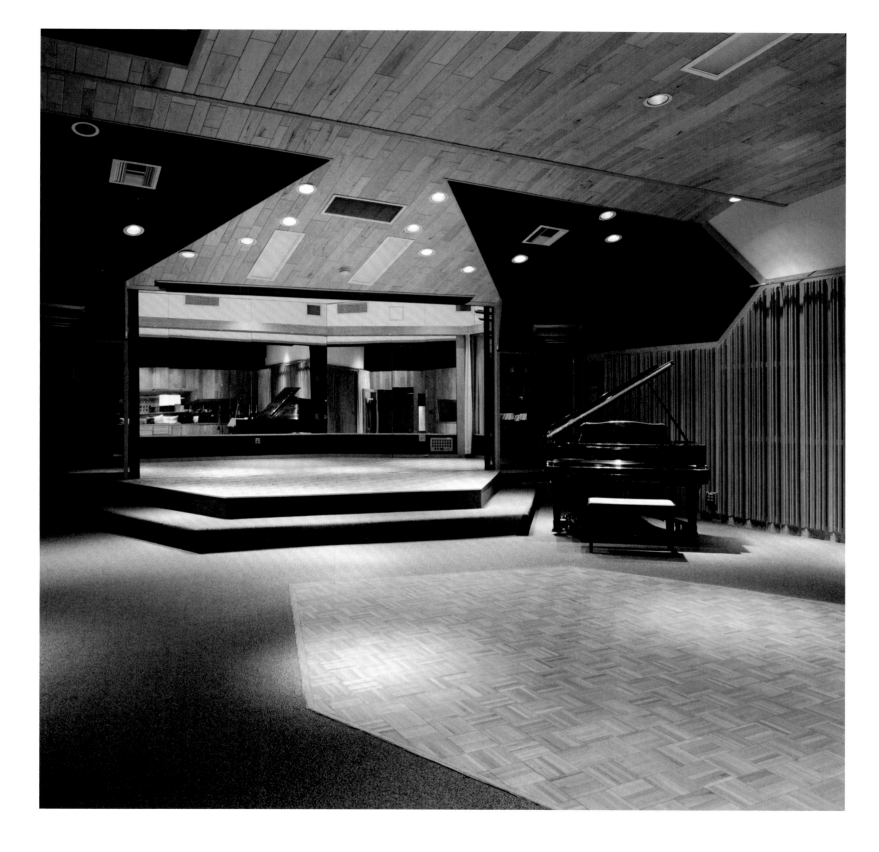

Westlake Recording Studios, Studio D, Los Angeles, CA — August 5, 2009

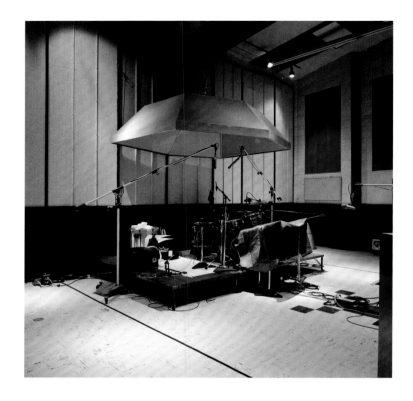

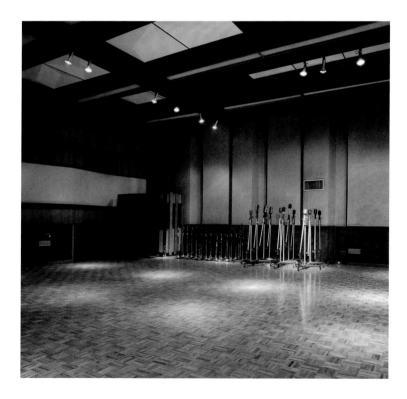

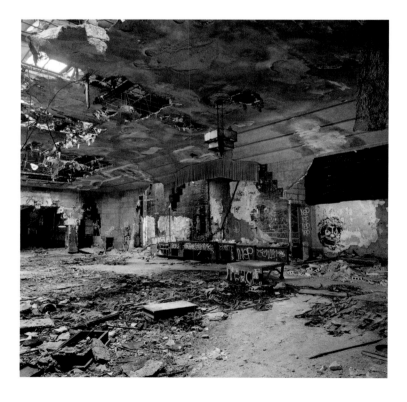

Festival Field (site), Newport, RI — April 9, 2014
United Western Recording, Studio A, Los Angeles, CA — August 10, 2009
United Western Recording, Studio A, Los Angeles, CA — August 5, 2009
Vanity Ballroom, Detroit, MI — December 6, 2016

170

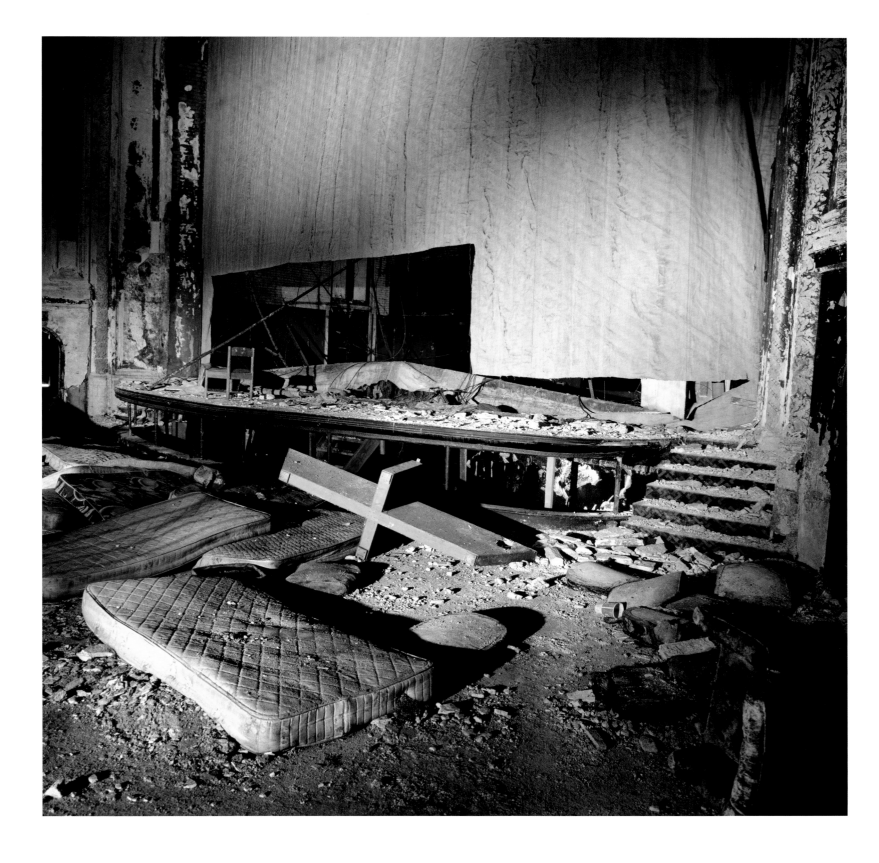

Eastown Theatre, Detroit, MI — October 31, 2008

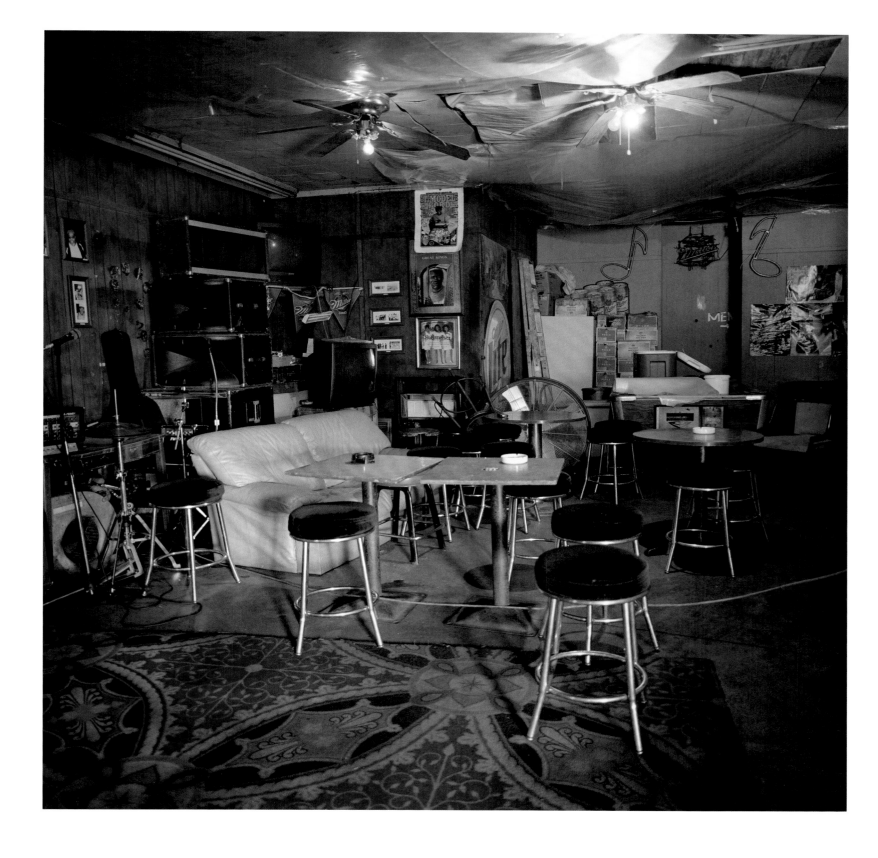

Red's Lounge, Clarksdale, MS — May 10, 2008

Tuxedo Junction, Upstairs, Belcher-Nixon Building, Birmingham, AL — January 19, 2010

Tuxedo Junction, Downstairs, Belcher-Nixon Building, Birmingham, AL — January 19, 2010

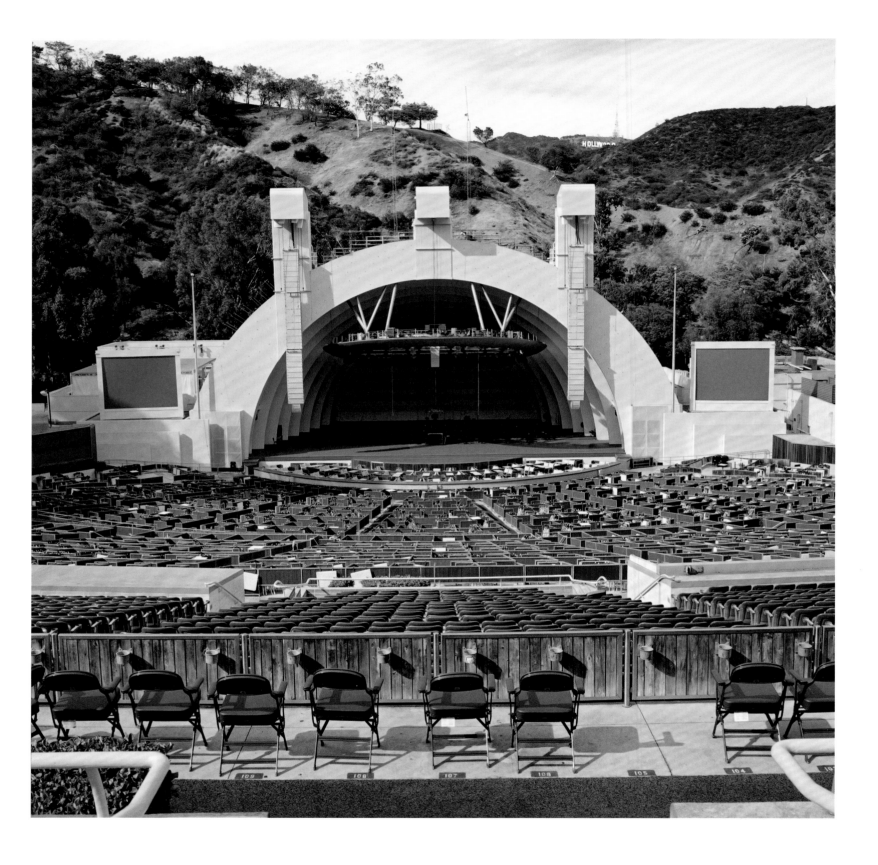

Hollywood Bowl, Los Angeles, CA — August 3, 2009

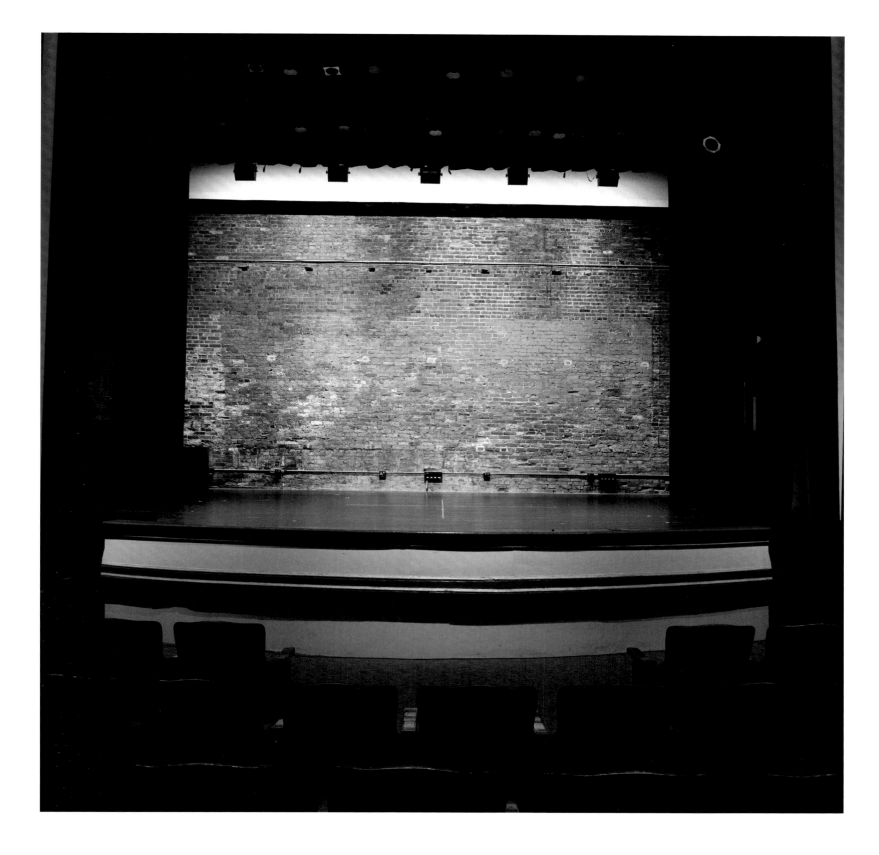

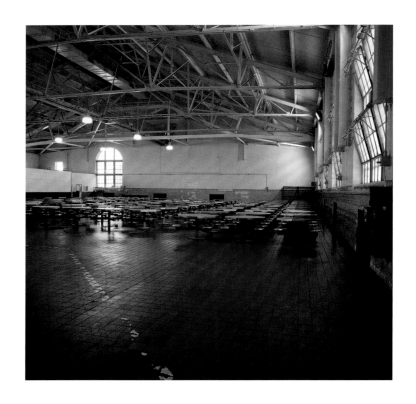
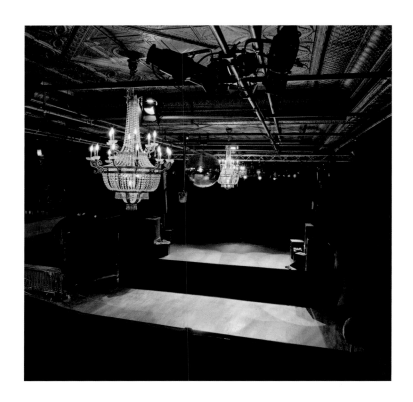
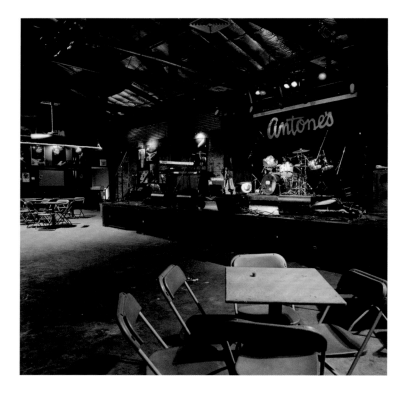
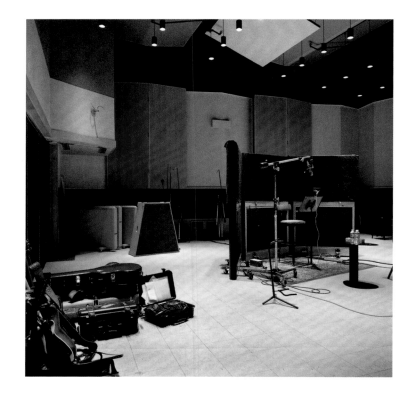

San Quentin State Prison, San Quentin, CA — November 10, 2015
Irving Plaza, New York, NY — March 8, 2016
Antone's Nightclub, Austin, TX — June 3, 2009
Capitol Studios, Studio B, Los Angeles, CA — July 28, 2015

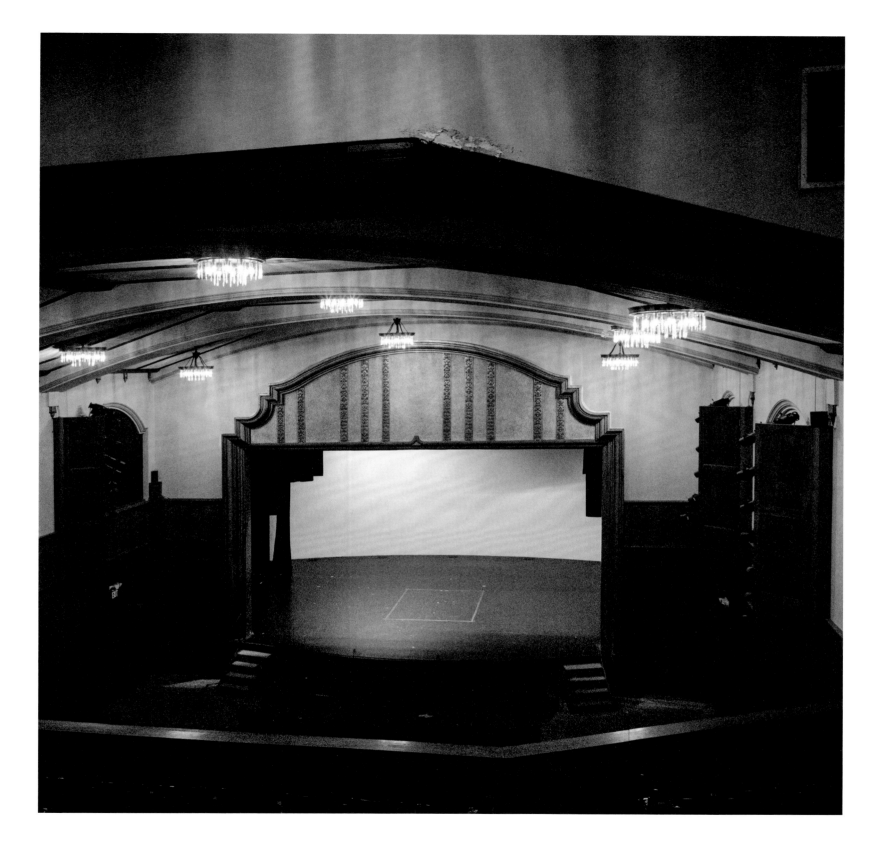

Lydia Mendelssohn Theatre, Ann Arbor, MI — April 22, 2015

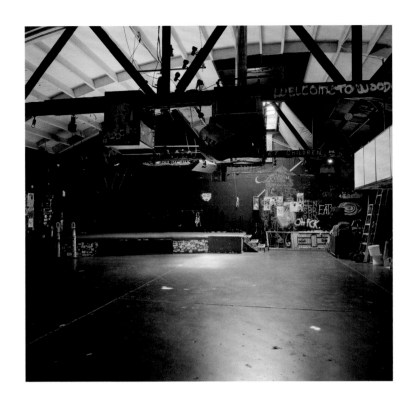

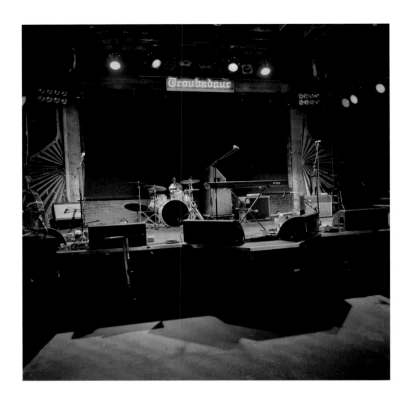

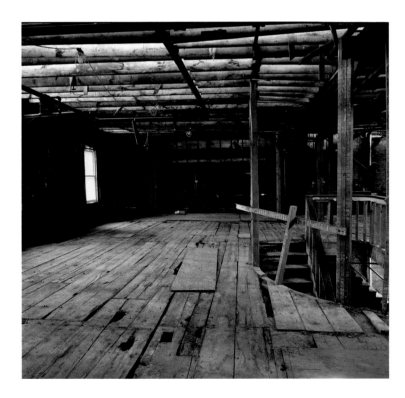

924 Gilman Street, Berkeley, CA — August 26, 2015
The Troubadour, West Hollywood, CA — August 4, 2009
The Western Front, Cambridge, MA — August 12, 2014
Dinner Key Auditorium (site), Coconut Grove, Miami, FL — February 24, 2015

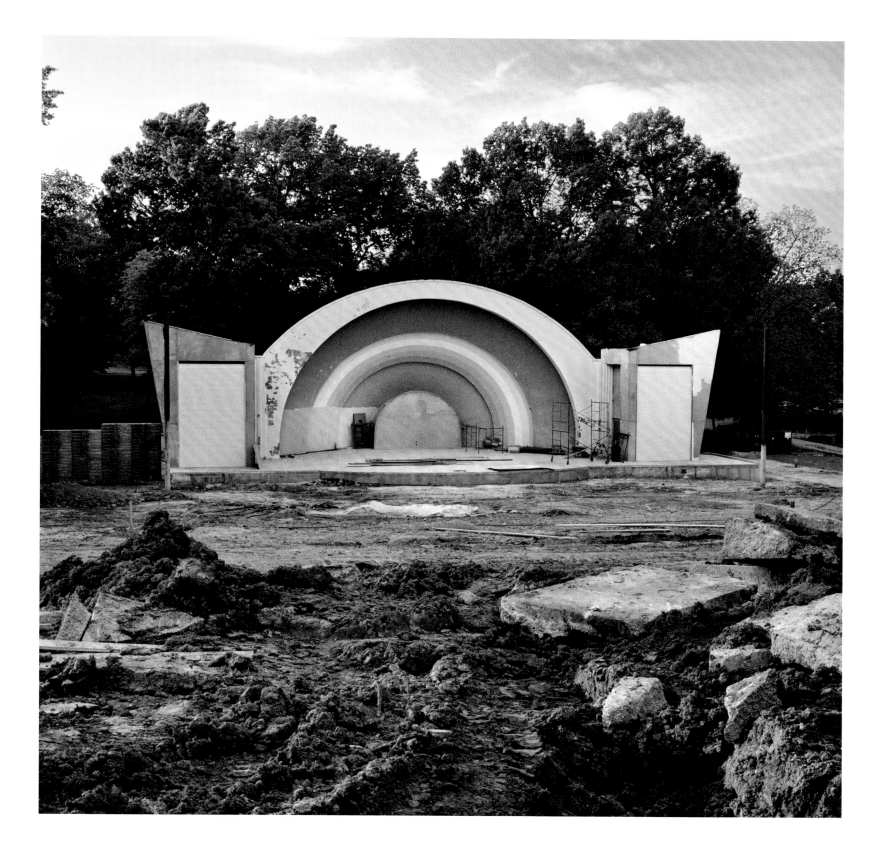

Overton Park Shell, Memphis, TN — May 5, 2008

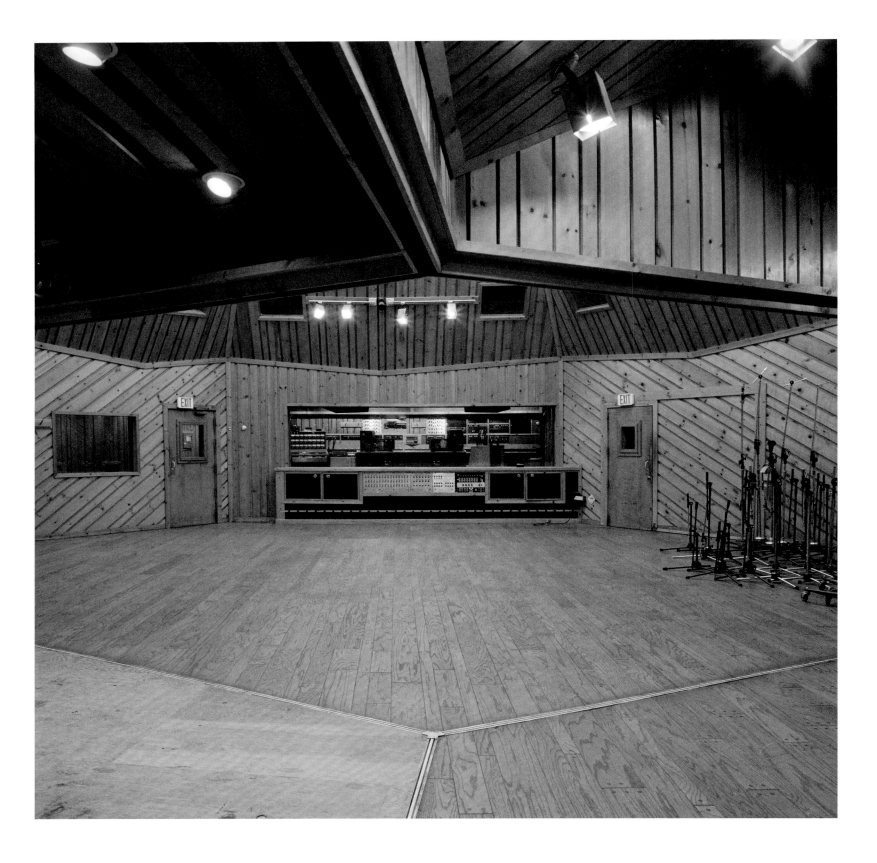

Power Station, New York, NY — November 27, 2017

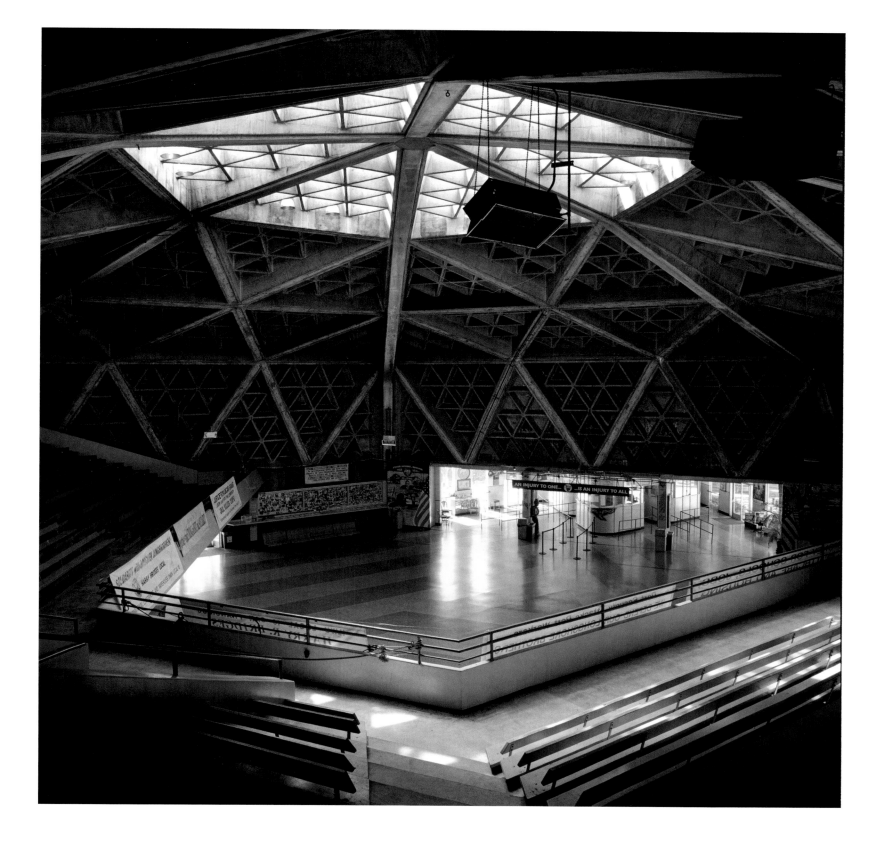

Longshoremen's Hall, San Francisco, CA — August 27, 2015

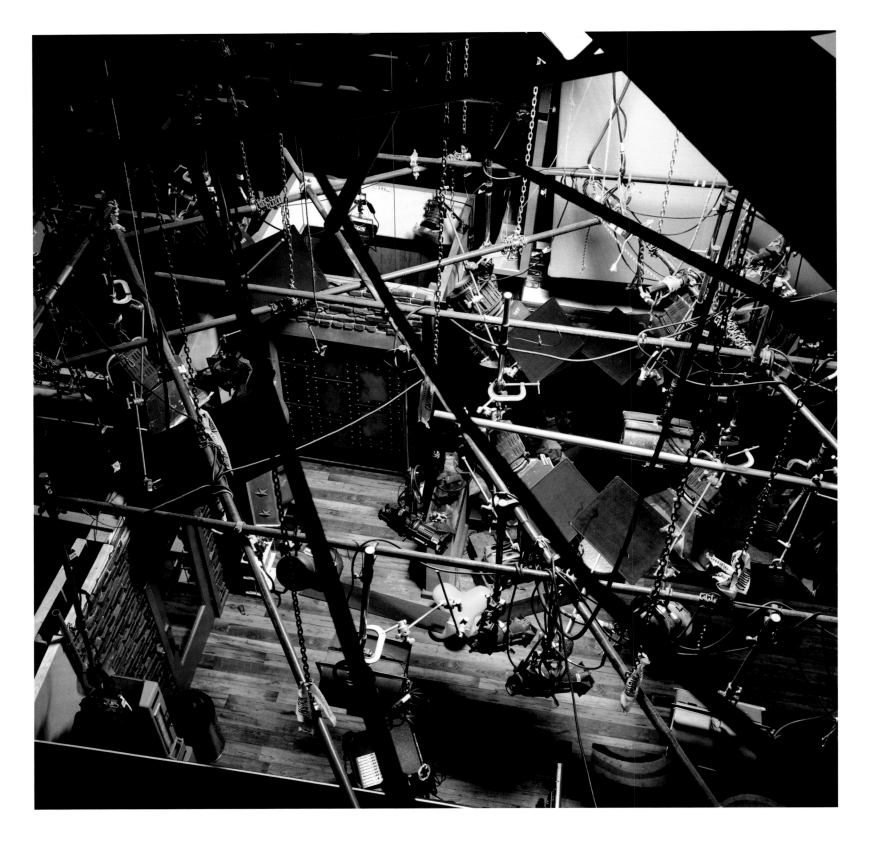

Earl Carroll Theatre, Los Angeles, CA — July 31, 2009

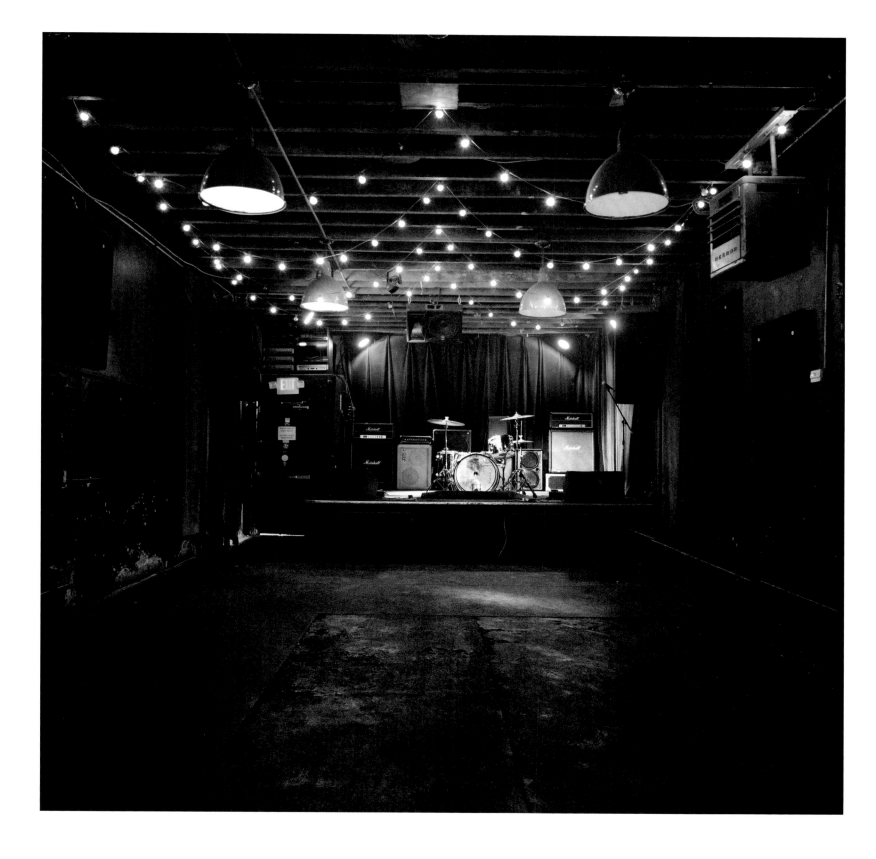

Caledonia Lounge, Athens, GA — June 22, 2015

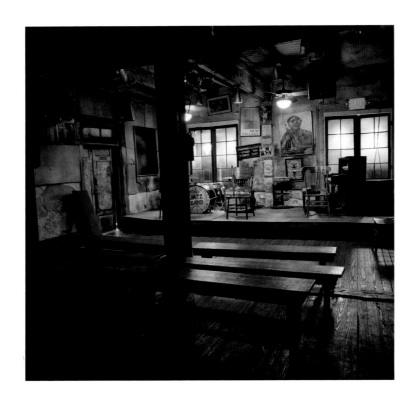

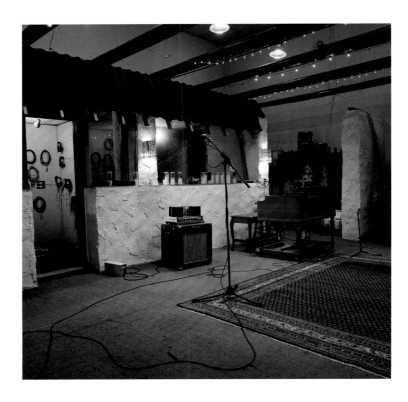

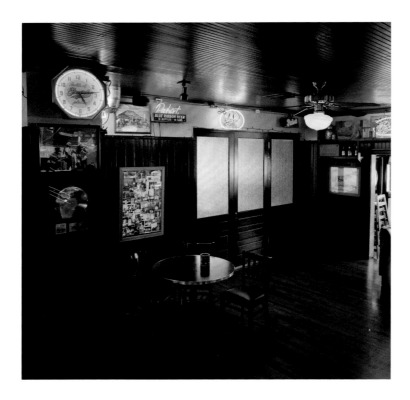

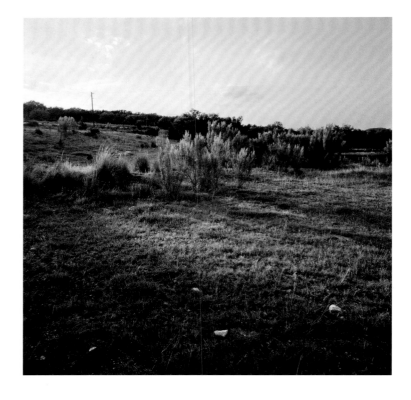

Preservation Hall, New Orleans, LA — May 13, 2008
SugarHill Recording Studios, Houston, TX — January 17, 2013
Threadgill's, Austin, TX — June 2, 2009
Dripping Springs Ranch, Dripping Springs, TX — June 1, 2009

186

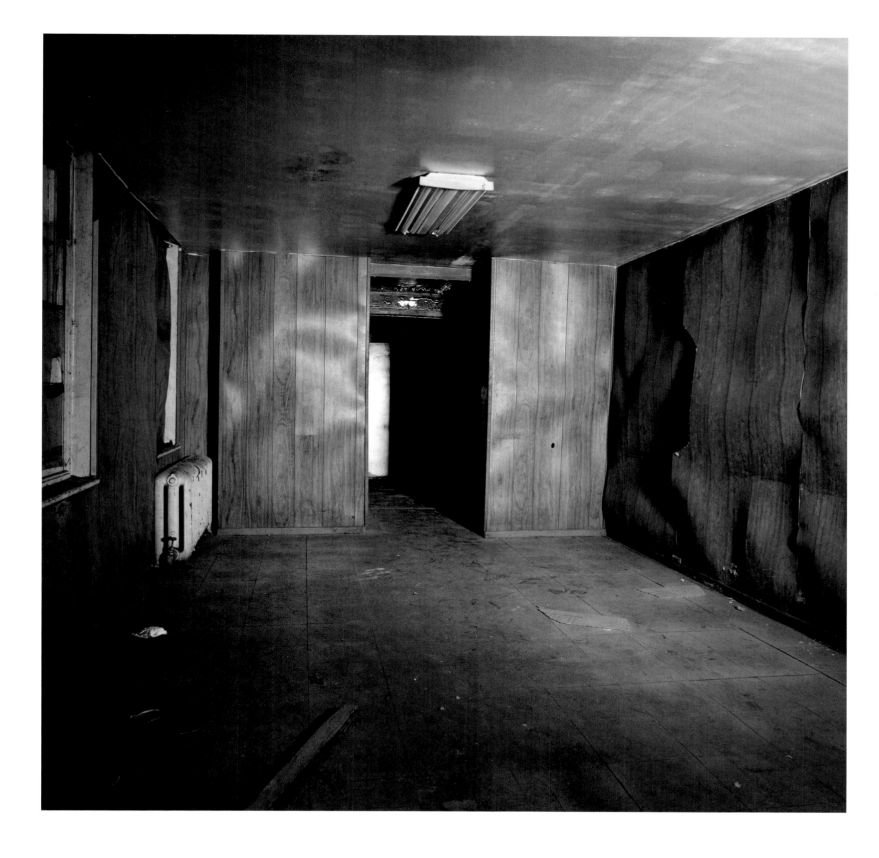

Second Fret (site), Philadelphia, PA — September 16, 2013

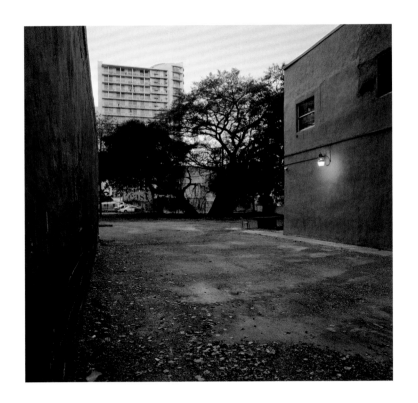

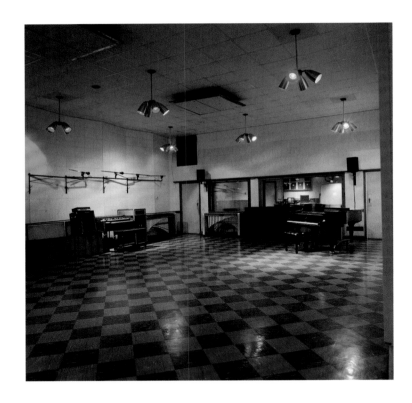

Tobacco Road (site), Miami, FL — February 23, 2015
Historic® RCA Studio B, Nashville, TN — January 19, 2010
Marble Bar (site), Baltimore, MD — August 13, 2013
Forest Hills Stadium, Queens, NY — April 2, 2014

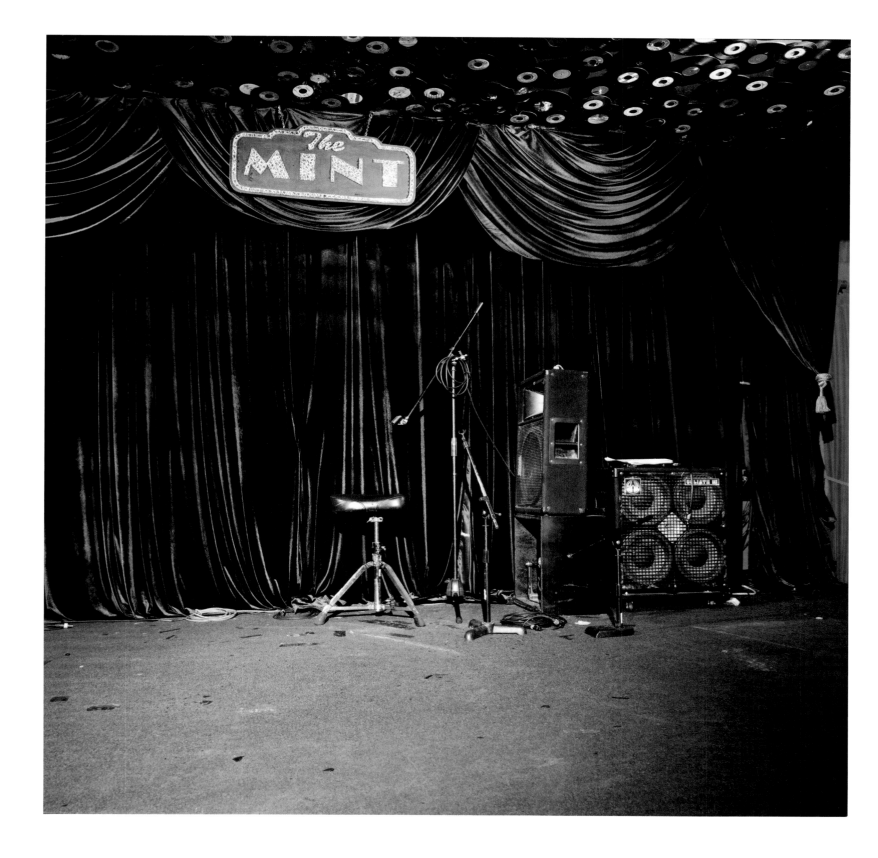

The Mint Bar, Los Angeles, CA — August 4, 2009

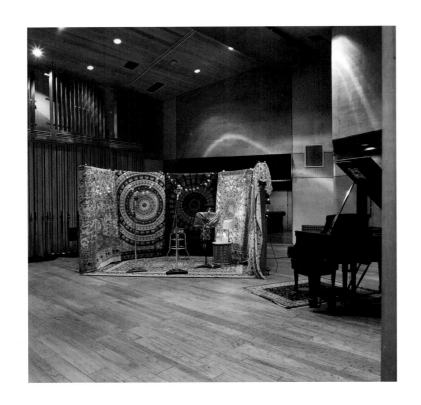

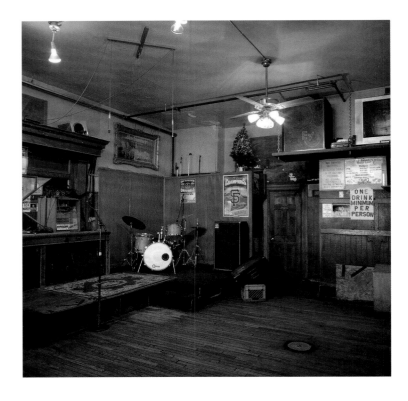

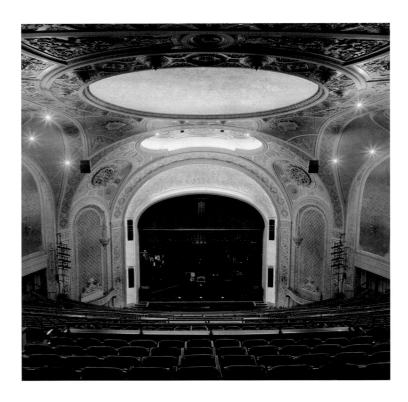

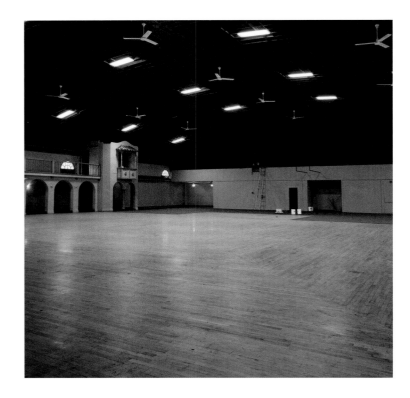

A&M Studios, Los Angeles, CA — August 1, 2015
The Saloon, San Francisco, CA — November 12, 2015
Paramount Theatre, Seattle, WA — November 18, 2015
El Torreon Ballroom, Kansas City, MO — January 15, 2010

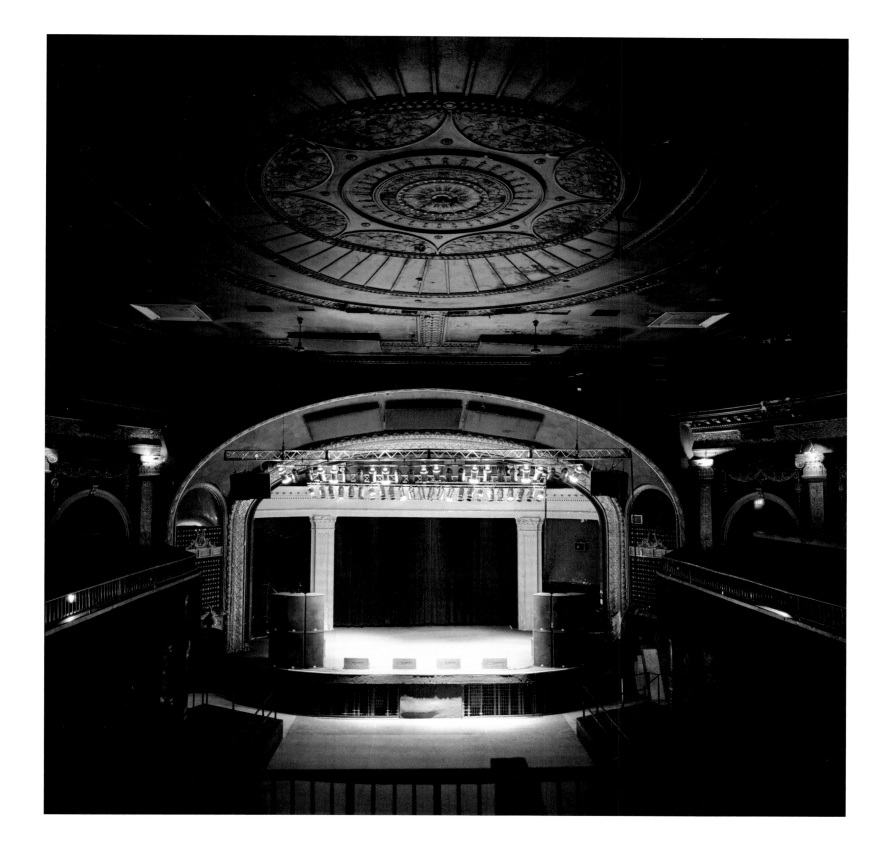

Newport Music Hall, Columbus, OH — September 16, 2008

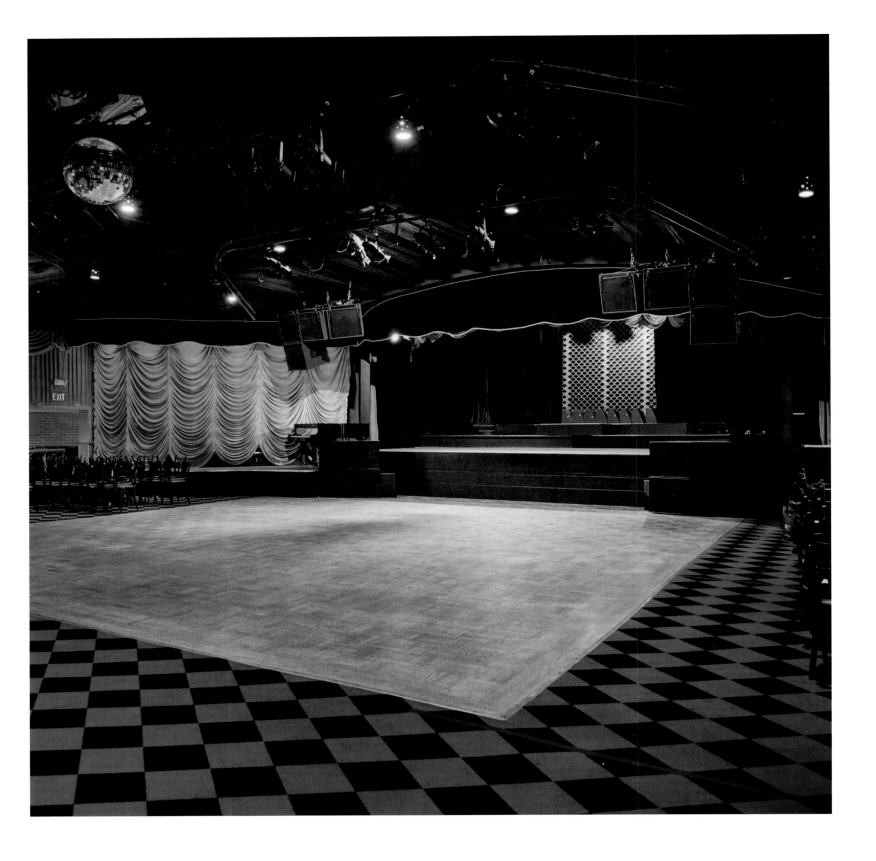

Bimbo's 365 Club, San Francisco, CA — November 12, 2015

American Bandstand (site), Philadelphia, PA — April 1, 2008

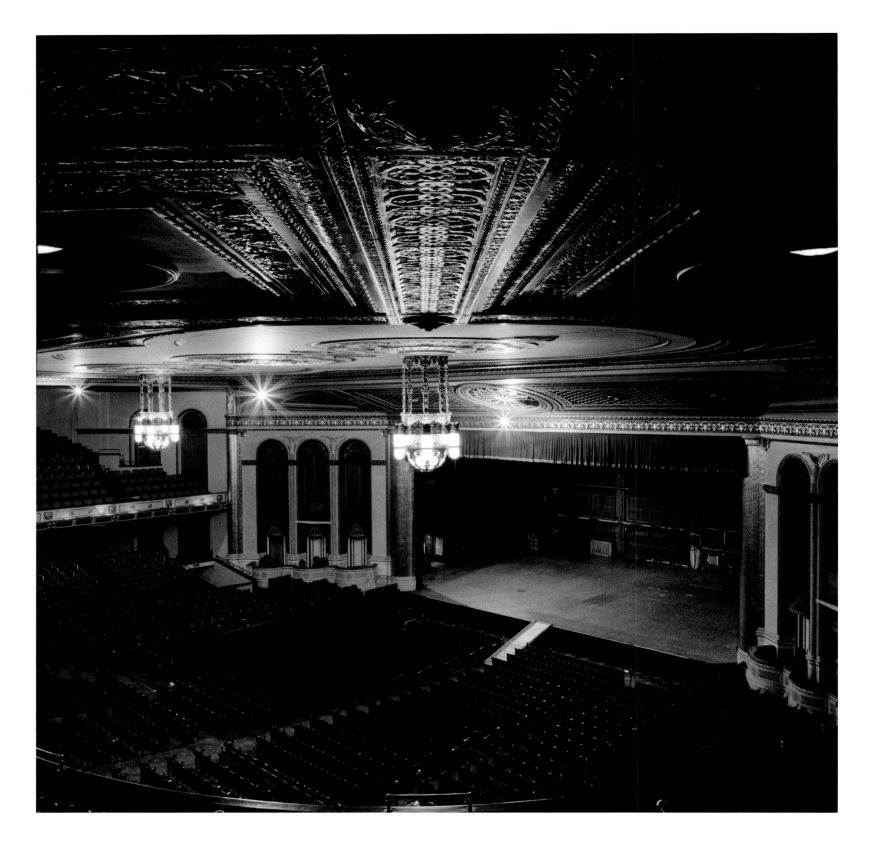

Masonic Temple, Detroit, MI — October 28, 2008

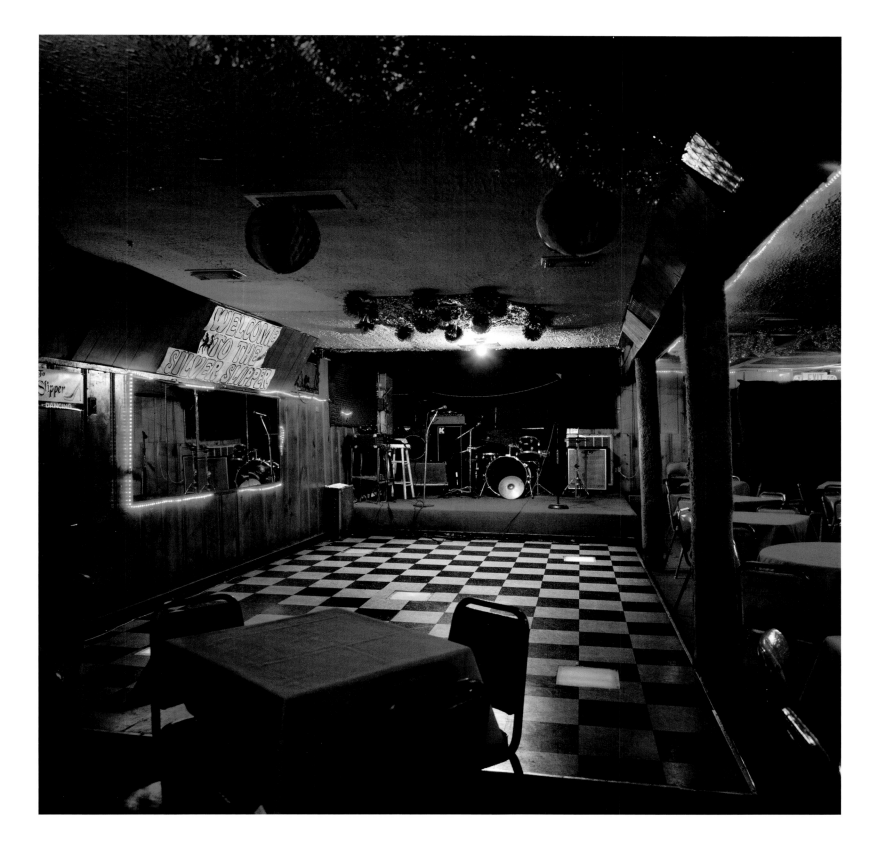

Silver Slipper, Houston, TX — January 18, 2013

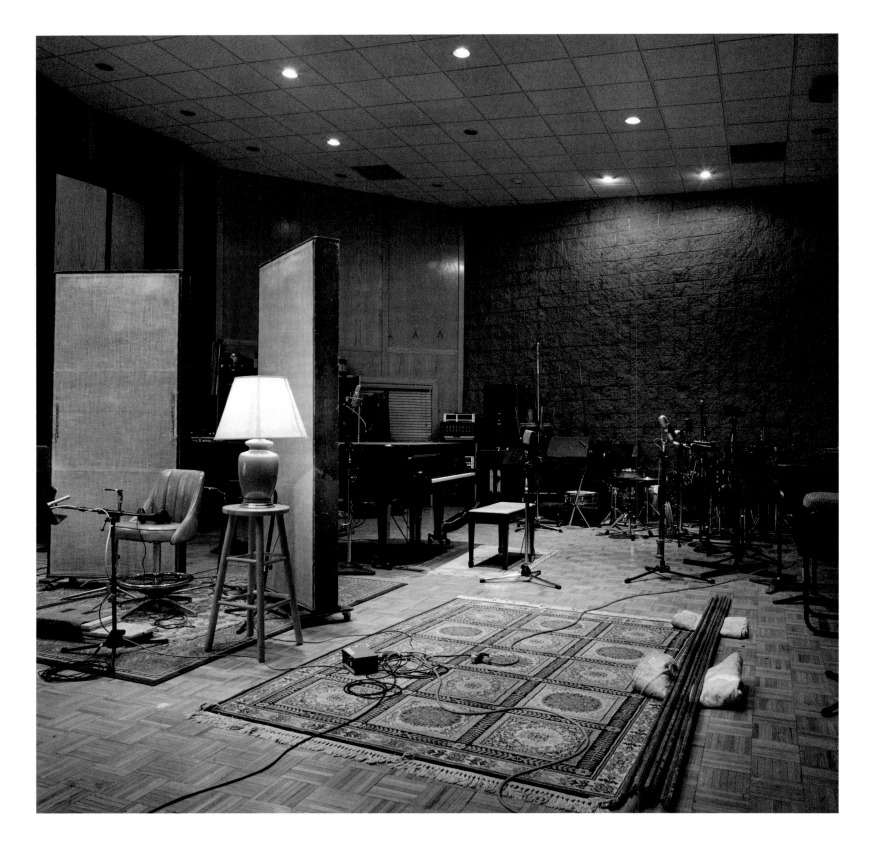

Kay Bank Studios (site), Minneapolis, MN — November 15, 2013

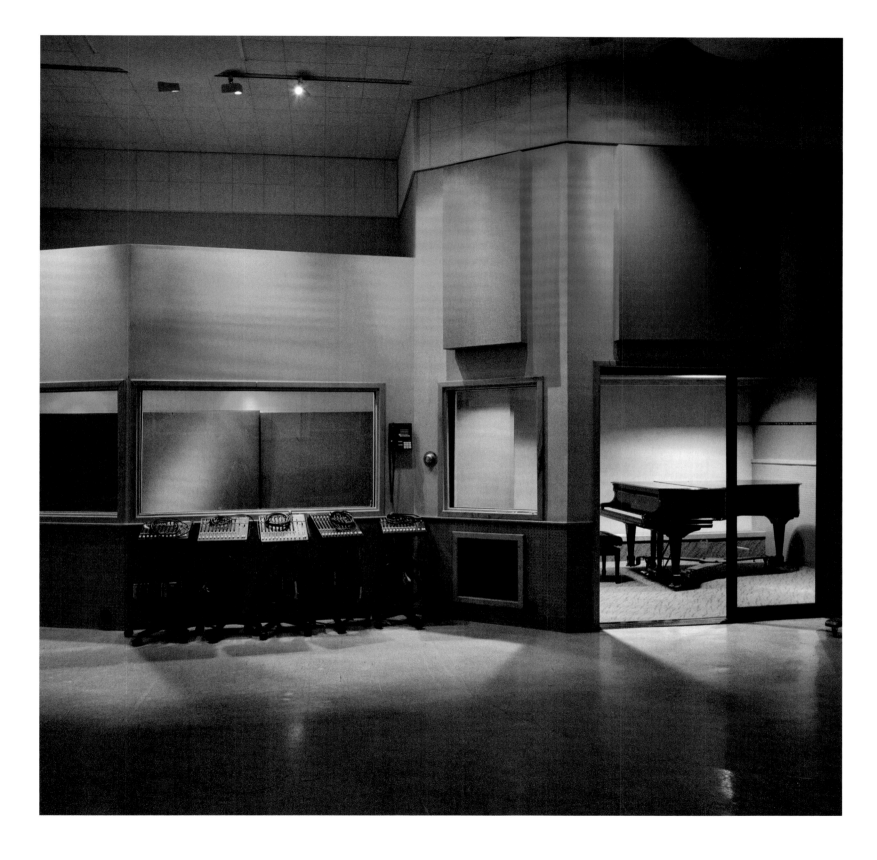

Sunset Sound Studios, Studio 2, Los Angeles, CA — August 5, 2009

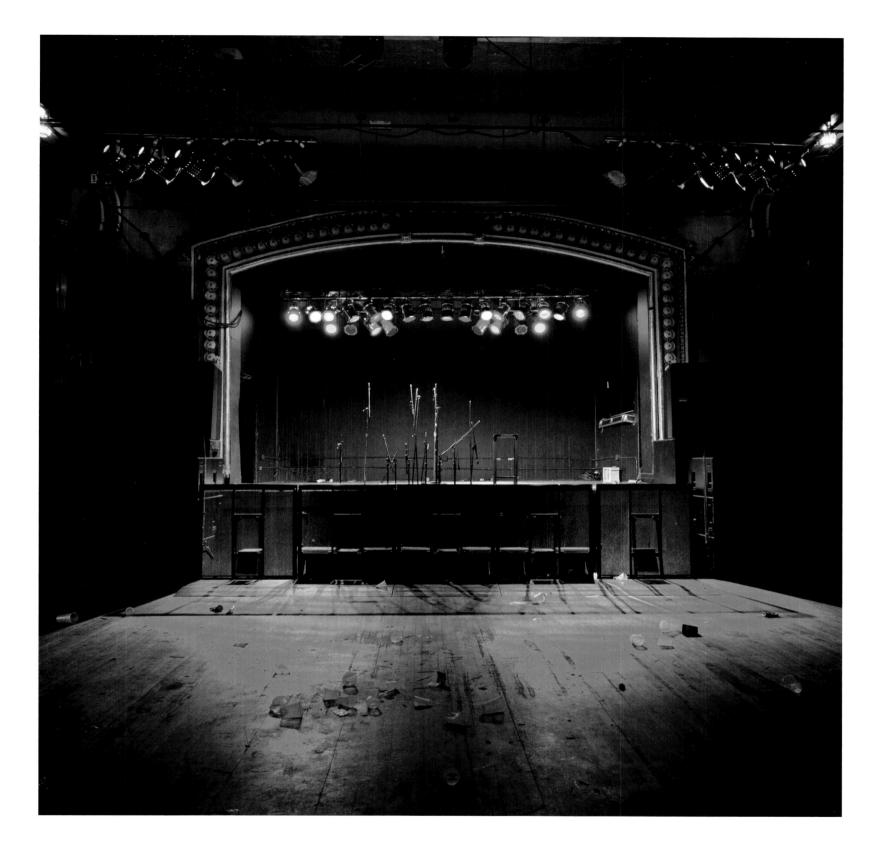

Saint Andrew's Hall, Detroit, MI — October 28, 2008

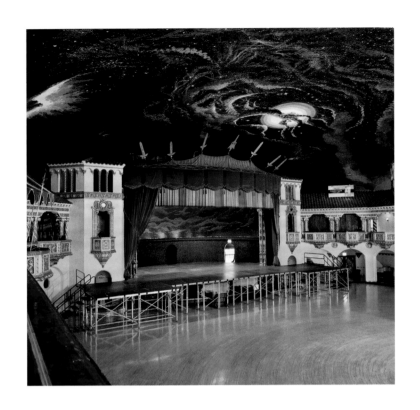

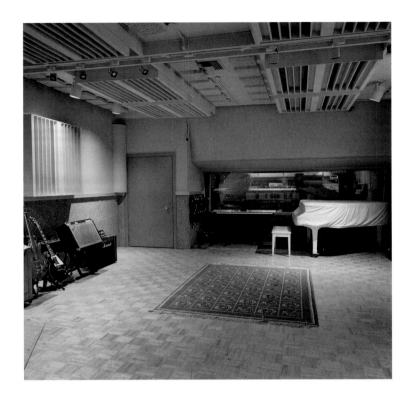

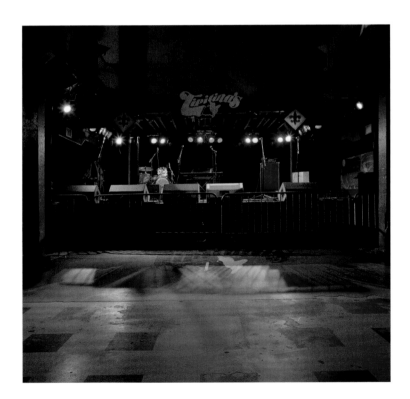

Aragon Ballroom, Chicago, IL — September 19, 2008
Hyde Street Studios, Studio A, San Francisco, CA — August 27, 2015
Tipitina's, New Orleans, LA — May 13, 2008
Congo Square, New Orleans, LA — March 15, 2016

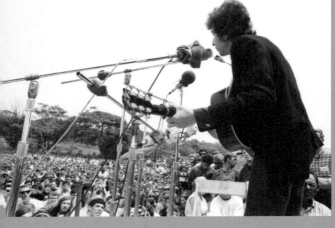

WESTLAKE RECORDING STUDIOS, STUDIO D,
LOS ANGELES, CA

The Westlake Recording Studios complex was founded in the early 1970s. After the massive success of Michael Jackson's *Thriller* produced by Quincy Jones at Westlake in 1982, the studio built Studios C and D. This is where Jones recorded Michael Jackson's *Bad* and *Dangerous* albums. **(See Westlake Recording Studios, Studio A, Los Angeles, CA.)**

FESTIVAL FIELD (SITE),
NEWPORT, RI

This field was the location for the Newport Jazz and Folk festivals from 1965 through 1971. In 1959, producer George Wein founded the Newport Folk Festival to exploit the growing popularity of the folk music revival. Both the jazz and the folk festivals were first held in Freebody Park, and in 1965 both events moved to the larger Festival Field. In that year folk fans witnessed the controversial "Dylan goes electric" set. At that time, Bob Dylan was a beloved songwriter and performer in the folk scene, and had appeared at Newport in previous years as a solo act, accompanying himself on acoustic guitar and harmonica. For this performance Dylan chose to lead a band with electric instruments, including white Chicago blues guitarist Mike Bloomfield. This offended some of the folk revival purists in the audience, garnering boos and criticism. Dylan's new sound would delight legions of rock and roll fans, who had no vested interest in traditional folk music, and make him one of the most popular acts in entertainment. **(See Freebody Park, Newport, RI.)**

UNITED WESTERN RECORDING, STUDIO A,
LOS ANGELES, CA

This suite of recording studios was built in 1958 as United Recording Corp. In 1961, the facility merged with Western Recorders to form United Western Recorders. The first project cut at United Western was Ricky Nelson's 1958 hit "Poor Little Fool." Frank Sinatra recorded many hits on his Reprise label in United Studio A, and the offices of his label, Reprise Records, were upstairs from the studio. Sinatra's daughter Nancy cut her 1965 smash hit "These Boots Are Made For Walkin'" in Studio B. Ray Charles also used Studio B to record his groundbreaking country-soul album *Modern Sounds in Country and Western Music*. For about three decades starting in the late 1980s, the studio operated as a part of Ocean Way, a complex of recording studios in Los Angeles, Nashville, and St. Barths. **(See United Western Recorders, Studio 3, Los Angeles, CA.)**

VANITY BALLROOM,
DETROIT, MI

This ballroom, designed in an Art Deco style with an Aztec motif, was completed in 1929. The second story featured a stage and a sprung dance floor surrounded by a balcony promenade. From the 1930s through the '50s, the Vanity presented the top swing era bands: Cab Calloway, Benny Goodman, and Duke Ellington, among others. In 1958, when big dance bands ceased to be financially viable, the ballroom closed. In 1964, the ballroom reopened once a week for dancing. Occasional rock concerts were also booked, with shows by bands such as the Velvet Underground, the MC5, and the Stooges, but this revival was temporary and didn't last past 1971. Two short-lived efforts in 1980 and 1983 to resurrect the Vanity also failed. **(See Grande Ballroom, Detroit, MI; Eastown Theatre, Detroit, MI.)**

EASTOWN THEATRE,
DETROIT, MI

Built as a movie palace in 1931, the Eastown was designed in a Renaissance revival style blending Spanish and Italian baroque elements. It was converted to a rock music venue in 1967. Standout concerts included the Faces, Muddy Waters, Alice Cooper, and Steppenwolf. Detroit rock and roll revolutionaries the MC5 played several shows here, with Iggy and the Stooges opening. The venue was forced to close in 1971 because of numerous permit violations and complaints of drug dealing on the premises. The Eastown struggled through a string of closings and brief re-openings through the 1970s. In the 1990s a series of rave dance parties were held, and eventually the space was taken over by a church. The building suffered extensive fire damage in 2010, and was razed in 2015. **(See Vanity Ballroom, Detroit, MI; Grande Ballroom, Detroit, MI)**

RED'S LOUNGE,
CLARKSDALE, MS

This single-story red brick building built in 1917 housed the LaVene Music Center for many years in the mid-twentieth century. The store was a source of records and instruments for African American musicians in Clarksdale. Ike Turner was a customer in the 1950s. Since the 1990s, this has been Red's Lounge that owner Red Paden describes as "just an ole juke house." Delta musicians like Sam Carr and T-Model Ford performed here. In front of Red's is a Mississippi Blues Trail historical marker honoring Clarksdale bluesman "Big" Jack Johnson, who played here regularly.

TUXEDO JUNCTION, UPSTAIRS, BELCHER-NIXON BUILDING,
BIRMINGHAM, AL

Built in 1922, this building once held the offices of Andrew Belcher, an African American dentist. Dentist and civil rights activist John Nixon took over Belcher's practice in 1951, working at the building until his 1988 retirement. From about 1930, the upstairs housed the ballroom and meeting hall of an African American fraternal society, the American Woodmen, and was the site of frequent dances. The location, at the corner of Ensley Avenue and Twentieth Street, was an intersection of two streetcar lines and the center of Black Birmingham's social life, with nightclubs and dance halls in abundance. The locals called this vibrant intersection Tuxedo Junction after Tuxedo Park, a popular area for African Americans located a few blocks away. Trumpet player and bandleader Erskine Hawkins grew up playing at the dance pavilion in Tuxedo Park, in local nightclubs, and at functions in the Woodmen's hall. In 1939, Hawkins wrote a tune called "Tuxedo Junction" that became a hit and big band standard, covered numerous times in the swing era. **(See Tuxedo Junction, Downstairs, Belcher-Nixon Building, Birmingham, AL.)**

TUXEDO JUNCTION, DOWNSTAIRS, BELCHER-NIXON BUILDING,
BIRMINGHAM, AL

The heyday of Tuxedo Junction as an entertainment and commercial district faded in the latter half of the twentieth century. The Woodmen ballroom on the second floor was converted to office space. For a short time in the mid-1980s, the downstairs was a nightclub called Black Pearl that put on punk rock shows.

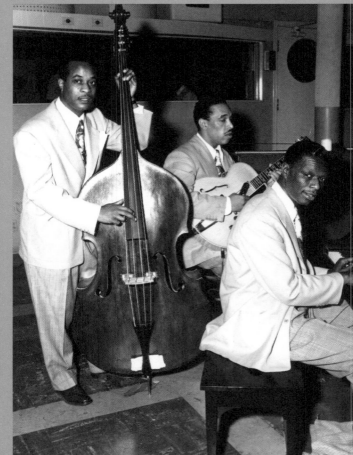

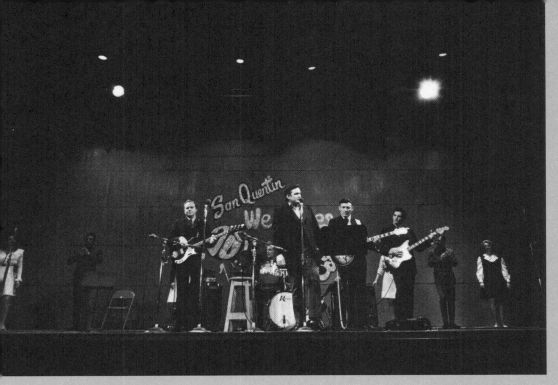

CAPITOL STUDIOS, STUDIO B,
LOS ANGELES, CA

The Capitol Records Tower, built in 1956 with its cylindrical tower capped by a 90-foot-tall spike, is one of the most striking office buildings in a city known for exuberant architecture. It also contains Capitol Studios A, B, and C in which some of the greatest pop and jazz recordings were made. The studios feature echo chambers designed by guitarist and recording innovator Les Paul. The late-1950s albums that revived Frank Sinatra's flagging career were recorded in Studio A—the largest—which allowed him to sing alongside the orchestra rather than in a separate vocal booth. Sinatra's favorite microphone is still in use. Buck Owens created his hugely influential "Bakersfield Sound" at Capitol Studio B. Rockabilly star Gene Vincent recorded in Studio B in 1957. Bobbie Gentry's smash "Ode to Billie Joe" and many of Glen Campbell's hits, including "Wichita Lineman," were also products of these studios.

LYDIA MENDELSSOHN THEATRE,
ANN ARBOR, MI

This small, oak-paneled, six hundred–seat theater on the University of Michigan campus opened in 1929. It has been a stage for student theatrical productions and academic events. The theater has also hosted music ranging from jazz, like Art Blakey and the Sun Ra Arkestra, to folk-rock artists like Ani DiFranco. On October 19, 1978, new wave band the Talking Heads played in support of their second album *More Songs About Buildings and Food*.

924 GILMAN STREET,
BERKELEY, CA

This is the home of the Alternative Music Foundation, a nonprofit, all-ages, collectively run club devoted to punk rock. Since 1984, Gilman has come to embody the "DIY" aesthetic and tight-knit community of punk and hardcore. The club grew out of a desire to create a space that could support bands and fans without the violence, racism, and sexism that troubled some hardcore punk venues. Green Day, the Offspring, and Rancid are among the most successful bands nurtured here. However, the club's commitment to underground music free of corporate influence often meant commercial success spelled the end of a band's relationship with Gilman; the Green Day song "86" describes the band being banned from the club after they signed a major label contract.

THE TROUBADOUR,
WEST HOLLYWOOD, CA

The Troubadour began in 1957 as a coffee house on La Cienega Boulevard before moving to its present location on Santa Monica Boulevard. Since the 1960s, it has

HOLLYWOOD BOWL,
LOS ANGELES, CA

This bowl-shaped amphitheater carved into the side of the Hollywood Hills has been the premier live music venue in Los Angeles since its construction in 1922. The concentric concrete arches forming the bandshell are an iconic architectural element, instantly recognizable from the Bowl's many appearances on film and television. Performances in the early decades were often operatic or classical music. In 1956, a concert featuring Louis Armstrong, Ella Fitzgerald, and Art Tatum became the best attended of all Norman Granz's "Jazz at the Philharmonic" series. The Beatles played the Bowl in 1964 and in 1965, and the Rolling Stones followed in 1966. Several live recordings at the Hollywood Bowl have been released commercially, including shows by the Beatles, Doors, Kingston Trio, and Joe Cocker.

DOUGLASS THEATRE,
MACON, GA

This theater was established in 1921 by Charles Henry Douglass, an African American businessman who was a member of the Theatre Owners Booking Association, a mostly white organization that booked African American vaudeville houses. This syndicate was the forerunner of the much more informal network of Black-owned venues and entertainers that came to be referred to as the Chitlin' Circuit. In addition to films and vaudeville, the Douglass Theatre hosted early jazz and blues greats like Bessie Smith and Ma Rainey. In 1957, a teenage Otis Redding won the amateur talent contest at the Douglass fifteen weeks in a row, after

which he was banned from the competition. The theater was an early showcase for two other Macon natives who found fame, Little Richard and James Brown.

SAN QUENTIN STATE PRISON,
SAN QUENTIN, CA

Completed in 1852, San Quentin is the oldest prison in California. It is named after its location, a spit of land in San Francisco Bay called Point San Quentin. Following the great success of *At Folsom Prison* in 1968, Johnny Cash recorded a live album at San Quentin in 1969. Cash had been making concerts at prisons a regular part of his touring for nearly a decade before the Folsom recording, driven by his deep personal connection with prisoners as human beings. That he chose San Quentin was significant because this was the site of his first prison concert on New Year's Day 1958. One prisoner who found some inspiration at that show was future country music superstar Merle Haggard, serving a sentence for burglary. The *At San Quentin* album was the first recording Cash made without his longtime guitar player Luther Perkins, who had died weeks before the concert. A decade later, the San Francisco punk band Crime played a concert for San Quentin inmates on an outdoor stage in the prison yard, dressed in uniforms similar to those of the prison's guards. Santana, the Grateful Dead, and Country Joe and the Fish also played concerts here; Metallica filmed a music video; and B. B. King recorded his 1990 album, *Live at San Quentin*. **(See Folsom State Prison, Represa, CA.)**

IRVING PLAZA,
NEW YORK, NY

This building was originally four separate brownstones that were combined into a hotel in the 1870s. In 1927, the hotel was gutted and turned into a ballroom-style theater and christened Irving Plaza, named for its location on Irving Place. Turning into a rock venue in 1978, in 1948 it was purchased by the Polish Army Veterans of America District 2 for use as a Polish-American community center. In addition to providing a stage to New York bands, Irving Plaza was often the first U.S. venue for bands from the British punk and new wave scene.

ANTONE'S NIGHTCLUB,
AUSTIN, TX

The first act to perform at Antone's was the zydeco legend Clifton Chenier and His Red-Hot Louisiana Band on July 15, 1975. In the 1970s and '80s, which was a lean time for many blues musicians, the club helped maintain the careers of dozens of blues originators in danger of being forgotten. Muddy Waters, B. B. King, John Lee Hooker, and Jimmy Reed are some of the artists Antone's presented during in those years. The club relocated several times from its original Sixth Street home to Anderson Lane around 1980, then to Guadalupe Street in 1981, and to West Fifth Street in 1997. Otis Rush, Albert King, Lou Ann Barton, Angela Strehli, and the Fabulous Thunderbirds have all appeared here. Stevie Ray Vaughan and Doug Sahm were also regular performers. Since this photograph was made, the club has moved to East Riverside.

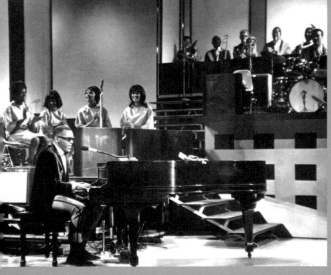

Ray Charles with his back-up singers and orchestra in a still from the *Big T.N.T. Show*, 1966.

been a vital platform for emerging talent. Elton John made his first U.S. appearance here in 1970; Buffalo Springfield played their first show in 1966; and three future members of the Byrds met playing gigs in 1965. James Taylor and Neil Young both debuted solo acts here in 1969. In the mid-1980s, the club was the birthplace of glam metal, with shows from bands like Poison and Mötley Crüe. Guns N' Roses played their first show at the Troubadour and later signed a major record deal. Comedy saw milestones at the club: In 1962, Lenny Bruce was arrested for obscenity for saying the word "schmuck" onstage, and Richard Pryor's 1968 debut album was recorded live at the Troubadour. In 1974, John Lennon and Harry Nilsson were ejected for drunkenly heckling the Smothers Brothers' set.

THE WESTERN FRONT,
CAMBRIDGE, MA

When Marvin Gilmore wanted to open a nightclub in 1967, it was a time when banks routinely refused to give loans to African American entrepreneurs. Gilmore's solution was to cofound the Unity Bank and Trust Company in Roxbury, the first African American–owned and operated commercial bank in Massachusetts. For forty-six years the Western Front hosted hundreds of jazz, reggae, and R&B artists. The nightclub closed in 2013.

DINNER KEY AUDITORIUM (SITE),
COCONUT GROVE, MIAMI, FL

The most notorious event in the Doors' history occurred in this auditorium in 1969. The building is a former airplane hangar, erected in 1917 at the Dinner Key

Naval Air Station. The facility was decommissioned in 1945 and the hangar repurposed by the city of Miami as an indoor arena. On the night of the concert, Jim Morrison, singer for the Doors, arrived at Coconut Grove over an hour after the show was scheduled to begin drunk. During the band's set he attempted to provoke the crowd. A fan doused him with champagne, inspiring him to remove his shirt and exhort the crowd to shed their clothes. Police watching the scene said that Morrison simulated masturbation at this point. On March 5, the Dade County Sheriff's office issued a warrant for Morrison's arrest, claiming he exposed himself on stage, shouted obscenities, and simulated oral sex on guitarist Robby Krieger. These charges were denied by the group. However, Morrison was tried and convicted. His accidental death in 1971 came before the appeal of his conviction could be resolved.

OVERTON PARK SHELL,
MEMPHIS, TN

The City of Memphis, with help from the Works Progress Administration, constructed this bandshell in 1936. A crowd of six thousand attended its dedication to hear a sixty-five piece orchestra, organized for the occasion. On July 30, 1954, Elvis Presley played his first paid concert here. The event was one of a series of Country Music Jamboree package shows promoted by Memphis DJ Bob Neal, billed as the Hillbilly Hoedown and headlined by Slim Whitman and Billy Walker. Elvis, backed by Scotty Moore on guitar and Bill Black on bass, performed "That's All Right" and other songs the band had just recorded at Sam Phillips's

Sun Studios. To release the nervous energy he felt performing before an audience, Elvis kept time with the music by shaking his leg throughout their set. This was the trio's first experience of the enthusiastic response Elvis's onstage movements would provoke in crowds of young women.

POWER STATION,
NEW YORK, NY

Built in 1927 as a Consolidated Edison electrical substation in Manhattan's Hell's Kitchen neighborhood, by the 1960s it was used as a television studio. From 1967 through 1971, the Gothic soap opera *Dark Shadows* was produced for ABC television. The space was converted to a recording facility called the Power Station in 1977. It quickly became a favorite of rock musicians and has produced dozens of bestselling albums: Bruce Springsteen's *Born in the USA*, Madonna's *Like a Virgin*, and David Bowie's *Scary Monsters* among them.

LONGSHOREMEN'S HALL,
SAN FRANCISCO, CA

Owned and managed by the International Longshore and Warehouse Union, this meeting hall was built in 1959. On October 16, 1965, a production team of hippies called the Family Dog, who promoted the rock concerts most closely associated with the Summer of Love, put together a program called "A Tribute To Dr. Strange: A Rock and Roll Dance Concert," which featured Jefferson Airplane, the Great Society, the Charlatans, and the Marbles. It was the first concert produced by the Family Dog and the first performance by the Great Society with singer Grace Slick, who joined Airplane the following year. The Trips Festival, held at the Longshoremen's Hall on January 21–23, 1966, drew as many as ten thousand paid admissions over three days. The event was a collaboration between Ken Kesey's Merry Pranksters; the Family Dog; and the Red Dog Saloon contingent, who had been staging their own psychedelic scene in Virginia City, Nevada. The template for the San Francisco scene was set: psychedelic rock music played at ear-splitting volume, under a swirling maelstrom of colored lights before a crowd of young people under the influence of mind-expanding substances.

EARL CARROLL THEATRE,
LOS ANGELES, CA

An exceptional example of Streamline Moderne design, the Earl Carroll Theatre was built in 1938. The glitzy supper club offered dinner and dancing as well as a stage show. After Carroll's death in 1948, the club was rebranded as the Moulin Rouge—not very successfully—and for

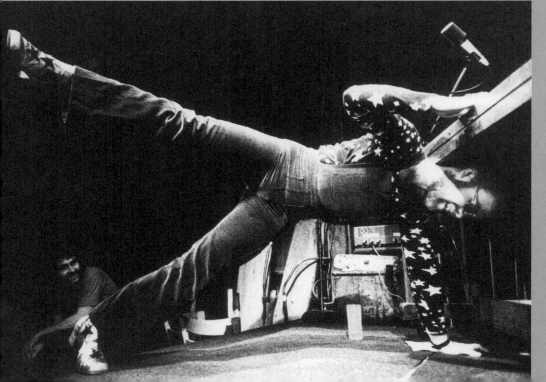

Elton John performing at the Troubadour in West Hollywood, August 25, 1970.

a time the popular television game show *Queen for a Day* was broadcast from the location. Then in 1965, the concert film the *Big T.N.T. Show*, a sequel to the *T.A.M.I. Show*, was filmed here. The concert film features performances by Ray Charles, Bo Diddley, the Byrds, Joan Baez, and Ike & Tina Turner. In 1966, the theater became the teenagers-welcome Hullabaloo Club. In 1968, it was the Kaleidoscope just long enough for Jefferson Airplane to play the opening, and then swiftly became the Aquarius Theatre for a two-year run of the musical *Hair*, though it was sometimes still used as a rock venue on Mondays, when the show had its day off. Into the '70s and '80s the theater was used for sundry television productions. **(See Santa Monica Civic Auditorium, Santa Monica, CA.)**

CALEDONIA LOUNGE,
ATHENS, GA

In 1980, a new band played their first show as R.E.M. at a venue called the Kaffee Klub at this address. The group had played one show two weeks prior, but performed without a name because they had been unable to agree on one. From 1981 to 1983, and again in 1987 to 1991, this was the 40 Watt Club, one of several locations for this nightclub. Bands featured at this incarnation included Fugazi, Bob Mould, Billy Bragg, the Melvins, and Robyn Hitchcock. In 1989, R.E.M. filmed a music video of "Turn You Inside-Out" at the 40 Watt. The club later became the Caledonia Lounge, which continued in the independent tradition of small Athens music venues by presenting local bands. **(See 40 Watt Club site, Athens, GA; 40 Watt Club, Athens, GA.)**

PRESERVATION HALL,
NEW ORLEANS, LA

The original 1809 building at this address, which housed a tavern, burned in 1816. In the following year, a free woman of color, Agathe Fanchon, built the current structure, which she owned until 1866. In the 1920s, this was the home and photography studio of Will H. Moses, and in the 1930s, of another notable photographer, Joseph Woodson "Pops" Whitesell. In the 1950s, Larry Borenstein managed an art gallery here, and also began hosting concerts of traditional jazz, hiring older New Orleans musicians. This was at a time when there were few jobs for these original creators, even in the city of jazz's birth. The beginning of Preservation Hall as we know it today—with the institution of a house band devoted to New Orleans jazz, played by musicians who grew up in the music—formally began in 1961 under the management of Allan and Sandra Jaffe. The Preservation Hall Jazz Band performs regular concerts at the Hall, touring, and making recordings on the Hall's record label.

SUGARHILL RECORDING STUDIOS,
HOUSTON, TX

Founded in October 1941 by Bill Quinn, this is the oldest independent recording studio in continuous operation in the U.S. In 1950, the name changed from Quinn Recording to Gold Star Studios. George Jones had an early string of hits here, and Lightnin' Hopkins recorded two hits: "T-Model Blues" and "Tim Moore's Farm." DJ J. P. "The Big Bopper" Richardson cut a novelty hit called "Chantilly Lace" that landed him on a rock and roll package tour featuring Buddy Holly and Ritchie Valens. From 1963 through 1973, producer Don Robey recorded extensively at Gold Star for releases on his Back Beat, Duke, and Peacock record labels. In 1964, Zydeco great Clifton Chenier made his first recording here, and in 1965 Doug Sahm's Sir Douglas Quintet recorded "She's About a Mover." From 1968 to 1970, the facility was known as International Artists Studio. During this brief period Texas psychedelic bands like the 13th Floor Elevators and Red Krayola recorded here. Veteran record producer Huey P. Meaux took over ownership in 1971, changing the name to SugarHill Recording Studios. Asleep at the Wheel, Todd Rundgren, and Freddy Fender recorded at SugarHill in the 1970s. Destiny's Child recorded their second album *The Writing's on the Wall* in 1998.

THREADGILL'S,
AUSTIN, TX

In 1933, the year Prohibition ended, Kenneth Threadgill bought a license to sell beer and converted his Gulf auto service station into a beer joint. Over the decades, Threadgill's became popular with musicians. In the 1960s, a weekly Wednesday night hootenanny brought in a college crowd. One University of Texas undergraduate who attended regularly was Janis Joplin, accompanying herself on autoharp while she sang the blues. In the 1970s, the structure was in poor shape, but after some renovation and a change in ownership, Threadgill's reopened in 1981 as a restaurant, with a renewed commitment to live music. It closed in 2020.

DRIPPING SPRINGS RANCH,
DRIPPING SPRINGS, TX

In the Texas hill country west of Austin is Dripping Springs ranch, the home of the first annual July 4 picnic and music festival, informally referred to as "Hillbilly Woodstock," sponsored by "outlaw country" artist Willie Nelson. In 1972, Nelson was invited to play a music festival called the Dripping Springs Reunion. Poor promotion meant the event was an under-attended financial disaster. However, Nelson liked the setting and concept of the country music festival so much that he decided to produce his own event the following year. His July 4 Picnic became a much anticipated annual affair.

The Everly Brothers on *American Bandstand*, 1960.

SECOND FRET (SITE),
PHILADELPHIA, PA

Owned and operated by Manny Rubin in the 1960s, the Second Fret was a coffeehouse located in the Rittenhouse Square area, the heart of Philadelphia's folk music scene. The small room was a venue for folk singers like Joni Mitchell and Dave Van Ronk and acoustic blues artists like Lightnin' Hopkins, Josh White, and Brownie McGhee and Sonny Terry. In addition to folk and jazz artists, which made the lion's share of bookings, the Velvet Underground played here several times in 1969 and 1970.

TOBACCO ROAD (SITE),
MIAMI, FL

Before its demolition in 2014, Tobacco Road had been one of Miami's oldest continuously operating bars, originally opened in 1912. In 1982, its life as a consistent live music venue began. National blues and jazz acts began playing here, including George Clinton, Koko Taylor, John Lee Hooker, and Dr. John. During the Prohibition years, the street level served as a bakery, with a speakeasy hidden upstairs. In the 1940s, it was transformed into a gay bar called Tobacco Road. After the City of Miami closed it temporarily on a morals charge, the bar's name drifted from the Chicken Roost, to Chanticleer to Shandiclere, until the 1970s when it finally became Tobacco Road again.

HISTORIC® RCA STUDIO B,
NASHVILLE, TN

Built 1956, Studio B has been called the birthplace of the Nashville sound. This brand of country pop, emphasizing lush background vocals and strings, came to be seen as the savior of Nashville's music industry, as rock and roll became increasingly popular and outsold the traditional country market. The Nashville sound both revived the genre's popularity and helped establish Music Row's reputation as a profitable recording center. Elvis Presley made more than two hundred recordings in Studio B. Eddy Arnold, Floyd Cramer, Roger Miller, Jim Reeves, and Dolly Parton are among the many stars who recorded hits here.

MARBLE BAR (SITE),
BALTIMORE, MD

The Congress Hotel was built in 1903 as the Kernan Hotel in French Renaissance revival style. It included such amenities as a Turkish bath; two vaudeville theaters; and a large rathskeller, a beerhall that featured a 72-foot-long bar carved from Italian marble. By the 1970s, the basement was a nightclub known as the Marble Bar. It hosted many early punk and new wave groups from 1978 through the mid 1980s, with acts like Iggy Pop, the Psychedelic Furs, and the Talking Heads. During the bar's heyday, John Waters superstar Edith Massey played shows with her own punk band and celebrated a birthday party here.

FOREST HILLS STADIUM,
QUEENS, NY

Originally designed by the West Side Tennis Club in 1923 as the home of the U.S. Open tennis tournament, the stadium began hosting concerts in the 1960s. The 1964 Forest Hills Music Festival was a series of concerts over six summer weekends with performances by acts including Barbra Streisand, Count Basie, Harry Belafonte, and the Beatles. The Rolling Stones took the stage in 1966, supported by two young American bands, the McCoys and the Standells. The Monkees filled the stadium three nights in a row in July 1967, with Jimi Hendrix opening. Hendrix had already played eight dates supporting the Monkees, but decided he'd had enough after Forest Hills and quit the tour. The Who played the stadium in 1971, with LaBelle opening. In 2014, the stadium presented a reunion concert of indie rockers the Replacements.

THE MINT BAR,
LOS ANGELES, CA

The attractive Art Deco facade of the Mint Bar is representative of design in 1937, the year this small club opened. While there has been no shortage of rock acts at the Mint, blues and soul has been a staple. Through the years the stage has seen Stevie Wonder, Bonnie Raitt, jump blues singer Jimmy Witherspoon, and guitarist Pee Wee Crayton.

A&M STUDIOS,
LOS ANGELES, CA

This was the recording studio for A&M Records. The brainchild of the label's founders, Herb Alpert and Jerry Moss, A&M took over the former Charlie Chaplin Studios in 1966, rebuilding two of the old movie company's sound stages and Chaplin's swimming pool into four recording studios and a mixing suite. The first album recorded was Sérgio Mendes and Brasil '66's *Fool on the Hill*. Joni Mitchell recorded her album *Blue* in 1971. Carole King recorded her hit solo album *Tapestry* here. The Flying Burrito Brothers, John Lennon, Cheap Trick, and Guns N' Roses are just a few of the artists who recorded here. In 1999, Universal Music bought A&M and in 2000, the recording studio was sold to the Jim Henson Company.

THE SALOON,
SAN FRANCISCO, CA

This North Beach bar claims to have been established in 1861, forty-five years before the 1906 earthquake and fires that wiped out much of the city. While there is some dispute as to whether this is still the same building, there has been a saloon at this spot since 1861. The Poodle Dog Café seems to have been its name in the Prohibition years. The bar has had many names over many years, most lost to time; it has been called the Saloon since 1984, and it has offered live blues nightly since the late 1960s.

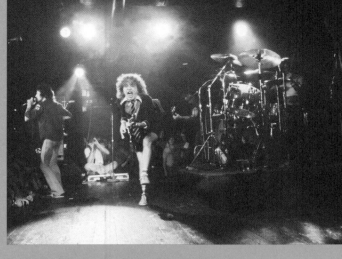

AC/DC performing at the Aragon Ballroom in Chicago, 1978.

PARAMOUNT THEATRE,
SEATTLE, WA

In 1928, Paramount Pictures built this opulent Beaux Arts movie palace, calling it the Seattle Theatre. Its massive Wurlitzer pipe organ was reportedly the largest instrument of its kind when it was installed, although the advent of sound in motion pictures would make musical accompaniment obsolete in just two years. Vaudeville acts augmented the film program in the 1920s. The theater was a movie house through the 1930s into the 1960s, then in 1971, the Paramount was reborn as a live music venue. Bruce Springsteen, the Kinks, and Bob Marley were among the artists to play here in the 1970s. New money for restoration came in the 1980s, and in addition to rock shows the Paramount presented pop performers like Frank Sinatra and touring productions of Broadway musicals.

EL TORREON BALLROOM,
KANSAS CITY, MO

The two-story red brick event hall opened in 1927 with a gala presenting Kansas City's own Coon-Sanders Original Nighthawk Orchestra, a band that made an important contribution to early jazz. During the swing era, many of the great big bands had engagements in the second-floor ballroom, including Cab Calloway. In the 1950s and '60s the space was a roller rink and occasional venue for rock and roll shows. In the early 1970s, under the name Cowtown Ballroom, it hosted concerts by Alice Cooper, Van Morrison, and Frank Zappa. In the 1990s and 2000s the smaller front room, billed as El Torreon Concert Room, offered hardcore, punk, and ska shows.

NEWPORT MUSIC HALL,
COLUMBUS, OH

Originally named the State, this theater was built in 1921, adjacent to the campus of Ohio State University. In 1970, it was remade as a music venue called the Agora, and finally in 1984 it became the Newport Music Hall. Primarily a movie house in its early days, as the Agora it hosted hundreds of musical acts. Chuck

Berry, the Beach Boys, the Grateful Dead, and the Velvet Underground all played in the early 1970s. Later acts included the Ramones, Elvis Costello, and the Psychedelic Furs. As the Newport Music Hall it has continued as a popular rock venue.

BIMBO'S 365 CLUB,
SAN FRANCISCO, CA

Operating under two different names with a series of owners, Bimbo's is one of San Francisco's oldest nightclub sites. A speakeasy and after-hours bar called Bal Tabarin in 1931, it consolidated in 1951 at its current address with what had been the 365 Club, formerly at 365 Market Street, becoming Bimbo's 365 under the ownership of Agostino "Bimbo" Giuntoli. The club was famous for "Dolfina, the Girl in the Fishbowl," a nearly naked woman who appeared to be swimming in a tank of water built into the bar. It was an optical illusion involving an aquarium, mirrors, and a stage in the basement. In the 1950s, Louis Prima and Xavier Cugat typified the acts that played here. The 1960s saw Motown stars like Smokey Robinson and Marvin Gaye and mainstream pop such as Glen Campbell and Neil Diamond. In the 1970s and '80s, Bimbo's hosted both private and public events and concerts, including an early venue for the San Francisco Jazz Festival. In the 1970s, theatrical San Francisco rock band the Tubes made their name by selling out Bimbo's regularly, several times with Iggy and the Stooges.

AMERICAN BANDSTAND (SITE),
PHILADELPHIA, PA

The long-lasting popular music television show *American Bandstand* aired in different versions from 1952 to 1989. The concept for *Bandstand* grew out of a local Philadelphia radio show aimed at teenagers called the *950 Club*. The television show, first presented by Bob Horn, developed into a nationwide pop institution. Hosted from 1956 until its final season by Dick Clark, the show featured teenagers dancing to Top 40 music. On each show, a popular musical

The Rolling Stones recording the album *Let It Bleed* at Sunset Sound Studios in Los Angeles, 1969.

act appeared in person to lip-sync one of their singles. The show was produced at the studio of the Philadelphia television station WFIL. This facility has the distinction of being one of the first designed specifically for television broadcasting, and was state-of-the-art in 1948, the year of its construction. In 1952, the facility expanded, and the newly completed Studio B was the home of *American Bandstand* until 1963, when the production left Philadelphia for Los Angeles. This photo is a section of the dance floor from the original *American Bandstand* set.

MASONIC TEMPLE,
DETROIT, MI

Opened in 1926, this is the largest Masonic temple in the world. By the 1910s, interest and membership in Masonic fraternities in Detroit had grown to such proportions that this grand building seemed necessary. The design called for three theaters, a Shrine building, the Chapel, eight lodge rooms, a drill hall, two ballrooms, office space, a cafeteria, dining rooms, a barber shop, and sixteen lanes of bowling. The auditorium's stage is the second largest in the U.S. It has been a major concert venue since the 1960s, hosting everyone from the Beach Boys to Mott the Hoople to the Rolling Stones. A typical bill from 1968: the Jimi Hendrix Experience headlines, supported by Soft Machine, MC5, and the Rationals. In 1979, the Undertones opened for the Clash. A highlight of Lou Reed's 1978 appearance was inviting Detroit vocalist Mitch Ryder to sing the Velvet Underground's song "Rock & Roll."

SILVER SLIPPER,
HOUSTON, TX

Alfred Cormier opened a hamburger restaurant in 1952 called Alfred's Place. By the 1960s, the club was featuring local musicians six nights a week. After the business expanded in the late 1960s Alfred Cormier's daughter took over management and renamed it the Silver Slipper. The club is a rare venue for zydeco, the music developed in Louisiana

and southeastern Texas by African American Creoles in the 1920s, evolving from a music called "la-la" usually played at house parties on fiddle, button accordion, and washboard. Clifton Chenier, Clarence Green, I. J. Gosey, and Lightnin' Hopkins are some of the top zydeco and blues musicians who have played the Silver Slipper.

KAY BANK STUDIOS (SITE),
MINNEAPOLIS, MN

Built as the Garrick Theatre in 1914, and later called the LaSalle, sound engineer Bruce Swedien converted this theater into a recording facility in 1953, calling it Swedien Studios. Daniel Heilicher and his brother Amos founded Soma Records ("Amos" backwards) in 1954 and produced records in cooperation with Vernon Bank, owner of Kay Bank Studios. In 1957, Kay Bank took over the recording facility from Swedien Studios. In the 1960s, the Soma label was responsible for a string of recordings that would define garage rock, including "Muleskinner Blues" by the Fendermen, the Castaways' "Liar, Liar," and the inspiration for countless teenage bands for decades to come, "Surfin' Bird" by the Trashmen. In the 1980s, this building became the offices of Twin/Tone Records, the independent label that was home to the Minneapolis-based bands the Replacements, the Suburbs, Soul Asylum, Babes in Toyland, and the Magnolias.

SUNSET SOUND STUDIOS, STUDIO 2,
LOS ANGELES, CA

Sunset expanded in 1966, added a new room, Studio 2. Led Zeppelin used Studio 2 for many recordings, including for "Whole Lotta Love" and "When the Levee Breaks." The Rolling Stones recorded and mixed parts of the *Let It Bleed* and *Exile on Main Street* albums here. The studio complex has contributed to over two hundred certified gold hit records over the years, including Prince's *Purple Rain* and *Pet Sounds* by the Beach Boys. In 1974, Ringo Starr's third solo album, *Ringo*, was recorded here. Among the many guest musicians who contributed

to the record were Starr's former bandmates, making this the last studio session on which all four Beatles collaborated.

SAINT ANDREW'S HALL,
DETROIT, MI

The St. Andrew's Society of Detroit was founded in 1849 to assist recent immigrants from Scotland and more generally to encourage appreciation of Scottish history and culture. The Society's hall was built in 1907, consisting of a large ballroom and several small meeting rooms. St. Andrew's Hall began to be regularly used as a rock venue in 1980. It was an indispensable element of the Detroit music scene in the 1980s and '90s for touring acts like Nina Hagen, Bauhaus, the Jesus and Mary Chain, the Cramps, and X. Two Detroit acts that got a start at St. Andrews are Eminem and Insane Clown Posse.

ARAGON BALLROOM,
CHICAGO, IL

Evoking a Hollywood movie set version of a grand plaza in Spain with mosaic tiles, luxurious balconies, terra-cotta ceilings, and crystal chandeliers, the Aragon Ballroom was built in 1926 in a Moorish revival style. Hosting most of the top names of the big band era, live concerts of the 1950s were broadcast on the WGN radio station from the Aragon Ballroom. Home to so-called "monster rock" shows in the 1970s, marathons of rock and roll acts lasted six hours or more, earning the venue the nickname "the Aragon Brawlroom" for its ensuing tough crowd. Among regional acts who played here over the years are the Shadows of Knight, Cheap Trick, Styx, REO Speedwagon, and Chicago bluesmen Howlin' Wolf, Buddy Guy, and Muddy Waters. In his essay written for this book, Iggy Pop mentions a 1988 show at the Aragon with the Ramones on the bill. The Ramones played the ballroom many times, as did Iggy, both as a solo act and fronting the Stooges.

HYDE STREET STUDIOS, STUDIO A,
SAN FRANCISCO, CA

This recording studio was built in 1969 by engineer Wally Heider as an extension of his already successful recording business in Hollywood. Many of its recordings came to define the late 1960s San Francisco sound, including albums by Creedence Clearwater Revival, the Grateful Dead, and Jefferson Airplane. Heider recorded groups from beyond the Bay Area too; T. Rex's *Electric Warrior* album, and a portion of Fleetwood Mac's *Rumours* were recorded here. In addition to rock acts, the studio also worked with jazz vocalist Jon Hendricks and Herbie Hancock's fusion band the Headhunters. In 1980, the studio was bought by local musician and producer Michael Ward, and

in this era Hyde Street Studios recorded the Dead Kennedys, Flipper, the Melvins, and Green Day. Chris Isaak's hit album *Wicked Game* was another recorded at Hyde Street.

TIPITINA'S,
NEW ORLEANS, LA

In 1977, the 501 Club opened and was soon renamed Tipitina's. The name is a reference to the song "Tipitina," written and recorded in 1953 by pianist and composer Professor Longhair, a frequent performer here until his death in 1980. Other acts include the Neville Brothers, the Radiators, Dr. John, and Trombone Shorty. In 2003, the nonprofit Tipitina's Foundation was created to preserve the musical culture of New Orleans. After the devastation of Hurricane Katrina in 2005, the Foundation offered support to local musicians, distributing over a million dollars' worth of aid. The building dates from 1912 and through its history had housed a gambling parlor, a gymnasium, and a brothel.

CONGO SQUARE,
NEW ORLEANS, LA

The fabled cradle of African American music in the nineteenth century, while Louisiana was still under French colonial rule, Congo Square was the one space in New Orleans set aside for enslaved people to express themselves artistically. By mayoral decree in 1817, public gathering of enslaved people was restricted to one day a week—Sunday— and only in this location, informally called Congo Square. Here, Africans could trade goods, sing, dance, and play music. This tradition continued in New Orleans after the Louisiana Purchase. This tiny bit of artistic freedom was a stark contrast to other cities in the U.S. that had always suppressed any traces of African culture in their enslaved population. The strength of this traditional African music became the bedrock upon which ragtime, blues, and jazz would build.

James Taylor; engineer Hank Cicalo; Joni Mitchell (back); Carole King; and producer Lou Adler in A&M Studios in Los Angeles, 1971.

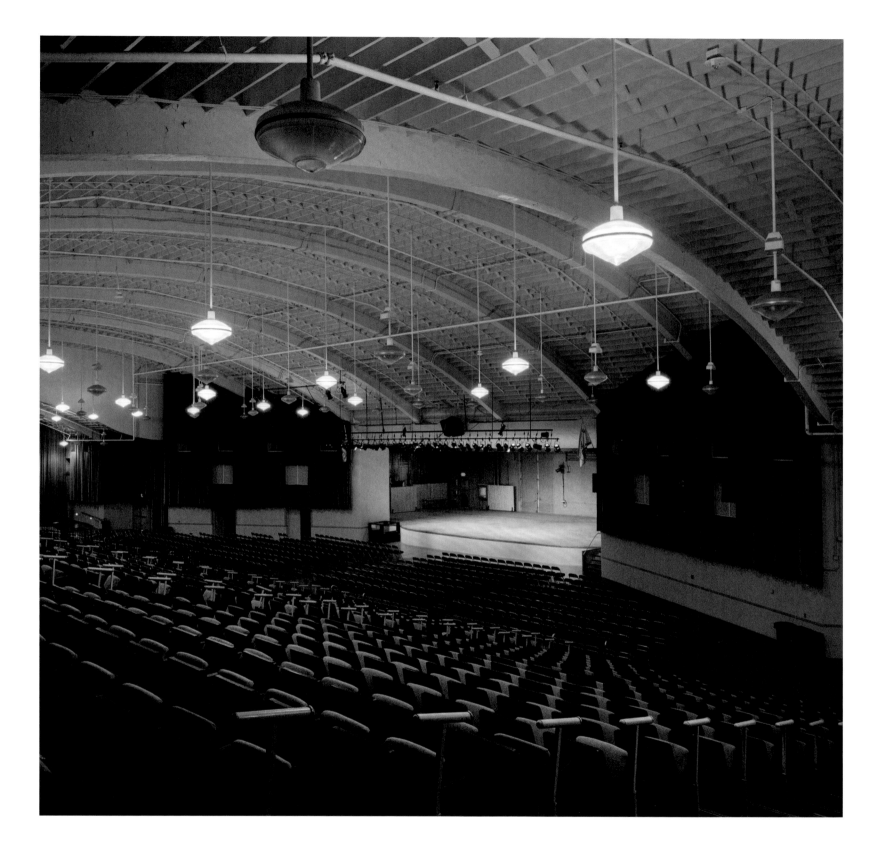

Fort Lauderdale War Memorial Auditorium, Fort Lauderdale, FL — February 25, 2015

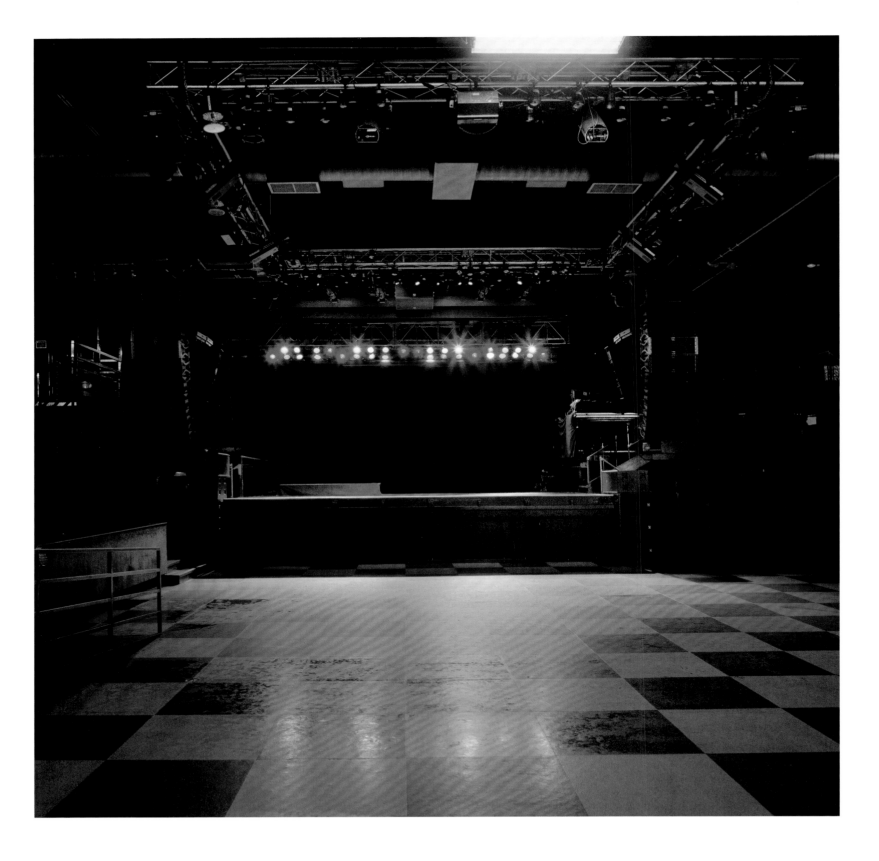

First Avenue, Minneapolis, MN — November 15, 2013

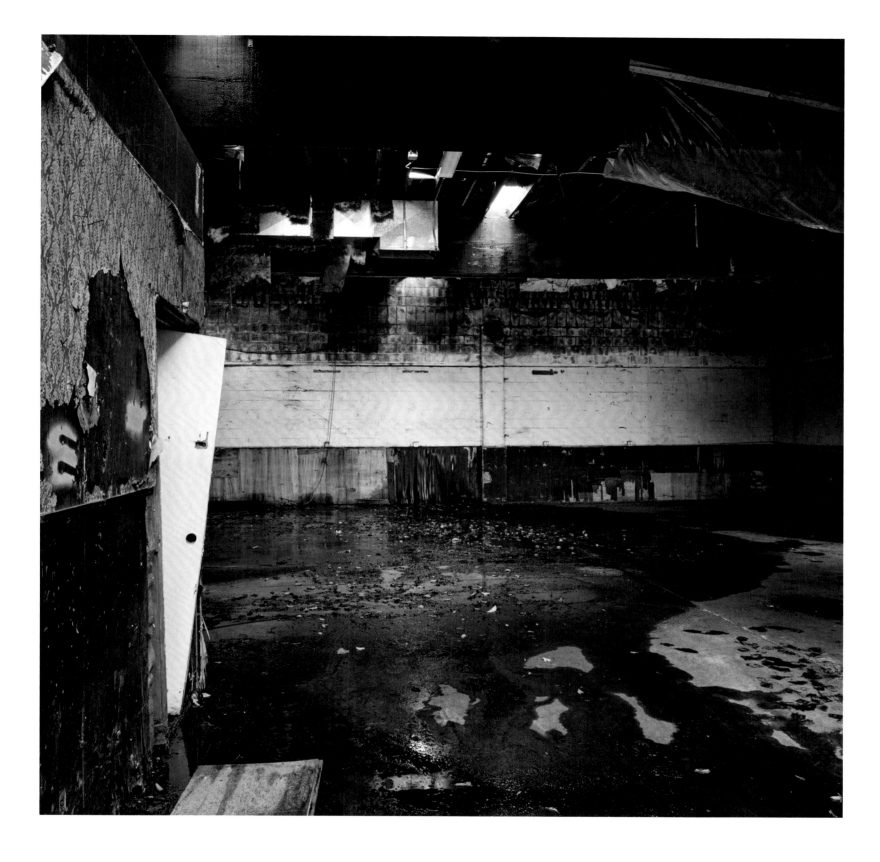

Cotton Club (site), Portland, OR — November 17, 2015

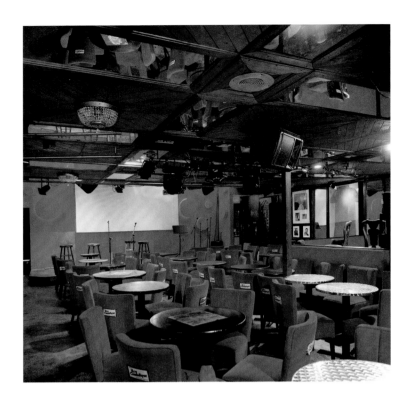

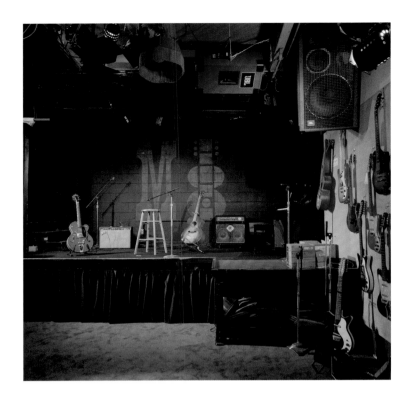

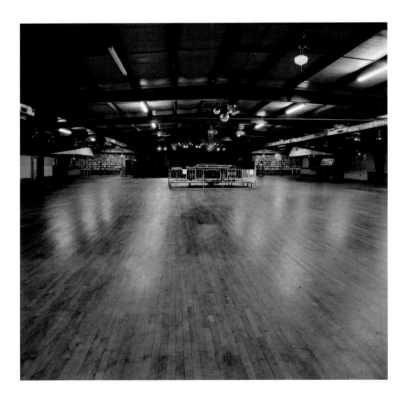

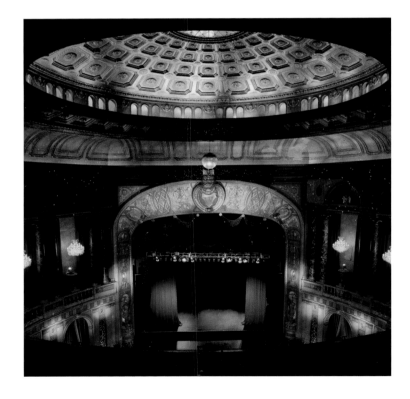

Hoy Como Ayer, Miami, FL — February 24, 2015
McCabe's Guitar Shop, Santa Monica, CA — August 6, 2009
Diamond Ballroom, Oklahoma City, OK — June 9, 2009
State Theatre, Detroit, MI — October 29, 2008

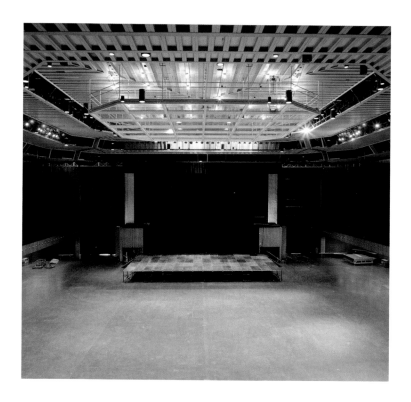

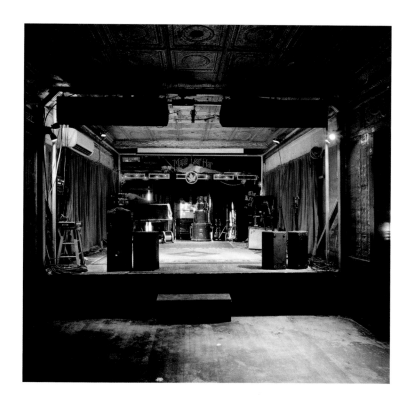

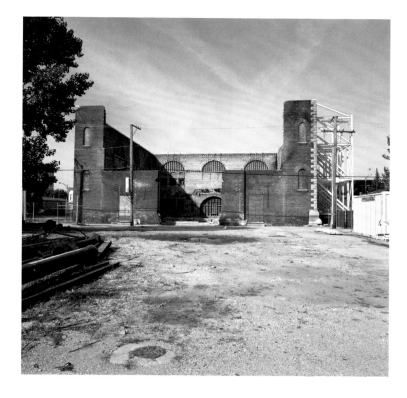

The Padded Cell (site), Minneapolis, MN — November 12, 2013
Bill Graham Civic Auditorium, San Francisco, CA — November 11, 2015
Maple Leaf Bar, New Orleans, LA — March 15, 2016
Pilgrim Baptist Church, Chicago, IL — September 19, 2008

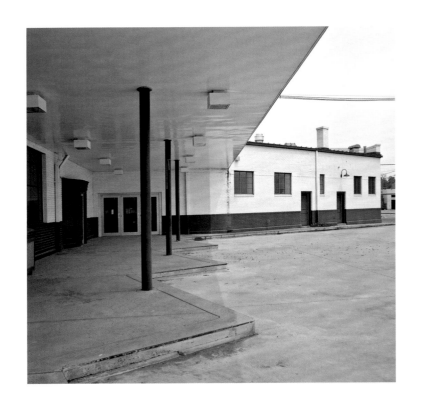

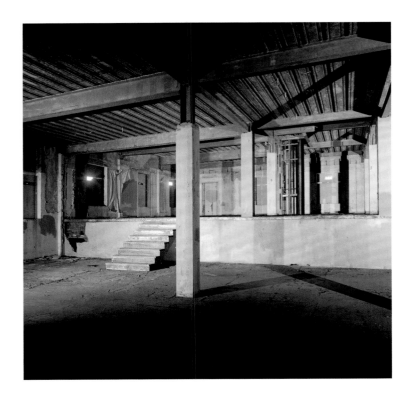

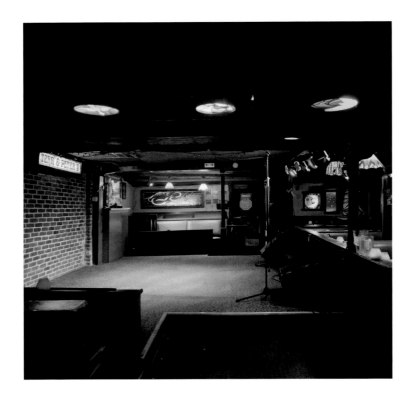

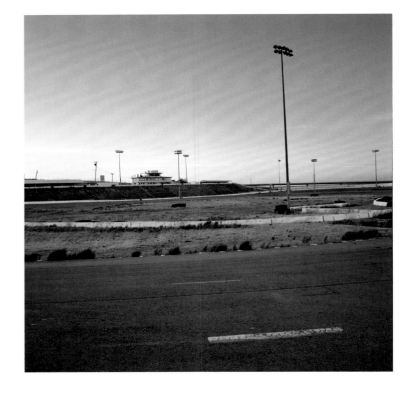

Greyhound Bus Station, Clarksdale, MS — May 10, 2008
Knights of Pythias Temple, Dallas, TX — January 14, 2013
John and Peter's, New Hope, PA — August 12, 2013
Altamont Raceway Park, Tracy, CA — August 24, 2015

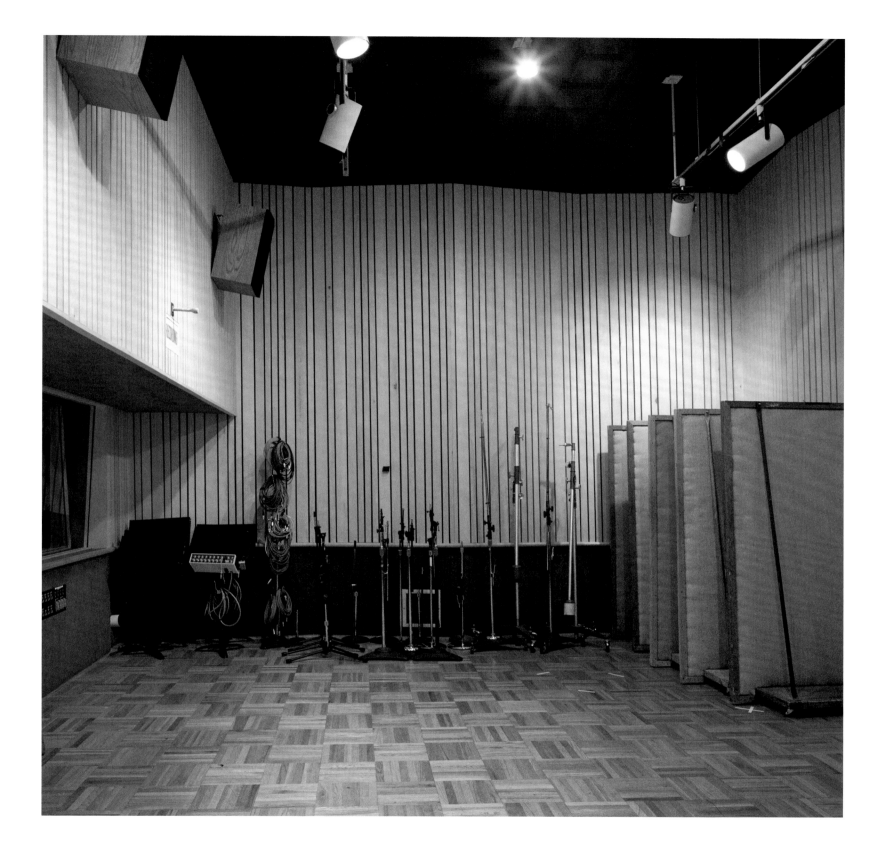

Fantasy Studios, Studio B, Berkeley, CA — August 27, 2015

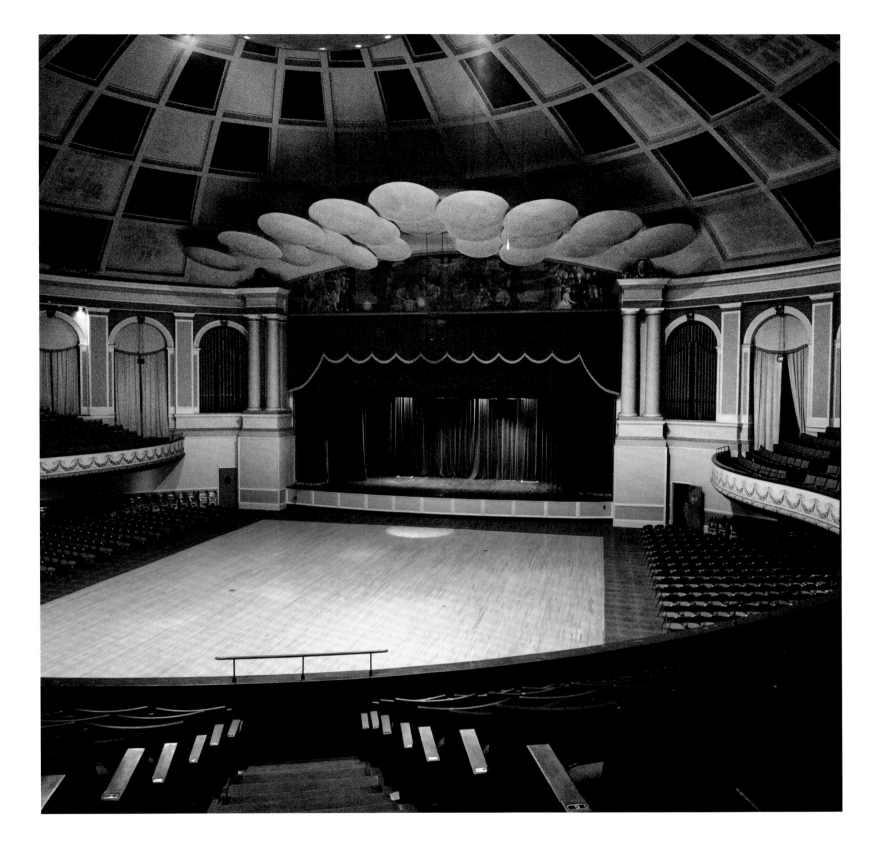

Macon City Auditorium, Macon, GA — June 24, 2015

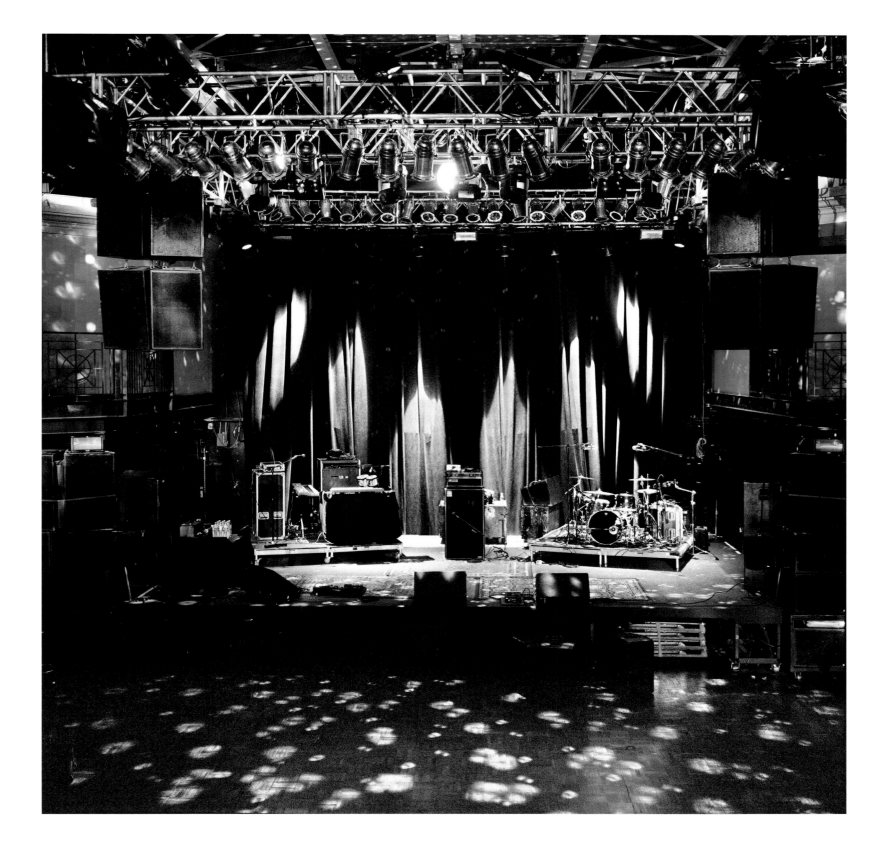

9:30 Club, Washington, D.C. — April 2, 2008

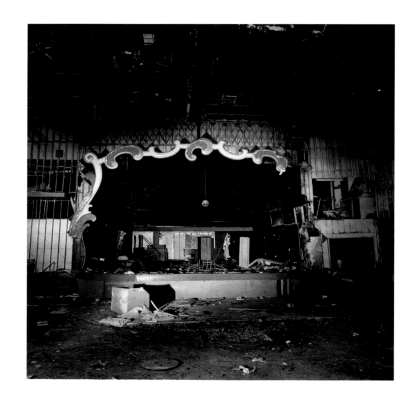
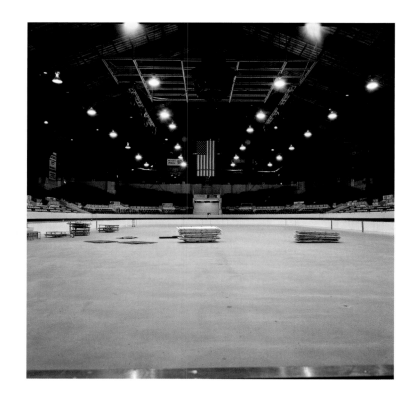
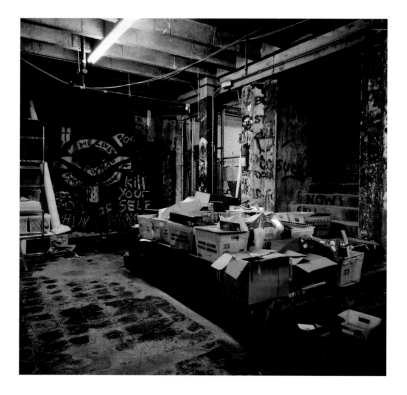
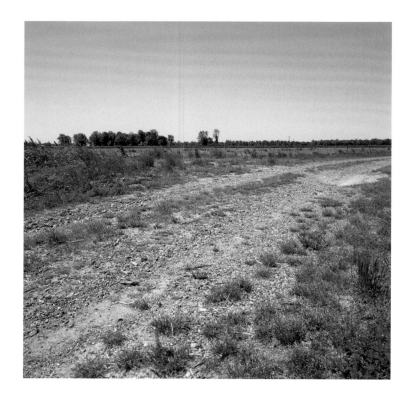

Latin Quarter, Detroit, MI — October 29, 2008
Indiana State Fairgrounds, Indianapolis, IN — September 17, 2008
The Masque (site), Los Angeles, CA — August 3, 2009
One "Crossroads," Clarksdale, MS — May 11, 2008

220

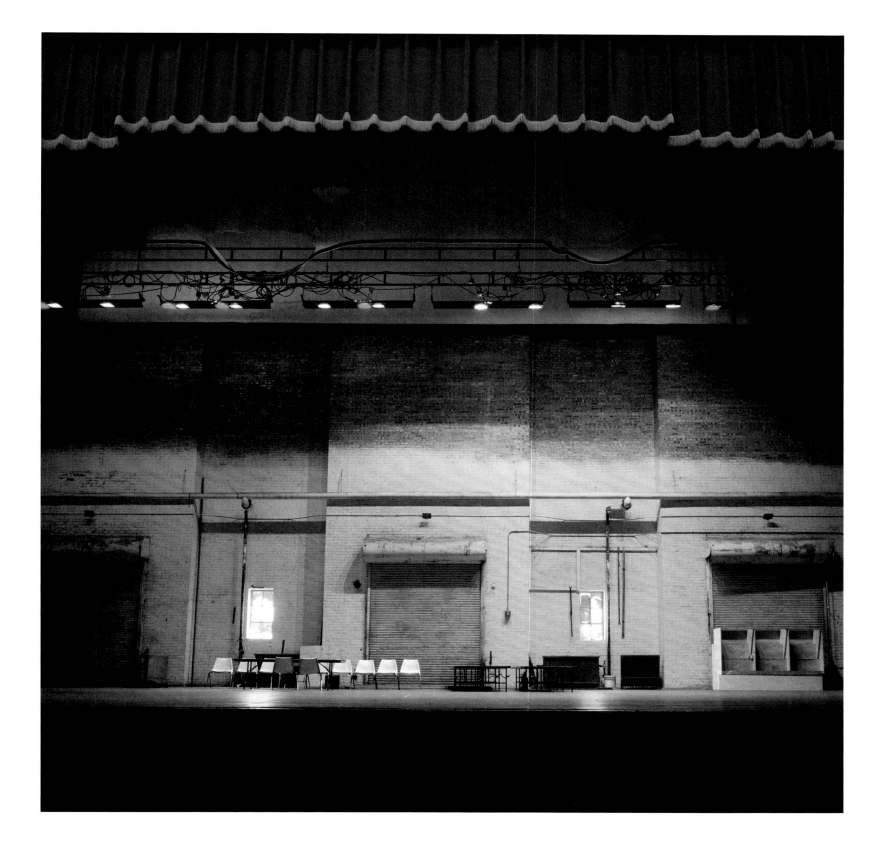

Shreveport Municipal Auditorium, Shreveport, LA — May 12, 2008

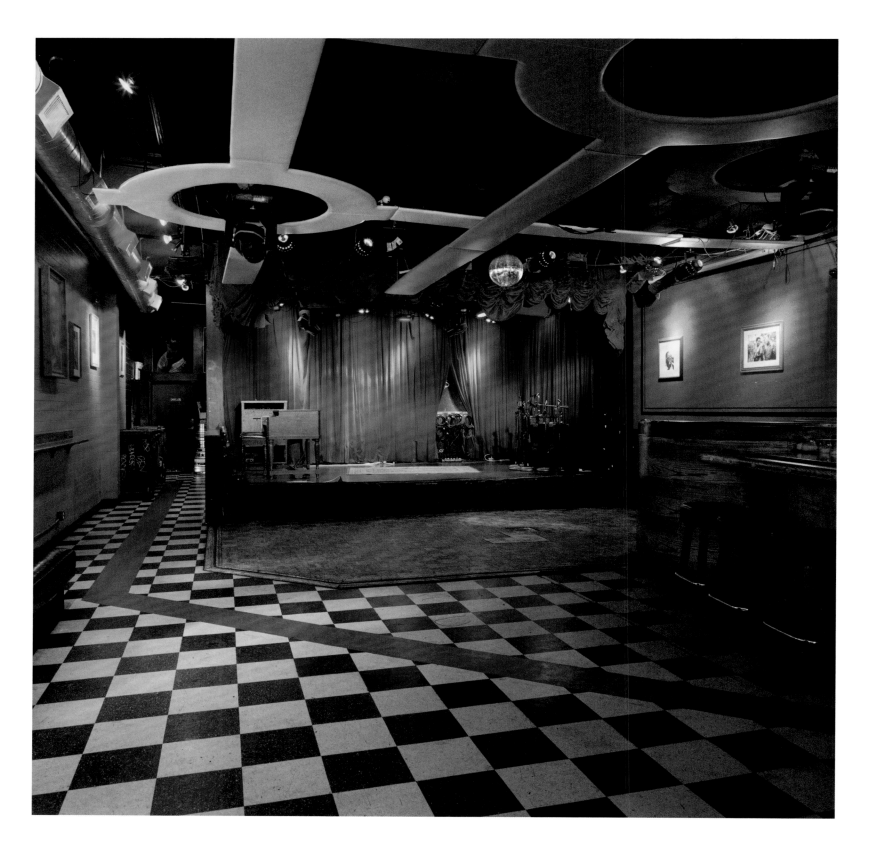

Boom Boom Room, San Francisco, CA — August 27, 2015

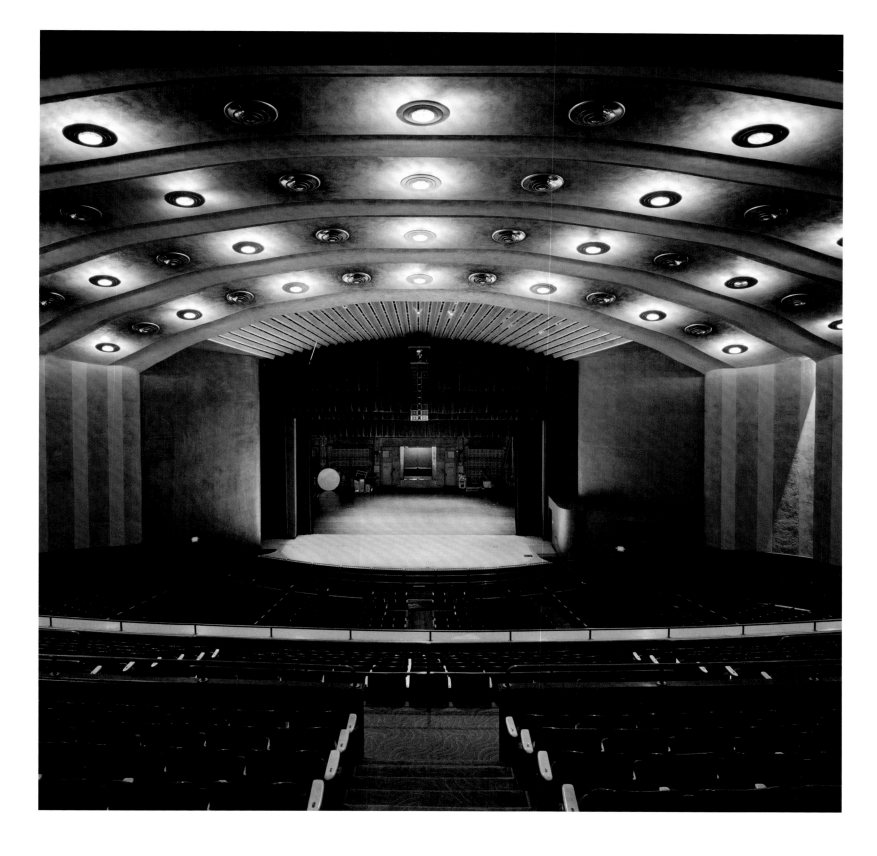

Berkeley Community Theater, Berkeley, CA — August 26, 2015

Peabody Hotel, Skyway Ballroom, Memphis, TN — May 6, 2008

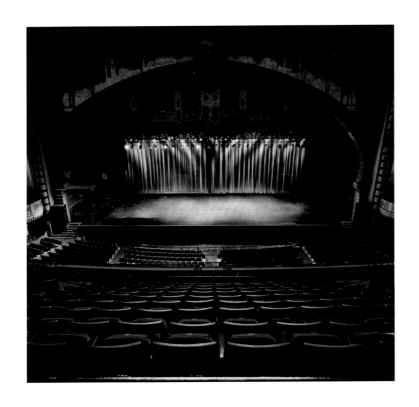

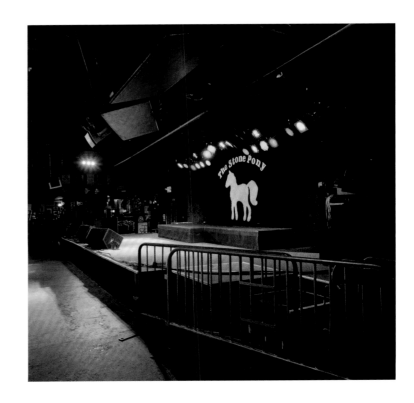

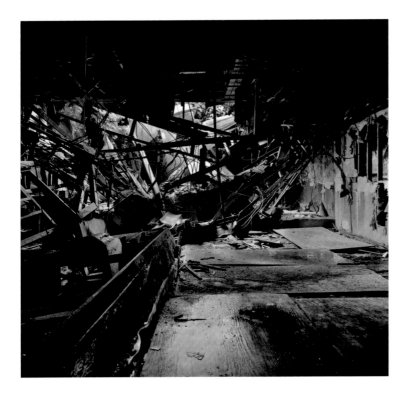

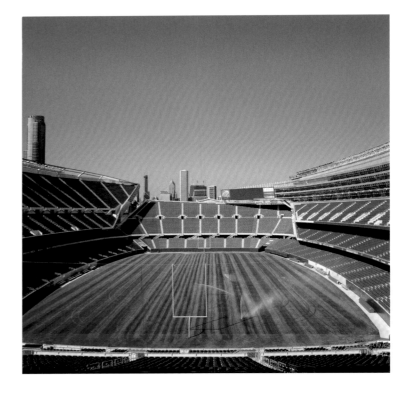

Shrine Auditorium, Los Angeles, CA — July 31, 2009
The Stone Pony, Asbury Park, NJ — August 14, 2013
Sphinx Club, Baltimore, MD — August 13, 2013
Soldier Field Stadium, Chicago, IL — September 17, 2008

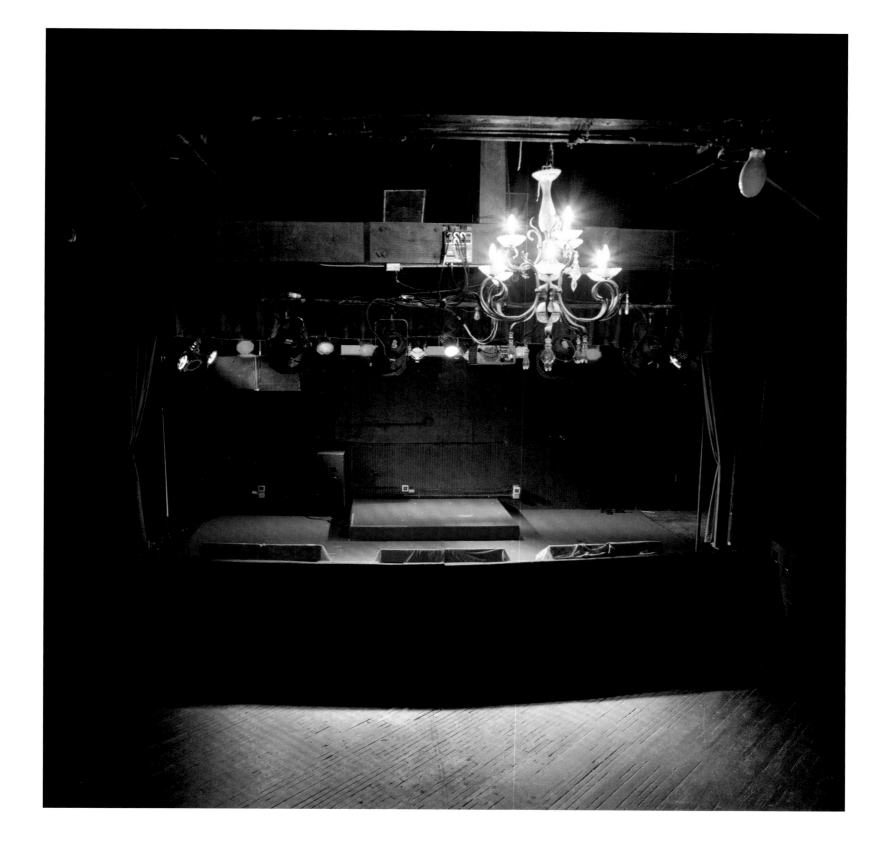

Fitzgerald's, Houston, TX — January 16, 2013

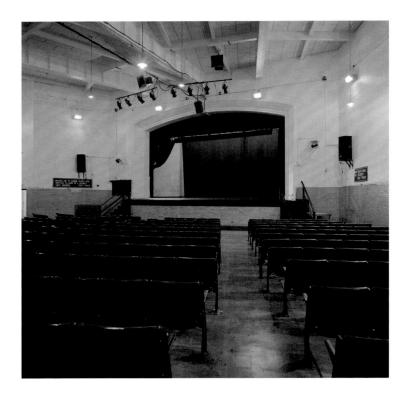

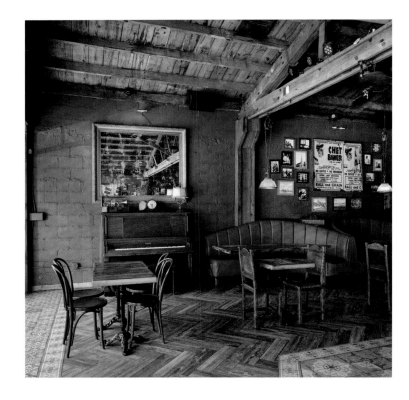

RCA Studio A, Nashville, TN — January 19, 2010
Roostertail, Detroit, MI — October 30, 2008
Sing Sing Correctional Facility, Ossining, NY — April 26, 2016
Ball and Chain, Miami, FL — February 25, 2015

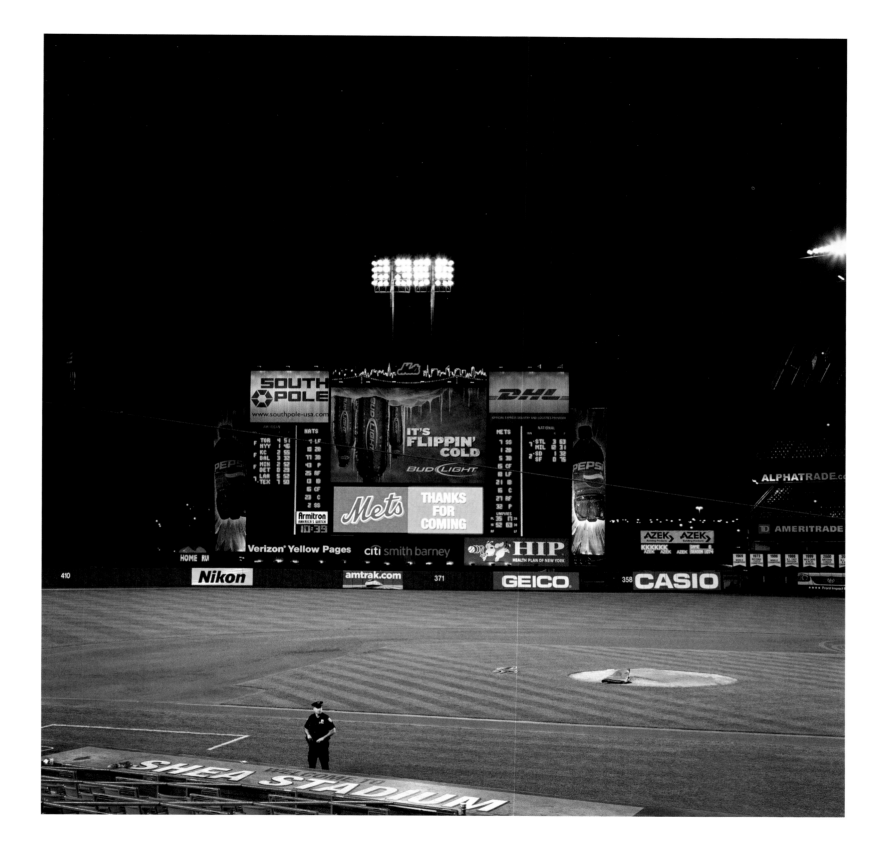

Shea Stadium, Queens, NY — September 24, 2007

231

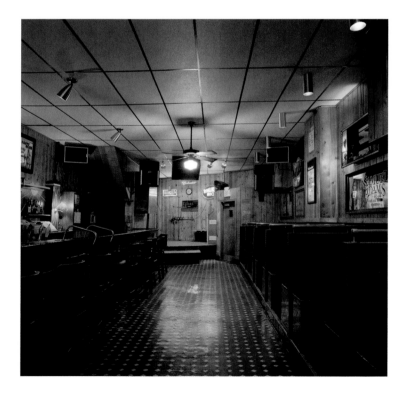

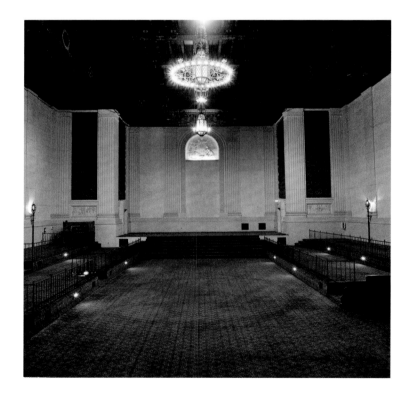

Granada Theater, Dallas, TX — January 11, 2013
The Roxy, West Hollywood, CA — August 7, 2009
Viking Bar, Minneapolis, MN — November 12, 2013
Park Plaza, Los Angeles, CA — July 28, 2015

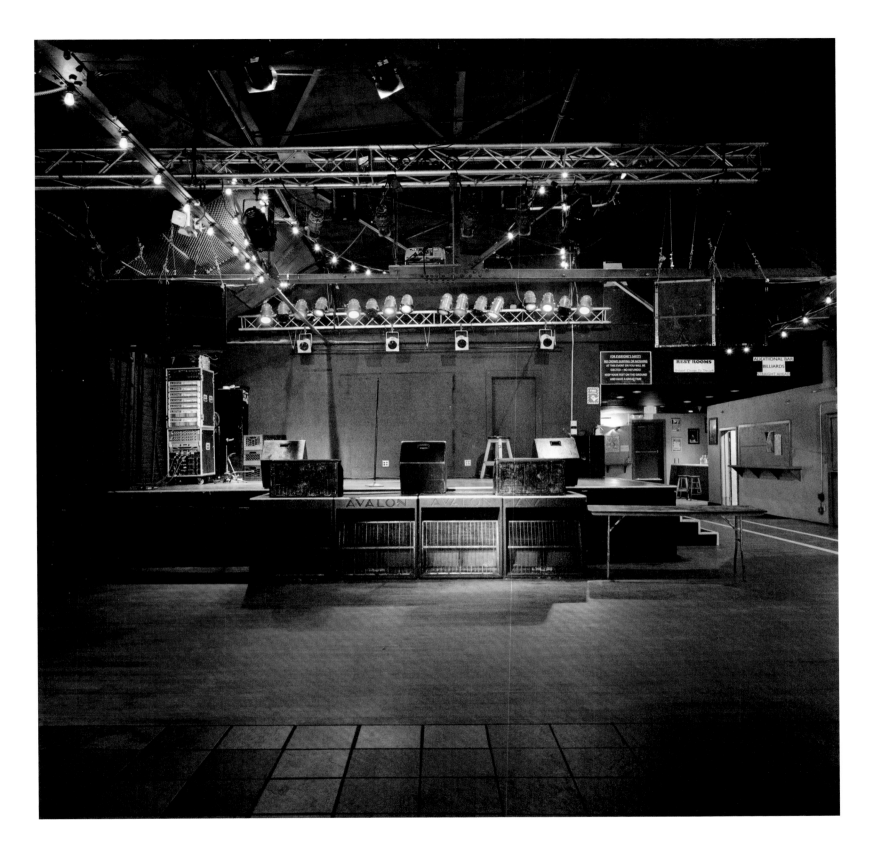

Harpers Ferry, Boston, MA — August 12, 2014

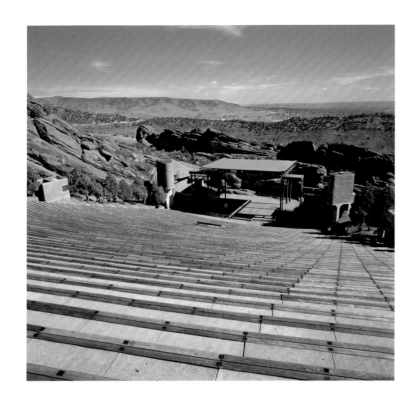
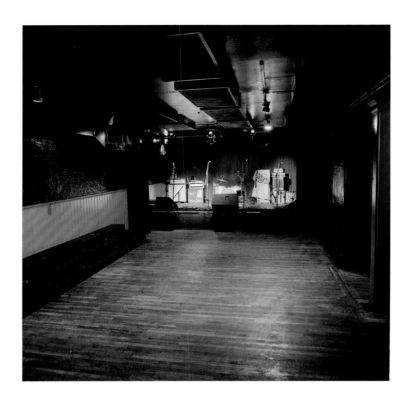
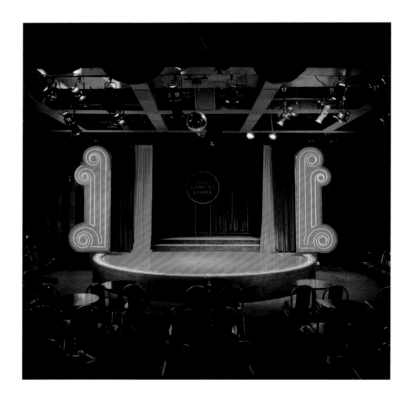

Red Rocks Amphitheatre, Morrison, CO — October 8, 2015
Maxwell's, Hoboken, NJ — July 16, 2013
Ciro's, West Hollywood, CA — August 10, 2009
Kezar Pavilion, San Francisco, CA — November 10, 2015

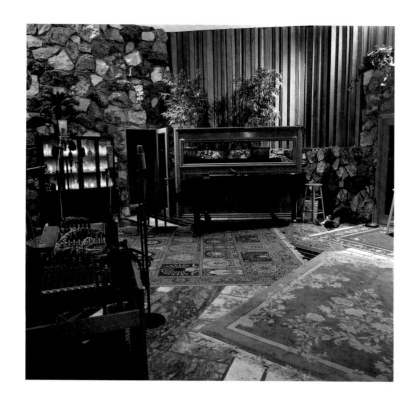

Robert Lang Studios, Shoreline, WA — November 18, 2015
Ed Sullivan Theater, *Late Night with David Letterman*, New York, NY — July 22, 2009
CC Club, Minneapolis, MN — November 17, 2013
Hatch Shell, Boston, MA — August 12, 2014

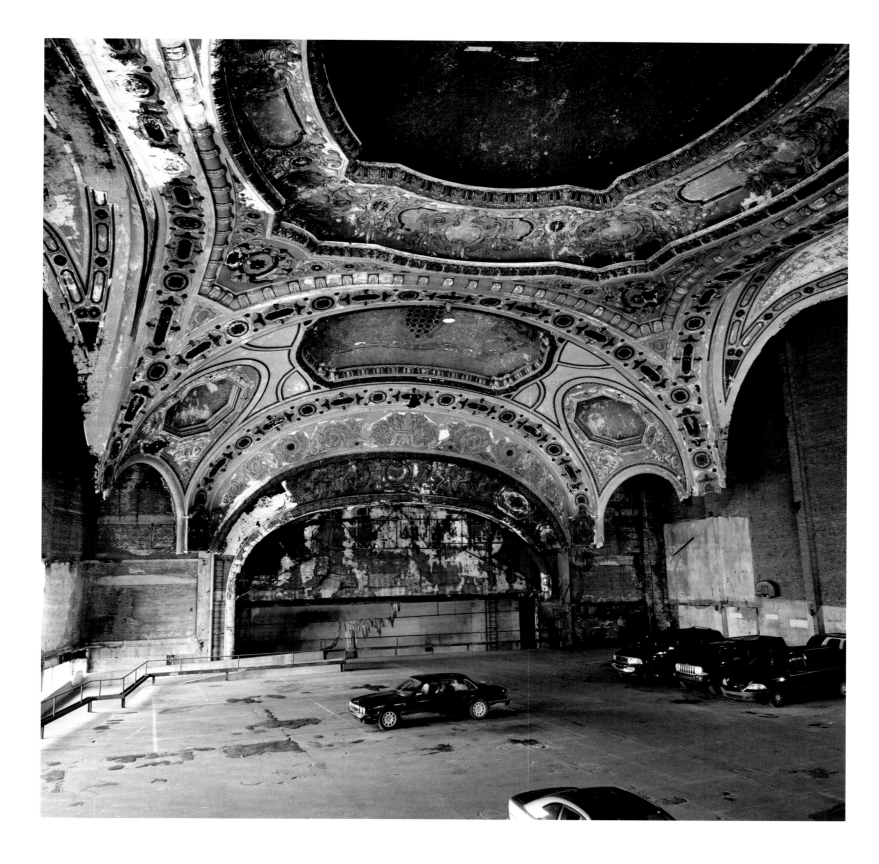

Michigan Theater, Detroit, MI — October 28, 2008

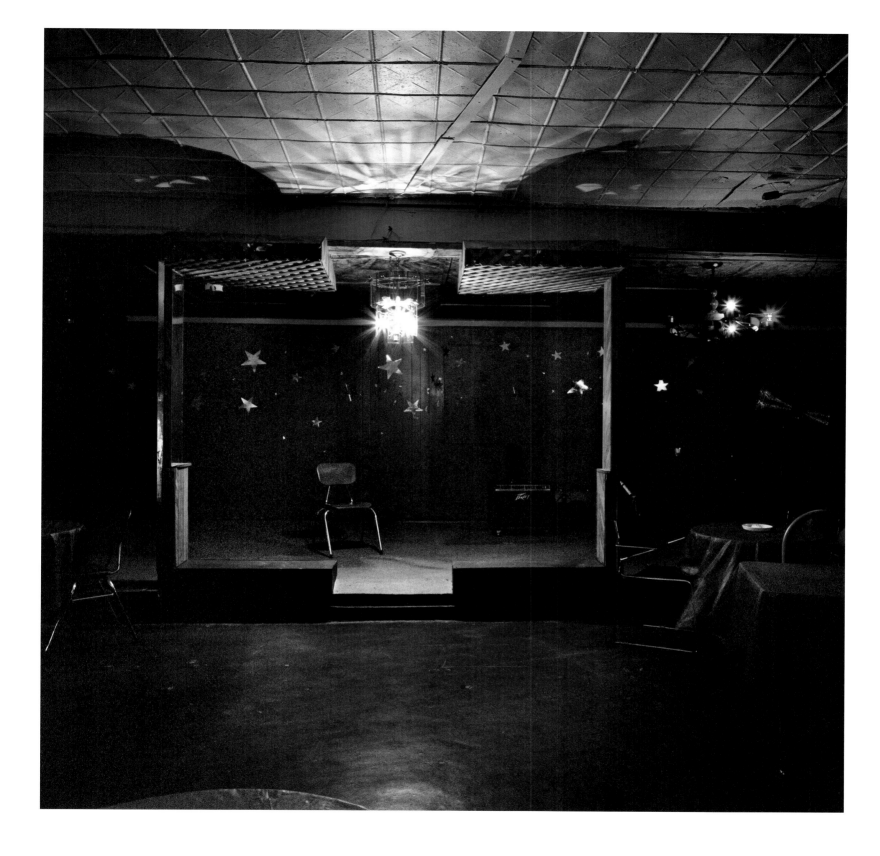

Club Ebony, Indianola, MS — May 11, 2008

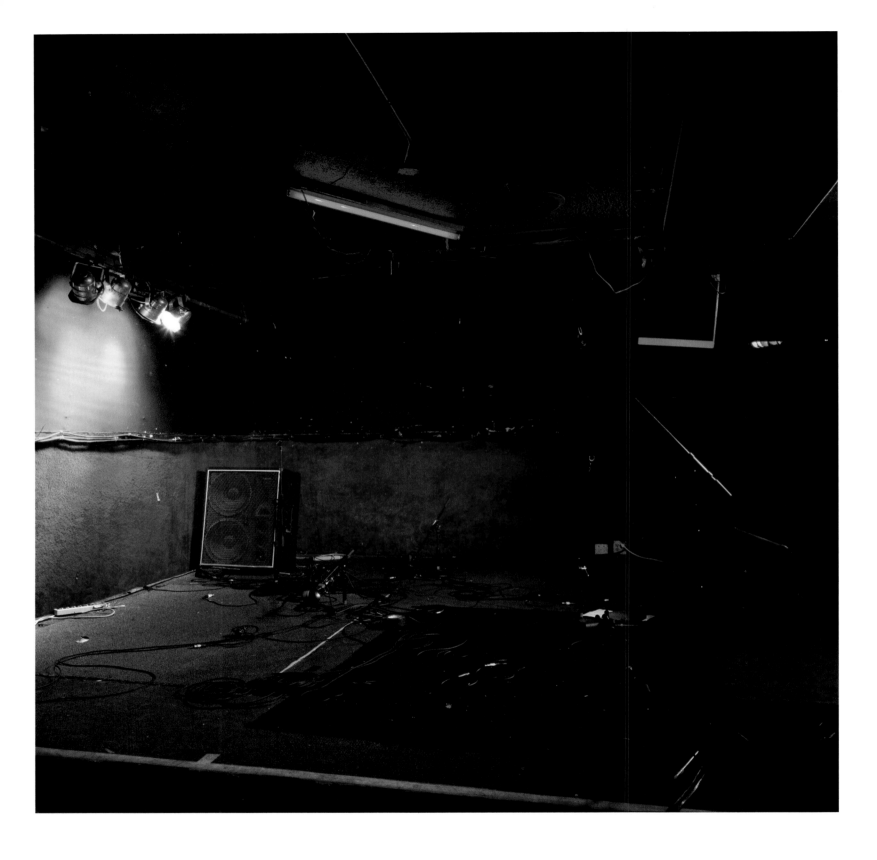

Blind Pig, Ann Arbor, MI — October 28, 2008

FORT LAUDERDALE WAR MEMORIAL AUDITORIUM,
FORT LAUDERDALE, FL

This auditorium, at the western end of Fort Lauderdale's Holiday Park, first opened in 1950 as a multi-purpose convention center and music and entertainment venue. Boxing and wrestling events were popular, as well as occasional concerts. On February 25, 1958, a rock and roll tour called "The Big Gold Record Stars" featuring Buddy Holly, Jerry Lee Lewis, Bill Haley and His Comets, the Royal Teens, and the Everly Brothers stopped here. The Crickets played behind the Everly Brothers on this date, because the promoters had failed to secure an adequate backing band.

FIRST AVENUE,
MINNEAPOLIS, MN

Two music venues housed in the same landmark building in downtown Minneapolis, First Avenue & 7th Street Entry are locally known as the Mainroom and the Entry. The Art Deco structure, built in 1937, was originally a bus depot; the space was remade as a nightclub in 1970. Joe Cocker opened this venue, then called the Depot. Frank Zappa and the Mothers of Invention, the Flying Burrito Brothers, Canned Heat, John Lee Hooker, the Faces, and Iggy and the Stooges were among the touring acts who played here. In 1972, it became a discotheque called Uncle Sam's. In 1983, the club took on a new name, First Avenue, and a new commitment to live music. The turn away from disco began on November 28, 1979, with a concert by the Ramones. The Flamin' Groovies and Pat Benatar followed soon after. The venue became a showcase for local acts including Curtiss A, the Replacements, the Suburbs, Soul Asylum, and Hüsker Dü. In the 1980s, First Avenue presented shows from popular touring bands like the Red Hot Chili Peppers, U2, the Pixies, and Joan Jett, making the club an indispensable resource for music fans in the Twin Cities. Prince performed at First Avenue several times, the first time in 1981 when it was still called Uncle Sam's. The club appears in Prince's film *Purple Rain*.

COTTON CLUB (SITE),
PORTLAND, OR

In 1963, African American entrepreneur Paul Knauls bought what had been a rather commonplace nightclub and turned it into a popular stop in the last years of the Chitlin' Circuit. The Cotton Club became a favorite for Black nightclub performers—Sammy Davis Jr., Duke Ellington, and Cab Calloway among them. In the late 1960s, it was the spot where entertainers loved to hang out when visiting Portland. Mama Cass or the Kingston Trio might take in the show if they were in town. The club closed in 1970.

HOY COMO AYER,
MIAMI, FL

In Miami's Little Havana, this nightclub presented Cuban artists like Albita and Malena Burke, as well as other styles of Latin American music for more than twenty years. The Spam Allstars were regular performers, blending Afro-Cuban, hip-hop, funk, and electronica in their unique sound.

MCCABE'S GUITAR SHOP,
SANTA MONICA, CA

This guitar shop started in 1958 as a section of Gerald McCabe's furniture store, down the street from its current location. During the 1960s folk boom, the guitar shop moved into its own space. Specializing in acoustic stringed instruments such as guitars, banjos, mandolins, dulcimers, fiddles, ukuleles, bouzoukis, sitars, ouds, and ethnic percussion, McCabe's has provided a stage for folk concerts since 1969. Townes Van Zandt, Tom Waits, Emmylou Harris, and John Fahey are a few of the artists who have performed to an intimate audience of folk music fans.

DIAMOND BALLROOM,
OKLAHOMA CITY, OK

This music venue and dance hall opened in November 1964. The stage, designed to look like a ranch patio, emulated the barn dance concept of the Grand Ole Opry's decor. Jerry Lee Lewis appeared here four times, beginning in 1967. In addition to Oklahoma's own Bob Wills, the ballroom featured performances by "outlaw country" artists Willie Nelson, Waylon Jennings, and David Allan Coe. The Bakersfield sound of Merle Haggard and Buck Owens was also in evidence in the 1960s and '70s. The 1980s and '90s found the bookings expanded to rock acts, including the heavy metal of Slayer and Megadeth, and grunge bands like Alice in Chains and Stone Temple Pilots.

STATE THEATRE,
DETROIT, MI

This grand Renaissance revival movie palace opened on October 29, 1925. The State Theatre was designed by architect C. Howard Crane. It resides on the street level of an Italianate office tower called the Palms Building. It was renamed the Palms-State in 1937, and then in 1946 the Palms, which it remained until 1982. It has been called the Fillmore Detroit since 2007. In the early 1980s, the State stopped showing films and became a live music venue. It hosted many touring bands and served as a venue for the Montreux-Detroit Kool Jazz Festival, an international event that draws top talent in jazz. Rock acts that have played here include Oasis, Urge Overkill, Danzig, and Kid Rock.

THE PADDED CELL (SITE),
MINNEAPOLIS, MN

For a time in the 1950s, this was a tough, workingman's bar called Harold's Club, which became the Padded Cell in 1955. The music was chiefly jazz: Dixieland legend Jack Teagarden played here, as did exponents of modern jazz like Kai Winding's Sextet and the Marian McPartland Trio. When the folk music revival began to catch fire in the early 1960s, the format turned to folk, and the nightclub became a key stop for touring acts. The Journeymen, a trio featuring Scott McKenzie (best known for his 1967 hit "San Francisco") and future Mamas and the Papas mastermind John Phillips, recorded an album called *Coming Attraction–Live!* at the Padded Cell in 1962.

BILL GRAHAM CIVIC AUDITORIUM,
SAN FRANCISCO, CA

Constructed for the Panama-Pacific International Exposition of 1915, the San Francisco Civic Auditorium served many functions through its long life, including hosting the Democratic National Convention in 1920, and the San Francisco Opera from 1923 to 1932. Long before promoter Bill Graham

B. B. King with his Gibson electric guitar nicknamed "Lucille," circa 1975.

Prince celebrating his birthday and the release of *Purple Rain* at First Avenue in Minneapolis, 1984.

staged his first concert, James T. Graham (no relation) managed the Civic Auditorium from 1954 to 1970, booking some of the biggest names in show business, including Elvis Presley, Judy Garland, Ray Charles, and Jefferson Airplane. The auditorium continued to stage big concerts as well as circuses, roller derbies, and Golden Glove boxing. In 1991, it was renamed Bill Graham Civic Auditorium in tribute to the consummate rock concert promoter.

MAPLE LEAF BAR,
NEW ORLEANS, LA

This bar in the Carrollton section of New Orleans opened in 1974 with a performance of Andrew Hall's Society Jazz Band. It features live music seven nights a week. James Booker, the Rebirth Brass Band, and Clarence "Gatemouth" Brown, along with other local artists, have been frequent performers. In 2005, during the immediate aftermath of Hurricane Katrina, the Maple Leaf presented the first post-Katrina concert in New Orleans, which was shut down by the National Guard for violating the citywide curfew still in place.

PILGRIM BAPTIST CHURCH,
CHICAGO, IL

Originally built as a synagogue in 1891, this was the home of Kehilath Anshe Ma'arav, the oldest congregation in Illinois, important in the development of Reform Judaism. In 1922, the building became Pilgrim Baptist Church. Thomas Dorsey was hired as musical director at Pilgrim Baptist in 1930, a position he held for fifty years. His tenure helped shape gospel music. Dorsey had been a successful blues singer and composer

in the 1920s before he was moved to reject what he saw as the glorification of sin in secular music. He brought the powerful ecstatic energy of his experience of the blues into his new career as a composer of sacred music. Dorsey popularized this new style of gospel music—a mixture of the nineteenth-century traditional African American spirituals with the blues, reinforced with handclaps and foot-stomping audience participation—through the National Convention of Gospel Choirs and Choruses. It caught on like wildfire in Black churches all over the country. Pilgrim Baptist was the heart of modern gospel music through the twentieth century, and every major musician in the genre has performed here. It played a prominent role during the Civil Rights era.

GREYHOUND BUS STATION,
CLARKSDALE, MS

This gorgeous example of Streamline Moderne design, built in 1942, was an important transportation hub for itinerant Delta blues musicians in the early twentieth century. In his essay for this book, Greil Marcus discusses the centrality of commercial bus service to the traveling musician's livelihood. In a profession that required constantly being on the road, and without the money to maintain a personal automobile, solo bluesmen had little choice. Marcus quotes the Robert Johnson lyric from "Me and the Devil Blues:"

> You may bury my body, ooh, down by the highway side / So my old evil spirit can get a Greyhound bus and ride.

(See One "Crossroads," Clarksdale, MS.)

KNIGHTS OF PYTHIAS TEMPLE,
DALLAS, TX

Designed by the African American architect William Sidney Pittman and opened in 1916, this was the state headquarters of the Grand Lodge of the Colored Knights of Pythias, a branch for African American members of the larger Knights of Pythias order. In addition to the Lodge, other Black organizations met here, making it the center of business, civic, and social life for African Americans in the Deep Ellum section of Dallas. Among the Lodge's amenities was the fourth-floor grand ballroom, used for dances and concerts. In March 1919, the Fisk Jubilee Singers, the first group in the country to popularize African American sacred music, performed in the ballroom. Bluesman Blind Lemon Jefferson performed here. **(See Central Avenue Crossing Elm, Dallas, TX.)**

JOHN AND PETER'S,
NEW HOPE, PA

Since opening in 1972, this homey club has featured live performances seven nights a week, with an emphasis on original music. Singer-songwriters Mary Chapin Carpenter and Norah Jones performed here early in their careers. In a louder vein, the club is a favorite of George Thorogood and the indie rock band Ween. The concept was to create an intimate environment like that found in a Greenwich Village coffeehouse during the 1960s folk boom. Transplanting a big city art scene to rural Pennsylvania was not as unusual as it first might seem, because for many decades this area of Bucks County has drawn artists of all kinds—transplants from New York seeking a quieter environment.

ALTAMONT RACEWAY PARK,
TRACY, CA

Built in 1966 as a motorsports race track, Altamont became notorious for the disastrous Altamont Free Concert of December 6, 1969. The Albert and David Maysles film, *Gimme Shelter* (1970) documents the concert featuring Santana; Jefferson Airplane; the Grateful Dead; Crosby, Stills, Nash & Young; and the Rolling Stones. The Hells Angels were unwisely hired to provide security for a fee of $500, paid in beer. Accounts vary as to who suggested it, but this unconventional solution to policing led to multiple beatings of audience members and several deaths, including a stabbing.

FANTASY STUDIOS, STUDIO B,
BERKELEY, CA

Fantasy Records was a San Francisco record label well known in the 1950s for West Coast "cool jazz" artists like Dave Brubeck and Chet Baker. Starting in 1968, the label struck pop gold with records by Creedence Clearwater Revival. In 1971, Fantasy relocated to Berkeley and built a recording facility to accommodate a growing roster of artists, still mostly jazz players, though pop acts would supply hits as time went on. In 1981 and 1983 stadium rockers Journey recorded huge hit albums. Chris Isaak, En Vogue, and Green Day produced some of their most successful music here.

MACON CITY AUDITORIUM,
MACON, GA

Capped by a copper-clad dome, this classical revival auditorium has hosted a variety of events since its 1925 opening. A mural above the stage depicts scenes from Macon's history, from Hernando de Soto's 1540 visit to World War I. In the 1940s, nightclub owner and entertainment promoter Clint Brantley began to book concerts here. In 1947, he produced a concert by gospel singer/guitarist Sister Rosetta Tharpe. A fourteen-year-old "Little Richard" Penniman worked at the concession stand and somehow contrived an invitation from Tharpe to open the show for her. Through the decades that followed, Brantley promoted shows starring Louis Jordan, Ray Charles, James Brown, John Lee Hooker, Otis Redding, and Sam Cooke.

9:30 CLUB,
WASHINGTON, D.C.

With the New York–based jazz-punk outfit the Lounge Lizards as headliners and the local new wave band Tiny Desk Unit as the opening act, the 9:30 hosted its first show in 1980. In the 1980s, the club became a favorite of touring punk and new wave bands, and an important all-ages venue for the D.C. hardcore scene. Go-Go, the local style of funk, was also a mainstay of the club. In 1996,

Santana at the Altamont Raceway Park in California, 1969.

the club moved to its current, more spacious address. The new 9:30 Club continued to focus on alternative music, booking bands like the Beastie Boys, Smashing Pumpkins, and Radiohead. The building was once home of the radio station WUST, which in the 1950s promoted R&B and rock and roll music on the popular program of Lord Fauntleroy Bandy, an African American DJ who spoke in a put-on posh English accent.

LATIN QUARTER,
DETROIT, MI

Opened in 1915, the Duplex Theatre in Detroit may have been the country's first two-screen movie house, comprising twin 750-seat auditoriums. Following a fire in 1922, the remnants were rebuilt as a ballroom named the Oriole Terrace. Legendary band leader Jean Goldkette managed it during the 1920s, when it was one of the biggest nightclubs in Detroit. In 1924, producer J. J. Shubert stole Joan Crawford out of the Oriole's chorus line for a part in a Broadway musical. For a time, the club operated under the name Grand Terrace. Another fire in 1940 necessitated another renovation, and another name: the Latin Quarter. This iteration was again successful, booking top talent like Duke Ellington; Sammy Davis Jr.; and 1960s Motown acts like Marvin Gaye, the Temptations, and the Supremes. It also hosted dance schools, recitals, and other local performances into the 1970s. From the 1980s until 1996, the club was a live music venue, with bands as varied as Sonic Youth, the Violent Femmes, and the Red Hot Chili Peppers appearing here before its final closure. The building was razed in 2012.

INDIANA STATE FAIRGROUNDS,
INDIANAPOLIS, IN

The 1955 Indiana State Fair was the venue for the first live performance of Tennessee Ernie Ford's iconic folk song "Sixteen Tons." Written in 1946 by Merle Travis, the song is about the hard life of a coal miner who finds it impossible to stay ahead of his debt to the mining company, no matter

how hard he works. Laborers and share croppers in the early twentieth century would have identified strongly with the working conditions described in the song. Ford recorded "Sixteen Tons" on September 17, 1955 at Capitol Studios in Hollywood. In less than two months it sold two million copies. **(See Capitol Studios, Los Angeles, CA.)**

THE MASQUE (SITE),
LOS ANGELES, CA

Los Angeles's first punk club was this basement off Hollywood Boulevard, on North Cherokee Avenue, around the corner from Musso and Frank's Grill, the venerable mainstay of the old Hollywood establishment. Opening on August 18, 1977, the Masque immediately became the nucleus of the nascent punk scene in L.A., and the clubhouse for bands including the Weirdos, the Dickies, X, Germs, Bags, the Screamers, Black Randy and the Metrosquad, and the Zeros. In addition to playing here regularly, some bands, like the Go-Go's and the Motels, rented rehearsal space. The club closed in January 1978. Founder Brendan Mullen subsequently opened a short-lived revival called Masque 2, and then Club Lingerie, which lasted from 1979 to 1991.

ONE "CROSSROADS,"
CLARKSDALE, MS

Of the many mysteries surrounding the master blues musician Robert Johnson, perhaps the most enduring is the legend that Johnson sold his soul to the Devil in return for his uncanny proficiency at the guitar. Various versions of the story abound. In some, the Devil takes the form of a large Black man who tunes Johnson's guitar at the crossroads. Similarly, different accounts point to a dozen different locations of the crossroads—this is just one possibility. On November 27, 1936, Robert Johnson recorded two takes of his song "Cross Road Blues" in room 414 of the Gunter Hotel in San Antonio, Texas. He makes no reference to the Devil or any bargain. **(See 508 Park Building, Dallas, TX.)**

SHREVEPORT MUNICIPAL AUDITORIUM,
SHREVEPORT, LA

This Art Deco auditorium opened in 1929 is notable for its lavish interior and the intricate brickwork of its facade. From 1948 through 1960, this was the home of the *Louisiana Hayride*, a weekly radio program that offered young musicians wide exposure early in their careers, Elvis Presley among them. Elvis's first appearance on the *Hayride*, in 1954, was met with a much more positive response than at the Grand Ole Opry, only two weeks prior. Elvis, with Scotty Moore and Bill Black, appeared on over fifty *Louisiana Hayride* broadcasts in the space of two years. Johnny Cash and Hank Williams also appeared on the Hayride in the early stages of their careers. In addition to the Hayride, the Municipal Auditorium presented shows by blues artists Lead Belly and B. B. King, and R&B stars like James Brown and Aretha Franklin.

BOOM BOOM ROOM,
SAN FRANCISCO, CA

Located in the historically African American Fillmore district, the Boom Boom Room opened in 1997, replacing another Fillmore institution of fifty years' standing called Jack's. The blues venue is named for John Lee Hooker's song "Boom Boom," his only single to place in the pop charts. Hooker lent his name and likeness but wasn't required to provide a financial stake in the business, which served as a hangout for Hooker during the last years of his life. Opening in 1933, Jack's was the first nightclub in the Fillmore owned by and catering to the African American community. Jack's and the neighboring clubs opened in the 1930s and '40s established the Fillmore as the place for jazz and R&B in San Francisco.

BERKELEY COMMUNITY THEATER,
BERKELEY, CA

Dedicated in 1950, this theater was designed in Art Deco style for Berkeley High School. The entrance is flanked by bas relief allegorical figures representing the arts. In addition to student

productions and school functions, the theater has staged numerous pop and rock concerts. In the 1960s, Berkeley students produced shows featuring the Byrds; the Doors; the Mamas and the Papas; Country Joe and the Fish; the Fugs; and John Lee Hooker. Rock shows have continued through the years, from Led Zeppelin to Devo. Metallica recorded *S&M*, their 1999 live album with the San Francisco Symphony, here.

WILSHIRE EBELL THEATRE,
LOS ANGELES, CA

Ebell of Los Angeles was a women's social club established in 1894. The clubhouse and theater were built in 1927. It has hosted lectures and a variety of musical events. In 1934, a twelve-year-old Judy Garland—then performing with her sisters under her real name, Frances Gumm—was discovered at one of the theater's weekly vaudeville shows and signed to a movie contract with Metro-Goldwyn-Mayer. The Dave Brubeck Quartet recorded a concert in 1953, released as *Dave Brubeck and Paul Desmond at Wilshire-Ebell* on Fantasy Records, an early album, in a year when they won both *DownBeat* magazine's readers' and critics' polls. The classical pianist Glenn Gould abruptly, and unexpectedly, ended his career with a final concert at the Wilshire-Ebell in 1964.

PEABODY HOTEL, SKYWAY BALLROOM,
MEMPHIS, TN

The Peabody Hotel opened on September 1, 1925, and from the late 1930s to the mid-1960s it promoted afternoon tea dances in the Skyway Ballroom. In the 1940s, future record producer and label owner Sam Phillips engineered afternoon radio broadcasts for WREC from the ballroom, with performances of big-name bands like Tommy Dorsey or Glenn Miller. The broadcasts were relayed nationwide on the CBS radio network. In the late 1920s, the Brunswick and Vocalion record labels used guest rooms in the Peabody Hotel as makeshift studios to record local blues musicians like Furry Lewis and Robert Wilkins.

SHRINE AUDITORIUM,
LOS ANGELES, CA

Beginning with the 1947 Academy Awards ceremony, the Shrine Auditorium has hosted numerous awards ceremonies over the years, including fifteen Grammy Awards. It has been a popular music venue as well. An Art Tatum concert recorded here was released on Columbia Records in 1952. Elvis Presley, with Scotty Moore and Bill Black, played the auditorium on June 8, 1956—the trio's first public West Coast appearance. Notable concerts include the Paul Butterfield Blues Band, the Velvet Underground, Sly and the Family Stone, Genesis, and the Tubes. Fugazi played here in 1995, and in that same year Frank Sinatra made his last television appearance with a taping of his eightieth birthday celebration. Designed in a Moorish revival style and completed in 1926, the building replaced an earlier Shrine from 1906 that had burned.

THE STONE PONY,
ASBURY PARK, NJ

One of the most famous music venues in New Jersey, the Stone Pony is best known for launching the careers of Bruce Springsteen and the E Street Band; Southside Johnny and the Asbury Jukes; and Bon Jovi. The space was originally a popular restaurant called Mrs. Jay's, which grew from a hot dog stand opened in 1922 into a restaurant and beer garden occupying half the block. Mrs. Jay's sold the restaurant building in the 1970s, retaining the beer garden, which finally closed in the late '80s. After short stints as the Jolly Trolley and the Magic Touch, the restaurant's new owners opened the nightclub called the Stone Pony in 1974.

SPHINX CLUB,
BALTIMORE, MD

Charles Tighman, owner of two previous nightclubs, opened the Sphinx as a private membership social club for African Americans in 1946. For the next two decades, the Sphinx sponsored formal dances, cocktail parties, charitable affairs, and art shows. It booked top talent like soul singer Sam Cooke and comedian Redd Foxx. The club was located in the heart of Black Baltimore's entertainment district, a fourteen-block section of Pennsylvania Avenue referred to as the "Avenue." As the first African American–owned hotel in Baltimore, the Penn Hotel was built on the Avenue in 1921. By 1945, there were dozens of nightclubs nearby: places like Wendall's Tavern, Gamby's, Dreamland, the Ritz and the Sphinx Club, now all gone.

SOLDIER FIELD STADIUM,
CHICAGO, IL

Soldier Field Stadium was built in 1924 as a memorial to U.S. soldiers who died

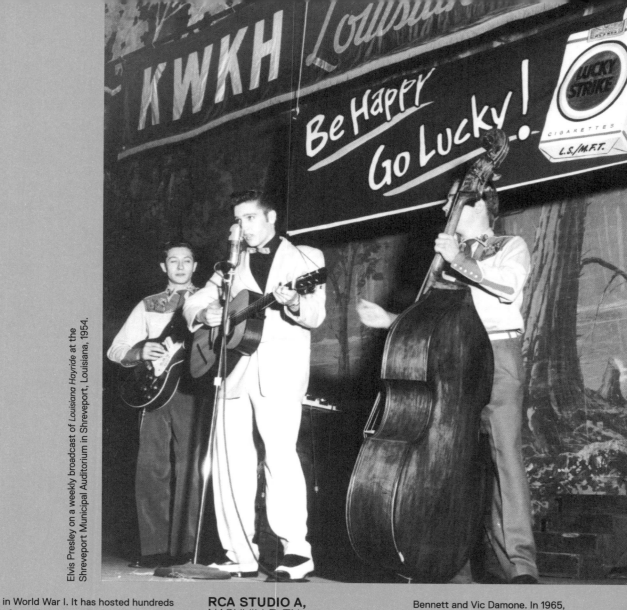

Elvis Presley on a weekly broadcast of *Louisiana Hayride* at the Shreveport Municipal Auditorium in Shreveport, Louisiana, 1954.

in World War I. It has hosted hundreds of sporting events in nearly a century of continuous operation. The stadium has also been the venue for many large musical events. On July 9, 1995, the Grateful Dead gave their last concert at Soldier Field. A month later month lead guitarist Jerry Garcia died.

FITZGERALD'S,
HOUSTON, TX

Dom Polski, a Polish community center, occupied this 1918 vintage structure until 1977, when it was recast as "Fitzgerald's." The late 1970s saw a variety of live music, from the outlaw country artist David Allan Coe to the blues and jazz singer Etta James. Beginning in the 1980s, the bookings took an indie rock turn, with bands like R.E.M., the Ramones, Soundgarden, and Sonic Youth all playing here. The club, which had been a popular mainstay of entertainment in Houston for forty years, closed in 2019 and the building was demolished.

RCA STUDIO A,
NASHVILLE, TN

Founded in 1964, Studio A was built by session guitarists Chet Atkins and Harold Bradley with record producer Owen Bradley. It became one of the most sought-after recording spaces and was crucial in the evolution of the Nashville Sound—the slick, commercial, smooth style of record production that dominated country pop music in the 1960s and '70s. The studio was used by hundreds of artists in a range of genres until 1977, when RCA closed its Music Row operations. The musician Ben Folds leased the building from 2002 to 2016 and was instrumental in the effort to preserve the studio from destruction by developers.

ROOSTERTAIL,
DETROIT, MI

This 1958 vintage restaurant, overlooking the river, was the height of mid-century sophistication in Detroit and provided a perfect showcase for acts like Tony

Bennett and Vic Damone. In 1965, the Upper Deck opened upstairs from the main dining room. Programmed by the owner's sons, this room was devoted to a younger rock and roll crowd. Alice Cooper played here in 1971. Monday nights at the Upper Deck became Motown Mondays, a weekly showcase for Motown Records talent like the Supremes, and Smokey Robinson. The Four Tops and the Temptations each recorded a live album at the Roostertail.

SING SING
CORRECTIONAL FACILITY,
OSSINING, NY

Completed in 1828, Sing Sing was the fifth prison built by New York State. On November 22, 1972, a concert featuring B. B. King; Joan Baez and her sister Mimi Fariña; comedian Jimmy Walker; and the Voices of East Harlem vocal ensemble was given for the inmates. King later said that the performance was his best. The show was organized by David Hoffman, a filmmaker who had been teaching at the

prison and who documented the show in a film titled *Sing Sing Thanksgiving*. Bruce Springsteen and the E Street Band played in the prison's chapel in December 1972.

BALL AND CHAIN,
MIAMI, FL

The Ball and Chain Saloon began life in 1935 as a gambling spot connected with organized crime. The club booked chiefly African American acts, and one of the attractions for Black entertainers was the promise of accommodation at the adjacent Tower Apartments, owned by the management. In these years of strict segregation, there were very few lodging options available for African American bands who played around Miami. The club was a favorite of Billie Holiday. White trumpeter Chet Baker also played here in the late 1950s. In 1957, Count Basie sued the club when it failed to pay his guaranteed fee, effectively bankrupting the Ball and Chain. The club reopened as the Copa Lounge Tavern, operating from 1958 to 1967.

SHEA STADIUM,
QUEENS, NY

Shea Stadium was the home of the New York Mets baseball team. It was demolished in 2009 to make way for the new Citi Field. The stadium opened on April, 17, 1964, five days before the New York World's Fair staged in Flushing Meadows—directly across the subway tracks from Shea. On August 15, 1965, the Beatles opened their second U.S. tour with a concert here before an audience of 55,600. It was the first rock concert in an arena of this size. The sound of the crowd overwhelmed any music the band created. The Beatles returned to Shea in 1966. Other shows of note include the 1970 Festival for Peace, a day-long music festival; Grand Funk in 1971, which broke the Beatles' record speed ticket sales; and a 1982 appearance by the Who, with the Clash opening the show.

GRANADA THEATER,
DALLAS, TX

This Art Deco theater was built in 1946 as a movie house. The interior features murals of scenes from history up to the Space Age's early days. It was converted into a concert hall with the addition of a sound system, lights, and a larger stage in 1977. The new venue had a promising start, opening with Kenny Rogers, but the experiment did not last and the space reverted to a movie theater soon after. In 2002, new operators refurbished the Granada, transforming it into a live concert venue once again.

THE ROXY,
WEST HOLLYWOOD, CA

Previous tenants of this building include a supermarket, which in 1957 became a burlesque theater called the Largo. In 1973, a group of investors—including A&M Records co-owner and record producer Lou Adler—remade the Largo into the Roxy, a nightclub with live music. The opening engagement was three nights of Neil Young and Crazy Horse. In 1974, Adler brought the London stage production of the *Rocky Horror Picture Show* to the Roxy for its U.S. premiere. The small bar upstairs called "On The Rox" is known as John Lennon's customary hangout during his notorious "lost weekend" period in 1973–74, where he was frequently accompanied in drunken revelry by Harry Nilsson, Keith Moon, and Alice Cooper. On August 6, 1976, the Ramones played their first California show at the Roxy. Performers who have released live albums recorded here include Bob Marley, Warren Zevon, and Frank Zappa.

VIKING BAR,
MINNEAPOLIS, MN

This was a popular stop on the folk and acoustic blues circuit in the 1960s. Local artists like "Spider" John Koerner, Bill Hinckley, and Judy Larson performed here regularly, as did the blues combo Willie Murphy and the Bees. Murphy was a piano player, guitarist, singer, and songwriter who produced Bonnie Raitt's debut album in 1971. Raitt was another frequent performer at the Viking early in her career. The Minneapolis Brewing Company built this two-story brick building in 1904, and it was a bar ever since with the exception of the Prohibition years, when it was a grocery store. It became the "Viking Bar" in 1959.

PARK PLAZA,
LOS ANGELES, CA

This eclectic mix of Beaux Arts, Art Deco, and Moorish architecture was constructed for the Benevolent and Protective Order of Elks in 1926. In the 1960s, it became the luxury Park Plaza Hotel. As the surrounding neighborhood decayed in the late 1970s, the hotel became the setting for a series of illegal nightclubs. On St. Patrick's Day, March 17, 1979, an all-ages punk rock show was booked into the former Elks auditorium with the Alley Cats headlining and the Go-Go's, the Plugz, and the Zeros opening. The Go-Go's were the only band that was able to play, however, because the Los Angeles Police Department arrived in full riot gear to close down the show, and incidentally beat up a few young punk fans.

HARPERS FERRY,
BOSTON, MA

Equidistant from both Boston College and Boston University, Harpers Ferry was a live music venue and bar in Boston's Allston neighborhood. Opening in 1970, its early days featured blues or R&B acts like Taj Mahal and Bo Diddley alongside rock bands like Jefferson Starship. Harpers Ferry was an important venue for the Boston hardcore punk scene in the 1980s and '90s. The nightclub closed in 2010 and reopened the same year as the Brighton Music Hall.

RED ROCKS AMPHITHEATRE,
MORRISON, CO

A bowl-shaped natural amphitheater existed at Red Rocks for many centuries; a temporary platform was built in 1906, taking advantage of this feature to stage concerts. The project to refine this site into a permanent venue was undertaken with help from the federal government's Civilian Conservation Corps and the Works Progress Administration. Construction of the theater began in 1936 and it opened in June 1941. Performances have spanned all genres, from classical to pop. The venue has been used repeatedly for live recordings. In August 1964, the Beatles played Red Rocks—an early rock and roll concert for the venue. They failed to sell out the show, only one of two times this happened during the tour. In 1971, several hundred people without tickets tried to crash the gate at a Jethro Tull concert, resulting in a five-year ban on rock acts at Red Rocks. U2 filmed their 1983 concert here, releasing the result on video-cassette as *U2 Live at Red Rocks: Under a Blood Red Sky*.

MAXWELL'S,
HOBOKEN, NJ

Beloved by fans and bands alike, Maxwell's was a vital incubator of the Hoboken music scene and a champion of indie rock throughout the 1980s, '90s, and into

the new century until its demise in 2013. It earned a reputation among musicians for supporting indie bands and drawing enthusiastic audiences. Introducing three original members of the Bongos and Glenn Morrow from the independent record label Bar/None, the first band to play Maxwell's was "a." The club became an essential stop for touring punk, indie, garage, and grunge bands. Several groups have recorded live albums here, including Guided By Voices, the Reigning Sound, the Meat Puppets, and the Replacements' *For Sale: Live at Maxwell's 1986*. Maxwell's was the home for Yo La Tengo's popular guest star-studded Hanukkah concert series.

CIRO'S,
WEST HOLLYWOOD, CA

Built in 1940, this nightclub has had several lives. First as Ciro's, the glamorous nightspot filled with Hollywood's elite. That era ended in bankruptcy in 1959. In 1964, it was resurrected as a rock and roll club called Ciro's Le Disc. The Ike and Tina Turner Revue played here in December of 1964, and the Byrds used regular appearances at Ciro's to develop their unique folk rock sound. In 1965, surf guitarist Dick Dale used the club to record *Rock Out With Dick Dale & His Del-Tones Live At Ciro's*. In 1967, the club was renamed the Kaleidoscope; in 1968 it was known as It's Boss; and by 1969 it was called Patch 2. The final stage of metamorphosis happened in 1972, when it became the Comedy Store, a venue for stand-up comedians.

KEZAR PAVILION,
SAN FRANCISCO, CA

Built in 1924 and used mainly as an arena for collegiate sports, the Pavilion seats four thousand and is owned and operated by the City of San Francisco. It is a smaller adjunct to Kezar Stadium, home to the 49ers football team from 1946 to 1971. The Pavilion is a popular music venue due its proximity to the Haight-Ashbury neighborhood. In 1966, Janis Joplin played here with Big Brother and the Holding Company. Kezar has occasionally hosted concerts with punk bands. On October 13, 1979, the Dead Kennedys and the Cramps supported headliners the Clash. San Francisco noise punks Flipper played here in 1981. The May 29, 1981, performance of Throbbing Gristle at the Pavilion was be the band's last until their reformation in 2004.

ROBERT LANG STUDIOS,
SHORELINE, WA

This recording studio—built in a private home in the Shoreline residential neighborhood—dates to 1974. Studio A was dug 30 feet down into a hillside abutting the main home, with poured concrete and exposed rock walls. Musicians based in the Northwest have recorded here in a wide range of styles.

One of the first to use the studio was jazz saxophonist Kenny G. Hip-hop artist Sir Mix-A-Lot and dozens of indie rock bands like Nirvana, the Foo Fighters, and Death Cab for Cutie, have recorded hits here.

ED SULLIVAN THEATER,
LATE NIGHT WITH DAVID LETTERMAN,
NEW YORK, NY

Originally built as Hammerstein's Theatre in 1927, this theater on the street level of a thirteen-story office building went by many different names before CBS radio network signed a long-term lease and began broadcasting here in 1936. In 1950, the theater was converted to television use and named "CBS Studio 50." The studio hosted the *Jackie Gleason Show* and *Arthur Godfrey's Talent Scouts* programs. The *Ed Sullivan Show*—the popular variety show launched in 1948—moved to Studio 50 in 1953. On the program's twentieth anniversary in 1968, the studio officially became the Ed Sullivan Theater. The program featured many outstanding pop music segments. Unlike many programs featuring music, these were performed live—not lip-synced. Of the hundreds of acts presented during the show's twenty-three-year-long run, perhaps the two that had the greatest impact were Elvis Presley's three appearances in 1956 and the Beatles' three dates in 1964. After the *Sullivan* show ended in 1971, productions included game and talk shows. In 1993, David Letterman's late-night talk show moved to CBS and into the Ed Sullivan Theater. *Late Night* featured live musical performances, often backed by the show's band led by Paul Shaffer. Currently the theater is home to the *Late Show with Stephen Colbert* with a band led by Jon Batiste.

CC CLUB,
MINNEAPOLIS, MN

A neighborhood venue dating back to Prohibition, the CC Club became a hangout in the early 1980s for Minneapolis indie rockers the Replacements, Soul Asylum, and Hüsker Dü. Its location across the street from Oar Folkjokeopus, an independent record store, was an attraction for young musicians. The bar's atmosphere was an inspiration for the Replacements' song "Here Comes a Regular."

HATCH SHELL,
BOSTON, MA

With an exterior finished in terrazzo tile and an interior finished in wood, Hatch Shell is an Art Deco outdoor concert venue opened in 1940, best known for hosting the Boston Pops Orchestra under the direction of conductor Arthur Fiedler in their annual July Fourth celebration. The Edward A. Hatch Memorial Shell presents many other free concerts throughout the warm summer months. Arlo Guthrie, James Taylor, Aerosmith, the Guess Who, and Green Day have played shows here.

MICHIGAN THEATER,
DETROIT, MI

At the time of its opening in 1926, this French Renaissance revival–style movie palace was the most opulent theater in downtown Detroit. The theater was built on the site of a townhouse that Henry Ford rented while working on his first automobile; his workshop was a coal shed in the rear. Its grand lobby was four stories high, laden with mirrors, a marble floor, columns, red velvet hangings, and large crystal chandeliers. Between each pair of columns hung an oil painting by a National Academy member. Silent films shown in the auditorium were accompanied by a full orchestra or a huge Wurlitzer organ that rose up from the floor. Shows usually started with an orchestra concert, two twenty-minute stage shows featuring variety acts, and then a film. Among the live performers in the 1930s and '40s were comedians like the Marx Brothers, Bob Hope, and Red Skelton, and big bands led by Benny Goodman, Glenn Miller, and Tommy Dorsey. Like most great movie palaces, the Michigan Theater fell on hard times—a victim of changes in the entertainment business. It changed owners several times and screened its final film in 1971. After a brief attempt at converting the theater into a supper club, in 1973 it was transformed into a concert venue called the Michigan Palace. Many of the top rock acts of the 1970s performed here, including David Bowie, the Stooges, the New York Dolls, Aerosmith, Bob Seger, Rush, KISS, and Badfinger. The venue closed in 1976. The following year, the building was gutted and a multi-level parking garage with space for 160 cars was installed.

CLUB EBONY,
INDIANOLA, MS

Opened in 1948 by Indianola entrepreneur Johnny Jones, this was one of the South's most important African American nightclubs. Under Jones and successive owners, the club showcased Ray Charles, Count Basie, Bobby Bland, Little Milton, Albert King, Willie Clayton, and many other legendary acts traveling the Chitlin' Circuit, the loose network of theaters and

nightclubs for Black entertainers. B. B. King bought the club in 2008 when its second owner, Willie Shepard, retired. It is now operated by the B. B. King Museum.

BLIND PIG,
ANN ARBOR, MI

The Blind Pig (another name for a speakeasy) opened as a café in 1971 and quickly became an important resource for live music in the university town of Ann Arbor. In the 1970s, it was primarily a blues venue. Koko Taylor, Lightnin' Slim, Roosevelt Sykes, and Detroit's own Boogie Woogie Red were some of the regularly featured acts in the early days, occasionally yielding the stage to rockers like the MC5. In the 1980s, the space expanded, as did the booking policy, and the Pig became a regular stop for touring indie bands like R.E.M., Soul Asylum, and Sonic Youth. A new band from Washington State called Nirvana opened for Soundgarden here in 1989. Nirvana returned to headline the following year, and in an MTV interview they cited the Blind Pig as their favorite place to play.

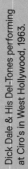

Dick Dale & His Del-Tones performing at Ciro's in West Hollywood, 1963.

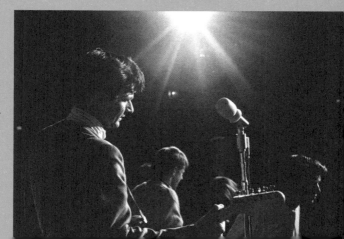

Greil Marcus
Hear In This Place

Spaces where music took place. Where something happened, and when people play there now they realize that they are standing on the same stage where—and let's say it's First Avenue in Minneapolis. Before you played here you used to wait in line on the sidewalk and look at the names inside the stars on the facing wall. It's sort of corny: names inside of stars. But then you're on stage and you realize that your right foot, just a step in front of your left, is in the same spot where Prince put his. You can almost imagine that there is an imperceptible depression on the stage. That he left a mark. And so you press down harder, as if you will, too.

Or, perhaps with even more force, you're in the crowd in the same place. You're looking up at the stage. You know that countless people before you stood where you are standing now, and when the show was over they walked out feeling as if the world had changed, as if nothing would ever be quite the same —and that, maybe the odds are a million to one, that will happen tonight, and everyone will feel it. The band plays this set every night; maybe it means nothing to them. It's their job, their work, their calling, even— they can't imagine doing anything else. But for you, it's as if you've entered into history. Nothing like this has ever happened to you before, and you can feel, with an odd combination of disappointment and satisfaction, that nothing like this will ever happen to you again. Because if it did, then that first time wouldn't be that special at all, would it? If it could happen anywhere, any time?

But it did happen anywhere, at any time. This book is a public history of those private moments. It is absolutely ephemeral—there are no people in the places Rhona Bitner photographed, no ecstatic faces, no swirling bodies. You have to imagine yourself into these places, and imagine what might have happened to you if you'd been lucky enough to be there when, as Bob Dylan put it when describing seeing Buddy Holly at the Duluth Armory, just days before his plane went down, "Something about him seemed permanent and he filled me with conviction.

Then out of the blue, the most uncanny thing happened, he looked at me right straight there in the eye and he transmitted something, something I didn't know what. It gave me the chills."

It is ephemeral, too, because while a building may be raised and events may take place there, the building can be razed to the ground and all traces of those events erased. Bitner's work is, among many other things, a history of how a place where history was made, public history, private history, a version of the American story, is just a deed. Here you will see that playing out, as the place where, once, he or she looked right at you—or could have, if you'd even been born when that person was on the stage—is torn down, sold, made into something else. Walls have ears but what happens when the walls are ripped out? What happens is this: if the right person decides to make it her job, her work, her calling to be that imaginary witness, to imagine herself as present when history was made, to testify that, once, part of a country's legacy was invisibly coded into a certain structure, then the walls, present or not, will also have voices. If you listen closely enough, they will tell you what they heard.

Thirteen years, from 2006 to 2018, and thousands and thousands of miles of travel, crisscrossing the continental USA, touching down in twenty-six states and the District of Columbia, are the parameters of Bitner's project: a travelogue through and retrieval of places where, from the second decade of the twentieth century on (but mainly "pre-Elvis to the Ramones," as she puts it—in these pages, from Sam Phillips's studio in Memphis to CBGB in New York), American musicians faced the public, whether it was tens of thousands in stadiums or a few dozen in a club, but mostly in theaters and joints: places where you can, looking now, feel both distance and intimacy. And the kind of history that has to twist itself out of itself to stay alive.

Retrieval: The Beatles played their last show at Candlestick Park, home of the San Francisco Giants,

in 1966. The Giants were in Philadelphia; I sat near first base, where I'd seen them play so many times before. The Beatles were on a stage set up in shallow center field. Three girls behind me had it all planned out: "OK, first, as soon as they start the first song, we shout GEORGE!" The forgotten Remains, from Boston, opened, followed by the unforgotten Ronettes; if any other bands ever played there I've forgotten or never heard about it. Today it is an RV park and a public recreational area; when Bitner got there in 2015 all that was left was a landfill. A river of trash, a dune, in the background one red remnant triangle of structure, a stadium pottery shard, pure Ozymandias. *Gather round, children, a tale I will tell—once, on this spot, history was made. Or unmade.*

At Central Avenue and Elm in Dallas in 2013, Bitner looked up from a slag heap of mud to a grimy freeway overpass that somebody once had tried to make at least marginally appealing with a series of rectangles bisected into red and beige triangles. The picture she made of the place says absolutely nothing on its face; she has captured its historical silence so completely that you can't even imagine traffic noise as you look. But in the 1910s and '20s, this was Deep Ellum, the loudest place in town. Blacks and whites crowding the streets as they did not do anywhere else in the brutally segregated city, in and out of bars, brothels, music joints, drug dens, sometimes places that were all of them at once. In 1915, maybe 1922, when you hit the corner where Central crossed Elm you might have stopped to hear "Blind Lemon" Jefferson singing "If you go to Deep Ellum, keep your money in your shoes"—or "Black Snake Moan." "See That My Grave Is Kept Clean." The most deathly version of "Jack O'Diamonds" on earth. "Matchbox Blues," recorded three decades later by Carl Perkins and the decade after that by the Beatles. The building blocks of American music. This is the place where it happened. Even if you know nothing of any of this, Bitner's simple identifying note will let you find out all of it, and you can be present at the creation. For a dime, Jefferson will play any song you can name.

Travelogue: in 2008, Michigan Theater in Detroit was a parking lot, but the ceiling still rose up like the cosmos itself. Frank Sinatra and Duke Ellington, Louis Armstrong and Benny Goodman played there, and then David Bowie and the Stooges, Bob Seger and the New York Dolls. Did they think it was camp, *Oh, this place is so trashy, so pretentious, it's perfect!*

Or did they think, *How am I ever going to live up to this? How can I blow into this void?* Twisted history: Ball and Chain in Miami was a mob joint that booked jazz musicians in the 1950s. When Bitner shot it in 2015, there were still posters for a Chet Baker show, No Cover, No Minimum, "the ruined prince of West Coast jazz" (Dave Hickey) not yet a ruin, his face fresh, looking not a day over twenty-five, white T-shirt, pompadour, and what did he think, playing there, what did the crowd think, sitting there? *Junkie on the bandstand with his own ball and chain—really. Man, you can't make this stuff up!*

There are teasing synchronicities as Bitner takes you through a parade of nightspots and halls and firetraps (some places so destroyed, so abandoned, so collapsed, so fallen down on themselves, that the eye can't put them back together as whatever they were): opulent theaters, punk monuments, blues emporiums, nightclubs. You might be looking at El Chapultepec in Denver, until it closed for good in 2020 with COVID-19 turning the streets into badlands, a leading jazz spot that went back to the 1930s. As Bitner found it in 2015, it's just a bar, small and warm, a place that in the 1940s you could have found in any town in the country, the sort of place that turns up in the third chapter of any Raymond Chandler mystery. Dark, but not too dark. You walk in, and even if people look up because they haven't seen you before, you feel like you've been there before, and if you're white and not a woman alone, or maybe even if you aren't or you are, the bartender doesn't ignore you and nobody catches their buddy's eye because you ordered wrong. There are a few padded stools on the left at the bar proper, likely as many upholstered booths on the right. In the back, under a lit-up neon sign for Coors Light with a saxophone on the left and a Modelo sign on the right, there's a slightly raised wooden platform with a couple of mikes, a compact drum set, a piano, a soundboard, an amplifier. This is Denver 2015, but it's also 1946, in *The Best Years of Our Lives*, with Harold Russell and Dana Andrews leaning over Hoagy Carmichael at the piano in Uncle Butch's bar in Boone City—Boone City, Ohio, maybe, or Illinois, but put your money on Indiana and you'd be right. That's the music you can hear in this place: Carmichael's "Washboard Blues." "Lazy River."

The music you can hear: hear is what happens, inside the contradiction of this book and its title. *Listen*—and yet formally every picture here is resolutely silent.

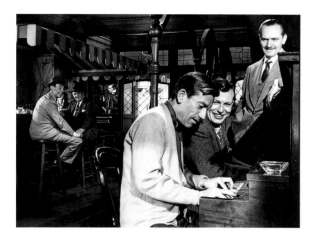

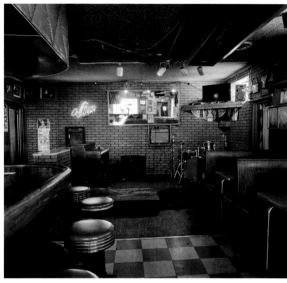

Fig. 1 — Still from *The Best Years of Our Lives*, 1946.
Fig. 2 — Rhona Bitner, *El Chapultepec, Denver, CO*, October 8, 2015, from the *Listen* Project.

With not a single living person to be found in any picture here, every room is empty. You don't see the B-52s fumbling through their first song at their first show when you look at the green painted walls and doorway at 653 North Milledge Avenue in Athens, Georgia, and they don't hover like ghosts, either. The images dare you to imagine that you are there to hear, to see, whatever happened in each place Bitner found and each place she has chosen, 299 places as collected here out of 395 places where she stopped and set up. And Bitner absents herself from her pictures as firmly as she emptied them of others, by never calling attention to herself as a photographer, as a chronicler, because as a witness her role

is so much deeper—so much so that she has no need to cater to the clichés of music photography; places for Bitner are what faces were for Richard Avedon. She avoids angles, dramatic perspectives up or down; as an artist she erases artiness. She shoots the places she has chosen, that have drawn her, directly, trying as deeply as possible to let the spaces speak for themselves, if they will.

There are different kinds of silences. The most silent picture here is the Greyhound bus station in Clarksdale, Mississippi, as it was in 2008. It's so empty that it could be a graveyard. No buses. You can perhaps hear wind—or is it seen? You want something to be moving through this clean, white structure with cool blue-gray trim, where starting in the late 1910s, after the Greyhound Bus Company was founded in Hibbing, Minnesota (the impossibly elegant concert hall in Hibbing High School, where Bob Dylan and his band played to their classmates in 1959, is on Bitner's map), blues singers left town or came back. Charley Patton, Son House, Willie Brown, after them Muddy Waters, Roebuck Staples, hundreds more. And yet this spot not only talks; it says one thing, over and over, has been saying it since the '30s, when Robert Johnson sat on a bench there, or maybe just a curb, the only place to sit as you look, working out the ending of "Me and the Devil Blues." He got it: "You may bury my body, down by the highway side / So my old evil spirit / Can get a Greyhound bus, and ride."

And that might take you back to the two empty rooms that, for me, sum up the whole book—because even if someone were to have stolen Bitner's idea, no one else would have ever thought to light in these places where, separated by twenty-seven years and something under a hundred miles by car, the kind of history Bitner has followed left no mark at all, except through her own eye.

One is in Raymond, Washington: the living room of the house on 17 Nussbaum Road where Nirvana played its first show in 1987 at a private party. It looks like a living room, not the sitting room of the local Elks Club, but it could be that, too—it isn't large. It's not easy to imagine Nirvana or any other band setting up here, or for that matter to see any kind of crowd, even six or seven, standing there to hear them. Except for a little flat-screen TV on a table and a fire in a woodburning stove, this looks like a room that's been closed off for years: the ugly

drapes, the over-upholstered chairs, the six-point deer head on the wall. Or maybe it was the coolest place in town in 1987 and after that first show someone came in determined to wipe away the fact that anything ever happened here. This photo is a crime scene; it's a detective story. And as you look into the picture, you begin to write it. There is, after all, a body.

Then there is the music room of Wilson High School in Tacoma, Washington, where a thread of the Sonics came together in 1960. As Bitner found it in 2015, there are more than a dozen blue chairs and music stands, scattered around a big room in front of a spinet, a small drum set off to the side. It's the easiest thing in the world to imagine Rob Lind walking in after classes, finding Gerry Roslie at the piano, picking up a saxophone—*what'd you know, what'd you like? "Long Tall Sally," I can do that. What about "All Around the World," that's trickier*—and realizing there was more there between them than an afternoon. So with a drummer friend, Bob Bennett, they formed a band, one of probably several hundred bands all around the world at that moment calling themselves the Searchers, and then another one that was coming together, this one with a name at least somewhat less common, the Sonics. Maybe something of the coldness of that music room came into the harshness of their sound: around the Northwest, it was the hardest sound to push back against. "The Sonics recorded very, very cheaply, on a two-track you know, and they just used one microphone over the drums, and they got the most amazing sound I've ever heard," Kurt Cobain once said. "Still to this day, it's still my favorite drum sound. It sounds like he's hitting harder than anyone I've ever known."

If you're holding this book in your hands, chances are you know Nirvana. You may not know the Sonics, even though the Sonics are still playing, and Nirvana played their last show in 1994. So you enter "the Sonics" on your phone, and do what the book says: you listen.

Natalie Bell

Unlimited Frequencies

"To photograph is to confer importance," Susan Sontag wrote, in one of her many timeless and maximlike observations.[1] On one level, Rhona Bitner's photographs of performance sites do just that. Gathered together, the photographs that compose *Listen* (2006–18) tell a story of American music history—primarily rock and roll and punk, with nods to the blues, jazz, and country that gave birth to them—from the crumbling interiors of ballrooms and music halls that have long since been left to decay, to the pristine gold-toned Graceland, to the faded faux ornamentation of high school auditoriums from Hollywood to Hibbing. They are not beautiful spaces, all of them—at least not in a conventional way. But this too is what Sontag meant, about leveling "discriminations between the beautiful and the ugly, the important and the trivial." This parking lot with an oddly ornate proscenium looks utterly mundane, but it is not. This drop-ceiling social club looks like any old VFW, but it's anything but. Each derelict basement space, empty gymnasium, and wood-paneled Midwest dive bar is a historic site of live music—a cultural diamond in the rough—and Bitner's archive of photographs serves as a kind of national registry.

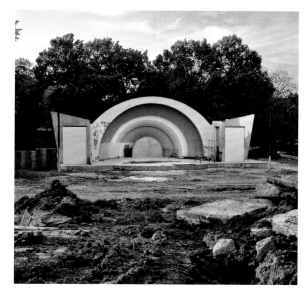

Fig. 2 — Gustave Le Gray, *Le Puy, cathedrale Notre-Dame, le cloitre en restauration (Le Puy, Notre Dame cathedral; the cloister in restoration)*, 1851. Bibliothèque nationale de France, Paris.

The fact that some of these sites are in a state of ruin, some nearly wiped off the map, and others perhaps on the brink after a year or more of forced closure from the pandemic is also an indication that many of these spaces represent a kind of endangered species. Which is also to say that Bitner's pictures participate, in at least one regard, in a photographic tradition of cataloguing disappearing sites. One might think all the way back to the early nineteenth-century photography of Gustave Le Gray, Charles Marville, Eugène Atget, or Nadar, who sought to document medieval Paris or archived its catacombs and ancient sewers—all of which faced imminent erasure under General Haussmann's regime of modernization. And it's true that the very photo that launched this project—that of New York City's CBGB, within a week and a half of the club's being shuttered—marks the turn of the subsequent century, and the rapid gentrification that continues to phase out that city's hopelessly aging sites. The fact that

Fig. 1 — Rhona Bitner, *Overton Park Shell, Memphis, TN*, May 5, 2008, from the *Listen* Project.

1 — Susan Sontag, "America, Seen Through Photographs, Darkly," in *On Photography* (New York: Farrar, Straus and Giroux, 1977), 21. Speaking of Alfred Stieglitz and Walker Evans, two canonical photographers of twentieth-century America, Sontag observes a lineage from Walt Whitman—a project that levels "discriminations between the beautiful and the ugly, the important and the trivial."

Bitner nosed her way into the CBGB space practically in its eleventh hour and made her image within the mere fifteen minutes she was allowed, signals an urgency (and undoubtedly a personal connection) that the artist felt, and suggests both documentary and historicist agendas at work in her desire to record what remains of these places before it's too late. With nearly four hundred photos in a series that spans eighty-nine cities across twenty-six states—and over thirteen years of knocking on doors, pitching and persuading over email and voice mail, hopping flights at the last minute when an opportunity arose—the project that is *Listen* is absolutely a labor of love, an obsession, and a commitment to documentation—but it is a work that exceeds that in its multiple conceptual and haptic dimensions.

Perhaps above all else, it is the idea of performing, or performance, that drives Bitner's photographs. Her work investigates the paradoxes and conundrums of performance's ephemerality: What is visible and what is not? What is indexed by the medium of photography, and what are those fluid, intangible, and ephemeral aspects that resist it? How much —or how little—can be conveyed by a two-dimensional photographic image? And how can a photograph engage the experience of the viewer the way live performance does?

In *Stage* (2003–08), for example, Bitner pictured stages in their barest moments, either at the beginning or the end of a performance. Embodied in these works, which she printed at 4 feet (1.2 meters) wide, is an overwhelming sense of anticipation, a pure theatricality altogether stripped of performance, performers, or narrative. *Stage* led Bitner on an odyssey of sorts as well: she visited twenty-three theaters over five years to build that set of images. For her series *Circus* (1993–2001), the spectacle became a site of study as a specific theatrical genre, and a way to zoom in on circus performers—and their construction and maintenance of personae. This series of 237 images was assembled over eight years as Bitner attended seventy-six performances with forty-six circus companies. Bitner's observation that people viewing the *Circus* series experienced discomfort or apprehension when looking at the clowns led her to explore this reaction and relationship in a subsequent project, *Clown* (2001). In this series, photographs of professional clowns offering their most serious gazes are printed to human scale so that when viewed, they mirror the scale of their viewer.

Fig. 3 — Rhona Bitner, *NV3*, 2004, from the *Stage* series.

Listen is a series that emerges from this lineage, as Bitner addresses histories of performance by turning her lens on historic sites, while taking us beyond the image itself. Within the realm of artists using serial photography to document, one might be tempted to look at a series like *Listen* and think of other projects driven by typologies or inventory. While there are careful parameters at work (no people, no additional lighting), and certainly an artful framing of the documented sites, Bitner has described this collection of photographs as a "simple inventory of places and spaces." And yet it would be completely missing the point to cast this body of work alongside other cataloguing projects, whether something de-skilled and conceptual like Ed Ruscha's built-environment panorama *Every Building on the Sunset Strip* (1966), or Bernd and Hilla Becher's artfully precise life project of capturing Western Europe's disappearing

Fig. 4 — Ed Ruscha, *Every Building on the Sunset Strip*, 1966, Collection Walker Art Center, Minneapolis. Collection Walker Art Center, 1997.

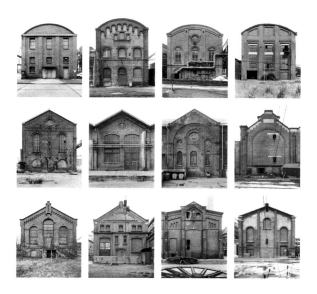

Fig. 5 — Bernd and Hilla Becher, *Industrial Facades*, 1967–92.

industrial-era architecture over the last four decades of the twentieth century. Bitner may share with Ruscha an interest in sites of nightlife and collective cultural consumption, and with the Bechers an interest in sites of energy production, but her work in *Listen* takes on a very different direction and its title is perhaps the most important signal.

As far as photographic inventories go, a close cousin might be Martha Rosler's *The Bowery in Two Inadequate Descriptive Systems* (1974–75). Rosler's work consists of twenty-four images of building fronts on New York's Bowery—a street that has never *not* been host to an outsize transient or unhoused population—and yet none of these images features a human figure in the service of the artist's social commentary. Instead, juxtaposed with each image is a set of typewritten words that describes altered states of mind: "plastered / stuccoed / rosined / shellacked," and so on. Departing from documentary or photojournalist strategies, Rosler uses language to conjure associations. In a similar gesture, Bitner uses language—specifically the title of the series, *Listen*—to signal a deeper conceptual project. In Rosler's project, the title warns: both these descriptive systems are inadequate, each for different reasons. In other words, there is no pure image—no pure reality, no pure thing-in-itself. Each picture's true subject is absent (the people), and the project's power is in how a viewer is invited to participate in, and then reflect on, the production of stereotypes.

Bitner's title, *Listen*, similarly signals a deeper agenda: nothing is ever just about looking, or what is visible at the surface. The image? That's just one of many inadequate descriptive systems. And just as the true subject of Rosler's project is that which is conspicuously absent, *Listen* too asks us to reflect on what's not there, which is the auditory experience that accompanies our encounters with live music. But I must also add that

Fig. 6 — Martha Rosler, *The Bowery in Two Inadequate Descriptive Systems*, 1974–75.
Fig. 7 — Rhona Bitner, *The Sutler, Nashville, TN*, January 21, 2010, from the *Listen* Project.

Bitner's series, as much as it is about sound, music, and listening, is also about absence and silence. It is the photographer tossing the cloth over her head to take the photograph and then also inviting us under. It is the photographic equivalent of John Cage's *4'33"*, a symphony of silence that is inextricably about sound. *Sit with the quiet and stillness of these spaces,* Bitner seems to say. *Now, what do you hear?* In the silence, the image becomes more radiant, and—unlike the cacophony of a concert or performance photo—in the silence of Bitner's spaces we can hear our memories emerge.

I'm also continually struck by the humility of Bitner's images. The project's serial subject calls to mind the work of Candida Höfer, but Bitner's often downtrodden spaces couldn't be further from the perfect symmetry of the majestic theaters and opera houses that Höfer idealizes in her photographs. Höfer's hyper-objective images seem to celebrate both the technical feats of photography and the opulence of these elite spaces. While they too are absent of people, they are less documents of a history or experience than they are objective studies of architectural iconography. And where Höfer's works have a deliberate timelessness to them—her photographs of fin de siècle sites would have looked the same for Atget—Bitner isn't interested in any such grandeur or flawlessness. Bitner's photos show us exactly what time has wrought on these spaces to the extent that sometimes what we see is merely observation of what's left. And where Höfer has an almost godlike wide-angle objectivity in her photos, Bitner takes us to a space and marks herself in each image's location and date, as though to say, simply, "I am here, in this place, on this day, this is what is left."[2]

Of course, all modes of photography—not just conceptual practices—work to inspire both imagination and memory, as we reflect on what is *there* but no longer *here*. Sontag, that poet of the photographic image, wrote, "A photograph is both a pseudo-presence and a token of absence. Like a wood fire in a room, photographs [. . .] are incitements to reverie."[3] Sontag is one of many who have mused on photography's mnemonic quality, and how memory or memorialization can be a balm to loss and melancholy. To an extent, the images that compose *Listen* participate in that

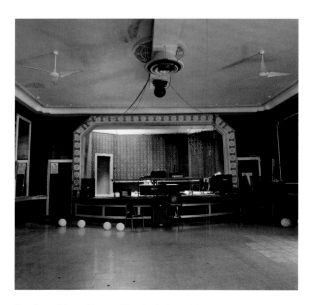

Fig. 9 — Rhona Bitner, *The Arch Social Club, Baltimore, MD*, August 13, 2013, from the *Listen* Project.

legacy. They have been described as "lonesome" and "heartbreaking" and evoking "material as well as spiritual loss."[4] Even if Bitner adamantly maintains that she is not bringing any nostalgia to the project ("I'm just trying to hear the sounds of the rooms as I find them"),[5] her photos absolutely do trigger a sense of longing. We can't help but suspect that many sites will soon be torn down for a new corporate arena, or condos, or a highway, and their histories will become buried in the footnotes of Wikipedia entries and in the graves of those who knew them best. And in the wake of a global pandemic that deprived people around the world of live music performances, and in a time when we are still told to avoid crowds and maintain social distancing, how are we not to look at these images and ache for the simple, sometimes squalid pleasure of packing tightly around a subterranean stage, smelling the bodies of strangers, and feeling the tingle of too-loud bass and reverb move through our bodies? Yes, that pining is inevitably there, even if is not part of the artist's intention,

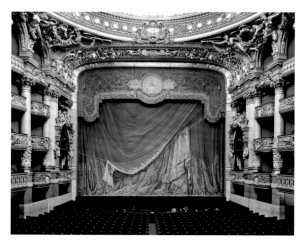

Fig. 8 — Candida Höfer, *Palais Garnier Paris XXXI*, 2005.

2 — Rhona Bitner quoted in Lenny Kaye, "Rhona Bitner: Listen," exhibition publication for *Static Noise: The Photographs of Rhona Bitner* at University Art Museum, California State University, Long Beach, January 27–April 15, 2012.
3 — Susan Sontag, "In Plato's Cave," in *On Photography* (New York: Farrar, Straus and Giroux, 1977), 12.
4 — Amanda Petrusich, "A Visual History of Rock and Roll, Room by Empty Room," *NewYorker.com*, August 22, 2016.
5 — Sam Gnerre, "Photo exhibit an homage to legendary music venues," *Daily Breeze*, February 2, 2012.

but Bitner's photographs also bear a relationship to melancholy that is very much outside our visual encounter. With *Listen*, Bitner homes in on photography's capacity to conjure sound. What actually is the relationship of reverie to sound? Of the photographic image to sound? If the word *imagination* is grounded in visuality—the image-making of the mind—what does it mean to imagine or remember sound? With their title, *Listen*, Bitner's images stir our auditory memory function and force us to reckon with the lopsidedness of memory—that is to say, the disproportionate weight we give to vision and visual experience.[6]

Elsewhere in our visual memory banks, on the threshold between conscious and subconscious, is the home of the uncanny. I suspect I am not alone in experiencing a feeling of strange familiarity in looking at these photos and sensing that I have been in some of those spaces. Some, it's true, I have been there, though I can't quite tell you when. Others linger in the uncanny lobby of the mind: I feel I have seen that white piano in the wood-paneled bunker, but then again, those glass-block windows don't seem to fit. And, come to think of it, wasn't it a Hammond B3 I heard in the space I am thinking of? And yet it feels like a space I've been in. Another university auditorium harks back to my first-ever concert, but I know for a fact that was elsewhere. Red curtains, red stages, red carpet and upholstery, red lights—after looking at Bitner's photos for a while, the ruby glow itself feels familiar.

There's one photograph in particular—a nondescript photo of an interior bedroom—that takes on the uncanny in curious dimensions while offering a layered testament to the project's themes. At the center of this image, a lamp stands on a bedside table and casts strange shadows on the wall behind. To the right, we can make out the edge of a large bed, with a bright red upholstered headboard, and to the left, a crimson slipcover coats an old armchair. At ten o'clock is a painting of a woman in a billowing ruby robe. "It took me seven years to get into that private loft," Bitner told me. "I wrote a letter every year."[7] What was driving her to this otherwise commonplace site? With this image we step into a private loft, but we also step into what was once Max's Kansas City, the storied New York City nightclub that was a prized hangout for a who's who list of musicians and artists in the late 1960s into the '70s—a site where countless

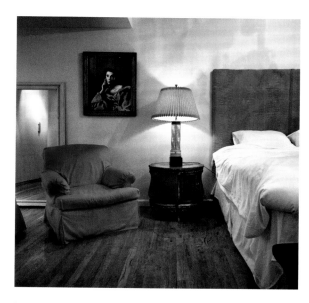

Fig. 10 — Rhona Bitner, *Max's Kansas City, New York, NY,* September 14, 2013, from the *Listen* Project.

musicians got their first exposure in New York, where you might find Andy Warhol and his Factory entourage in the back room, or Adrian Piper doing a performance piece, or, in later years, glam rock and punk rock dominating the stage. With an almost forensic sensibility, Bitner positioned the camera where the audience would have been, looking toward the stage that would have been, or rather, once was, behind that wall. It is a relatively unremarkable image, but the punctum (to borrow a coinage of Roland Barthes) —the accidentally poignant, telling detail—is the portrait hanging on the wall. That image is a painted reproduction of a famous portrait of Sarah Bernhardt by the early French photographer Nadar. The French stage actress, known for her vivid, flamboyant style, effectively embodies the idea of performance—here, her image is a cipher for a larger conceptual project that drives Bitner's work. The Nadar reference, too, coincidental as it may be, casts a connection to the history of photography, linking Bitner's project to that of Nadar and so many others. This work absolutely participates in photography's effort to index the world around us, and in doing so to show us what *is*, and, often in a recuperative sense, what *was*.

6 — In calling out this asymmetry, it's also worth acknowledging the technological advancements that have made our phones handheld memory banks, further reinforcing the predominant function of memory as one of calling up images.
7 — Rhona Bitner, email to the author, September 22, 2021.

In Bitner's project, however, this occurs through calling on our sensory memory and affective memory. By showing us silent images—sites rich with sonic histories but depicted void of any people or performance—we are invited to "listen" and attune ourselves to their other frequencies, and where each one of us might intersect with them. What are the histories that we can sense? And how many events and histories can a single image hold? In *Listening to Images*, Tina M. Campt writes of a practice of listening to "quiet photography" as a way of attending to the unspoken relations that structure them. In doing so, Campt reminds us that, because of how sonic frequencies operate, sound can be *felt*, even if it can't be heard. While Campt's project takes up a different subject within the realm of photography, she too conjures a project of attending to the haptic and the sensory—to "affective

Jim Osterberg (later known as Iggy Pop) who saw the Doors perform at the University of Michigan intramural sports auditorium in Ann Arbor—were inspired to further transform the landscape of American rock and roll. This richness of encounter, and the enduring importance of *presence*, is what drives a series like *Listen* and ultimately ensures that the frequencies that can be heard—and felt—with each image are as unlimited as each work's viewers.

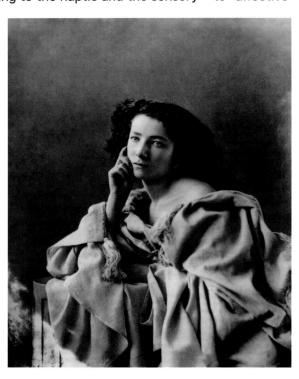

Fig. 11 — Félix Nadar, *Sarah Bernhardt*, 1865.

frequencies" and how they "move, touch and connect us to the *event* of the photo."[8] Within Bitner's work, these frequencies are both affective and forensic— personal histories merge with cultural histories and we are reminded that American music (like all forms of culture) is made not only by those in the spotlight, but by those who gave life to the performances as the audience, and in some cases—like the young

8 — In Campt's generative reading, this "listening" is an encounter that entails looking at and reclaiming photographic archives picturing dispossessed Black subjects of the African diaspora. In considering the sonic and haptic frequencies of vernacular images like passport photos, ethnographic photos, early twentieth-century studio portraits, and convict photos, Campt engages "the discourse of fugitivity in African Diaspora studies and black feminist theory" to understand the shared and contrasting features of vernacular photography and compulsory image-making practices. See Tina M. Campt, *Listening to Images* (Durham, NC: Duke University Press, 2017), 9–11.

Jason Moran

Afterword

"You have to play the room."

This is a phrase that touring musicians often use because they spend countless hours performing in rooms they don't quite know. If a heavy metal band goes into a concert hall like Carnegie Hall, they'll find that the acoustics of a stadium and a room built for acoustic music are extremely different. The artist is charged with finding a way to "play the room." This generally means: learn the parameters of the room just enough so that your music can be felt by the audience. Throughout Rhona Bitner's portrayal of these spaces, we see the rooms often vacant —yet entirely vibrant.

These spaces are vessels for the mystic brew that entices us all as listeners. Our ears are the antennae, and the sound we digest changes our bodies. When we depart the venue for the outside world, we buzz with a sense of renewal. The best bands, in the best rooms, work this way, collaborating with the physical space—similar, say, to a sommelier pairing wines with courses.

Some of our favorite rooms to hear live music in have a sensibility that is just as rich as the musician's repertoire. If Muddy Waters sits in a juke joint stomping the blues, the floorboards help us feel Waters's intentions. When Shirley Horn sings "I've got the world on a string" from the basement of the Village Vanguard in New York, the maroon curtains around the stage hug each phrase. The proximity of the audience to her electrifies the Vanguard as well: they must descend a red-walled staircase to reach the underground venue in Manhattan's Greenwich Village. I think of this basement as a pulpit of sorts where a kind of freedom bursts off the stage, sparking the changes America needed, and still needs.

It is not that each of these spaces aspires to be the other. The rooms coat themselves with an identity. As a performer, it is what I notice when I walk into a room to perform: Where are the walls? What is on the floor? Where are the speakers? What is the sight line? Each of these questions can be answered logically or sonically. I choose music to find a place in the space.

Recently, I was in a discussion with the house music DJ Carl Craig. He talked about finding the right tempo of a room. Considering the distance of the wall to the speakers, he selects music that allows the sounds enough time to hit the back wall without creating a slapjack that distorts in the room. There are frequencies that, when amplified, awaken and create a buzz in the entire space. In Bitner's images, I see not only the spaces where bands play, audiences cheer, staff serves booze, but also the spaces where those frequencies live and manipulate.

Spanning the country, Bitner gives us a sense of the many ways sounds and bodies unite. Someone, or something, has to be the caretaker of these spaces.

Bricks from the Lenox Lounge demolition site.

A few years ago, I was living in Rome for the summer. History, in its violent complexity, is on full display there. Archaeologists continue unearthing past civilizations. In America, I can watch a bulldozer demolish the Lenox Lounge in Harlem without any irony. Out of disgust, I went to the demolition site and asked one of the construction workers for a few bricks. He passed some to me, and I keep them to this day because I know these spaces alter history.

The music of Billie Holiday or John Coltrane that worked the Zebra Room in the back surely unlocked many a listener. A few months after collecting those bricks, I returned to the demo site and was heartbroken that not only had the building been flattened, but excavators had dug beneath Lenox Avenue, uprooting a history in Harlem. Today, a Wells Fargo bank occupies the space, with no irony, from cultural currency to economic currency, just as the East Village's Fillmore East is also a bank now.

Listen is so vital. These venues are repositories. They catch and harness energy and history. When an audience walks in to hear a band, they have to trust the room just as much as they trust the artist. We all walk into the space to listen together. The sound artist and deep listening innovator Pauline Oliveros took me and my band through a deep listening retreat. She made us aware of the layers of hearing. There is sound within our bodies, sound in the room we sit in, and sound outside the room. We listened to each layer for twenty minutes. What we were made conscious of was the orchestra that exists when we are "silent." With no need to say it out loud, Oliveros instructed us: "Be conscious of all of the sound around you before you make your own first sound." It was a profound lesson.

Within each of these spaces photographed for *Listen*, there is a cacophony of how the space works. It is no coincidence that the letters in the words *silent* and *listen* are the same. Reminders of the power of silence and thankful for the sounds that listeners capture in their bodies. It is imperative to experience space and sound over and over again, in a variety of rooms, to learn a variety of traditions. From the front porch to the concert hall, find the vibration.

Biographies

Rhona Bitner is an American artist. Since the 1990s, her conceptually rigorous and carefully researched studies of aspects fundamental to theater and performance have generated thoroughly crafted, comprehensive bodies of work. Bitner's photographs have been widely exhibited and are included in the public collections of the Art Institute of Chicago; the American Society of Composers, Authors, and Publishers; the John & Mable Ringling Museum of Art; University Art Museum, California State University, Long Beach; the Wellin Museum, Hamilton College; and the Whitney Museum of American Art. In France, her work is represented in the Centre National des Arts Plastiques; Fonds National d'Art Contemporain; Fonds Regional d'Art Contemporain, Bretagne; Maison Européenne de la Photographie; and the Pinault Collection. She has been awarded grants and fellowships including a Pollock-Krasner Foundation Grant and a New York Foundation for the Arts Fellowship in Photography. She is on the faculty of the School of the International Center of Photography in New York.

Iggy Pop is considered to be the godfather of punk and is widely acknowledged as one of the most dynamic stage performers of all time. Punk bands past and present have knowingly or unknowingly borrowed from him and his late-1960s/early-'70s band the Stooges. His recordings include the Stooges' three seminal LPs, two solo albums cowritten and produced by David Bowie in an epic musical alliance, and more than thirty subsequent studio and live records. Iggy and the Stooges were inducted into the Rock and Roll Hall of Fame in 2010, and he received a Grammy Lifetime Achievement Award in 2020. Supporting his mission of introducing new music to open-minded listeners, he hosts a popular weekly radio show, *Iggy Confidential*, on BBC Radio 6 Music.

Jon Hammer is a writer, researcher, and painter living in New York. He plays rhythm guitar in the hillbilly boogie band Susquehanna Industrial Tool & Die Co.

Greil Marcus's *Mystery Train* was published in 1975. Since then, he has written many books, including *Lipstick Traces: A Secret History of the Twentieth Century* (1989), *Under the Red White and Blue*: *Patriotism, Disenchantment, and the Stubborn Myth of the Great Gatsby* (2020), and most recently *Folk Music: A Bob Dylan Biography in Seven Songs* (2022). With Werner Sollors, he is the editor of *A New Literary History of America* (2009). He was born in San Francisco and lives in Oakland, California.

Natalie Bell is curator at the MIT List Visual Arts Center, where she has organized solo exhibitions of Matthew Angelo Harrison and Raymond Boisjoly (both 2022) as well as Leslie Thornton and Sreshta Rit Premnath (both 2021). She was previously associate curator at the New Museum, New York, where she organized more than a dozen solo exhibitions and cocurated several major group exhibitions. She has edited or coedited more than a dozen exhibition publications and has published widely.

Jazz pianist, composer, and artist **Jason Moran** is the artistic director for Jazz at the Kennedy Center. He has released seventeen solo recordings for Blue Note Records and Yes Records. He scored Ava DuVernay's *Selma* and *13th*, and the HBO film adaptation of Ta-Nehisi Coates's *Between the World and Me*. His visual art is in the collections of MoMA, SFMOMA, the Walker Art Center, and the Whitney Museum of American Art. Moran was named a MacArthur Fellow in 2010. He teaches at the New England Conservatory.

Éric Reinhardt is the author of eight novels translated into several languages, including *Cendrillon* (2007), *L'Amour et les forêts* (2014), and *Comédies françaises* (2020). He also wrote the scenario for a ballet by Angelin Preljocaj for the Bastille Opéra, *Siddhartha* (2010), as well as a play, *Elisabeth ou l'Équité* (2013). Adept at artistic exchanges, he has participated in reading performances with the group Feu! Chatterton, the singer Bertrand Belin, the electronic musician Maud Geffray, and the ballet dancer Marie-Agnès Gillot. In 2015, he filmed the latter in *Je vous emmène*, a short film created for 3e Scène, the Paris Opéra's digital platform. In 2018, Reinhardt wrote the scenario and musical architecture for *Et in Arcadia Ego* for the Opéra Comique, staged by Phia Ménard. An independent art book editor, he has conceived books with Gilles Clément, Christian Louboutin, Fabienne Verdier, Dolorès Marat, Magnum Photos, and Rudy Ricciotti.

The *Listen* Project

"This map hung on my studio wall from
the first to the last day of the *Listen* Project.
The pins represent the cities I visited." —R. B.

Acknowledgments

Little did I know, on that crisp October day in 2006 when Hilly Kristal and BG Hacker welcomed me at CBGB, what an odyssey lay ahead. The years that followed have so far been the time of my life.

This project would have been impossible without the assistance and generosity of venue owners, general managers, stage managers, lighting engineers, marketing staff, and others at each stop on that odyssey: people who opened their doors and allowed me to listen and record their part in American music history.

Special thanks to AEG/Goldenvoice; Ronald M. Druker and Crossroads Presents; Jerry Mickelson and JAM Productions; Live Nation; and MSG Properties for making time for me in their overbooked schedules.

Lee Foster, thank you for believing in this project when it was just a few notes on a page.

My gratitude to Ryan Aigner, Gary Ault, Ken Aymong, Michael Bailey, Jeff Barnes, Dan Boyd, Kenneth Broad, Steve Burdick, Joanne and Gordon Cicala, Lisaann Dupont, Robert Dye, Leo Early, Roy Ellis, Brad Evans, Mark Ferber, Trevor Fletcher, Jerry Foley, John Fry, Tom Gaff, Rodney Hall, John Howell Jr., Roland Janes, Paul Knauls, Tom Lubinski, Al Machera, Cristina McGinniss, Henry McGroggan, Boo Mitchell, Keena Moore, Susan Morrison, Tisa Mylar, John Nixon, Red Paden, Knox Phillips, Lucas Reiner, Tim Samuelson, George Scott, Luca Serra, Maureen Sickler, Allen Sides, Jeff Smith, Joe Smith, Lina Stephens, Rudy Van Gelder, Brian Wagner, Bob Watkins, Dan Workman, and Gail Zappa. Sincere appreciation to Kristina Khokhobashvili, Lt. Sam Robinson, and the men at *San Quentin News* for a morning full of grace and laughter. I wish I could include a companion volume to thank everyone by name. Please know how much I treasured meeting each of you and how grateful I was for your warm welcome.

I deeply regret the venues I didn't get to before they vanished. Given the vastness of this subject, I can only hope that rather than encompass or exhaust it, I have been able to suggest its dimensions and variety, to illuminate it, and to convey the fascination it holds for me.

To Ben Folds, Chris Frantz, Alain Johannes, Rob Lind, Elvis Perkins, Lee Ranaldo, Sonny Rollins, Gerry Roslie, Chris Stein, Chris Walla, and especially Lenny Kaye—my admiration and appreciation. What an honor.

To Marc Blondeau and Philippe Davet, who believed in the idea of *Listen* when I could barely articulate it, and who have supported my work unfailingly all these years: *mille et un mercis.*

To Michael Zilkha, who enabled me to reach the end of this journey: thank you for everything.

And thank you to the Fondation Cartier pour l'art contemporain; the Elizabeth Foundation; the New York Foundation for the Arts; the Pollock-Krasner Foundation; the School of the International Center of Photography; the Sharpe-Walentas Studio Program; and Ucross Foundation for essential support and help.

This book exists because Éric Reinhardt believed in it and turned a dream into a reality. For your keen eye, knowledge, and patience, thank you, always.

To Natalie Bell, Jon Hammer, Greil Marcus, Jason Moran, and Iggy Pop, humble thanks for your eloquent words and support.

To Charles Miers, Catherine Bonifassi, Victorine Lamothe, and the team at Rizzoli, my deep gratitude. To Marine Gille, Jean-François Gautier, Camille Bonnivard, and Clément Regard, my sincerest appreciation for creating this beautiful volume.

Thank you to Blondeau & Cie, Étienne Bréton of Saint Honoré Art Consulting, Cabinet Corinne Hershkovitch, and Kristina Larsen for their efforts in realizing the French edition.

I am blessed with wonderful and generous friends and colleagues, all of whom had a hand in the making of Listen. You encouraged and supported me with unfailing enthusiasm and humor. Thank you Tracy Adler, Ondine Angarola, Debi Ani, Bill Arning, Emmanuel Barbault, Paul Bárcena Mapi, Virginie Bergeron, Bruno Blanckaert, Linda Blum, Nicolas Bos, Anne Cartier-Bresson, Jon Cancro, Gonzalo Castillo, Élodie Cazes, Dorothée Charles, Dominique and Maurice Choueka, Rob Colvin, Mike DeCapite, Antone DeSantis, Sharon Dynak, Julia Fish, Jane Friedman, Linda Gammell, Kuan Kimm, Min Kwak, Wendy Laister, Suzanne Nicholas, Patrick Owens, J. John Priola, J. Fiona Ragheb, Richard Rezac, Michele Roche, Paul Rutner, Barry Schwabsky, Christopher Scoates, Claire Sherman, Olivier Souchard, Bryan Thomson-DiPalma, Pascale and Olivier Thoral, Gilles Tiberghien, Bob Tilden, Sydney Weinberg, and Howard Yezerski. And in loving memory of Craig Duffy and Amy Lipton.

BG and Tamar Hacker, dearest friends, there are no words now known or yet to be invented good enough to convey my thanks. I could not have done any of it without you.

Above all, thanks to my intrepid friends and assistants on the road. It was a joy to have you by my side: Allison Bolah, Jarrett Chen, Guillaume Dufresnoy, Grant Gutierrez, June Hony, Gary Martin, Susie Mayr, Joseph Pescatore, Seymour Max Polatin, Daniel Ramirez, Matt Sauer, Sasan Sotoodehfar, Erin Walters-Bugbee, and to my excellent studio manager, Akshay Bhoan.

To my dear parents, rock stars in their own right, who taught me to never give up. Leon and Shula Bitner, this book is for you with all my love.

Finally, I made this project for the musicians—past, present, and future—who enrich our lives with their talent. Thank you for a lifetime of marvelous listening.

—Rhona Bitner

Credits

Listen

First published in the United States of America
in 2022 by Rizzoli International Publications, Inc.
300 Park Avenue South
New York, NY 10010
www.rizzoliusa.com

Texts: Natalie Bell, Jon Hammer,
Greil Marcus, Jason Moran, and Iggy Pop

Editorial and Artistic Direction: Éric Reinhardt
Graphic Design: we-we.fr

Publisher: Charles Miers
Editorial Director: Catherine Bonifassi
Editor: Victorine Lamothe
Production Director: Maria Pia Gramaglia
Managing Editor: Lynn Scrabis

Editorial Coordination: CASSI EDITION
Vanessa Blondel and Lili Doillon

Image Processing: Les Artisans du Regard, Paris

Printed in Italy

2022 2023 2024 2025 / 10 9 8 7 6 5 4 3 2 1

ISBN: 978-0-8478-7257-2
Library of Congress Control Number: 2022930889

Visit us online:
Facebook.com/RizzoliNewYork
Twitter: @Rizzoli_Books
Instagram.com/RizzoliBooks
Pinterest.com/RizzoliBooks
Youtube.com/user/RizzoliNY
Issuu.com/Rizzoli